JOHN HUNT

Brian O'Connell is a former chairman of Shannon Heritage, the State company which operates a network of cultural tourism venues, such as Bunratty Castle, in Counties Limerick and Clare. In that role, and as a member of the Hunt Museums Trust, he had the opportunity to observe the economic and cultural legacy that John Hunt left to the region. He has spent years travelling world-wide researching the life of Hunt and his impact internationally on the art world.

He initiated the publication in 2004 of an oral archive on regional development pioneer, Brendan O'Regan. He is the co-author of 'In Bello Fortis', a biography of Tipperary man General Sir William Parker Carrol, published in Spanish by Fundacion Gustavo Bueno, Oviedo, May 2009.

JOHN HUNT

THE MAN,
THE MEDIEVALIST,
THE CONNOISSEUR

BRIAN O'CONNELL

THE O'BRIEN PRESS
DUBLIN

First published 2013 by
The O'Brien Press Ltd.,
12 Terenure Road East, Rathgar,
Dublin 6, Ireland.

Tel: +353 1 4923333; Fax: +353 1 4922777
E-mail: books@obrien.ie.
Website: www.obrien.ie

ISBN: 978-1-84717-138-2

1 2 3 4 5 6 7 8
13 14 15 16 17

Cover picture credits: (Back left and right), Dr
Philiip Nelson Bronze Altar Bell and Romanesque
Enthroned Madonna © Hunt Museums Trust
and Hunt Museum Ltd., (Front flap, top), The
South Solar, Bunratty Castle, Photograph © Liam
Blake courtesy of Real Ireland Design; (bottom),
Caherconlish Late Bronze Urn © Hunt Museums
Trust and Hunt Museum Ltd. (Back flap), The
crannog at Craggaunowen, Co Clare, courtesy of
Shannon Heritage.

Printed and bound in Poland by Białostockie
Zakłady Graficzne S.A.
The paper in this book is produced using pulp
from managed forests

Dedication

This book is dedicated to the people of the rural community around Lough Gur, County Limerick, who, amidst the wartime deprivations of 1940s' Ireland, reached out to embrace a pair of strangers, John and Putzel Hunt, who had come by chance to live among them. The warmth with which they accepted the couple, led the new arrivals to stay in Ireland, with all the benefits that were to follow from that decision for their adopted homeland.

Acknowledgements

There are many individuals to whom I would wish to express my sincere thanks for their help and co-operation in writing the life story of John Hunt.

I should firstly express a particular word of appreciation to Trudy Hunt, and to commend her most admirable determination to ensure that the true story of the kindly father she lost in her teenage years was revealed. Without the benefit of her unstinting co-operation, quietly maintained over many years, and her faith in my ability as an author to carry out the task required, this book may never have been written.

A most special debt of gratitude is owed to Dr Peter Harbison for his recollections of working closely with John Hunt, and giving me the benefit of his knowledge on a wide range of issues. In particular, his guidance on archaeological matters, and advice as an experienced author himself, was quite invaluable and much appreciated, as was his most generous input of time in reading the various drafts of chapters as they emerged.

Several individuals who knew John Hunt personally were happy to share some of their memories of him from decades earlier. I am particularly grateful to the late Sandy Martin and former Sotheby's director, Howard Ricketts who provided time for several interviews in this regard. Others who shared personal recollections included: Cian O'Carroll, Brendan O'Regan, Pa Crowe, Liz Wilson, Maurice Linnell, Sister Regina O'Brien, Grace Cantillon, Mary Geary, Joan Duff, Des O'Malley, Jim Burke, Jane Williams, John O'Connor and David Davison.

Staff members of the following institutions were most helpful in facilitating access to their records and dealing with my queries: The V&A Art Library; The V&A Museum Archives; The British Museum; The British Library; The Fitzwilliam Museum, Cambridge; The Courtauld Gallery, London; The Hammersmith and Fulham Archives and Local History Centre; Watford Central Library; Hertford Library; The Somerset Heritage Centre, Taunton; The Wiener Library, London; Library of Durham Cathedral; The Walker Art Gallery, Liverpool; The Burrell Museum, Glasgow; Imperial War Museum; The Churchill Archives Centre, Cambridge; The National Archives, Kew; King's School Archives, Canterbury; St. Bartholomew's Hospital Archives; The Portman Estate; English Heritage, Newcastle upon Tyne; Royal Institute of British Architects, London; British Film Institute; Stadtarchiv and The Jewish Museum, Worms, Germany; Stadtarchiv, Mannheim; The Swiss Federal Archives, Berne; Limerick City Library, The National Museum of Ireland; The National Library of Ireland; RTÉ Archives; Military Archives, Dublin; Registry of Deeds, Dublin; National Archives of Ireland; The Jewish Museum, Dublin; The National Gallery of Ireland; Boole Library, University College, Cork; The Walters Museum, Baltimore; The Virginia Museum of Fine Arts, Richmond; City of Vancouver Archives; The New York Public Library; Hearst Castle Collections, California. Particular mention should be made of Victoria Reed, Curator for Provenance at the Museum of Fine Arts, Boston, and Christine Brennan, Collections Manager, Department of Medieval Art and the Cloisters at the Metropolitan Museum of Art, New York who were most helpful during extended visits. Pat Wallace, Director of the National Museum of Ireland, made available the Museum's files on John Hunt and the Emly Shrine and Naomi O'Nolan facilitated access on several occasions to the records and images held in the Hunt Museum, Limerick. University of Limerick history graduate, Grainne O'Brien, assisted with research on certain Irish archives.

Victoria Dickenson, Harriet Allen, Rosemary Bolster and Richard Hunt, all relations of John Hunt in England, provided extensive genealogical records on the Hunt family as well as some personal recollections. Cian O'Carroll, John Quinn, Dr Edward Walsh, Jerry O'Keeffe, Dr Joyce O'Connor and John Ruddle read parts of the book in draft and provided much invaluable advice and encouragement.

Special appreciation is due to John Ruddle, CEO Shannon Heritage Limited, and Alan English, Editor, The *Limerick Leader*, for the support of their organisations towards the publication of the life story of someone who made such a significant contribution to the Mid-West region of Ireland.

Michael O'Brien of The O'Brien Press took a leap of faith in the project and was most supportive of my efforts. Other members of The O'Brien Press staff were at all times most helpful in getting the book to publication.

Finally, I should like to thank my wife Phil and my daughters Anna, Jennifer and Stephanie for their forbearance on occasions and their encouragement at all times, and their assistance in reading and editing drafts of the text.

Contents

A Yetholm Shield in the Hunt Museum, Limerick.

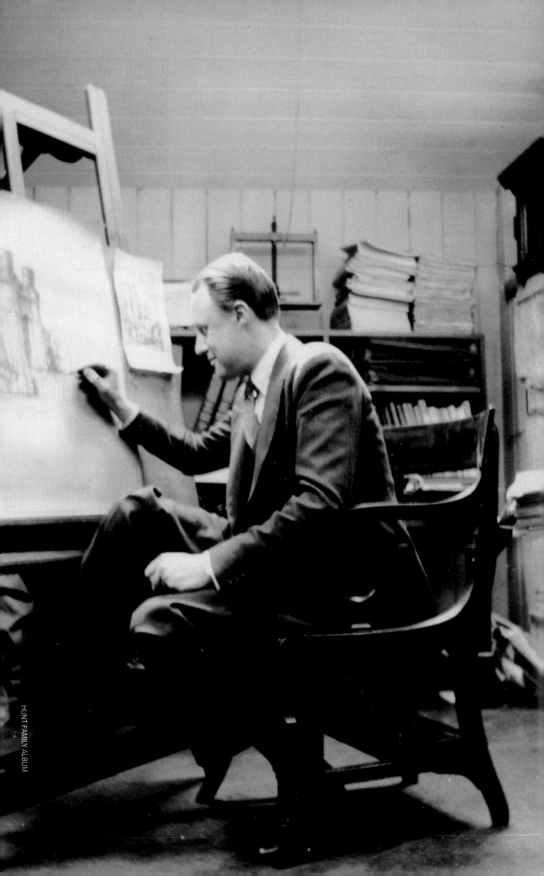

Introduction

The numbers are dwindling of those who personally knew John/Jack Hunt (1900-1976), and I count myself fortunate to be among them. Brian O'Connell, in contrast, never met him, but has brought him back to life in this engaging biography of a man whom I knew to be kind, benign and so willing to share with others his immense store of knowledge on matters medieval. I only had the pleasure of John's company during the last decade of his life. However, because he was not one to boast of his achievements, Brian's book has opened my eyes here to many details that John never told me about, concerning his family background, his earlier career and his wide circle of friends, both within and outside the world of art.

These latter did not include Nazi-sympathisers, and one of Brian O'Connell's main achievements, although it only occupies a minor part of his text, was to liberate John Hunt's good name and reputation from totally unfounded slurs cast upon them in certain quarters in recent years. In contrast, Brian shows how he strove desperately, but, sadly, in vain, to get one particular family of Jews out of Germany in the months preceding World War II. Equally, Brian has disposed of the rumours circulating about John Hunt's alleged involvement in spiriting the Emly Shrine out of Ireland to the United States – simply by discovering who the real culprits were. From my personal knowledge, I can confirm that such a deed would have been totally contrary to Hunt's ideals, for he always insisted that Ireland's treasures should remain in the country. He put his money where his mouth was by acquiring important Irish Bronze Age objects in England and repatriating them to Ireland. Many such objects are now displayed in the great Hunt Collection in Limerick, the contents of which John and his wife Gertrude generously gifted to the Hunt Museums Trust to hold on behalf of the people of Ireland.

The Hunts have merited a worthy champion in Brian O'Connell. He was

given free access to the rather slim collection of family papers by John Hunt's daughter, Trudy, and his daughter-in-law, Patricia, whose husband, John Jr, fought so valiantly, during the last few years of his all too short life, to house and manage his father's collection.

Dr. Peter Harbison

CHAPTER 1

The Early Years

Many people live all their lives without a glimpse of greatness.
He was given many talents and … used them to the full … he
achieved a fantastic amount in one lifetime.
Sybil Connolly[1]

As the light began to fade on a bleak January day, in a graveyard on the edge of Dublin Bay, the mourners huddled for shelter against the penetrating westerly winds. It was clear that a person of some importance in Irish life was being laid to rest. The Taoiseach, Liam Cosgrave, who had personally expressed his deepest sympathy to the widow of the deceased, was represented at the removal by his aide-de-camp, and the President of Ireland, Cearbhall Ó Dálaigh, had attended the funeral mass.[2]

John Durell Hunt, medievalist, scholar, collector, and art dealer, had died on 19 January 1976 after a short illness, and was interred that cold afternoon in St Fintan's Cemetery, Sutton, near his former home in Howth. He was survived by his widow, Putzel, and his children, John Jr and Trudy.

In Ireland, through his involvement in the Arts Council and the National Monuments Advisory Council, Hunt had been at the centre of the art world for a quarter of a century. He had helped to restore two medieval castles in County Clare, which formed the nucleus of the biggest heritage attraction outside Dublin for foreign visitors. His private collection of artworks had been vested in the Irish state, and plans were well underway to open a new museum in Limerick to display a selection of its most valuable pieces.

In London, Joe Floyd, Chairman of Christie's, wrote: 'He will leave a gap which can never be filled in the fast vanishing ranks of old fashioned true connoisseurs'.[3] Across the Atlantic, Richard Randall, museum director and long-time friend wrote: 'I am sad indeed … for the world which will only realise slowly what a man it has lost.'[4] This view of Hunt's international standing was echoed by James White, Director of the National Gallery of Ireland: 'Whenever I have travelled in great museums abroad, the names of John and Putzel were an immediate introduction to deep scholarship and knowledge – they truly have been of the inner circle of medievalists who speak a language that can only be learnt over 60 years of application'.[5]

Objects which Hunt had once owned or dealt with were displayed in many of the world's temples of artworks, including the Victoria and Albert Museum in London, the Metropolitan Museum of Art in New York, the Museum of Fine Arts in Boston and the Burrell Museum in Glasgow. He had been the principal advisor on medieval art to Sotheby's in London for almost two decades and had undertaken commissions for art collectors including Randolph Hearst, Harry Guggenheim and the Aga Khan.

Yet, despite his prominent public profile, there was something 'ever elusive' about John Hunt.[6] How had he made the money to acquire his collection of artworks in a world where most collectors had either inherited wealth or had become wealthy by succeeding in large-scale commercial activity? In Ireland, where everyone knew, or thought they knew, all about their neighbours, who exactly was this man who spoke with the cut-glass vowels, so clearly polished in an English public school?

In the immediate aftermath of his death, Hunt was widely claimed as being Irish-born. The *Irish Press*, in reporting his passing, described him as: 'Mr. Hunt who came from near Newmarket-on-Fergus, Co. Clare', a claim repeated by *The Irish Times*.[7] An obituary published later that year in the *North Munster Antiquarian Journal* described him as a native of 'Thomond', the ancient name for the Mid-West region of Ireland, and Limerick City was identified as his birthplace in two other learned accounts of his life.[8]

However, references to Hunt's background in the local press in Limerick,

where he had first lived after coming to Ireland, made it clear that he was not from the area. One report stated that he was 'born in England … of Irish extraction and his one great ambition, long since realised, was to live in the land of his forefathers'.[9] Later reports specifically identified this Irish descent as having come through his parents, both said to be from Thomond. One claimed that: 'the late John Hunt was the son of John Hunt from Co. Limerick and Effie Jane Sherry who came from near Newmarket-on-Fergus'.[10] A similar assertion of his father's Irish lineage can be found in official files dating from his very earliest years in Ireland.[11]

This acceptance of first-generation Irish ancestry was reflected in a publication launched by the Hunt Museum Trust in 1993, which claimed that 'John Hunt's family was from Limerick', and a display board on the first floor of the Hunt Museum in Limerick stated categorically that 'John Hunt's parents were from Limerick and Clare'.[12]

Yet, although Hunt did have Irish ancestors, none of them were from Limerick or Clare and neither he nor his parents or grandparents had been born in Ireland. Hunt's immediate antecedents were all English, mostly from an upper middle-class professional background. However, one maternal great-grandmother was indeed Irish-born and, almost certainly, Hunt shared the mistaken belief, held by several other Hunt family members in England, that one paternal great-grandmother was an Irish governess.

It is perhaps not too difficult to understand why Hunt's background was so widely misunderstood. His holding of an Irish passport, his deep interest in Irish history and archaeology and his occasional use of 'Ó Fiach', the Irish version of his surname, would undoubtedly have created a widespread assumption that either he or his immediate antecedents were Irish. While there is no evidence of deliberate dissimulation by Hunt about his background, he perhaps felt entitled to make reference to an Irish pedigree, given that he considered himself to some degree to be Irish.

He may also have had pragmatic reasons for emphasising such origins at the expense of his English roots when he first came to live in County Limerick, since the Irish War of Independence, which had ended less than twenty

years previously, had left a certain residue of hostility towards English people in some quarters, particularly in rural areas.

Whatever the reasons, the mystique surrounding Hunt was to have unexpected repercussions almost three decades after his death when questions about his background were raised. Among the more attention-grabbing of these was the suggestion that 'further investigation is needed to establish the reasons and circumstances by which John Hunt obtained Irish citizenship and an Irish passport, especially in the light of unconfirmed suspicions of espionage activities by the Hunts.'[13]

John Durell Hunt, known to family and close friends as 'Jack', was born on 28 May 1900 at 28 St John's Road, Watford, Hertfordshire, England, a thriving commuter town to the north of London. His father, John Hunt Sr, had married a local woman, Effie Jane Sherry, in 1899 and settled in Watford, commuting to his newly-established architectural practice in Marylebone.

Jack's paternal grandfather, Frederick William Hugh Hunt, was also an architect and surveyor who had specialised in church architecture. At the relatively early age of thirty-one he had been appointed as surveyor of the estate of Viscount Portman, one of the largest landowners in London and, from 1885, was employed as the Portman Estate agent.[14] He lived with his wife Mary Louisa (née Vinall), in a series of substantial residences, with a retinue of a half-dozen staff to care for his household and family of twelve children.[15] At the time of Jack's birth, Frederick Hunt's home was a splendid five-storey Georgian house at 18 Dorset Square, Marylebone.

Jack's eight Hunt uncles were typical of the emerging middle class, and quite successful in their chosen careers. His father, as well as a younger brother, Robert Vinall, studied architecture, and two others, Edward Lewis and Lawrence Charles, qualified as doctors. Andrew Allan, having studied at Oxford, became an Anglican clergyman, and Walter Simeon was an engineer. Frederick Giles, a Cambridge law graduate, became a business confidant and

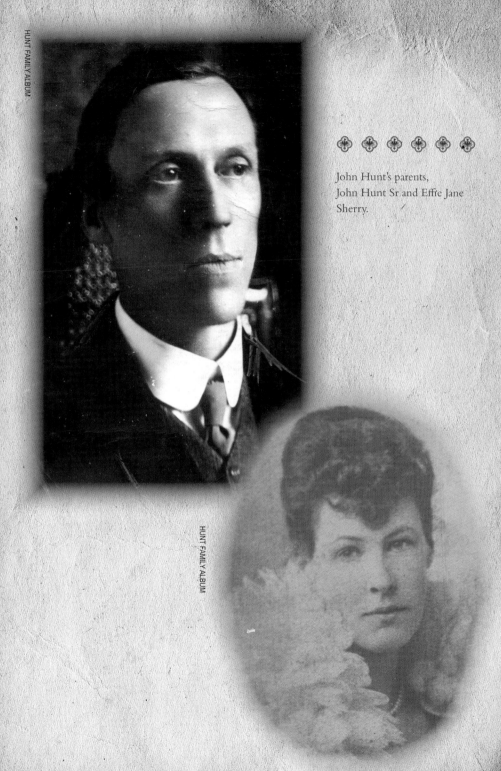

HUNT FAMILY ALBUM

HUNT FAMILY ALBUM

❖ ❖ ❖ ❖ ❖ ❖

John Hunt's parents,
John Hunt Sr and Effie Jane
Sherry.

15

legal advisor to Lord Leverhulme, Chairman of Lever Brothers, then the largest company in Britain. The youngest son, Arthur George, was killed in action with the Irish Guards in northern France, just seven days before the end of the Great War.[16]

Jack's maternal grandfather, Henry Sherry, was a solicitor, based at Gray's Inn in the City of London, who acted for the family estate of his wife, Gertrude (née Harwood). They lived in a substantial villa residence in Watford, with its own gate lodge and accommodation for several full-time staff.

The family environment that Jack was born into mirrored the discipline and rigour of the late Victorian era. A new set of middle-class values with a strong emphasis on religion and education prevailed, along with a 'children should be seen and not heard' attitude to childrearing which involved leaving home at an early age to board at a small preparatory school where religion was a major feature. This was followed by attendance at a prestigious public school and later by professional training or entry to Oxford or Cambridge.

Jack grew up in Watford 'among his mother's people'. 'Granny' Sherry had a deep interest in family history and insisted that Jack, her first grandson, was given 'Durell' as his second name in honour of some heroic British Naval ancestors. Jack's pride in his Durell ancestry was reflected when, for a number of years in his early thirties, he adopted the double-barrelled surname of 'Durell-Hunt'.

Granny Sherry was a source of both family wealth and a sense of Irish ancestry. Her mother, Annie Jane Blake (b.1816), had been born in Tuam, County Galway, Ireland, and was a member of one of the most prominent of the Norman 'tribes' who settled there in the late twelfth century. Granny Sherry had inherited a considerable fortune through her mother, who had succeeded to an estate valued at £210,000 in Fulham, a Middlesex village that within a few years would be absorbed into the suburbs of west London.[17] Many of the roads built when the holding in Fulham was developed were given names with family associations, with Blake Gardens and Tyrawley Road recalling connections with Galway and Mayo respectively.[18]

The reality of Irish ancestry on the maternal side of Jack's family was

reinforced on the Hunt side, although this particular belief in Irish roots was almost certainly without foundation. His grandfather, Frederick Hunt, born out of wedlock in Bedworth, Warwickshire, was fancifully believed by some family members to have been the outcome of a liaison between some unidentified member of the family of Lord Portman and an Irish family governess. The official records present a more mundane picture of both of these notions. Frederick Youle Hunt (b.1841) was registered as the son of Sophia Hunt and Frederick Youle; the latter believed to be an English merchant who traded in South America. Sophie Hunt's ancestry can be traced for at least four generations in Warwickshire and Leicestershire, with no Irish links.

It is not clear how the young Frederick was able to break free from the rigid class structure of mid-Victorian England, attend boarding schools, and obtain an apprenticeship as a trainee architect. Possibly one of the two wealthy families for whom his mother worked in Bedworth paid for the education of Sophia Hunt's only son. The legend of the Irish governess, however, persisted and several of Jack's Hunt relations recalled that: 'we always grew up with a sense of being part Irish and felt that Jack living in Ireland was really him just going back to his roots'.[19]

Jack's father, John Hunt Sr, entered his father's office in 1891 and eventually established his practice at 24 York Place, Marylebone, in partnership with John Hudson, another former apprentice of his father. The practice prospered reasonably well, receiving several commissions on Portman Estate properties, before it was dissolved in 1910, after which John Hunt Sr worked generally as a sole practitioner. It may well have been during the preparation of initial designs for a new church at Callowland, in Watford, that he met his future wife. The young couple were married and set up home in Watford in 1899. Their first-born son, Jack, arrived in May of the following year. A second son, Hugh Sacheverell (Claude), was born four years later, followed by four daughters, Joyce (b.1905), Rosalie (b.1907), Eila (b.1910) and Greta (b.1912).

As the Edwardian era and the new century dawned, the architectural profession in Britain enjoyed an elevated status, with commensurate financial rewards, its members combining technical knowledge and artistic sensitivity to create the edifices appropriate to a country at the heart of the world's greatest empire. John Hunt Sr might reasonably have expected that similarly propitious circumstances might continue for his own family.

As had been the case with his father and uncles, Jack was sent, at around the age of six, as a boarder to a primary school for boys, Greencroft, where he remained for three to four years.[20] He then attended the Tower School at Dovercourt, Essex, a preparatory school that focused on preparing young boys for entry examinations into public schools. There is an indication in a letter he wrote to his mother from here that he had already begun a fledgling career as an antiquarian, referring to 'being one off the set of regimentals'– probably a collection of military insignia and uniforms.[21] In September 1914, having been awarded an exhibition (scholarship) that covered some of the school fees, he went as a boarder to The King's School, Canterbury, one of the longest established and most prestigious public schools in England.

The King's School was located within the precincts of Canterbury Cathedral, a splendid example of the earliest Gothic architecture in England, which must have left indelible marks on the impressionable fourteen-year-old. Sir Hugh Walpole, who had attended King's School some sixteen years previously, wrote:

> I would be ready to wager that no boy who lives for a number
> of years under the protecting wing of one of the loveliest
> cathedrals in the world is likely to be quite unaffected. Something of that grey stone, of those towering pinnacles, of the
> music and the green lawns and the flowering May will be a
> gift from his parents for all his life.[22]

Based on his later life, in which he was to display a respect and awe for

❖ ❖ ❖ ❖ ❖

Jack, aged five, with his mother
and baby brother, Claude.

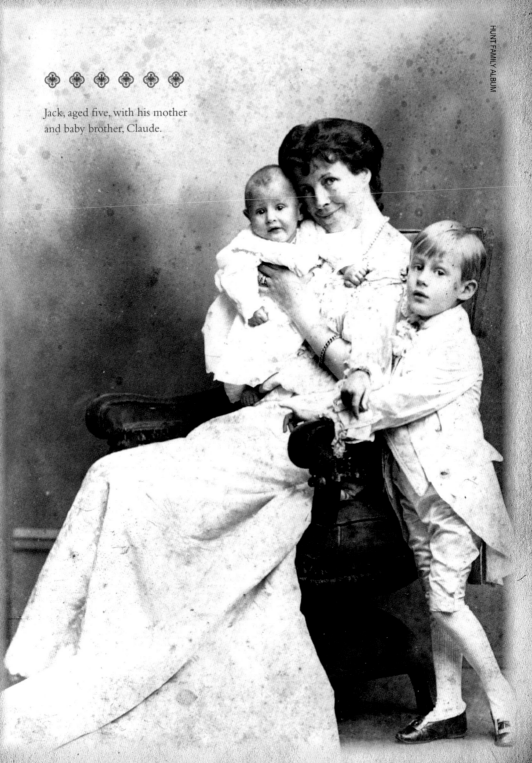

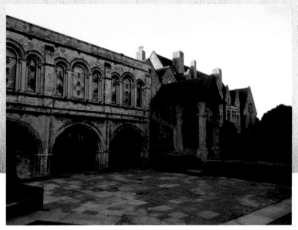

The King's School,
Canterbury, which Jack
attended as a boarder
from 1914 to 1916.

Gothic architecture, a love for medieval artworks, and a deep and abiding interest in religion, one can certainly make the case that Hunt was 'not unaffected' by his time at King's School. Apart from the magnificence of the great buildings, the cathedral contained one of the finest displays of medieval artwork anywhere in Britain. The stained glass dated from the twelfth century and was designed to relate the stories of the Bible to illiterate pilgrims. These memories were to remain with Hunt throughout the years. When, in later life, he came into possession of six of the twelfth-century stained glass panels from the cathedral, they were numbered among his most cherished possessions.

The deep spirituality that Hunt displayed in adult life was stimulated by the pervading religious ethos of the King's School, which specialised in producing men intending to become Anglican clergymen and placed an emphasis on Religion, Greek and Latin. The school day began at 6am with a psalm and litany, and ended at 5pm with a psalm, litany and a prayer, with attendance at matins and vespers required on Sundays and feast days. One can picture the young Jack going to vespers from a description sketched by a former pupil:

> A crocodile of boys, shuffling silently through dark vaulted
> passages along well worn flag stones on our way into the
> school chapel in the Cathedral on dark Sunday evenings in
> winter. There was a ghostly, celibate purity about this, inspired
> by thoughts of generations of monks who had walked there

before us way back in medieval times.[23]

The narrow focus of the education at King's was described in mocking tones by Somerset Maugham in his thinly disguised autobiographical novel, *Of Human Bondage*:

> The masters had no patience with modern ideas of education, which they read of sometimes in The Times or The Guardian, and hoped fervently that King's School would remain true to its traditions. The dead languages were taught with such thoroughness that an old boy seldom thought of Homer or Virgil in later life without a qualm of boredom; and though in the common room at dinner one or two of the bolder spirits suggested that mathematics were of increasing importance, the general feeling was that they were a less noble study than the classics. Neither German nor chemistry was taught, and French only by the form masters.[24]

Hunt frequently made classical allusions in his correspondence and was later comfortable in translating Latin inscriptions on art objects. However, according to the King's School archives, he did not make much impact academically in his first year, finishing fifteenth out of sixteen.[25] Nevertheless, he did win the Lower School Divinity prize and did much better the following year, finishing eighth out of twenty and again winning a prize, this time for English Literature. The only other record of his time at King's School shows he was a member of the Officers Training Corps in the rank of private, with his army logbook noting that he completed '93½ parades'. Having joined King's just weeks after war had broken out, the traumatic impact of the conflict would have coloured Hunt's experience of life at the school throughout his time there. The school magazine carried regular accounts of the 750 former scholars who were fighting in the war. [26]

In sending his eldest son to The King's School, John Hunt Sr cannot have anticipated the devastating financial impact that war was to have on his profession as an architect. Construction was largely suspended due to a shortage of materials and, with little work available, many architects enlisted in

the armed forces, to the extent that the profession 'lost a disproportionately higher number of its youngest and brightest stars on the fields of Flanders'.[27] Hunt Sr had acquired The Manor, a substantial property on Church Road in 1913, but, just four years later, moved to a much smaller property, Ryecroft, at nearby Park Road.

Jack left after only one term of his third year, in December 1916, and, with a view to preparing for a career in medicine, was enrolled at the Educational Institute of Scotland in Edinburgh. Here he sat the 'Preliminary Medical Examination in General Education recognised by the General Medical Council', passing in English, Latin and French in July 1917 and in mathematics in January 1918.

In June 1918, following the raising of the age of conscription to fifty-one, the forty-eight-year-old John Hunt Sr volunteered for the army. This must have strained family finances further as his children were dependent on him as the family bread-winner. John Hunt Sr was assigned to the Rail Construction Troop of the Royal Engineers as a sapper (private) and threw himself diligently into his work. He was shipped out to Salonika in Northern Greece, just five days before the Armi-

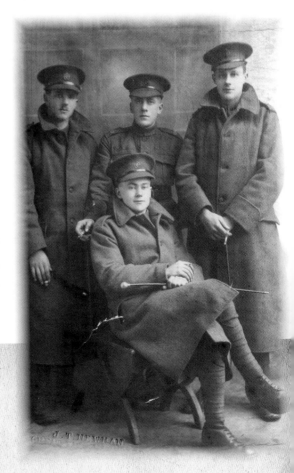

Jack and his army colleagues. He is standing, far right.

HUNT FAMILY ALBUM

stice, and was injured a few weeks later. He was shipped home in March 1919 and demobbed, whereupon he set out to re-establish his practice.

Meanwhile, in October 1918, Jack joined the Inns of Court Officer Training Corps based at Berkhamsted, Hertfordshire, some fifteen miles from the family home in Watford. He transferred in May 1919 to the Kings Royal Rifle Corps and was clearly proud of his army service, keeping several photographs of himself in uniform as lifetime mementoes. He sent one such photograph, published as a postcard, to his younger brother Claude, then a pupil at the King's School in Ely, near Cambridge.

Having completed almost two years of military service, Jack chose to study to become a doctor. On 6 January 1920 he entered St Bartholomew's Hospital (Bart's) in London, signing the register as 'J. Durell Hunt'. He successfully passed examinations in pharmacy, biology, physics and chemistry over the next two years. There is no record, and at least three conflicting explanations, as to why he didn't complete his medical studies. Jack described himself as 'a spoiled doctor … so interested in art that I spent my time in the British Museum and such places instead of studying at medicine'.[28] Richard Marks, biographer of William Burrell, wrote that Hunt had to abandon medical studies for health reasons.[29] It has also been suggested that 'his father could not provide tuition fees'.[30] Whatever the reasons, sometime, probably in 1924, Hunt left Bart's Hospital and took the plunge into the world of art and antiques.

Hunt could hardly have received a better apprenticeship than the next eight years in two closely related businesses, White Allom & Co. and Acton Surgey Ltd. Working with both firms must have given him some idea of the business opportunities in supplying works of art to wealthy private collectors and museums with access to substantial funds. It also provided him with a network of contacts with potential suppliers and buyers of such objects, which stood him in good stead in the years to come and gave him, albeit in a junior role, exceptional exposure to one of the most buccaneering eras in the antique trade.[31]

After the Great War, the antiques trade in Britain had expanded at an

unprecedented rate. With the widespread demolition of country houses providing dealers with 'an undreamt-of mountain of salvage … the antique shop became ubiquitous in country towns and larger villages'.[32] Overseas demand added to this trade since *arriviste* Americans sought to decorate their new mansions with oak panelling, ceilings, chimney pieces and mantelpieces, salvaged from the demolition of country houses in Britain and abandoned chateaux in France. In the best-known novel of Roaring Twenties America, F Scott Fitzgerald describes Gatsby's mansion as having 'a high Gothic library, panelled with carved English oak, and probably transported complete from some ruin overseas'.[33] Further demand came from the curators of American art museums who began to install period rooms as part of their display of European decorative arts. Many such rooms were shipped across the Atlantic from the demolition of some 500 properties in Britain alone in the interwar years, and the export of period rooms became a particular specialisation of White Allom & Co.[34]

White Allom was, at the time, the world's most famous interior decorating company,

A Gothic Canopied Seat of exceptional rarity: dated and bearing the Arms of the Earls of Ormond.

Ancient Works of Art *Fine Panelled Rooms*

ACTON SURGEY Ltd

3, Bruton Street, Bond Street, W.1

Telegrams "ACTGEY, WESDO, LONDON."

A 1930s' advertisement from Acton Surgey.

manufacturing interiors in London and New York to complement the archi-
tectural salvage recovered from the properties of the European aristocracy.
The firm's principal, Sir Charles Allom, had received a knighthood from
King George V in 1913 for the re-decoration of Buckingham Palace and
acted as antiques advisor to Queen Mary.[35] In New York, White Allom's most
high-profile project involved designing and furnishing the rooms to display
the art collection of steel magnate Henry Clay Frick. There
is no record as to what exactly Hunt's role was in White
Allom, although he may have been engaged in sourc-
ing architectural salvage.[36] There have been references
to him having studied architecture, probably during his
time at White Allom where other staff members took
architectural courses at the Regent Street Polytechnic.[37]

By the late 1920s, Hunt had moved on to work as a
buyer with Acton Surgey, a business formed in 1926
by two former White Allom employees, Gladstone
Murray Adams-Acton and Frank Surgey.

The firm's major break was obtaining the
contract from Sir William Burrell, the most
prolific art collector in Britain at the time,
to refurbish the interior of his man-
sion at Hutton Castle in Berwickshire,
Scotland. This project was to last for
more than six years and the supply of
furniture, fittings, tapestries and sculp-

tures by Acton Surgey, particularly
many large items of architectural sal-
vage, such as oak panelling and stone
chimney-pieces, brought the firm's

The prolific art collector, Sir William
Burrell, who became Hunt's most
important client in the pre-war years.

final bill to Burrell to more than £57,000.

During the next six years, Acton Surgey also sold hundreds of pieces of
architectural salvage to American customers, including at least a dozen com-

plete period rooms. Customers included not only wealthy businessmen but also some of the larger museums, and the Philadelphia Museum of Art and the Metropolitan Museum of Art in New York were among the earliest institutions to erect period rooms in their galleries.

Surgey had started to source pieces of medieval and Renaissance art f[...] Burrell, who had signalled his wish to develop this area of his collection [...] the business of refurbishment of period rooms began to decline, a signific[...] part of the firm's business soon involved buying and selling art objects, particularly from the medieval and Renaissance period.

Sometime in 1932, Hunt was given notice by Acton Surgey, presumably due to a decline in the sale of period rooms to the US after the Wall Street stock market crash of October 1929. Whether Hunt would have chosen this particular time to establish himself as a dealer is unclear, but it was probably inevitable that, sooner or later, he would have set up in business on his own. The experience and the knowledge of the art trade that he had gained in the previous eight years was now to be put to good use. Working as a buyer for Acton Surgey, Hunt developed contacts with many members of the aristocracy who, in changed economic circumstances, were disposing of works of art that had been in their families for generations.

It is also likely that he had already made his first contact with an important future client, Alice Head, who was William Randolph Hearst's personal representative in Europe, and the biggest single buyer of period rooms from Acton Surgey during Hunt's time there. Hunt would also have seen the potential market in America for European artworks, not only from wealthy private individuals but also from art museums. He initially came into contact with the Metropolitan Museum of Art in New York through his role in Acton Surgey, and was there when the latter firm concluded a significant deal with the Philadelphia Museum of Art to supply an oak panelled Tudor period room in 1929.[38]

Hunt's interest in the restoration of ancient castles may also have been sparked by projects undertaken by his employers, including Hearst's medieval castle in Wales and the interior of Sir William Burrell's castle in Scotland.

Most importantly, Hunt had made a very favourable impression on Burrell, a person who would soon become his most important client.

From the 1920s we can also glean the first evidence of Hunt's deep spirituality. At the age of twenty-five he converted to Roman Catholicism and was baptised on Christmas Eve, 1925 at the London Jesuit headquarters.[39] Just over a year later, on 11 February 1927, he was confirmed by the Auxiliary Bishop of Westminster, Joseph Butt, at Westminster Cathedral. Hunt was to maintain his strong religious beliefs throughout his life and chose to reflect this aspect of his character in his work and his friendships. He 'was a man of profound spirituality. Art divorced from religion had no meaning for him. The monks who inspired the creation of the Cross of Cong would have found in him a kindred spirit. The crucifix, however artistic in design, was always for him the source of his deep abiding faith, a faith that inspired every action of his life'.[40]

During the 1920s there were to be several milestones in Jack's family life. His eighty-year-old grandfather, Frederick Hunt, passed away on 16 July 1921, leaving an estate of £12,990. Jack's father moved from Watford in 1925 to a new home, at 10 Royal Crescent in west London, where he lived with Effie and the younger family members and ran his architectural practice. He passed away at the age of fifty-nine in October 1929, leaving a modest estate valued at £2,200. Following this, Jack moved to live with his mother at Royal Crescent for a number of years.

John Hunt Sr seems to have had a good relationship with his eldest son and may have influenced him in many of his pursuits. Certainly, Jack always affirmed that it was through his father, who he described as 'an architect with a passionate interest in art and archaeology', that he originally got his love of ancient things. [41] An American journalist, who interviewed him in 1970, maintained that: 'His father, an architect and archaeologist, started (him) on the collecting jag when he was 12, after he scuffed up a flint arrowhead on an English country road.'[42] She quoted Jack's recollection of the incident: 'When I took it home my father held it in his hand and wove such a story for me of the primitive hunters who had lived there and what their life was

like, that every object I've handled since brings the same sort of thrill'.[43]

John Hunt Sr was not as successful in the field of architecture as his father, Frederick, nor did he enjoy the same level of prosperity or status. The main impression of John Hunt Sr in family lore was of someone who was artistic, not very driven, possibly indolent, and certainly not very good at making money.[44] The family oral tradition is that money was in short supply, particularly from the post–war years to the time of his death. A grand-daughter of John Hunt Sr recalled her own mother speaking frequently of her grandfather's disregard for material goods: 'he was always giving things away' and recalled a story of him arriving home one evening without his overcoat, which he had handed over to some poor person he had met in the street.[45]

Jack enjoyed an active social life as a tall, handsome young bachelor in 1920s London.[46] Photographs from that period show him dressed smartly, or in dapper outfits on the running board of racing cars. However, as we shall see later, sometime around the beginning of the next decade, his social life and career paths were to merge when he met someone who was to become his partner, in every sense of the word, for the rest of his life.

Becoming an art dealer 1933 to 1940

*Art dealers bridge the academic and the commercial worlds. They are
scholars and salesmen, custodians and collectors. They are daring and
dashing, discrete (sic) and sometimes devious bargain-hunters and
promoters. They are curious, and that is what art is about – discovery.*

Carter B Horsley [47]

Hunt started in business as an art dealer in January 1933, operat-
ing from 13 St James's Place, Piccadilly, a peaceful cul-de-sac in
'the quietest part of aristocratic London'.[48] He often styled himself 'John
Durell-Hunt', and continued to use this surname until late 1934, when he
reverted to 'Hunt'. The exclusive St James's district, with its royal residences
and gentlemen's clubs, was close to the centre of the art trade, a short stroll
from London's most exclusive galleries and antique shops, as well as the two
leading art auction houses, Sotheby's and Christie's.[49] Sydney Burney, an
'innovative gallery owner and collector in his own right' shared the premises
at St James's Place, but the two businesses operated separately.[50]

During the next seven years, the life of John Hunt underwent a radi-
cal change. At the start of the decade he had been employed in a relatively
modest position as buyer for a firm, established only three years earlier, which
dealt in architectural salvage and medieval art. He lived with his widowed

mother in a leasehold property in Holland Park, along with a half-dozen male sub-tenants, and his employers in 1932, the worst year for unemployment of Britain's 1930s depression, had dispensed with his services, leaving him without a job.

There is no evidence to suggest that he had yet made any impact on the art world. No trace of him can be found earlier than 1933 in the correspondence files of any art museum or gallery, or in the transaction records relating to any significant art object. Nor had he ever been published or quoted in any learned art publication.

Yet, before the decade ended, Hunt had established himself as possibly the most prominent dealer in medieval art in Britain. His scholarship in relation to works of art from the medieval era had been accepted by respected antiquarians, including many leading art and museum curators, for whom he had sourced precious objects which had greatly augmented their collections. There is no record of Hunt receiving any financial windfall through inheritance, yet his changed financial circumstances were reflected in the eleven-bedroom mansion he had acquired in Buckinghamshire.[51] Here he displayed many of the precious artworks that already formed the nucleus of a lifetime's

Poyle Manor, the substantial property in Buckinghamshire owned by the Hunts 1936-1946.

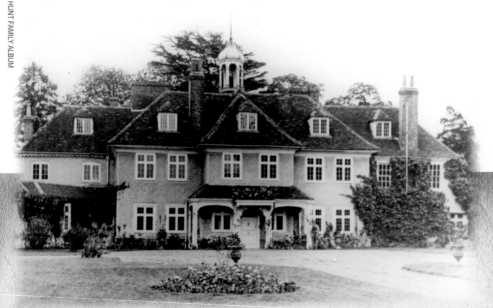

collection and entertained his clients who were, in most cases, also numbered among his circle of friends.

From the outset of his career as an art dealer, Hunt focused his efforts on objects from the medieval period, from the late years of the Roman Empire in the fourth century to the beginning of the sixteenth century. In a letter to prospective clients, he set out as the scope of his proposed activity: 'specialising in fine early Works of Art, particularly in early sculptures and metal work'.[52] A reviewer who inspected one of the first collections of objects he had for sale noted: 'The pieces to be found here are much out of the common and always difficult to come by. Mr Hunt is a keen seeker after rarities, specialising mainly in early periods'.[53]

This focus was unusual for its time and presented a significant business challenge, given the relatively limited market for such objects. While other dealers in London sold medieval pieces as part of their general trade in antiquities, nobody else, apart from Frank Surgey, one of his former employers at Acton Surgey, made it a specialisation. As one dealer commented: 'It is not an easy market to walk into as … it takes a great deal of study and patience. Pieces are rarely signed or documented, and there are so many fakes and 19th-century pastiches out there.'[54]

Medieval art had only been 're-discovered' in the middle of the nineteenth century, with art critics such as Ruskin, the architect Augustus Pugin and the pre-Raphaelite artists inspiring a renewed interest in all aspects of medievalism. Before that time, the medieval period was viewed as a dark age, in artistic terms, which had been eventually redeemed by the Renaissance. Only during the second half of the nineteenth century, and the early years of the twentieth, had significant collections of medieval art been formed by wealthy businessmen such as J Pierpont Morgan in the US and the Frenchman, Louis Carrand.

However, when Hunt set out his stall there were still many factors which lessened interest in objects from the medieval period, particularly for private collectors. One was that the great majority of such objects were religious in character, as opposed to the fine art objects crafted for wealthy patrons or

royal rulers from the Renaissance period onwards. Most medieval art pieces had been created by sculptors as an expression of religious devotion to a divine God – *ad maiorem dei Gloria* – and were used for various Christian rites or as prayer objects. In Protestant countries, such as Britain, medieval art was associated with Catholicism and, as a result, few had an appreciation of its artistic merit or any interest in collecting it.[55]

There was also the difficulty of provenance. As many medieval art objects had been dispersed through centuries of political and religious turbulence in mainland Europe and Britain, the history of their ownership was rarely known. The iconoclasm of the Reformation in the sixteenth century had led to the destruction of countless statues and religious images. In England, the majority of religious art objects were destroyed, either during the dissolution of the monasteries by Henry VIII, or the implementation of the Act against Superstitious Books and Images in the reign of Edward VI.[56] The trade of sculpting in alabaster, a soft crystalline form of gypsum suitable for carving fine details on indoor sculptures, was completely wiped out, although Nottingham had been the foremost centre of this craft in Europe for almost two hundred years.[57] Towards the end of the eighteenth century the French Revolution had led to the demolition of thousands of churches and abbeys in rural France, including such artistic wonders as the Benedictine monastery at Cluny, which housed the second largest church in Christendom.

The prevailing attitude of indifference towards medieval art was exemplified in Britain during the restoration of the windows at Canterbury Cathedral in the 1850s when much of the stained glass, crafted by some of the most skilled glaziers of the twelfth century, was removed and cast aside, to be replaced by contemporary reproductions.

Other issues, such as the size and materials of medieval art objects, discouraged widespread interest in such objects by private collectors. Many religious sculptures, designed for churches, were too large to display anywhere except in museums or in the grandest mansions. While precious metals, such as gold and silver, were frequently employed by the skilled medieval metalworkers, many of the objects were made from what were perceived as lesser materials,

such as wood or alabaster. In other cases, where more perishable materials were used, such as in tapestries or clothing, frequently all that survived were fragments of the original piece. In the context of wealthy patrons purchasing art to display in their domestic surroundings, there was no established fashion for such items amongst the growing body of interior decorators in the early decades of the twentieth century.

All of these factors meant that, for all practical purposes, the market that Hunt intended to serve was going to be mainly museums and the very largest private collectors. The potential clientele for these rare objects was unlikely to be sourced from a passing trade.

Having decided precisely what niche of the art dealing business he was going to engage in and identified his potential market, the challenge for Hunt was two-fold, namely to source the artworks and find potential clients. In both of these endeavours the evidence suggests that he was extremely successful. He was familiar with the exceptional business opportunity that the art dealer Joseph Duveen had seized in matching an extensive supply of art from Europe – mostly paintings – to meet a seemingly inexhaustible demand from wealthy Americans in the early decades of the twentieth century. He had also been able to observe close-up, through his time spent working both at White Allom and Acton Surgey, how a substantial trans-Atlantic business, running to several million pounds a year, had been created in the export of architectural salvage, including complete period rooms, to the US.

The essence of Hunt's career was his observation that, despite what has been described as 'the nineteenth-century re-discovery of European medieval art', a great supply of it was still lying unrecognised or unappreciated in churches and family collections, and that most collectors and museums, due to their limited understanding of such pieces, had little interest in acquiring it. [58] However, Hunt believed that if he could source such objects, relate the story of their artistic significance and hopefully discover some persons of elevated status in the provenance chain, there was a worldwide market to be served. In pursuing his objectives Hunt had to become a 'taste maker'. [59]

Much of the worth of an art dealer, such as Hunt, lay in his ability to

find unique sources of valuable objects through his skills at art sleuthing. As a result, there is a cloak of concealment about many of the objects he dealt with and, in the majority of cases, very limited provenance. It was universally accepted that asking an art dealer where he sourced an object was as impertinent as asking a doctor to produce the references in the medical textbooks on which he based his diagnosis of a patient. If Hunt were to disclose from whom an art treasure had been acquired, it would result in others going to the same source. Indeed, in all his correspondence with potential customers, he was never once asked where he had acquired an object, unless it was something which he had bought at a public auction. So it is not unusual to find Hunt going to great lengths to provide details on the provenance of objects during the Middle Ages, but never having to disclose where he himself might have acquired the piece three months earlier.

In the 1930s, there was no export licensing regime in the UK for objects of cultural interest and no other intrusion by officialdom in the entirely unregulated business of art dealing. Cultural goods could be freely exported from Britain, no matter what their value or importance as 'national treasures'.[60] Indeed, the inclusion, for the first time, of antiques and works of art in a wide-ranging licensing regime for exports in 1940 was not done to preserve cultural heritage, but rather to ensure the full remission of scarce foreign exchange from the overseas sale of such objects to wartime Britain.[61] Yet, even in the absence of any legislative control, there is some evidence that Hunt held the view that objects of cultural significance, in the context of national heritage, should ideally be restored to their place of origin.

As Hunt established himself in the art world, his personal life too was changing. There are no precise details as to when he first encountered a

Gertrude (Putzel) Hartmann, on the day of her First Communion, 15 April 1917.

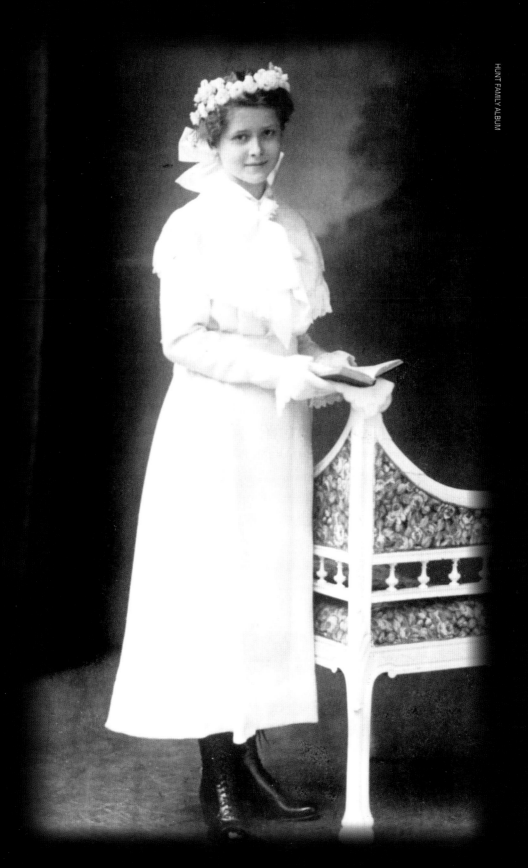

brown-haired, blue-eyed German, Gertrude Kreitz (née Hartmann), known affectionately to all as 'Putzel'. They met in London sometime after she had moved there following her application, in August 1929, for divorce from her husband of four years, Peter Robert Kreitz.[62] They may well have got together while attending an evening art course because Putzel, in a 1970 interview, made reference to 'when Jack and I were courting in art school in London'.[63]

Putzel was born on 6 February 1903 and baptised in the *Alt-Katholisch* church at Schloss Mannheim (Mannheim Castle).[64]

Sometime later her parents separated, and her mother took Putzel and her brother to live with their grandparents in the staff quarters of Schloss Mannheim where their grandfather, Heinrich Messel, was employed in the office of the District Court. Putzel's mother re-married in 1911 and moved to Baden-Baden but Putzel continued to live with her grandfather at Schloss Mannheim. Putzel's time at Schloss Mannheim awakened in her a love of art, since part of the extensive collections of the Grand-Duke Friedrich of Baden had been stored for many years in the castle cellars. While her grandfather has often been described as the curator of the collection, it is more likely, given the collections were not on public display and his background, initially as a prison officer and later as a court official, that any role he may have exercised in relation to the collection was over its security. But, living in the Schloss, one can surmise that Putzel would have had the opportunity to have regular access to view the art treasures stored there.

The chaos that swirled around Mannheim in the aftermath of the Great War and the early years of the Weimar republic left a deep impression on Putzel, then in her teenage years. Mannheim Castle became a particular target of mob outrage after the German communists, known as the Sparta-cists, took complete control of Mannheim in February 1919 and formed a Soviet Republic. *The Times* related that: 'The crowd marched on the mili-

Opposite: Jack and Putzel on their wedding day, 21 June 1933, with Jack's mother, Effie Jane and his sister, Joyce.

tary and civilian prisons, forced the entrances and released the prisoners. They then proceeded to the castle where documents, typewriters and furniture were thrown into the streets and burnt. Mannheim station was captured by the Spartacists and the town completely isolated'.[65] The authorities responded by declaring martial law and, when the army eventually regained some degree of control over the city, Putzel witnessed the execution of many of the Spartacists in the castle grounds.[66] Riots, shootings and general lawlessness continued in Mannheim for the next five years.

Apart from the normal romantic attraction, the relationship between Jack and Putzel also merged their life interests and careers. A report of one particular deal, which Putzel claimed 'set us up to begin life', illustrates that, from their earliest days as a courting couple, romance and business were intertwined: 'Jack bought … a small gilded bronze bird he had found on a barrow in a Portobello market stall' as a present for her.[67] Putzel, noticing that the bird was from the twelfth century, refused to accept it as a present and offered instead to sell it, which she did successfully in Germany where the bird was part of a celebrated ancient reliquary and, 'with the gilt bird money as a starter, the couple married

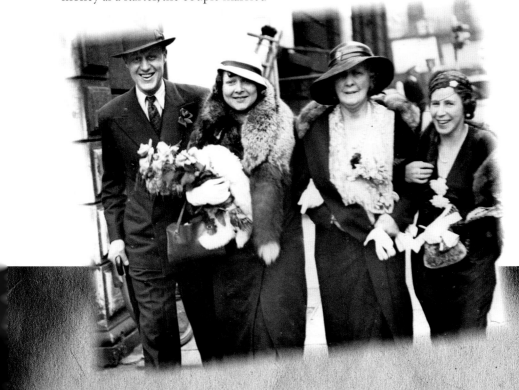

and pooled their skills for finding and identifying long-lost treasures'.[68] In another interview, she referred to their joint interest in antiquities, recording that 'when we married everyone said that it was because he wanted two statues that I had. But of course it wasn't that. We always had the same interests.'[69]

Jack and Putzel got engaged in April 1932 and, after Putzel's divorce was finalised in February 1933, the way was clear for their wedding. Because she was divorced and *Altkatholisch*, it was not possible to have the ceremony in a Roman Catholic church and so the wedding took place in Marylebone Registry Office in London. Because of Hunt's sense of spirituality and his conversion to the Catholic Church, he may have regretted the absence of a church ceremony. Their wedding, on 21 June 1933, was witnessed by Jack's mother, Effie Jane, his eldest sister, Joyce, and art dealer Sydney Burney.

The close relationship between the petite Putzel and the tall and handsome Jack was noted by many of those who knew them, as were their many differences in character. Jack was polite, charming and well-spoken but somewhat diffident, disorganised and inclined to take a back seat in his wife's presence. Putzel, on the other hand, was forceful, outspoken and gregarious, but very charming with men, particularly older men. In business they were very much a team, although Jack liaised with the larger clients, those with family heirlooms to dispose of, who would never, in the prevailing mores of the 1930s, have contemplated the idea of doing business with a woman. Both were extremely bright, with a passion for art, but Jack was more academic and Putzel more practical and commercial. Putzel did not appear to share Jack's deep spirituality.

The earliest record of Hunt's art dealing business dates from January 1933 and consists of correspondence with the Metropolitan Museum of Art in New York (known as the 'Met') in which Hunt was offering to sell a set of Nottingham alabasters. This first letter was sent to James Rorimer, then a

young curator at the Met: 'No doubt you remember me from Messrs. Acton Surgey. I have recently started in business on my own account, specialising in fine early Works of Art, particularly in early sculptures and metal work'.[70] During his days at Acton Surgey, Hunt had come into contact with several museum curators, as well as some of the larger collectors in the US and, probably observing their success with period rooms, he clearly perceived an opportunity to supply them with medieval art as well.

The letter to Rorimer is interesting in that it provides evidence of some of the characteristics of Hunt's *modus operandi* as an art dealer. Firstly, he had a particular appreciation of the material on offer, Nottingham alabasters being a lifelong interest of Hunt. Secondly, the offer was unique: 'They are the only altarpiece that has appeared on the market for the last 50 years, with the exception of the small one the South Kensington secured'.[71] And, thirdly, Hunt had an inside track to get a good deal directly from the owner: 'the alabasters are curiously enough in the possession of a picture dealer who has rather an exaggerated idea of their importance, but as I am in touch with the owner, I should probably be able to come to reasonable terms if you are interested'.[72]

In his first few months as a dealer Hunt achieved a significant breakthrough when he discovered two exceptional medieval ivory panels, which he sold to London's Victoria and Albert Museum – usually referred to as the V&A – for the considerable sum of £210. One, an English tabernacle wing (1240-50), was the subject of a scholarly paper by the world's leading expert on ivory carvings almost sixty years later, where it was stated that 'there is enough that is distinctive about it to set it apart from the mass of other gothic reliefs … it may be considered as one of the earliest English Gothic ivories to have survived'.[73]

Less than two months after his wedding, Jack accompanied his wife on an extended visit to her mother who lived with her second husband at Baden-Baden, in the beautiful Black Forest area of Germany. Having just started a business, Jack had more things on his mind than enjoying the famous mineral spas of the town and the continental sojourn became a working holiday, which lasted for two months. With Putzel as interpreter, as well as taste guide,

they visited churches, antique shops, dealers, art museums and collectors, buying art treasures which were to form the greater part of their stock-in-trade on their return to London. During the trip, they stayed in Germany, Switzerland and France and may have also gone to Austria and Italy, as they were to do on a later occasion. Later that same year they returned again to Baden-Baden for a two-week stay over Christmas and New Year and, during the summers of 1934 and 1935, came back again for extended six-week trips during which they travelled widely searching out medieval artworks.[74]

Hunt had the ability to cultivate some very wealthy clients. In a September 1933 letter to Preston Remington, a curator at the Met, he refers to a meeting in Zurich with 'my friend, Mr Philip Lehman'.[75] Lehman, a Jewish-American banker and art collector, had been assembling, with further additions from his son Robert, what was to become one of the finest collections of European art in America, now housed in the Lehman wing of the Met. The correspondence indicates that Hunt may have seen Lehman, whom he had met recently in Zurich during the latter's annual trip to Europe to acquire art objects, as his most important American client, as he later adds: 'I hope to come to America to see the Lehmans next spring'.[76]

In the letter to Remington, Hunt offered the Met some medieval treasures, the most important of which had been acquired on his extended honeymoon: 'Since leaving Acton Surgey I have been fortunate enough to discover several very important works of art of medieval and early periods … I have been really very lucky in the finds I have made'.[77] He then proceeded to give Remington considerable details on a half dozen of these finds, the most important being what he described as 'the largest and finest piece of Byzantine material, excluding Charlemagne's mantle and such things, in existence'.[78] He makes reference to having purchased two life-size figures by the greatest Lorraine artist of the Renaissance, Ligier Richier, locally claimed as a pupil of Michelangelo. These figures, representing Mary and John at the foot of the cross, were believed to be 'in all probability the only examples of Richier's work outside the Lorraine Churches', apart from thirteen other pieces in the Louvre in Paris.[79] Here, Hunt provides us with a brief glimpse

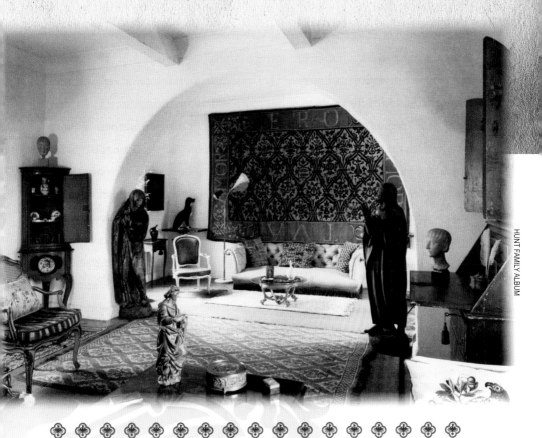

The Hunts' drawingroom in Lough Gur, with two Ligier Richier statues of The Virgin and St. John the Evangelist in foreground.

into his ability to sniff out precious treasures – he had somehow managed to persuade the church to part with the statues, telling Remington that he 'got them from the church he [Richier] made them for'.[80]

Jack and Putzel very soon gained a reputation for exceptional ability at 'art sleuthing', with a leading British art publication attributing their success in acquiring 'rare and fascinating examples of Gothic art' to being 'ardent travellers who comb out-of-the-way places on the continent with exemplary perseverance'.[81] This reputation was to last a lifetime, with an American journalist claiming years later that 'their fame as collectors with an uncanny sense of divination is a legend'.[82]

Finding sources in continental Europe for many of the artworks he traded

was a significant element in Hunt achieving success as a dealer. A review of provenance records in museums of some 300 pieces that passed through his hands during the pre-war period shows that more than forty percent had been acquired outside England, mostly from France and Germany.[83] This was to set him apart from most other London-based dealers whose objects were mainly sourced in Britain.

Despite Hunt's expectations of doing business with American art museums, it would be some twenty years before he made any significant sales to these institutions, which were to become important clients from the 1950s onwards. Nevertheless, he continued to develop relationships with many of the curators on their visits to Europe and regularly sent them details and photographs of objects which he had for sale.

He did, however, have limited success with important American collectors. In 1936 he sold, to an agent of William Randolph Hearst, a valuable collection of twenty-two ancient Greek vases a day after he had purchased them, for £330, from the Dean and Chapter of Durham Cathedral.[84] Intriguingly, in the Hearst warehouse card at the time, there is no reference to the collection having come from Durham Cathedral, but instead as

The Shulman Painter, Mixing Bowl, Greek/ South Italian, 4th Century BC.

being previously owned by a 'Mrs A Hunt, Loose, Kent'.[85] As Loose is the tiny village where Hunt's mother then resided, it could be presumed that a certain subterfuge occurred to disguise the provenance of the vases, possibly at the behest of the initial vendor.

Hunt also sold several pieces to Philip Lehman and his son Robert. These included an embroidered cover which he sold to Philip in 1936 and a mid fifteenth-century jewelled pendant, reputedly owned at one time by Mary Queen of Scots, and drawings by leading artists of French, Flemish and German origin, sold to Robert between 1936 and 1938.[86]

In early 1934 Hunt moved from St James's Place and set up a gallery a short distance away at 30c Bury Street in Mayfair, just around the corner from the Christie's headquarters on King Street. The location of the gallery on Bury Street meant that there was 'passing trade' in the sense that buyers visiting Christie's, Spink's or nearby antique shops would find it convenient to drop in to Hunt to see if he had anything new in his specialised field. However, the vast bulk of his time was spent not behind a counter but out in

John Hunt's stand at the Antique Dealers' Fair, 1934, displaying some of the wares of his Bury Street premises.

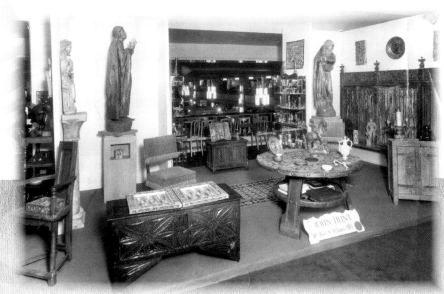

HUNT FAMILY ALBUM

the field attending auctions of the contents of large houses, or meeting others with works of art for sale, whether they be auction houses such as Sotheby's or dealers with barrows on the Portobello Road. In addition, he spent considerable time in libraries and museums researching the background of the objects that he either had for sale or was hoping to acquire.

Hunt set up his gallery at a time when dealing in antiques was becoming established as a trade. In the face of the economic woes of the early 1930s, and the decline in buying power of so many wealthy collectors following the Wall Street crash of October 1929, the British Antique Dealers' Association had organised the first large antiquities show, described as the *Art Treasures Exhibition,* at Christie's in King Street in October 1932. The criteria that defined 'antiques' as objects more than a hundred years old was set at the first *Antique Dealers' Fair and Exhibition* in July 1934.

In the 1930s, Hunt's main market was that of wealthy private collectors in Britain and continental Europe and, to a lesser degree, museums with collections of medieval objects. A key breakthrough in establishing himself as a dealer occurred when he became a trusted agent for the most prolific art collector in Britain at that time, someone who 'no one in Britain during his lifetime or since has been able to touch … as a collector'.[87] William Burrell, a member of a prominent family of ship owners from Glasgow, first met Hunt in 1932 when he was working for Acton Surgey. 'Burrell quickly formed a high opinion of his abilities and, when the firm gave Hunt notice and was unwilling to give Burrell his address, he went to the trouble of tracking him down'.[88] Their first recorded deal was in November 1933, and for the next six years Burrell became Hunt's most important client.

The Hunts were to develop an exceptionally close association with Burrell, described by Putzel as 'one of the great experiences in my life'.[89] She went on to contrast Burrell's renowned caution in his dealings with most people he encountered in business and the art world: 'first of all he didn't trust anyone', with the rapport which he eventually evolved with herself and Jack: 'he believed in my judgement … he had such complete faith which we were thrilled about, you know, we were just so happy – Sir William believes in us!'[90]

In the same interview, Putzel described how an early clash between Burrell and herself on the issue of haggling over price may have helped to define the relationship: 'He asked the price, it must have been twenty pounds or something and he said I'll give you fifteen … that's what he did to everybody; I think part of the fun in his life was bargaining. I said, "No, Sir William, if we are coming to any agreement to work together it'll be much better for both of us if we never bargain". He gave me a look … he looked down underneath the glasses and said "Umph all right"'.[91]

Today, the Burrell Museum, with over 8,000 objects, is considered to hold the finest collection in Britain assembled by a single individual. There are few collectors who can stand comparison with Burrell in scope and breadth. His collection includes paintings, furniture, tapestries, ivories and bronzes from around the world, ranging from the pre-historic eras up to the twentieth century. It even incorporates Romanesque stone archways from the collection within the structure of the museum itself. The chief strength of Burrell's collection is the late Gothic and early Renaissance works of art from Northern Europe. Hunt's role in helping to create the collection was recognised by the Keeper of the Collection, William Wells, in a letter written to Hunt five years after Burrell's death, in which he said: 'I am more than impressed by how much the Collection owes to you for some of its finest pieces'.[92]

According to Richard Marks, the first Curator of the Burrell Museum, both Jack and Putzel were counted among the seven specialists, an inner circle of tried and trusted advisors, who acted as Burrell's agents in different areas of his collecting. Hunt filled this role in the fields of medieval and Elizabethan furniture and *objets d'art* and, along with the other 'insiders', was 'as close to Burrell as any other individual outside his immediate family'.[93] Marks noted that: 'Burrell was already an important collector of medieval tapestries, furniture and stained glass before he became acquainted with Hunt, but his purchases of the smaller *objets d'art* of the period 1300-1530, particularly Limoges enamels, ivories and bronzes, only attained any significance through Hunt's agency'.[94]

Hunt's relationship with William Burrell was a key element in his com-

mercial success, in that it gave him a steady stream of income. In all, he sourced some 275 objects for the Burrell Collection between 1934 and 1957 at a cost of £45,000, and more than eighty percent of that sum (around £34,700) was spent in the five year period between 1935 and 1939. In most cases Hunt had already sourced the objects and was selling as principal, but in others he was acting as an agent buying on Burrell's behalf, for which he was paid an average commission of about five percent. If we assume Hunt enjoyed a modest mark-up of twenty percent on the objects that he sold as a principal, this would still have given him an estimated £1,200 per year from his dealings with Burrell alone, certainly more than he might have expected to earn had he continued on his planned medical career and entered general practice in Britain.

Hunt's most important role in forming Burrell's collection was undoubtedly in sourcing late medieval tapestries. He provided him with twenty such items, mostly woven in France, Flanders and Switzerland in the fifteenth century, at a cost of £18,000.[95] The most valuable tapestry depicted the mar-

Tapestry depicting the marriage scene of Mary of Burgundy to the Holy Roman Emperor, Maximillian I in 1477.

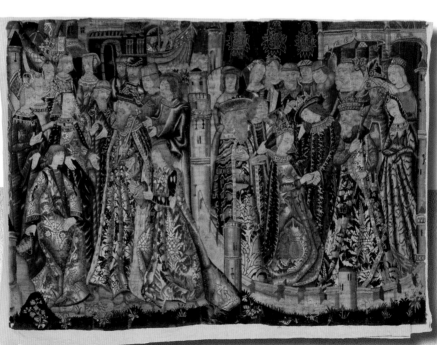

riage scene of Mary of Burgundy to the Holy Roman Emperor, Maximillian I in 1477, a significant historical event that brought Burgundy and the Netherlands into the Hapsburg Empire.

Hunt seldom revealed any details about the immediate source of the tapestries, several of which had been in his own collection for quite some time, including *The Camel Caravan*, a large piece (12ft x 21ft) that spent a year in the drawing room of the Hunt home at Poyle Manor in Buckinghamshire.

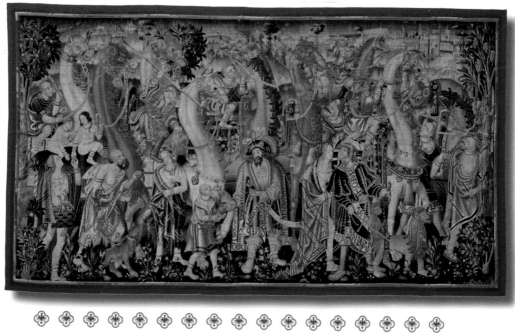

The Camel Caravan Tapestry

Burrell himself considered that the tapestries were the most valuable part of the collection, a view endorsed by experts in the field: 'In some areas, notably medieval tapestries and stained glass, it (the Burrell Collection) is second among British Collections only to the V&A'.[96]

Possibly the best known object Hunt sold to Burrell was a small copper alloy plaque from the Pitt-Rivers Collection, found in 1833 in the Temple Church in London 'during some of the repairs which have of late taken place in that edifice' and generally known as the 'Temple Pyx'.[97] Dating from the

early twelfth century, it is suggested to depict three Roman soldiers guarding Jesus's tomb at the Holy Sepulchre who had fallen asleep during the Resurrection. It was probably attached to the end of a pyx, a small shrine containing the consecrated host, and is usually attributed to England.[98] The nose-pieces on the helmets are similar to those of the warriors shown on the Bayeux tapestry, and other details such as the kite-shaped shields, the pointed shoes and dress details have been a subject of great interest to antiquarians. Marks suggests that Hunt overcame Burrell's lack of interest in items from the Romanesque period and persuaded him to purchase the item by appealing to his patriotism: 'if he didn't acquire it, it would certainly be snapped up by an American museum or private collector'[99]

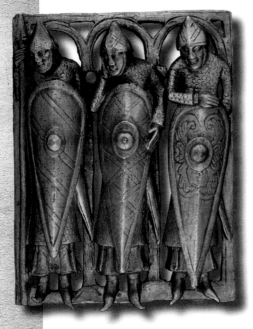

The Temple Pyx

The other objects sold by Hunt to Burrell covered a wide spectrum of art from the medieval period including such objects as French ivories, Limoges enamels, English alabasters, Gothic candlesticks and carved Flemish wood panels. The provenance of objects was not always known when purchased and Hunt seems to have had an interest in providing such information even after he had sold the item to Burrell. Despite the expertise of both Hunt and Burrell, one piece, a Tau cross in ivory purchased for £260 in November 1938, was subsequently shown to be a forgery.

From his earliest days as a collector, Hunt's passion for art meant that he had a strong attachment to many of the objects he acquired and sometimes refused to sell them at any price, even to such an important client as Burrell. One of these was an English ivory, *Enthroned Virgin and Child* (1290–1300),

known from its colouring as the 'Brown Madonna'. It had been acquired by Putzel, who gave it to Jack as a birthday present in 1932.[100] After Hunt's death, Putzel sold this piece to The Cloisters collection at the Met for a six-figure sum and its significance in medieval art is reflected by its description on the Met website: 'Long hidden in private collections, this ivory sculpture is one of the great masterpieces on view at The Cloisters'.[101]

It is reported that Burrell was anxious to acquire this piece and, having failed to persuade Hunt to part with it, asked him to find another Madonna.[102] Eventually, in early 1936, Hunt sourced a French boxwood figure of *Virgin and Child* (c.1320) and sold it to Burrell for £500.[103] Burrell's wish to acquire certain objects which Hunt would not sell, but instead sourced a comparable replacement, explains why many items now in the Hunt Collection in Limerick have companion pieces in the Burrell Collection.[104]

Unlike Hunt, Burrell had no academic proclivities and never published anything on the objects in his collection. Although a wealthy man, he spent less than £1,000,000 in total in building his collection, with an average expenditure of £20,000 a year between 1911 and 1957.[105] This was achieved by pursuing bargains and by careful planning of the tactics to be employed at auctions, in partnership with his shrewd selection of agents, such as Hunt. Burrell also made use of Hunt's knowledge of medieval needlework to help him avoid buying objects that had been subject to extensive additions or restoration:

The Ivory Brown Madonna.

'Gertrude Hunt recalls how Burrell had her husband crawling over tapestries and carpets to try to get a precise estimate of the amount of re-weaving they contained'.[106]

Another important collector who Hunt gained as a client during his early days in Bury Street was Dr Philip Nelson from Liverpool, 'a learned and respected antiquarian and one of the most important British collectors of the inter-war years'.[107] Born in 1872, Nelson was a medical doctor who had become a full-time collector at a relatively young age and, like Burrell, came from a family of successful ship owners. Unlike Burrell, however, Nelson was highly academic and had close associations with Liverpool Museum, which purchased more than half of his collection of classical and medieval antiquities on his death in 1953. He was also a founding member of the archaeology department at Liverpool University, which awarded him a PhD in 1930 for his research on medieval painted glass.

Nelson's collecting was carried out on a much smaller scale than Burrell's, but Hunt was his most important source of antiquarian objects in the years leading up to the war. In 1935 he purchased an altar cruet from the Pitt-Rivers collection at a cost of £100 and, in 1939, a miniature gold crown ornamented with emeralds and rubies for £115, which Hunt recorded as having been 'dug up in 1772 from the pavement outside the White Tower, at the Tower of London'.[108] Hunt also supplied Nelson with jewellery, such as rings and bronze brooches, and religious objects including pyxes, a thirteenth-century cross, and candlesticks.

The Hunts and Nelson became good friends, constantly exchanging information or seeking each other's advice on matters of antiquarian interest and visiting each other's houses. Nelson carried out extensive study into many of the more interesting objects he acquired, publishing the results of his investigations in academic journals, and a few of the pieces supplied by Hunt became the subject of such publication. In doing this work, Nelson relied in the first place on information from Hunt, as well as on opinions from contemporary experts in the field. The first object acquired from Hunt in July 1934, 'a small bronze gilt figure of a man rising from the tomb', was

published by Nelson the following year and a large enamelled Limoges altar cruet, which Hunt sourced from the Pitt-Rivers Collection, was published in January 1938.[109] A twelfth-century Mosan or English bronze altar-bell, published by Nelson in 1933, was later acquired by Hunt for his own collection.[110]

Perhaps the most important piece which Nelson published, and Hunt later acquired, was a twelfth-century gilt bronze Mosan crucifix, attributed to the school of Rainer of Huy, also now in the Hunt Museum.[111] Hunt was especially proud of this particular piece, loaning it to the Manchester *Exhibition of Romanesque Art* (1959).

There were many cases where the younger Hunt sought help from the more experienced Nelson in trying to understand the history of various medieval objects he had acquired. On one occasion, he sent Nelson details of an enamel pricket candlestick he 'found' and enclosed well-drawn hand sketches of three coats-of-arms on the base.[112] Later, Hunt forwarded his own drawings of a silver gilt casket, believed to be late fifteenth-century, that he himself was planning to publish (and eventually did twenty-six years later) and sought assistance in trying to interpret inscriptions on it, saying: 'you are so clever about such things, I am hoping you might be able to elucidate it for me'.[113] The thrill of excitement that Hunt got from his discoveries is highlighted in a letter to Nelson: 'When you next come to town I will tell you about something marvellous we have found'.[114]

❁ ❁ ❁ ❁ ❁ ❁ ❁ ❁

Top right: Dr Philip Nelson altar bell
Above: Ranier de Huy crucifix

The learned Nelson found, in the much younger Hunt, an equal in intelligence and scholarship. For Hunt, Nelson was one of the role models for his career

England) to Princess Mary of Modena in 1673.

An article from *Connoisseur* in 1938 describes Hunt's gallery:

> John Hunt, whose little shop in Bury Street S.W.1 has the air
> of a casket, always enshrines a number of those precious early
> bibelots that gladden the heart of the mediaevalist. One thinks
> how Anatole France would have revelled there, inventing
> suitable legends as he examined each treasure. Always search-
> ing for pre-renaissance objects, Mr. Hunt lights on the most
> surprising discoveries. Where we wonder did he pick up the
> silver-gilt book cover of the XIII Century embossed with a
> crucifixion scene? [130]

A review in the *Burlington Magazine* of the 1938 *Antique Dealers' Fair* also records how medieval art, which had not even received a single mention in a similar review just four years earlier, had now arrived on the antiquities scene. The reviewer noted that the exhibition was noteworthy for the presence of examples of sculpture of the Middle Ages and Early Renaissance:

> English and continental medieval works of art are to be seen
> at Mr John Hunt's stand on which there is a group of a dozen
> English alabasters. Remarkable for its condition is the panel
> with the head of St John the Baptist on a charger, which
> preserves its touches of original colour and
> gilding; on either side are St Peter and
> St William of York. The panel con-
> tained in its original wooden case
> dates from about 1470. [131]

Queen Mary, wife of King George V, was a regular customer at Bury Street and would frequently be driven down from Buckingham Palace to see what new

Alabaster head of John the Baptist.

medieval treasures Hunt had acquired. She regularly picked up and kept small items that caught her eye and there was no question of her paying for them. After this had happened a few times, Hunt made enquiries and was told that a record was kept of the items taken and all would be returned to him when Queen Mary died. Hunt would get no notice of these visits and, on one occasion, he had just taken delivery of a collection of ceramic chamber pots which he was sorting out on the floor when Queen Mary's carriage pulled up outside the door. Hastily piling all the pots away into a wooden cupboard, Hunt found that the door wouldn't close, so he stood against it and greeted Queen Mary while Putzel showed her their latest treasures. After some time, the Queen noticed that Hunt was still in the same place, keeping the door of the press closed, and said: 'Ah now Mr Hunt I see that you are hiding your greatest treasures from me in that press. You must let me see them'. And so Hunt sheepishly had to move away while the bemused Queen inspected his collection of chamber pots.[132]

Hunt was quite academic in his approach to studying medieval objects and kept himself abreast of anything published on ancient works of art in learned journals. In some cases it was only with considerable experience and study that antiquarians could begin to surmise how, where and, in many cases, for what purpose, the object had been created. There was a significant commercial imperative for such research, 'since the makers of most medieval sculpture are anonymous, pieces that can be attributed to a known artist or building are particularly valued'.[133]

One example of the financial rewards of Hunt's academic research is his dealings with a parade helmet or 'Burgonet', a close-fitting piece of facial armour made of steel and attributed to the Italian Renaissance workshop of the Negroli brothers of Milan, of whom Filippo was considered to be 'the most innovative and celebrated Italian armourer of the era'.[134] The medievalist, Professor Peter Lasko, claimed that Hunt had once described the acquisition of the Negroli helmet as 'his break into the big league'.[135] Originally discovered by a dealer in a sale of 'theatrical junk' in 1935 and bought for a few pounds, it was brought to Sir James Mann, a leading expert on arms and

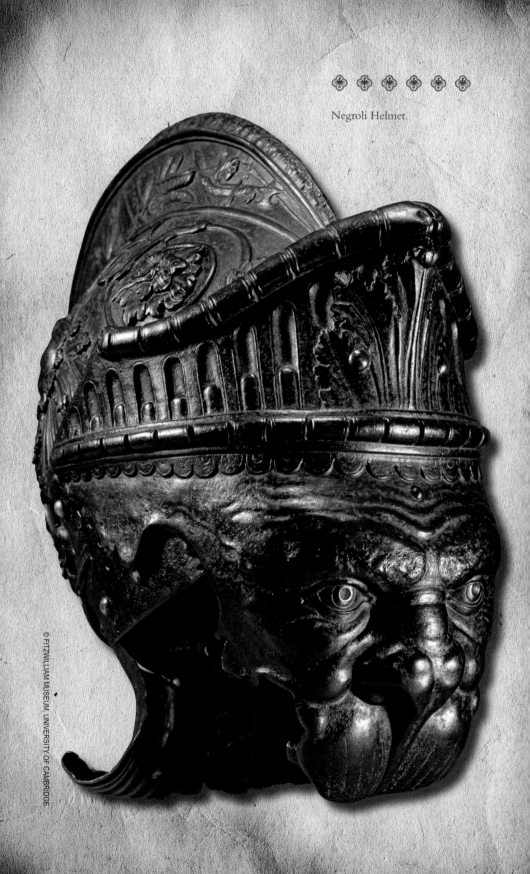

Negroli Helmet.

armour who failed to established its origin. Hunt later identified it as being from the Negroli workshop, acquired the piece for £200 in 1937, and sold it to the Fitzwilliam Museum in Cambridge the following year for the considerable sum of £1,750.[136]

Sometime after their marriage in June 1933, the Hunts had moved from St James's Place to a substantial three-storey detached house right on the River Thames at Southlea Road, Datchet, near Windsor.

In July 1936 they acquired a new residence, just three miles away, which announced their commercial success as dealers in works of art to all who knew them. Poyle Manor was an eighteenth-century reconstruction of a twelfth-century manor on the Buckinghamshire border, just seventeen miles from central London. The eleven-bedroom mansion was set on fourteen

The interior of the Hunt residence at Datchet, near Windsor.

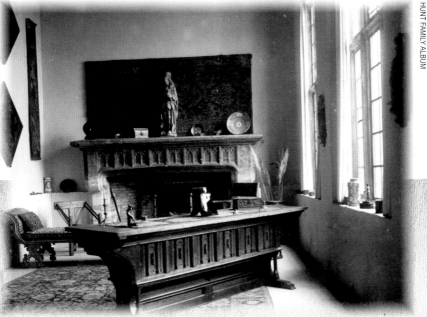

HUNT FAMILY ALBUM

acres of landscaped grounds, which included a number of fine specimen Indian bean trees and an ancient millstream. Described by the auctioneers as 'one of the few remaining ancient manor houses near London – rich in historical associations' it had all the requirements for stately living, with three panelled reception rooms and ample accommodation for a large staff in the many additional buildings on the estate, including a converted coach-house, a seven-roomed cottage and a lodge.[137]

No doubt the reference to the property's past caught the eye of the Hunts. Remains of the twelfth-century moat, on which several archaeological investigations had been carried out, were evident in the grounds of the manor, which had also been recorded in a forced exchange of properties between King Henry VIII and Lord Windsor. A final attraction may have been the magnificent grounds where Jack and Putzel first applied their gardening skills, something which they were to repeat in their later residences.

Poyle Manor's high ceilings and large rooms gave the Hunts, for the first time, the opportunity to display some of their collection of art objects in a living environment. This particularly applied to the larger pieces, and one of the few surviving photographs of the manor shows the rear reception room decorated with medieval items including an 11ft tapestry as well as the 6ft thirteenth-century stone sculpture of St Malo, now in the Museum of Fine Arts (MFA) in Boston.

They were proud to display the joys of Poyle Manor and its grounds to many of the individuals they dealt with in the art world, even extending such hospitality to their families. Writing to Ralph Edwards, the V&A's Keeper of Woodwork in the autumn of 1938, Hunt asked: 'When are you coming down to Colnbrook with the family? There is no bathing but roast

Opposite: The rear reception room at Poyle Manor, with the stone sculpture of St Malo, now in MFA Boston, by the window, and an oak table from Durham Cathedral, now in the Burrell Museum, at left.

chestnuts', later repeating the invitation: 'We hope you will bring the boys down sometime soon after Christmas. If this weather goes on they can skate on the pond'.[138]

In reviewing Hunt's pre-war career as an art dealer in London, the focus must be on trying to understand how he achieved commercial success and, given his formal lack of education in art history, how he gained acceptance as an expert on medieval art among leading antiquarians. In relation to his business success, part of the answer must lie in the fact that Hunt possessed in exceptional measure two of the essential prerequisites for success as a dealer in works of art – a passion for the arts and an artistic 'eye'.

Contemporaries noted the veneration he displayed for many of the medieval works of art, which were not merely his stock in trade, but objects whose possession gave him much pleasure. One observer described Hunt's love of medieval art: 'I retain a vivid impression of John Hunt showing me almost with awe a pomander which he had just bought; the reverence stemmed from his belief that it had belonged to a French king and he could scarcely believe that it had come to rest in his hands.'[139] While Hunt's aestheticism gained him the reputation of being 'notoriously difficult about selling objects from his collection', it was not a hindrance to his career as a dealer since 'any dealer who wanted to attract wealthy clients had to have a collector's instinct'.[140] Richard Marks has described the conflicting passions that Hunt experienced in his art dealing:

> One reason for [Hunt's] high reputation was his love of and sympathy for medieval art, which sometimes clashed with his commercial interests; unlike many dealers he collected for himself in the very field in which he traded.[141]

The other essential trait of the most successful dealers was an artistic 'eye'. Whether looking at works of art in a collection, an auction room or a roadside barrow, Hunt frequently had to skim quickly, yet thoroughly, through a vast array of maybe hundreds of objects while retaining his magical ability to spot things that had either exceptional artistic merit or were significantly undervalued. One of the world's leading experts on furniture has recorded

how he 'learnt many years ago from Jack how to look at objects and how to appreciate their worth.'[142] A director of Sotheby's was to remember him later as 'one of the few who fundamentally understood how and why something was made. Most tended to give a quick decision from a casual glance – but not Jack; it was his way of looking at things that I have tried to emulate – and it has stood me in good stead'.[143] This ability required years of training: 'There was no other way to educate the eye except ... to look and look until you had trained yourself to observe subtleties that escaped all but the keenest of observers'.[144]

Many contemporaries have spoken of Hunt's quiet and gentle personality, his polished manners and speech, and the generosity with his time that enabled him to develop good relations with those he dealt with. His public school background was also likely to have been of assistance in his dealings with the many wealthy English families who, due to changing financial circumstances, were considering for the first time the relatively new concept of selling family heirlooms.

Hunt had created a unique niche by his focus on medieval art, and his extensive travels throughout Europe had enabled him to discover art treasures which few other British dealers could bring to the market. However, he lacked both organisational and financial skills. Fortunately, Putzel's contribution to the partnership compensated for any shortfalls on Jack's part. One of their partners in art dealing in the post-war years, who witnessed their relationship as a couple and as joint business partners at close range, saw Putzel as 'the one in that relationship who wore the trousers ... I always felt that Putzel had the sharp commercial instinct whereas Jack was the intellectual and in many ways less practical'.[145]

As the 1930s drew to a close, with war clouds darkening over Europe, Hunt was close to having 'made the fortune which enabled him to achieve the dream of all dealers who love their métier – retirement to collecting for his own pleasure'.[146] In one of the last Sotheby's auctions that he attended before the war, Hunt set up a future dealing coup by acquiring a fifteenth-century set of three German wooden carvings of the Magi for just £16.

Having removed a layer of crude overpainting to reveal the original work-
manship, he would sell these pieces, within thirteen years, for more than two
hundred times the price he paid.[147]

His improved financial circumstances also enabled him to devote time,
with little prospect of commercial benefit, to a long-standing passion for
archaeology and, in July 1939, Jack and Putzel shared in the excitement of
one of the most significant investigations of a prehistoric tomb ever made
in Britain. This was the excavation of the seventh-century Anglo-Saxon ship
burial of a local king at Sutton Hoo in Suffolk, considered to be the greatest
archaeological find in England from the early medieval period. Hunt's link
with Tom Kendrick was probably the reason why he was permitted to go
to Sutton Hoo. Because of the risks of looting, the 1939 excavation had to
be conducted with great speed and secrecy over a period of no more than
three weeks and all the 137 objects discovered were swiftly removed to the

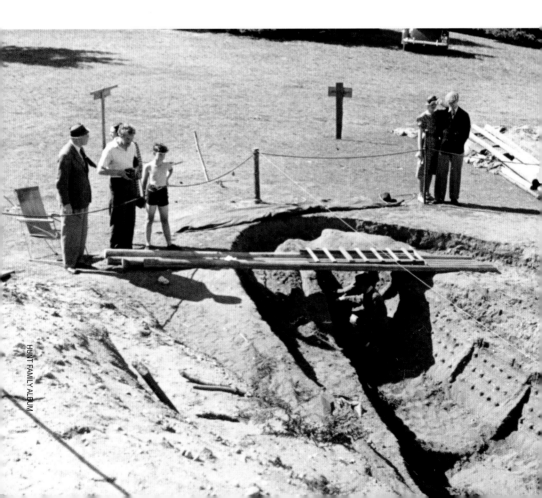

British Museum. Jack and Putzel lived on-site in their caravan, assisting in the archaeological dig and taking many photographs which showed the excavated outline of the burial vessel in the sand.

In that fateful summer, on the peaceful coastline of Suffolk, Jack and Putzel were probably unaware that their life's path was about to take a dramatic change of direction and that Jack would soon apply his newly acquired knowledge of archaeology in a foreign land. When they returned from the excavations, they worked to prepare accommodation at Poyle Manor for two guests from Germany, due to arrive any time soon, whom they anticipated might be staying with them for some time to come. Notwithstanding the fact that the darkening clouds of fear and uncertainty over Europe presaged serious implications for Jack and Putzel themselves, they pressed on to make Poyle an oasis of tranquillity for their expected visitors.

Left: The archaeological investigation of the excavation of the seventh-century Anglo-Saxon ship burial at Sutton Hoo in Suffolk in 1939 at which Jack and Putzel attended.

Coming to Ireland
1940

*Arrangements are being made for representatives of a number of
important firms to visit the United States of America ... and they will
take with them a collection of works of art. The dollar proceeds of such
sales have to be surrendered to the Treasury for the use of the nation.*
Major Lloyd George[148]

The events of *Kristallnacht* on 10 November 1938 prompted the
Hunts to take the initiative to try to help one of their many
Jewish friends, an antique dealer named Philipp Markus, to get away from
the city of Worms.[149] Having visited Germany on at least seven occasions
since their marriage in 1933, they could see the impact of Nazi rule. They
were also informed by regular contact with several Jewish refugees living in
London, such as the department store owner and collector, Adolf Beckhardt
from Frankfurt.[150]

For centuries, Worms had been home to one of the oldest Jewish commu-
nities in Europe, with legend and oral tradition stretching back to pre-Chris-
tian times when *Vormatia* was a city on the western border of the Roman
Empire known to its Jewish residents as *Little Jerusalem*. Philipp Markus had
an antique business 'highly acclaimed by experts' in a fine three-storey sub-
urban house at Rudi-Stephan Allee 20, where he lived with his wife, Anna

Magdalena Schock, a Protestant. [151] A patriotic German, he received a medal for bravery in the Great War, and later formed a chapter of the German Jewish World War Veterans' Association.

After the Nazis came to power in January 1933, the law as it was established in Worms for hundreds of years ceased to operate. Worms had become a lawless city for Jews. The Nuremberg Laws made the mixed marriage of Philipp and Anna a crime in the eyes of the state. By November 1938 almost sixty-five percent of the community had gone abroad, leaving just 400 behind. Any doubts the Markuses might have had that the terror of the previous five years would cease and life return to normal were finally removed by *Kristallnacht*. [152]

Based on an order to arrest all prominent and able-bodied Jewish men, Philipp was rounded up early that morning and locked up in the local police station, along with eighty-six others. At midday he was marched out with the other prisoners and ordered to clean up the streets and footpaths of the shopping district, which were littered with glass and goods from Jewish shops. Without leave to contact Anna, Philipp was herded into one of three trucks and sent to the concentration camp at Buchenwald. He was one of only seven prisoners from Worms who managed to gain his release within days, when he produced his medals and documents to prove that he had been decorated for his service to Germany in the Great War.

Worms was changed forever after *Kristallnacht*. Those Jews who remained 'lived in a perpetual state of shock …

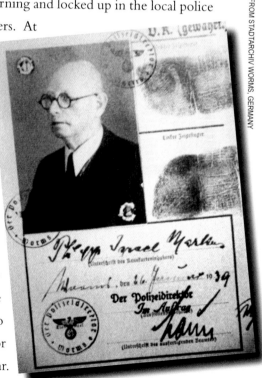

The identity card of Philipp Markus.

there was no one who would look a Jew in the eye, no one who engaged him in conversation'.[153] After the November 1938 decree banning Jews from engaging in all economic life, Markus could no longer operate his business as an antique dealer. He and Anna made up their minds to leave Germany and try to go to London, where they knew other German Jewish refugees and their fellow antique dealers, Jack and Putzel Hunt.[154]

The Markuses communicated with the Hunts shortly after Philipp's release from Buchenwald, telling them of their plan to leave Germany, and received a reply from Putzel, offering them accommodation in her home at Poyle Manor and the job of cook to Anna. Because of this 'loyalty and human kindness', in contrast to the cold indifference of their Christian neighbours in Worms, Philipp and Anna wrote: 'You probably have no idea how happy you made us with your letter. We appreciate your loyalty towards us. Our friends, strangers to you, had tears in their eyes while reading your letter.'[155]

The Hunts offered to make an application to the British Home Office for visas for the Markuses and Jack agreed to act as guarantor by providing a bond to the Home Office through a Mr Weil of the German Jewish Relief Agency. This involved a commitment of £100 per person and accepting responsibility for the upkeep of the Markuses. Most of the guarantors were Jews living in the UK, so the Hunts were among the minority of non-Jewish guarantors. After the Hunts had signed the appropriate guarantee for the Home Office, the nearest British Consul to Worms contacted the Markuses, who wrote excitedly to the Hunts: 'Through your love we have obtained the permit for Anna and myself'.[156]

Throughout the next eight months, Philipp and Anna continuously expressed their love and gratitude for their friends' efforts to help them, and their anxiety to escape comes through in their letters: 'You will realise that we are really very keen on leaving the country. On the other hand, however you have to understand that the winding-up is taking longer than we had anticipated'.[157] The correspondence shows how the assets of Jews were seized on their leaving Germany. 'Officially non-Jewish people are allowed to take 10% of their belongings with them which would not be too bad … Mrs

Beckhardt was permitted to take parts of her jewellery and the rings she was wearing.'[158] And: 'what else I am able to take out, I cannot say at the moment, I hope that Anna as a non-Jew may keep her everyday silverware and her jewellery.'[159]

The letters are sprinkled with glimpses of the warmth and kindness of the Hunts and their desire to help Philipp and Anna leave Germany. Even though Jack at the time had some serious health issues, they put their own lives on hold for their friends. Putzel wrote: 'If you want to bring your furniture we can empty two rooms for you, one to be used as living room and one as bedroom if you think you feel more at home with your own furniture. If you do not bring your furniture I will furnish a little living room and a nice bedroom so that you can feel at home'.[160] The two couples had friends in common, many of whom had successfully fled from Germany, and the Markuses wrote: 'Please say hello to all our friends and people we know who you will see in the meantime.'[161]

The final letter from Worms, on 18 August 1939, shows how agonisingly close the Markuses came to escaping from Germany: 'Our legal consultant informed us that it will take another 14 days or up to three weeks before we can get away from here'.[162] Two weeks after that letter was written, Germany invaded Poland, Britain declared war, and all entry visas were cancelled. Anna and Philipp were trapped in Worms. When the UK entry visa for the Markuses was cancelled, Philipp and Anna applied for permission to go to the US. They were put on a waiting list but never obtained a visa.[163]

On 25 April 1940, the Markuses had to give up their home at Rudi-Stephan Allee because it was owned by Anna, and a Jew could only live in Jewish-owned or designated housing.[164] They were moved by the authorities five times over the next two years, with one chronicle noting: 'The art dealer Philipp Markus with his Protestant wife, although he was very ill, was forced to change dwellings repeatedly in Worms with the resettlement obligations.'[165]

One can imagine the anxieties of Philipp and Anna on 19 March 1942 as they said goodbye to many of their friends. On that day some seventy-

Philipp Markus

WORMS, den 25. Dezember 1938

(handwritten German letter, largely illegible)

Liebe Trude, lieber Jack !

Ihr werdet Euch wohl keinen Begriff
machen können, welche Freude Euer
Brief uns bereitet hat. — Selbst wenn aus
dem Projekt unserer Uebersiedlung nach
London nicht wird, was wir natürlich
...

Philipp Markus

Worms, 25th December 1938

Dear Trude, dear Jack,

You probably have no idea how happy you made us with your letter. Even if our plan to move to London comes to nothing, which of course would be a pity, we still appreciate your loyalty towards us. Our friends, strangers to you, had tears in their eyes while reading your letter. Should it really come to a move we certainly will not be a burden to you. You know that I really know my business and know how to support Anna and myself. The fact that Anna may prepare Jack's favourite dishes makes her happy already now. The most important thing now would be that you obtained an entry permit for us and we would like to ask you to take steps as soon as possible so that it arrives here as soon as possible. We take it from your letter that your health is quite good which we can also tell of us. Once more we would like to thank you very much for your loyalty and human kindness. We return your Christmas and New Years greetings devoutly.

Yours, Anna and Philipp

Above: Letter of 25 December 1938 from Anna and Philipp Markus about obtaining an entry permit for Britain. **Left and Below:** The last letter from the Markuses, just two weeks before the outbreak of war.

Worms, den 18. August 1939.

Liebe Trude und lieber Jaques !

Vor lauter Abwicklung kommen wir erst heute dazu,
Euern lb.Brief zu beantworten. Wir hoffen, dass die fettlose Diät
dem lb.Jaques Genesung gebracht hat. Dir lb.Trude geht es, wie wir
hoffen auch recht gut, vor allen Dingen aber, dass Du gesund bist.
Wir beeilen uns natürlich, baldigst zu kommen, Ihr müsst aber ande-
rerseits verstehen, dass die Auflösung immerhin längere Zeit bean-
sprucht, als wir gedacht haben. Sobald wir unsere Papiere haben,
werden wir abreisen, der Lift folgt nach. Handgepäck und Pass
gut führen wir mit.— Wir wären Euch sehr dankbar, wenn Ihr un...
mitteilen würdet, wohin der Lift adressiert werden soll, um ...
meiden, dass derselbe wochen-oder monatelang bei einem Spedi...
untergestellt werden muss. — Wäre es nicht besser, wenn Ih...
leicht noch 14 Tage oder 3 Wochen zur Erholung aufs Land g...
würdet, denn es wird ja immerhin nach Rücksprache mit unse...
Rechtsberater noch 14 Tage bis 3 Wochen dauern, bis wir vo...
fortkommen.—

Mit viel Vergnügen haben wir gelesen, dass Eure Hundchen ...
Ankunft warten, Anna freut sich schon jetzt darauf, dass ...
Direktion in Eurem Zoologischen Garten übertragen erhält...
lich sind die jungen Gänse mittlerweile recht hübsch gew...
Unsern "lb.Seppl" lassen wir zurück, Freunde werden den...
zu sich nehmen. Für uns wäre es undenkbar, das arme Tier ...
Alter in Quarantäne geben zu müssen.

Nun wünschen wir Euch fürdehin alles Gute in der Erwart...
lich ein paar Zeilen von Euch zu erhalten. Grüsset alle ...
Freunde und Bekannten, mit denen Ihr zusammenkommt.— E...

Herzliche Grüsse Euer...

 Anna...

Worms, 18th (?) August 1939

Dear Trude and dear Jaques,

We are so busy with our winding-up preparations that it is only today that we are able to answer your dear letter. We hope that the fat-free diet has brought relief and recovery to dear Jack. We hope, dear Trude, that you keep well also, the main thing however is that you are in good health. We wish to come over to you as soon as possible, of course; on the other hand, however, you have to understand that the winding-up is actually taking longer than we had anticipated. As soon as we have received our papers, we will depart and the transport will follow. We will carry with us hand luggage and accompanying passenger freight. We would be very grateful to you, if you could let us know the address to which we can direct the transport, so as to avoid that the effects would have to be stored with a removals company for weeks or even months. Would it not be an idea for you to go for a couple of weeks, 2 or three weeks, to the country to get a good rest? Our legal consultant informed us that it will take another 14 days or up to three weeks before we can get away from here.

We read with much pleasure that your doggies are waiting for our arrival. Anna looks forward to take over the 'director's post in your zoological garden. I hope that the young geese in the meantime have become very pretty. We have to leave behind our "dear Seppl", some friends of ours will be happy to adopt him. It would be unthinkable to have the poor animal put into quarantine at his age.

We wish you all the best for the time ahead and we look forward to receive a few lines from you very soon, if convenient. Please say hello from us to all our friends and people we know who you will see in the meantime.

Best love to you both.

Yours,

Anna and Philipp

nine people reported to the Jewish Community Centre, Hintere Judengasse, wearing exaggerated amounts of clothing and, as instructed, piled all their belongings into the centre of the street. Their names were read out and they began a march through the city of Worms to the railroad station. From here they were shipped east, without food or drink, over the next few days, to Piaski in Poland. The occasional postcard arrived from Poland over the next few months, but these gradually ceased as more and more of the deportees died. Within six months of the March deportation, sixty percent had perished from cold and famine.

In June 1942 the Markuses were moved into the heart of the old Jewish ghetto to the Old Age Home where more than forty elderly people lived in one building, many of them in very poor health. Plans for the final removal of Jews from Worms continued apace, but the lists excluded Philipp Markus among the small handful of some six Jews who were *Mischehen* (married to Christians). On 27 September 1942, the Markuses watched as 'nearly 100 old and infirm people, many of them too weak to carry their own baggage, were forcibly removed' from the Old Age Home and shipped to Theresienstadt near Prague in Czechoslovakia. [166] During the following winter most of the deportees 'died horrible deaths from exposure and neglect'.[167] For the next nine months, Philipp and Anna lived alone in the Old Age Home. One other Jew, Alfred Lang, still lived in the former Jewish ghetto.

In June 1943 the Markuses were moved from the Old Age Home and, on 7 January 1944, the Nazis revoked the legal protection from deportation of Jews who were *Mischehen*. Philipp Markus, by now seventy years of age, was immediately seized by the Gestapo with a view to being deported to a concentration camp.[168] Just nine days after his arrest, he died in the police station, with the official Gestapo report stating he had died on 16 January from 'natural causes'. Published studies of the Holocaust in Worms record his death rather differently as: 'Killed by Gestapo, Worms'.[169] Philipp Markus's name is today inscribed on the plaque to the *Martyrs of the Holocaust in Worms,* on the inside wall of the rebuilt synagogue. In the Holocaust records he is shown as the last Jew to be killed in Worms.

After the war, Anna Markus regained possession of her house and died there on 19 August, 1949. It is probable that Putzel visited Anna during post-war visits to her mother in Baden-Baden and heard her account of the war-time horrors which she and Philipp had endured. The Hunts made a deliberate effort to retain a memory of these two dear friends. Only nine items of correspondence survive in Hunt family papers from the decades before they moved to Ireland in 1940. The Markus correspondence represents seven of these nine letters.

Even before the outbreak of war, Putzel was mindful of the strong under-current of anti-German feelings which prevailed in Britain. She had been living in the UK for more than ten years and had acquired a British passport in 1936, but many people had painful memories of the Great War, which had ended just twenty years earlier, and attitudes were still coloured by the campaign of propaganda against everything German. During the pre-war years there had been an increasing number of German Jewish refugees fleeing successive waves of Nazi oppression and, between 1933 and 1939, the number of refugees admitted to Britain was 'perhaps 90,000, of whom 85 to 90 percent were Jewish' with the German-born population increasing from 20,000 to 70,000 in that period.[170] The refugees included 10,000 children who had come to Britain without their parents under a programme known as *Kindertransport*. Ironically, the presence of these refugees heightened anti-German prejudice in Britain, with little distinction drawn between the Nazis and the German people in general.

Given the prevailing public mood, the Hunts were aware how difficult it would become for Putzel to remain in Britain if war was to break out. She would almost certainly have been cut off from any contact with family members in Germany since even a simple letter to her mother would have laid her open to the charge of 'corresponding with the enemy'.

Perhaps inspired by a trip to Dublin which Jack made in May 1938, the

Hunts saw the benefit of a base in neutral Ireland. Later that year, they rented a flat at 21 Molesworth Street, Dublin, a fine Georgian house located less than one hundred yards from the National Museum. Apart from this lease being of assistance in dealing with the difficulties faced by Putzel, as we shall see later, no other explanation can be found, either in business or social terms, for entering into such an agreement. The flat, described by a later tenant as 'a bit grim for someone coming from a mansion in England', consisted of only two rooms and a toilet, to which the Hunts were later to add a bath. [171]

There is no evidence that Hunt had any communication of either a business or social nature with anyone in Ireland prior to 1936, when his role in the disposal of the Pitt-Rivers Celtic gold collection is recorded in the correspondence files of the National Museum of Ireland. This correspondence would also create a link, which would resurface with sinister overtones almost seventy years later, between Hunt and Dr Adolf Mahr, an Austrian-born archaeologist and Director of the National Museum of Ireland in Dublin since 1934. Mahr was one of several Germans appointed to senior positions in the public sector in Ireland by the Cumann na nGaedhal Government (1923-1932), led by Taoiseach William T Cosgrave, in an attempt by the newly created Irish Free State to reduce its reliance for expertise on the former colonial masters, Britain.

Mahr was an archaeologist of major stature. Pat Wallace, Director of the National Museum in 2006, considered him to be a '*wunderkind* … the scientific founder and father (of Irish archaeology)'.[172] He claimed that Mahr scoured the country buying artefacts for the museum and 'multiplied the intake of objects several times'.[173] Mahr was on familiar terms with Taoiseach Eamon de Valera, as recounted by a Scottish archaeologist, Dr Howard Kilbride-Jones, whose archaeological investigation in Drimnagh, Dublin, was denied funds by the Minister for Finance in 1938.[174] At a lunch meeting he explained the situation to Mahr who said: 'We will go and see Mr de Valera'. At 4pm they knocked on de Valera's door, explained the situation and left half an hour later with a personal cheque from de Valera for £400.[175] When de Valera was asked 'is this coming out of your pocket?' he replied, 'No, I shall

get Mr McEntee (Minister for Finance) to reimburse me.'[176]

Mahr was also an enthusiastic and committed supporter of the Nazi Party. This may have been driven by nationalist feelings and bitter resentment that his home place, Alto-Adige, had been taken from Austria and incorporated into Italy as part of the Treaty of Versailles in 1919.[177] On the Jewish question, Mahr's biographer suggests that he was not anti-Semitic, and he certainly did have Jewish friends, including one he tried to assist in escaping from pre-war Austria.[178] However, there is ample evidence that Mahr, imbued in the whole culture of Nazism, was complicit with the central anti-Jewish tenets of its racial policies.[179]

The first recorded correspondence between Mahr and Hunt was in January 1936 when Hunt made an exclusive first offer to the National Museum of a collection of ten Irish gold ornaments from the Pitt-Rivers Museum in Farnham. As Director of the National Museum, Mahr was the point of contact for any art dealer who had antiquities of Irish origin for sale, and it was only in that context that the files of the National Museum reveal any evidence of contact between Hunt and Mahr. Hunt enclosed provenance details on the ten items involved and suggested a price of £1,550 for the collection. Mahr neither acknowledged nor responded to the letter and, almost four weeks later, Hunt wrote again seeking a response. Both letters from Hunt to Mahr were very formal. Following the second letter, Mahr sent a note to the Secretary of the Department of Education setting out the text of Hunt's letter and recommending a commitment of up to £1,000 to acquire the collection. There is no evidence that the request was approved and Hunt then reportedly offered the collection to the British Museum, who also declined. The collection was then sold to the American newspaper owner William Randolph Hearst.

The second recorded contact between Hunt and Mahr concerned the possible purchase of an ancient seal of the O'Neill clan. In May 1938, Hunt brought over from London an ancient seal (1345), purportedly of Hugh Reamhar O'Neill, then belonging to Lord Braye, an English earl. During the visit, which was his first meeting with Mahr, Hunt was shown around

the museum and later wrote that: 'I enjoyed my visit to Ireland immensely particularly for the opportunity it gave me for seeing the wonderful things you have in your Museum. I am amazed at the number of things you have added lately'.[180]

Following the Hunt visit, Mahr asked the renowned antiquarian Charles McNeill for his opinion on the seal. McNeill replied that the seal is 'well known' and a good bargain at the price of £55 offered by Hunt. McNeill went on to say that the seal had belonged to Horace Walpole in the eighteenth century and that 'its authenticity had never been questioned'.[181] The museum did not purchase the seal, either because it was not interested in its purchase or, as the second of Hunt's letters indicated, Lord Braye had changed his mind.

The third recorded contact occurred in July 1939 and involved the same collection of Irish gold ornaments that Hunt had tried to sell to the museum in 1936. Barely three years after William Randolph Hearst had acquired this collection, he had to put it up for sale at Sotheby's as part of a major disposal of his famous art and antique collections forced upon him by his creditors. Mahr got approval from the Department of Education to bid up to £300 for some of these items and engaged a London agent to carry out this work. This figure was much lower than the original offered price of £1,550 in 1936, reflecting a general fall in market prices, but the objects were not sold at the Sotheby's auction. Hunt immediately wrote to Mahr: 'You will remember that some years ago I showed you some important Irish Gold Ornaments', and offered to negotiate with Hearst's agent on the museum's behalf. [182]

Mahr wrote to the Secretary of the Department of Education on 14 July, describing Hunt as: 'A reliable dealer who always acts for the British Museum and whom I know for a couple of years through an introduction to me by our friend Mr. T.D. Kendrick, Keeper of the Antiquities Department of the British Museum', adding that 'he is trustworthy'.[183] Mahr got clearance from the Department and sent a formal reply to Hunt, giving him authority to negotiate the purchase of the objects at a price up to £600, which was rather unrealistic given that the collection had been bought in for £680.[184] Just

five days later, Mahr sailed from Cork for Hamburg with his family, ostensibly as the official Irish representative to the Sixth International Congress of Archaeology in Berlin, but also planning to attend the Nazi party rally at Nuremberg in September. He never returned to Ireland and there is no evidence of any subsequent contact between Hunt and Mahr.

As well as being a convenient safe haven for Jack and Putzel, the lease of Molesworth Street provided an Irish address, which may have been of some considerable help to Jack in obtaining a certificate of naturalisation and an Irish passport. At the time of his passport application, the question of Irish citizenship was muddled, with conflicting positions on either side of the Irish Sea. As far as the British Government was concerned, those who lived in Ireland were still British citizens under the 'common citizenship of Ireland with Great Britain'.[185] In Ireland, the Irish Nationality and Citizenship Act (1935) defined Irish citizenship, and acknowledged that certain un-named 'other countries' (exclusively Britain and colonies and members of the British Commonwealth) also granted citizenship to Irish citizens. Section 23 of the said Act, headed: 'Mutual citizenship rights between Saorstát Éireann and other countries' provided for reciprocal rights to the citizens of such countries. However, despite an unequivocal undertaking given in the Dáil, Taoiseach Eamon de Valera was never in a position to formally honour his commitment to reciprocal citizenship, because the British government did not recognise Irish citizenship in the first place. Nevertheless, the fact that mutual citizenship rights for British citizens had been promised by the Taoiseach, and the principle of such rights enshrined in Irish legislation, may have prompted a favourable response by Irish officials on the relatively rare occasions where British citizens applied for Irish citizenship.[186]

Against this background, and despite the fact that Hunt did not qualify as a natural-born Irish citizen under the terms of the 1935 Act, he had relatively minor hurdles to overcome to obtain a certificate of naturalisation. Citizenship could be given to anyone who could produce as references 'three citizens of Saorstát Éireann who are in a position to testify to the character of the applicant' and who 'bona fide intend if and when such certificate is issued'

to have their 'usual or principal place of residence in Saorstát Éireann'.[187] With a lease already in place in Dublin, Hunt would have had little difficulty in satisfying officials of the credibility of this latter commitment and did not have to surrender his British passport.

In the weeks before the outbreak of war, with no sign of Jack's passport being issued, the possibility of internment must have loomed large in the minds of the Hunts following the passing of the Emergency Powers (Defence) Act, on 24 August 1939. Regulation 18B, published under the Act a week later, widened the powers of internment without trial, which had heretofore only applied to aliens, to British subjects whom the authorities 'considered to be have been recently concerned in acts prejudicial to the public safety or the defence of the realm'.[188] However, on 30 August 1939, just two days before the German invasion of Poland, Hunt's Irish passport was issued by the office of the Irish High Commissioner in London.

Hunt immediately applied for an exit permit, which was issued by the British Foreign Office on 7 September, and he and Putzel travelled from Holyhead to Ireland the following day.

The Hunts used this visit to remove some of their smaller valuables for safe-keeping in

John Hunt's Irish passport and exit visa.

Ireland, bringing with them a collection of Celtic gold coins, which were lodged in a bonded warehouse in Dublin to defer payment of import duty.[189] After the initial panic following the outbreak of war, things settled down considerably and, a few weeks later, the Hunts returned to the relative calm of Britain to pick up the pieces of their life there. For the time being their fears about internment had abated.

The outbreak of war had a major impact on the art world in London. Museums closed most of their departments, auctions of house contents declined, as did sales at the big auction houses, Christie's and Sotheby's, and many dealers ceased to trade. A prominent antique dealer described the difficulties of continuing in business: 'I am giving up my bookshop and am storing my books in my antique shop which I am closing down very shortly … I should have liked to have remained open but the twelve months' slump has made it impossible for me to do so from a financial point of view. My secretary has been driving a hearse since the outbreak of war … You can well imagine that I am very worried.'[190] In December 1939, the London collector, Dr Walter Leo Hildburgh, reported on the prevailing situation: 'The Hunts have withdrawn to their country fastness. Leitch & Kerin have closed up presumably 'for the duration'. Robinson & Fishers' rooms have closed – temporarily, they say – but Foster's Auction rooms have gone into liquidation, I'm told. Stevens is, too, I'm told, closed. Nothing much is available for the dealers, it seems, so they don't do much business'.[191]

Despite Jack's Irish passport and the flat in Dublin, there is little to suggest that, during the 'phoney war' period from September 1939 until April 1940, the Hunts had taken any final decision to leave Britain. Jack continued to conduct business, in so far as it was possible in wartime, from his home at Poyle Manor. He was one of the dealers who, in January 1940, covered the expenses of an exhibition of *Masterpieces of Painting and of Craftsmanship* in Sotheby's Galleries in Bond Street, with ten percent of the entrance fees going to the Red Cross. Publicity for the exhibition emphasised that 'every dollar they can spend on these pictures, silver etc., is directly helping the Allies' and would give them 'the additional satisfaction of having contributed

something, however modest, towards winning the war'.[192] The Hunts' stand displayed a case of medieval and Renaissance works, including a Henry VIII Mazer bowl, a statue of St George and the dragon, a pair of bronze candlesticks and a pair of alabaster effigies.[193] Somewhat uncharacteristically, none of the pieces had a religious motif.

After the fall of Denmark and Norway in April 1940 and the subsequent invasion of Holland, Belgium and France, the 'phoney war' ended and, with a German invasion looming from across the British Channel, an air of nervous uncertainty swept the country.

Within days of his accession to power, Winston Churchill is widely reported to have issued an instruction in reference to enemy aliens to the Home Secretary, John Anderson, to 'Collar the Lot'. In other words, even if they had fled from Nazism, they should be locked up first and questions asked afterwards. Churchill's edict was promptly acted upon, and with ninety percent of the 60,000 refugees from Germany, Austria and Czechoslovakia being Jewish, the vast majority of the 28,000 people interned were Jewish refugees.[194] The Hunts must have viewed the situation with some trepidation, concerned that, if the British authorities could intern thousands of German-born Jewish refugees, what might the future hold for Putzel?

In late May 1940 stories appeared in all newspapers to the effect that a 'fifth column' of sympathisers had helped the German conquest of Norway and Holland. Aliens became targets of the press and also of government officials anxious to solidify morale in the face of a hated enemy, believed to be on the point of invasion. The *Daily Mail*, a newspaper that had supported Oswald Mosley and the British Union of Fascists in the 1930s, failed to see the irony in leading a campaign to have all aliens interned, with headlines declaring: 'Disquiet about Britain's fifth column is growing'.[195] In a similar vein, the *Dispatch* ran with the headline: 'Hitler has a Fifth Column in Britain made up of Fascists, Communists, peace fanatics and alien refugees in league with Berlin and Moscow'.[196]

Following the evacuation from Dunkirk in early June, widespread acts of violence were carried out against members of the public who were either

born in the enemy countries or were of enemy alien descent. Intense rioting against Italian shops and cafes took place in Liverpool, Edinburgh and other cities.[197] The British Government had assembled a black propaganda unit, later the Political Warfare Executive (PWE), which heightened the climate of suspicion of those who were alien-born by posters with catch-phrases such as 'Careless Talk Costs Lives'.

In their rather isolated 'country fastness' at Poyle, the Hunts were more exposed to the overly suspicious mood of Britain under siege than if they had lived in London. The local road signs and village names were all removed, so as not to be of assistance to an invader, and their only means of transport was by train or bicycle since they could not use their car, due to the unavailability of petrol. Local campaigns to 'rout the rumour' and an 'anti-gossip week' in Uxbridge, less than three miles from Poyle, were organised for the purpose of warning people about saying anything that might be overheard by German agents, presumed to be lurking everywhere to pick up information to be relayed to Berlin.

In early May 1940, a Lutheran pastor was appointed as a local curate at St Peter's church in the village of Iver, barely four miles away from Poyle Manor. The pastor was a refugee who had escaped from a Nazi concentration camp where he was interned 'for failing to subscribe to Hitler's demands at the start of the war', and was due to be ordained in the Church of England by the Bishop of Oxford.[198] Because he was German, the appointment led to an outcry and public protest meetings in the area and, within a week, the Bishop 'with extreme regret' cancelled the ordination and the unfortunate pastor was interned.[199]

The popular sentiment was clearly reflected in a letter published by the *Daily Sketch* which said: 'The time has come when all persons of German origin should be locked up as potential enemies and interned. There is no such thing as a friendly German.'[200] A popular journalist justified his demand for the internment of all Germans by saying that 'their dirty tricks would make your hair stand on end, particularly the German women'.[201]

Hunt's niece, Rosemary Bolster, recalls the family discussions about the

intimidation of her Aunt Putzel at Poyle Manor.[202] She remembers her parents telling of windows in the house being broken by stones, of noise being made at night by locals rattling tin cans and, most vividly, of excrement being dumped on the doorstep. The situation was not helped by the fact that the Hunts were relatively new residents of Poyle Manor and without established relationships with the local community in the nearby village of Colnbrook.

Putzel, on several occasions, told of a complaint made following an invitation to some neighbours to come to Poyle for a social visit with some refreshments. In the prevailing atmosphere of suspicion, one of the guests reported to the police that some drawings on the entrance hall wall were detailed maps of the River Thames valley and, as such, of benefit to invading Germans.[203] Despite subsequent reassurances from the police after they had visited the house, the incident added to the climate of tension.

As it transpired, if Putzel had remained in Britain, she was unlikely to have been interned. As a naturalised British citizen, she was not subject to the various Aliens Acts which would have placed her on the register of the 85,000

Poyle Manor entrance hall, showing drawings on the wall that were fancifully suggested to be maps of the River Thames valley and potentially useful to German invaders.

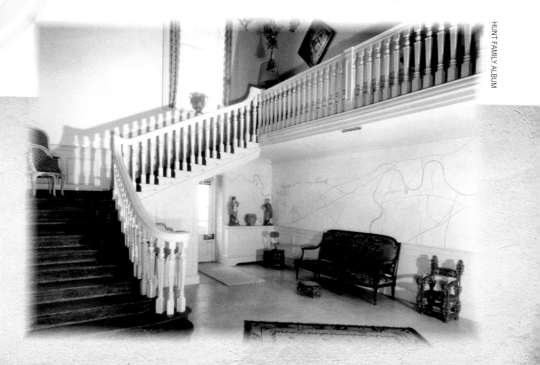

HUNT FAMILY ALBUM

aliens interviewed by tribunals and exposed her to the blanket internment of aliens without evidence. With no evidence of behaviour on her part 'prejudicial to the defence of the realm', her British citizenship, with its guarantee of *Habeas Corpus*, would have protected her from internment under Section 18B of the Emergency Powers (Defence) Act 1939. However, in the climate that prevailed in June 1940, it was reasonable for the Hunts to assume that the law on internment might be amended to include all persons of German descent, even if they were loyal British citizens, and this uncertainty must have been the central reason for the Hunts' decision to leave Britain.

Faced with the unpleasantness at Poyle, a concern about the possibility of internment for Putzel and uncertainty over future access to their Irish bolt-hole, there was only one choice for the Hunts and that was to move to Ireland. Complications arose in June 1940 when a new restriction decreed that exit permits for travel to Ireland could henceforth only be issued for trips 'of national importance'.[204] Hunt was now faced with the task of establishing that his travel was 'of national importance', not the easiest challenge for someone whose professional career path had never ventured outside the realms of the arcane art world. However, with some ingenuity, he managed to satisfy the requirement by obtaining official approval for a scheme to sell artworks in America to generate foreign currency for Britain. He described the plan in a letter to his friend Tom Kendrick in the British Museum: 'We had a recommendation from the D. of Overseas Trade and are going as agents for some important collections which we must endeavour to dispose of in the USA and bring back the dollars which the country needs so badly ... the authorities look benignly on their export. I do not know that I wholly agree but under the circumstances etc.'[205]

On 28 June 1940 the British Foreign Office issued an exit permit, valid for fourteen days, which allowed Jack and Putzel to travel to Ireland as a first stage on a voyage to the US. Their property at Poyle was made available for the war effort, and Hunt wrote that: 'the house at Poyle is being taken over as a hospital by two doctors under the W.O. as a treatment centre for re-education of shell-shock victims.'[206] The Hunts did not return to the UK

until after the cessation of hostilities in 1945.

Departing from Britain during wartime must have been a considerable wrench for Jack. In the context of his membership of the army after the First World War, in which his father and uncles had served, he must have felt an enormous sense of hurt by the way in which his wife had been treated. He was also cutting himself off from London, the epicentre of his chosen career as an art dealer and collector. The Hunts never spoke about the trauma of their move from England, instead throwing themselves wholeheartedly into their new life in Ireland.

CHAPTER 4

The Lough Gur Years

Among the God-sends that have come to our country in the past half-century, John and Gertrude must rank high.
Dom Bernard O'Dea[207]

Like millions of others on the move throughout Europe during that fateful summer, the Hunts were uncertain about their future when they landed in Dublin in July 1940, to stay at their flat at 21 Molesworth Street. Shortly after his arrival, Jack wrote to Tom Kendrick at the British Museum that they were planning to 'collect a few things which have been offered to us and then move on to USA as this is only the first stage in our journey'.[208] He also mentioned the idea of travelling onwards to America in his initial meetings with staff of the National Museum of Ireland in Dublin, one of whom wrote: 'I understand that if he should fail to sell this material in Ireland Mr. Hunt proposes soon to take the collection to America with a view to selling it there'.[209]

While the US offered much greater opportunities to trade in works of art and, in July 1940, looked a much safer bet to avoid being embroiled in war than Ireland, it was that much further away from families and friends caught on opposite sides of the mounting conflagration in Britain and Germany. The Hunts had no family or close friends in either Ireland or the US, merely

a limited number of acquaintances in the worlds of art and archaeology. Their decision, not only to remain living in Ireland, but to immerse themselves in the study of Irish heritage, and in Jack's case to adopt an Irish persona, was prompted by the experiences that followed their arrival.

One of Hunt's first moves, within days of arriving in Ireland, was to arrange for two collections of Irish antiquities to be released from bond at the Customs House in Dublin, where they had been deposited during his visit the previous September. He made contact with the National Museum and offered to sell them both collections for £900.[210] One collection consisted of approximately 250 Irish bronze objects and two silver pieces, and the other was a group of nine Irish gold objects, all of which had been acquired by Hunt from the estate of Captain John Ball.[211] The collection was viewed on behalf of the Antiquities Division by Professor RAS McAllister, the head of the Department of Celtic Archaeology at University College Dublin (UCD), and Dr Joseph Raftery, then an assistant archaeologist at the National Museum, both of whom considered it to contain 'many items of special interest'.[212] Nonetheless, based on a briefing note by Dr Michael Quane, the Department of Education initially took the position that it was 'not prepared to purchase these collections'.[213]

However, museum staff, led by Andrew Wilson Stelfox, who described Quane's report as 'evidence that was very one-sided and biased against the purchase', led a rear-guard action which quickly succeeded in having this decision reversed.[214] As a result, Raftery was given authority to enter negotiations with Hunt. Based on the Department's limited financial resources, a counter-offer of £600 was made but rejected and, in conjunction with Hunt's stated unwillingness to consider splitting the collections, no deal was done.[215]

Hunt must have mentioned his interest in archaeology to Raftery because, writing to Kendrick, he mentioned that Raftery had told him 'that of course all excavation has stopped with the exception of Ó Ríordáin's' and noted that he 'may have to go down in that direction & hope to have a look at it'.[216] As it turned out, in terms of being able to develop his interest in archaeology,

prompted by his father in boyhood and further whetted by participation in the excavation at Sutton Hoo, Hunt's arrival in Ireland was timely.[217] Partly as a result of the Harvard Archaeological Mission to Ireland (1932–1936), surveying and excavation of archaeological sites had developed significantly in the 1930s. Public awareness of archaeology had increased, and the small band of Irish archaeologists had gained valuable experience. Also, in 1934, some of the expense of archaeological works had been subsidised for the first time under an unemployment relief scheme. Professor Seán P Ó Ríordáin of University College Cork (UCC), taking advantage of such assistance, initiated and led a series of labour-intensive excavations at sites in Counties Limerick and Cork.[218]

In the summer of 1940, Ó Ríordáin's main archaeological programme was at Lough Gur in County Limerick. So, after staying at their flat in Molesworth Street, Dublin for more than a week or two, Jack and Putzel headed down to visit Ó Ríordáin and view the excavations at Lough Gur.

This trip was to have life-changing consequences for the Hunts. It is unlikely that Ó Ríordáin knew Jack prior to his visit, but the latter's first-hand experience of the archaelological excavations work at Sutton Hoo, allied to his exceptional understanding of the medieval period, made him someone who could be of assistance to the Cork professor. From Hunt's point of view, the unique experience of working on an archaeological programme presented him with the opportunity to indulge one of his long-time passions. So the Hunts decided to remain at Lough Gur for the summer and participate in the investigations there.

❀ ❀ ❀ ❀ ❀ ❀ ❀

Professor Seán P Ó Ríordáin of University College Cork and University College Dublin.

At Lough Gur, the Hunts lived in the fifteenth-century Bourchier's Castle, provided for the excavators by Count John de Salis, a British diplomat whose

Jack at his first archaeological 'dig' near Lough Gur, 1940.

family were formerly the principal land holders in the area.[219] Here they shared the somewhat cold and cramped quarters with Professor Ó Ríordáin and up to twenty-five students from UCC and UCD.[220]

When Hunt arrived, excavations at Lough Gur had been ongoing for almost four years and the finds had received widespread coverage in Ireland, both in local and national newspapers. The excavations had acquired political overtones and, to a degree, had taken on the mantle of a Gaelic cultural crusade. For the nationalist majority in the newly independent Irish Free State, still struggling to assert an Irish identity, the discovery of the extensive prehistoric artefacts at Lough Gur was important, not merely as a cultural record, but in providing evidence that the original inhabitants of the entire island were a distinct and ancient Irish race.

Earlier that year, Ó Ríordáin's address to the Geographical Society had been reported under the striking headline of: 'Archaeology – Enemy of Partition'.[221] Writing that the work at Lough Gur had helped produce results of national significance, Ó Ríordáin quoted from a recently published book by

Dr Grahame Clark of Cambridge:

> It is hardly possible to discuss any major problem of Irish
> archaeology without implicitly demonstrating the essential
> unity of the country and emphasising the artificiality of the
> partition. The free development of archaeological research is
> the finest imaginable propaganda for the liquidation of parti-
> tion and the full achievement of Irish unity.[222]

Not surprisingly, this led to a prompt retort in the *Ulster Journal of Archae-
ology*, which stated that 'remarks of this sort are unworthy of a scientist …
whenever Ireland has possessed a fairly homogeneous culture it has formed
part of the wider cultural zone of northern and western culture.'[223]

The theme that the excavations at Lough Gur provided evidence of an
ancient Irish race was elaborated in the *Irish Press* under the headline: 'Miss-
ing Link Found in Limerick'.[224] The gist of the article could be found in an
opening rhyming couplet which read:

> Long, long ago, beyond the misty space of thrice a thousand
> years / In Erin old there dwelt a mighty race, taller than
> Roman spears.[225]

The following day, an editorial in the same paper pointed to the signifi-
cance of the work at Lough Gur in international, as well as national, terms:

> The results of archaeological research at Lough Gur were cal-
> culated not only to stir but to baffle the imagination. Nobody
> whose blood is Irish can fail to take an interest in the work
> that is being carried on quietly and scientifically on this most
> richly productive of all the sites which bear a clue to the shape
> of things Irish in the immemorial past. A nation must look to
> its past as well as to its future and a knowledge of our begin-
> nings however remote is essential to the building up of our
> story as a race.[226]

Hunt immersed himself in the field-work at Lough Gur with enthusiasm.
Despite his lack of formal training or academic qualifications in the field of
archaeology, Ó Ríordáin was clearly satisfied with his capabilities in this area.

Shortly after his arrival at Lough Gur, Ó Ríordáin appointed Hunt as joint superintendent of a 'trial excavation' on the remains of two houses from the medieval period at nearby Caherguillamore, about three miles west of Lough Gur. This was the first purely medieval site in Ireland to be excavated and the extensive range of materials unearthed yielded information on the physical construction, as well as the lifestyle, of a medieval household in Ireland.[227] Hunt's initial involvement at Caherguillamore, which ran from July to October 1940, was later mentioned in various press and journal reports. A national newspaper reported: 'Valuable information on housing conditions in Ireland during the middle ages was unearthed during excavations by Mr. J. Hunt at Caherguillamore (County Limerick) last year'.[228] An engineering journal provided more details of Hunt's work:

> Two earthen mounds were excavated and proved to be well
> constructed houses of stone, one dating from the late thir-
> teenth century and the other somewhat later which appear to
> have been occupied for about two hundred years.[229]

Hunt quickly gained Ó Ríordáin's respect as an expert on medieval objects, particularly ceramics, where his art background enabled him to interpret pottery sherds discovered during the excavations. Ó Ríordáin attributed the identification and dating of various items from the medieval period to Hunt in several publications. In a 1942 paper on a major excavation of a ring-fort at Garranes in County Cork, Ó Ríordáin refers twice to Hunt's opinions on a metal shears used in leather-work and in dating some pieces of glazed pottery.[230] Another paper, on the excavation of a fort at Ballinspittle in County Cork, credited Hunt with identifying fragments of a sixteenth- or seventeenth-century Bellarmine jug and attributing a sixteenth-century Irish origin to other pieces.[231] Writing on the investigation of a post-Tudor period house at Knockadoon in Lough Gur, Ó Ríordáin wrote that the interpretation of all the glazed pottery found is 'almost entirely based on information supplied by Mr. John Hunt M.A.'[232]

Having spent some four months sharing accommodation with Professor Ó Ríordáin in the spartan surroundings at Bourchier's Castle, the Hunts,

with winter closing in and the excavations nearly complete, were ready to leave Lough Gur. They had clearly enjoyed their first four months in Ireland and decided to remain there rather than travel on to the US, but questions as to where they might live remained. Writing to Joseph Raftery in late October, Hunt noted that Putzel 'wishes she had somewhere of her own', adding that 'it is still lovely down here, but I feel it is about time we got back to Dublin'.[233] However, with propitious timing, advertisements appeared in the *Limerick Leader* for a lakeshore property at Lough Gur, looking across at the Black Castle and the diggings on Knockadoon Hill. The house, along with some sixty acres of land in two lots, had been deserted since the death of the previous owner, Patrick Hayes, some years previously, and was due to be sold at auction on 8 January 1941. The lot on which the house stood was described as follows:

> The lands and handsome dwelling on Lot 1 are beautifully
> situated on the shores of the beautiful lake of Lough Gur
> where plenty of fishing and shooting surrounds. The dwelling
> is almost a new one (2 storey, slated), containing on ground
> floor, kitchen, large diningroom, 3 bedrooms, also 2 bedrooms
> on second storey. The out-offices are built of stone and cov-
> ered with iron ... The lands are also well noted for their milk
> and fattening production. It is an ideal home for anyone in
> quest of same.[234]

Hunt decided to purchase the entire property, and a simple explanation for this 'Eureka moment' was offered, years later, by a local observer: 'He liked the district so much, and the kind reception he got from the people there, that he decided to stay.'[235]

Notwithstanding the splendour they had been accustomed to in their Buckinghamshire mansion at Poyle Manor, the Hunts proceeded to make this modest nineteenth-century farmhouse their main residence for the next thirteen years. Major improvements were required and, as it was wartime, Putzel recalled how 'building and other materials were virtually unobtain-able; at first we had practically to "camp out" in the house until it gradually

The Hunt house at Lough Gur, viewed from the lake.

became more comfortable and finally reached its present form'.[236]

Hunt now had a base from which he could engage in his passion for archaeology. During the following summer he continued his work at Caherguillamore, in conjunction with Ó Ríordáin, who recognised his contribution by allowing him to share co-authorship of the findings published in 1942.[237] He also assisted Ó Ríordáin and the Trinity College Dublin (TCD) geology lecturer Frank Mitchell in the investigation of Early Bronze Age pottery at Rockbarton Bog near Lough Gur.[238] The report by Mitchell and Ó Ríordáin noted further finds made by Hunt during 1942, including Beaker pottery and four stone axes.[239]

Soon after Hunt had settled at Lough Gur, he became the first point of contact on all matters of local archaeology. Professor Ó Ríordáin and his helpers were only there in the summer months but, living there all year round, Hunt became the resident expert. He later told of how a succession of farmers came to him with finds of stone axes, unearthed as a result of war-

time tillage obligations on land that had not been ploughed for years. Those working the land kept an eye out for finds and became discerning as to an 'ordinary stone' and one that had 'been worked'.[240]

In 1941, a report headed 'Finds in County Limerick – Valuable Archaeological Records' read:

> In the course of work on a quarry near Caherconlish last
> April an urn burial of Late Bronze Age date was discovered by
> County Council workmen who did not realise its importance
> ... Mr William Conway who had worked at Lough Gur in
> 1940 saw the pottery recently and, knowing it to be ancient,
> brought a fraction to Mr John Hunt, Lough Gur, who with
> Professor Ó Ríordáin immediately went to Caherconlish and
> rescued as much of the vessel as was to be found.[241]

Hunt's status as an archaeologist was further acknowledged during the winter of 1941 when, for the first time, he took sole charge of the excavation of a site in Ennis, County Clare, where a sewage disposal plant was being constructed. Dr Raftery visited the location and, given the possibility of it being the site of the former palace of the O'Brien chieftains at Clonroad, further investigation was deemed justified and Hunt was appointed to lead the excavation on behalf of the National Museum. The Department of Defence and the Irish Air Force took aerial photographs of the site in order to assist Hunt in trying to re-construct the ancient structures on the landscape.

Hunt published his findings on Clonroad More in 1946 which, unusually for an archaeological report, began with a quotation from a medieval Irish text, *Caithreim Thoirdealbhaigh* (*The War Annals of Torlogh*), reporting the burning of the palace of Clonroad in 1311.[242] While the site excavated turned out not to be the site of the ancient palace, two of his more important finds indicated what Hunt described as

The Late Bronze Age urn discovered at Caherconlish.

'a rich and cultured occupation in the neighbourhood'.[243] In one case he reported the discovery, for the first time in Ireland, of a piece of polychrome ware, a very fine pottery produced during a narrow timeframe around the end of the thirteenth century in the Saintonge region of south-west France. The other significant find was a bronze spout, terminating in a grotesque head, which Hunt attributed to the Meuse district of Flanders.

From the time that the Hunts settled in Lough Gur, right through to the early 1950s, Jack's unpaid work in the field of archaeology became the main activity in his life. His role as an 'amateur', unpaid archaeologist was unconventional in many respects. A survey of published excavations from the early 1940s in Ireland shows that most were written by individuals attached either to museums, or to educational institutions, and with degrees in archaeology. Hunt would soon set about correcting the latter omission by undertaking studies towards a master's degree in the subject at UCC. From an economic point of view, one must surmise that he and Putzel were able to maintain a reasonable standard of living, relying on the capital acquired in their pre-war dealings, their self-sufficiency as food producers and some prudent property investments they were to make in Limerick City.

Having found an outlet through archaeological activity, and the work on making the Lough Gur house a home, the Hunts also faced up to the challenge of integrating into a new society and began to develop an ever wider circle of social contacts. Many of their friendships in the Limerick area developed with members of the Thomond Archaeological Society, an organisation they had both joined during their first year living at Lough Gur. The society held regular meetings and field trips and published an annual journal, edited by Fr (later Monsignor) Michael Moloney, with various learned pieces on the archaeology and history of the North Munster area. Jack served as vice-president of the society from 1965 until his death, contributed six articles to the journal, spoke at a number of its meetings and facilitated member visits to several archaeological excavations on which he was working.[244]

Within his first year of membership, Jack delivered a paper to the society in November 1941 entitled 'Hidden Treasures', to which the *Limerick Leader*

devoted almost a full page.[245] The subject matter ranged from valuable objects of gold and silver that had been hidden away as treasure trove, to archaeological finds of pieces of pottery or human bones which could provide a unique insight into unravelling the story of people in ancient times. The paper provided a clear statement of his excitement at discovering a new treasure: 'a magic word which has always had a fascination for inquisitive men.'[246] He also showed his modesty and self-deprecation in his role as an archaeologist, saying in his opening remarks: 'forgive me if I interrupt your learned series of lectures with such a seemingly frivolous subject'.[247] The paper also illustrated Hunt's professional discretion and personal modesty in that he showed slides of several objects he discussed in his paper, such as the Temple Pyx he had sold to the Burrell and the Negroli Helmet he had sold to the Fitzwilliam Museum in Cambridge, without ever mentioning anything about his own role in discovering them.

The society bridged various long-established cultural divides in the North Munster area, with clergymen of both main religious denominations holding leading positions, along with prominent members of the old Anglo-Irish ascendancy and the emerging Catholic professional class. Many of its members shared the Hunts' interest in antiquities, and Putzel's extrovert personality and innately gregarious nature proved invaluable in making friendships: 'she was the most fantastic networker I ever met, linking everything; she had an uncanny knack of seeing what was going on and very good at giving full attention to the person she was talking with'.[248]

Fr Moloney, a parish priest who later became Diocesan Secretary to successive bishops of Limerick, had developed an abiding interest in history and the arts during his time studying for the priest-

The Hunts' close friend, the Right Reverend Monsignor Michael Moloney.

hood in Rome and became a great friend and 'Hunt's closest confidant'.[249] He also instructed Putzel in the Roman Catholic faith prior to her conversion and baptism at St Patrick's Church, Limerick, in May 1942.[250]

The Limerick chemist, Stan Stewart, a 'delightful character' and 'pivotal person for everything cultural that was going on in Limerick', revealed the antiquities of the Thomond region to Hunt's keen eye on many Sunday outings to explore the 'ould shtones' of Counties Limerick and Clare.[251] Bicycles were the vehicles normally chosen for these wartime excursions. Stewart 'who lived on his bike', introduced cycling as a mode of transport to Hunt, who later recalled how: 'during the war I visited every ancient site in Ireland on a bicycle'.[252]

The Limerick dentist, Charlie O'Malley, and his wife, Judy, also became friends of both Hunts, as their daughter, Grace Cantillon, recalled:

> Jack was always arriving into our house for Scotches in the
> evening. He was very gentle; he was beautifully spoken and
> had very, very, very good manners. He was extremely willing
> to give time to young people – you would display an inter-
> est in something and he would be absolutely there. They both
> shared this absolutely incredible ability to look, and to see ...
> he would draw out a crucifix and my mother would say, "Oh
> Jack, not another crucifix figure" and he would say, "Oh but
> Judy this one is completely different" and he would then go
> into the minutest detail – "Look at the eyelids, the way the ear
> is moulded, the nostrils – it is completely different from the
> last one" – he made you look at things in a completely differ-
> ent way, this was one of his huge talents.[253]

In parallel to his archaeological endeavours, Hunt set about extending the house at Lough Gur by converting some of the outbuildings, turning a hayloft into a third upstairs bedroom and creating a garden terrace at the rear. He was a skilled handyman and enjoyed working both on the house and the garden. Writing to Raftery on Jack's behalf, Putzel noted that 'Jack is plastering and so eager on it that he thinks of nothing else' and, later, that

'in his spare time Jack is building a greenhouse but I am afraid it will be too late for tomatoes this year'.[254]

They filled the old lime-wash plastered rooms with many of their most precious antiques formerly at Poyle. These included an Irish dresser, a Sumerian sculpture, a painting by French Realist painter Constantin Guys, a Spanish Gothic tapestry, eighteenth-century faience pottery from Strasbourg and an eighteenth-century Regency bookcase. Their early twelfth-century limewood figure of the Virgin from the lower Rhine, known as the 'Enthroned Madonna', was prominently displayed.

The two early medieval wooden statues by Ligier Richier stood at either side of an arch in the drawing room and a Picasso painting dedicated to one of the artist's favourite cafés in Barcelona was placed appropriately in the kitchen and dining room.[255]

Many medieval domestic pottery items were used as everyday utensils and, in the decoration and furnishings, the Hunts incorporated as many features of

Above: Putzel in the garden at Lough Gur.
Left: Romanesque Enthroned Madonna.

Irish craftsmanship as possible.

The Hunts adapted well to living at Lough Gur as a rural farm couple. Their neighbour, Pat Hickey, recalled how 'They integrated very well into the local community and went to mass every Sunday … They were a very gentle and down-to-earth couple.'[256] Sr Regina O'Brien, one of a family of seven children who lived on a dairy farm next-door, can vividly recall the 'warm and sincere' couple … 'happy to mix with ordinary people … obliging and generous'.[257] As the Hunts had no milch cows,

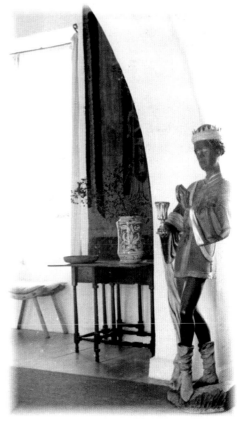

Above: View of the kitchen at Lough Gur with artworks including a menu card by Picasso of the Four Cats Cafe in Barcelona.
Right: Caspar of the Three Kings at Lough Gur.

their workman would collect milk from the O'Brien farm each day and, on Sundays after mass, the task of supplying the milk to the Hunts was under-taken by the O'Brien children. She recalls Jack and Putzel as being most obliging to their neighbours. As they were the only ones in the area with a car, the Hunts would regularly be called upon to bring local people on emergency trips, such as to hospital.[258] Jack and Putzel always gave the seven O'Brien children presents for Christmas and, in order to assess the most suit-able presents for each, the Hunts would come themselves to collect the milk from the O'Brien farm each year in November.

Hunt was also known in the locality as a man with medical knowledge. Sr Regina recalled him bringing his 'Red Cross box' to the house to insert stitches in her sister's forehead on the kitchen table after she had suffered a bad fall, and also being summoned when another infant sibling swallowed a nail. Hunt had seemingly decided that the four years he had spent at St Bartholomew's Hospital in London were going to be put to some beneficial use in rural Ireland!

Because of the shortages of the wartime period, the Hunts had to be largely self-sufficient for their food and fuel. They kept their own herd of dry-stock cattle, looked after by a local 'gardener-handyman-of-all-work', had a small orchard with about two dozen trees, a greenhouse, and grew all their own vegetables and 'every kind of herb, thyme, mint, tarragon, chives, parsley, basil, tansy, borage, sage, marjoram, savory.'[259] They produced many fruits and veg-etables that were not grown by anyone else in the area, including strawber-ries, artichokes, grapes and tomatoes from their new greenhouse.[260]

Putzel's nationality and her German accent were of some curiosity, both in the farmhouses of Lough Gur and the drawing rooms of Limerick city: 'The locals used to be fascinated with Putzel because she'd be up at half-past six in the morning and she'd have bedclothes hanging out the window being aired – it was a very German thing'.[261] However, their friend, Dr John Devane, who shared Hunt's interest in the local history and archaeol-ogy and often hosted Sunday lunches attended by Hunt at his Pery Square, Limerick home, was 'outraged by an anti-German attitude towards her in

some quarters in Limerick'.[262]

The Hunts' world had moved far from the galleries of Mayfair and the splendour of Poyle Manor. Jack wrote to Tom Kendrick at the British Museum, on a November day when he had risen early to herd some of his animals on foot for four miles along cold dark roads to a fair:

> My Dear Tom … I find time somehow amongst other things
> to raise a few cattle for beef. I was up at 4 ('old time') this
> morning in the moonlight to a cattle fair in Bruff; after stand-
> ing in the dirty streets slushing about in cow dung & drink-
> ing luck pennies in the dark pubs I came back about 2 this
> afternoon to find your letter.[263]

Hunt did not delegate the task of selling his stock to his handyman or a neighbouring farmer and, while we can detect some distaste on his part at the conditions that prevailed at the fair (the filthy conditions at the quarterly street fair in Bruff were notorious) and what he perceived as the quaint customs associated with Irish cattle dealing, he had no qualms about getting his hands, and certainly his boots, dirty as part of his assimilation into his new surroundings. [264]

While there is no evidence that Hunt ever lied about his ancestry, it is difficult to believe he was unaware that, from his earliest years living at Lough Gur, a widespread impression had emerged that he was either Irish-born or of Irish parentage, with close family ties in the Limerick/Clare area. Despite the fact that he had come from England with the accent and manners of the British upper class, he took a deep interest in the history of ancient Ireland and, in particular, of the Limerick area. His deep involvement in what was considered to be work of national importance at Lough Gur could reasonably have been assumed to be driven by a sense of patriotism. It was not too great a leap of conjecture to assume Hunt was connected to one of the many branches of a well-known Hunt family, closely interwoven into the historical fabric of the county. These descendants of another 'John Hunt' had acquired considerable estates in Limerick in the late seventeenth century at Curragh Chase near Askeaton. Members of this family had later intermarried with

many of the leading gentry in the county and two members of this same extended Hunt family had served as mayors of Limerick in the early nineteenth century.[265]

Several accounts have been recorded of the welcome visitors received from the Hunts at their Lough Gur home and the pleasure gained by viewing their medieval treasures. Mannix Joyce, a Limerick author and historian, described his first visit to the Hunts' Lough Gur home:

> A large window looked out on the lake from the kitchen that, in Irish country fashion, was also living-cum-dining room. Most eye-catching item of furniture was a lovely old dresser holding a shiny array of delph. But just how unusual this house was may be judged from the fact that hung on the walls of the kitchen was a painting of Jack B Yeats, and a sketch by Michelangelo.
>
> Elsewhere in the house were carved statues of the fifteenth, sixteenth and seventeenth centuries from France, Spain, Bavaria and Italy. And you could expect to find any kind of unusual object in the house. For example in the hallway there was a collection of dog collars most of them exquisitely worked in precious metals and leather. One had been worn by a dog that had belonged to the Prince Archbishop of Salzburg. I and my companions had tea with the Hunts on that occasion. It was the first time that I tasted rye bread.
>
> The purpose of our visit to the Hunt homestead was to collect some objects which John Hunt had promised to lend us for a historical exhibition in Bruree which was being organised in connection with *An Tóstal*.[266] We came home with a car full of exhibits which included stone and bronze axes, methers, burial urns, Penal crosses, Spanish rosaries and some of the original documents from the trial of St Oliver Plunkett. The lending of all those rare and valuable objects shows what kind of man John Hunt was. He liked to help activities

of this kind and was always ready with advice and encourage-
ment. My first contact with him was in the mid-1940s when
I received a letter from him inviting me to visit some excava-
tions he was then engaged on in the Cushcountryleague (*sic*)
area. The letter was signed in the Irish form of his name, Sean
Ó Fiach.[267]

Fr Bernard O'Dea, OSB, from Glenstal Abbey, recalled his first visit to the
Hunts' home in a homily delivered more than forty years later:

> I knew them when they lived in the converted farm-house,
> perched on the edge of Lough Gur. On privileged outings, a
> band of young monks would hop on their bikes and hit for
> the Hunts, where we were guaranteed a feast on various levels.
> [268]

The Hunts' taste in the decoration of the house may have brought them
to the attention of the young Brendan O'Regan, who had been appointed,
in 1943, by the Minister for Industry and Commerce, Sean Lemass, to run
the catering facilities at the flying-boat base at Foynes. O'Regan was 'really
entranced by the interior decor' of the house at Lough Gur where the Hunts
had incorporated a Gaelic theme into the decor by the use of bawneen-style
wool curtains and wall hangings.[269] He asked that they be given a brief to
assist him at Foynes, which was under the control of the Irish Military, and
a letter from a Captain N Hewett was forwarded to Military Intelligence in
Dublin:

> Seeking permission for Mrs Hunt to come to Foynes to assist
> with the decoration of the I&C restaurant at the request of Mr
> O'Regan. Mr O'Regan who is the manager of the I&C res-
> taurant here wishes to enlist the temporary help of the above
> as they are experts in interior decoration. Mrs Hunt however
> is a German national and before asking her to come to Foynes,
> your views on the matter are solicited.[270]

A hand-written note on the same file states that 'the CSO phoned Captain
Hewett to say that they are not to be brought to Foynes'.[271] But O'Regan,

whose initials, BOR, provided the nickname 'Bash on Regardless', was not a man to be thwarted by bureaucrats. Jack and Putzel went to Foynes to plan and supervise the re-decoration of the restaurant.[272] A contemporary report describes their work there as:

> A spacious room, indirect lighting diffusing a cosy warmth
> over a moss-green carpet, on which the cerise upholstered
> Irish oak furniture makes a vivid splash. Most of the tables are
> arranged with wall settees in corners and the off-white but-
> toned cerise of chairs and curtains in dyed bawneen material.
> Flower bowls are fitted against the wall. Over one wall hangs
> a strikingly lovely sort of tapestry, Slovenian or Slovakia, I
> guessed, but it turned out to be an 18th century Irish Quilt
> made not many miles from the port. Connoisseur John Hunt
> discovered it.[273]

Hunt continued to widen his contacts in Irish archaeology. He was mentioned in 1943 by Ada Longfield, the wife of the Inspector of National Monuments, Harold G Leask, as providing various suggestions in her published paper on some elaborately carved late eighteenth-century tombstones.[274] During the summer of 1944 he assisted Professor Michael Duignan of University College Galway (UCG) in the excavation of the important early medieval monastic site of St Peakaun at Toureen, near Cahir, County Tipperary, partly funded by the Royal Irish Academy. The finds, described as 'some of the most important archaeological discoveries of recent years', included two Romanesque windows, four stone crosses and more than thirty stones with sculptures and inscriptions in early Irish.[275]

Despite the restrictions on travel created by wartime petrol shortages, the Hunts paid frequent visits to Dublin, where their new contacts included Edward McGuire of Brown Thomas, Kurt Ticher, the Jewish silver specialist, as well as Dr Raftery of the National Museum.[276] In April 1942 Hunt was invited to lecture at the Academy of Christian Art in Dublin on 'Irish Crucifixial Figures with special reference to Ireland'. The Academy had been set up in 1929 by Count Plunkett to foster a debate on art that would be

appropriate for Irish churches, where it was seen that there was neither a style of architecture nor any art theme for furnishing them. In his talk, Hunt made the interesting point that Ireland was the first country in Western Europe with a thriving artistic heritage prior to it becoming Christian.[277] As a result, depictions of scenes from the story of Christ's life, such as the Crucifixion, had been interpreted for the first time in the Western world in Ireland by stone carvers who showed the figure of Christ in a loin cloth.

During his war years in Lough Gur, Hunt also kept up regular correspondence with many in his former circle of friends with antiquarian interests in London, including Tom Kendrick of the British Museum.[278] Having left his library of books at Poyle, Hunt was hampered in replying to some of Kendrick's queries by the research sources available in Ireland. On one occasion he lamented that 'the National Museum doesn't even possess copies of the Antiquarian's Journal!! except for a few odd old ones, or the P.S.A.!!'.[279] In February 1943, Kendrick visited Lough Gur and addressed the Thomond Archaeological Society in Limerick on 'Viking Taste in Western Art'.

In May 1943, Mrs Viva King, a prominent London society hostess, addressed the Thomond Archaeological Society on 'Religious Subjects on Domestic Glass' and stayed with the Hunts at Lough Gur.[280] She recalled her stay there as follows: 'They had made what in Ireland is called a cabin into a miniature palace. I cannot go into the fascinating history of this gifted pair.'[281]

Prior to her stay with the Hunts, King stayed in Dublin with the British Embassy press attaché, John Betjeman, who was busily trying to cultivate pro-Allied sympathies in Ireland. From the time of Betjeman's appointment, it was clear that his main task would be 'to attempt to influence Irish opinion by all possible means … he soon became the object of widespread rumour and official suspicion that he was pursuing a covert as well as an overt role'.[282] Mrs King was working at the time on relief to the victims of the London Blitz and commented on those who attended her Limerick lecture: 'I found Irish friends loyal to England – ex-members of the various ceramic societies we belonged to, who came to my lecture'.[283] Hunt later arranged for her to have a second visit to Ireland when she lectured in Dublin and spent some

more time relaxing there away from the privations of war-time London.[284]

From the Hunts' earliest years in Ireland there are records of them making gifts as benefactors. The earliest such donation dates from 1942 when Putzel gave two items to the National Museum in Dublin. The first was a decorative bird made of 'silver wire worked on coloured silks' and described as either a 'Lady's dress ornament or from a stump embroidered casket, English mid-seventeenth century'.[285] The second item was described as 'Dutch Cap (Lady's). Brocade enriched with gold, tinsel, sequins and coloured stones – mid-eighteenth-century'.[286]

In November 1945, with the war over, Hunt made a gift of a crucifix to the Taoiseach, Eamon de Valera, 'as a small token of our gratitude for God's providence in having preserved this country from the horrors of war through your great leadership'.[287] Hunt signed the letter in Irish with the words '*Nár lagaí Dia do Lámh, Mise le meas*' (may God not weaken your hand), I (am) with respect', giving credence to other reports that both he and particularly Putzel had studied the Irish language.[288] Some weeks after the presentation, de Valera brought the Archbishop of Dublin, John Charles McQuaid, to see the crucifix and, on 9 January 1946, passed it over to him on the basis (as he explained in a letter to Hunt) that 'it seemed better that it should be preserved in some place of worship rather than in a museum'.[289]

In February 1948, Putzel donated a 'badge of gold and enamel inscribed with the name Thomas Moore and the date 1812' to the National Museum. Over the next thirty years there were to be at least ten separate formal donations to the National Museum, all of which were dealt with by Putzel.

In 1945, Hunt finally completed his studies for a Master of Arts degree in the Archaeology Department of UCC, which he had commenced initially under Professor Sean Ó Ríordáin with a thesis on 'Medieval armour in Ireland as exemplified on existing effigial monuments'.[290] He had travelled all over war-time Ireland on a bicycle, with only the writings of a few earlier antiquarians, such as Limerick man Thomas Johnson Westropp, to guide his visits to graveyards and churches where the monuments he sought, mostly of Norman knights, had been sculpted in stone.

Hunt received his degree in January 1946 and developed the material in his thesis further in a paper, published in 1950, entitled 'Rory O'Tunney and the Ossory Tomb Sculptures' which dealt with the work of the sixteenth-century master mason who sculpted a quarter of all the effigial tombs that have survived from that era in Ireland.[291] Medieval stone sculpture in Ireland became a lifetime interest for Hunt and became the topic of his most important work, *Irish Medieval Figure Sculpture 1200-1600,* published some thirty years later.

The period during which Hunt lived in Lough Gur was to be the most prolific in terms of his contributions to academic and learned journals, and he published no less than sixteen separate papers or commentaries between 1942 and 1954. These included seven different pieces in the *Journal of the Royal Society of Antiquaries of Ireland* (RSAI), an organisation of which he became a council member in March 1950. These ranged from the description of a Sheela-na-Gig from Caherelly, near Lough Gur, to a paper in which he challenged the prevailing attribution to a sixteenth-century Archbishop of Cashel of a tomb in the cathedral there.[292]

In the postwar period, when he was free once more to travel back and forth to the UK, Hunt still used Lough Gur as a base and continued to involve himself in cultural activities in the region. During a six-month visit to the UK in 1945-6 he sold Poyle Manor, but arranged with the new owner to store many of his art treasures, particularly some of the larger objects, in a garage there for the next six years.

Although his art dealing activities had been largely put on hold while he pursued his archaeological and antiquarian interests in Ireland, V&A archives from early 1946 record a variety of relatively minor acquisitions from Hunt, ranging from a twelfth-century sandstone corbel (£50), a drawing (£40) and the gift of a ballot bag. Later that year, the V&A Director Leigh Ashton sourced from Hunt a red-lacquered day-bed (£250) by Giles Grendey as part of a consignment for the National Gallery of Victoria (NGV) in Melbourne, Australia.[293] The object is one of only two daybeds in the world by this famous eighteenth-century London cabinet-maker who numbered

members of the British and Spanish nobility among his clients. In 2011, the piece was highlighted among the gallery's twenty 'best-loved art-works'.[294] Hunt also renewed his generous donations to the British Museum and, in early 1946, his friend Kendrick acknowledged the receipt of two items, one 'an amuletic brass engraved with religious and magical inscriptions and the signs of the zodiac' and the other 'a wooden hand with an ivory sleeve'.[295]

After Hunt moved to Ireland in 1940, his contact with Sir William Burrell, his most important customer up to that time, decreased, although he stored two large pieces of oak furniture at Poyle Manor on Burrell's behalf for the duration of the war, and delivered them later to Burrell's home at Kelvingrove, in Scotland. They still occasionally did business; in 1947, for example, Burrell purchased a fine fourteenth-century Swiss tapestry of the *Madonna and Child with St James* from Hunt for £525. In total, Hunt sold some ninety-five items to Burrell during the post-war period, but these were generally of a lesser value than those sold in the 1930s. To a large degree, Burrell considered that his comprehensive collection from the Late Gothic period, where Hunt could bring his specialist expertise to bear, was complete.

Burrell's final purchase from Hunt was an early sixteenth-century oak table, with an elaborate trestle support and panelled linenfold, originally from the kitchen of Durham Cathedral. For many years Hunt had this table in a prominent position in the drawing room at Poyle Manor and resisted repeated efforts by Burrell to purchase it from him. When he sold Poyle in 1946 it became one of the items stored in the garage there and was eventually sold to Burrell in 1952 when Hunt finally removed all the items stored on the property, it being far too large to move to his home in Lough Gur. Burrell, then ninety-one years of age, recorded his pleasure at finally acquiring this object from Hunt in his purchase book: 'I have bought a very important table which I have known about for years, but which I didn't think would ever come our way as Mr. Hunt steadfastly refused to sell. I have paid £2,025 for it plus carriage'.[296]

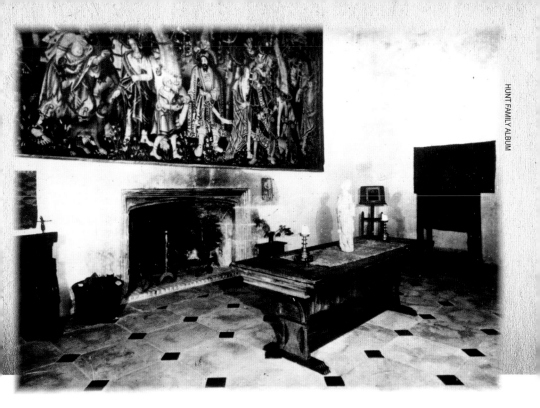

An early sixteenth-century oak table, originally from Durham Cathedral, seen here in Poyle Manor, but now in Burrell Museum.

Throughout the war Putzel had been very conscious of the traumas being endured by her family in Germany. Her two brothers were killed at the battle of Stalingrad and, towards the later stages of the war, she described in a letter to Joe Raftery her suspicions that starvation was occurring on a wide scale from reports of her mother spending most of the day queuing to obtain bread. [297] Since direct shipment of food or other items to Germany was impossible, Jack wrote on at least three occasions to an art dealer in Luzern and succeeded in getting coffee sent from neutral Switzerland to Putzel's mother in Germany.[298]

After the war, Putzel managed to get access to her mother in Baden-Baden, despite the tight security controls that severely restricted travel, especially from abroad. She later described 'the difficult position' in which she had been placed by the war in 'wanting the Allies to succeed and, at the same time not wanting Germany to be destroyed'.[299]

Putzel's mother, Paula Leinenbach, November 1943.

Jack and Putzel, in the post-war period, resolved to support Irish efforts to alleviate the suffering of children in post-war Europe, then ravaged by a severe shortage of food and accommodation. From late 1946, a thousand children from the war-torn continent, mostly German, were evacuated to Ireland and housed by Irish families for up to three years under 'Operation Shamrock', an initiative by the Irish Red Cross. Putzel had agreed to foster a child and, in 1949, took care of Gerlinde Demmer, a young German girl from Kaiserswerth, Düsseldorf. A more long-term commitment, which over-lapped the final months of the young Gerlinde's stay at Lough Gur, involved fostering a teenage German girl, Dorothea Brummer, from Berlin. Dotie, as she was known, had survived the horrors of war, including the Dresden bombings, and her family lived in communist East Berlin in the post-war era.

The Hunts paid for her education at the Faithful Companions of Jesus (FCJ) convent secondary school in Bruff, County Limerick, and later at UCD where she studied for an Arts degree.

In 1949 Hunt was to begin his most high-profile archaeological investigation at Ballingarry Down near Ballylanders in County Lim-erick. Hunt's excavation, on what was initially assumed to have been a Norman house-site, revealed the presence of a series of superim-posed buildings, pointing to habi-tation from early Christian times. Hunt addressed the Archaeological Society at UCD in March 1951 on

Dorothea (Dotie) Brummer, the German teenager who was fostered by the Hunts.

his findings and, that September, provided a tour of the site to visiting delegates of the Prehistoric Society, mostly archaeologists from Britain. Hunt described the discoveries at Ballingarry and asserted that a piece of Chinese pottery discovered there indicated that Chinese traders had visited the Shannon Estuary around the time of St Patrick, some 1,500 years earlier. However, apart from reports of his lectures and interviews on the subject, Hunt's work at Ballingarry has never been published.[300]

In November 1950, Hunt loaned objects from his collection to the Holy Year Exhibition in the newly built Church of Our Lady of the Rosary, Ennis Road, Limerick, organised by his friend Monsignor Moloney. The objects loaned included the Galway Chalice (1633), the Cashel Pyx, and a collection of eighteenth-century Irish rosaries. The highlight of the exhibition was the return of the Ardagh Chalice (*c.*800) to its native county. The following year, Pope Pius XII became another recipient of a donation from Hunt when he was presented with an 'artistically worked diamond encrusted ring' through the good offices of the Irish Ambassador to the Holy See.[301]

In 1952, Hunt was described as the 'prime mover' behind a unique event, the *Art Treasures in Thomond Exhibition*, organised by the Friends of the Limerick City Gallery.[302] This exhibition brought together the most valuable art objects owned by various collectors in Thomond, and put them on display for the general public to have 'an unique opportunity to view the Art Treasures that have lain hidden in Munster houses, in many cases for three or four hundred years'.[303] He served as joint honorary secretary of the exhibition committee, presided over by Monsignor Michael Moloney, and including the novelist Kate O'Brien, Lord Inchiquin, Putzel and various members of the clergy of both denominations among its members. Lenders to the exhibition included the Earls of Dunraven and Inchiquin, Lord and Lady Doneraile, the Bishops of Limerick and Killaloe, Glenstal Abbey and a further sixty or so exhibitors, making up a veritable 'who's who' of the leading professional and business people in the region.

In line with a distinctly religious theme to the exhibition, it concluded on 9 June 1952 with a special 'Artists' Mass' presided over by the Bishop

of Limerick, Most Rev. Patrick O'Neill, in the Church of Our Lady of the Rosary (1950). Both Jack and Putzel had been very closely involved with Monsignor Moloney in furnishing this church. Designed by Donegal architect Liam McCormick, its design was cited as 'one of the more significant recent contributions to Irish Ecclesiastical Architecture and Art'.[304] At Hunt's prompting, various artists from the 'living art movement' in Ireland were invited to contribute to the decoration of the church, including Evie Hone, Oisín Kelly, Fr Jack Hanlon, Brother Benedict Tutty OSB and Andrew O'Connor. Hunt donated several objects from his collection to the church, including a very valuable sixteenth-century Spanish crucifix, which is now located in the sanctuary.

Hunt's good standing with the Catholic diocese in Limerick was in evidence the following year when he was provided with an important introduction for a business trip to Spain. Bishop O'Neill wrote a reference for Hunt in Latin describing him as of 'impeccable character, a good Catholic and very deserving of the (goodwill of the) church' and asking that Spanish churchmen 'receive him well and help him in his purpose'.[305]

Hunt's most significant contributions to the Catholic Church in the Limerick Diocese involved the O'Dea Mitre and Crozier of the Bishop of Limerick. These are the only precious objects from the medieval period in Ireland still in the same ownership today as when they were first made. They can justifiably be claimed as the most important Irish art treasures from the period and were originally made in 1418 by an Irish craftsman, Thomas O'Carryd, for the Bishop of Limerick, Conor O'Dea. The Limerick Mitre with its thin silver plates, gilded and jewelled, and pearls fashioned as flowers, is the most precious of those made for Bishop O'Dea. The crozier is a beautiful example of Gothic metalwork. It is unique because of its size, being one metre long, and incorporates an exceptional level of detail with intricately wrought figures cast in silver, representing various groupings of the Trinity, the Holy Family and several saints.

Hunt's first involvement with these items saw him publish, in 1953, at his own expense, a forty-eight-page booklet – half of which consisted of black

The O'Dea Crozier.

and white photographs of the pontificalia – in which he described both trea-sures with scholarly authority.[306] Most unusually, he was able to illustrate how the objects had changed over the previous century and a half by studying detailed water colour drawings of both objects made in 1808, which were housed at the Society of Antiquaries in London. Hunt also set out the tech-niques by which each of the objects was constructed, describing, in the case of the mitre, how the 160 jewels were inserted into the gilded silver plates. The cost of publication was £250, a significant sum at the time but, as well as the objects' great significance as Irish art treasures, Hunt's family link to these objects might also have encouraged him to publish. The drawings from 1808 had been attributed to Thomas Weld of Lulworth Castle, and Hunt was aware of his family's descent on his mother's side from that family.[307]

Hunt's love of the O'Dea Mitre and Crozier was to be enduring and, in 1962, he arranged for the treasures to be restored by experts at the British Museum and the V&A, again at his own expense. Christy Lynch, the man-ager at the restored Bunratty Castle, tells of how Hunt asked him to collect a long wooden box from Monsignor Moloney and bring it from Limerick to Dublin on the train, without telling him what was in it. Having left the crate on the platform at Limerick Junction while he had a cup of tea, he continued on his journey and only discovered what he was carrying when Hunt met him at Dublin's Kingsbridge Station (now Heuston Station) and revealed the precious nature of his cargo. The V&A restored the crozier free of charge and Hunt paid a bill of £150 charged by the British Museum for the repair of the mitre.[308]

In October 1964, while the mitre and crozier were being repaired in London, the Hunts' great friend Monsignor Moloney died following a car crash and the Hunts dedicated the restoration as a gift in his memory.[309] After their repair, the two items went on display in August 1965 for three months at the V&A. The display created quite some interest, with one London jour-nal describing the objects as 'Ireland's greatest Gothic treasures'.[310] The V&A, in a surprisingly bold statement, asserted that the crozier was 'much more authentic than that of Bishop Wykeham at New College Oxford', the latter

object being long considered as the finest example of early English silver-work.[311]

Hunt personally brought the objects back to Bishop Henry Murphy and, in 1966, suggested that the bishop should place the mitre and crozier, along with the Arthur Cross, in the new St Munchin's diocesan school at Corbally, as a nucleus for a new diocesan museum. Setting out his belief in the power of ancient religious objects, he wrote to Bishop Murphy:

I think the diocesan students should have the opportunity of constant association with these treasures. Subconsciously, as I know from my own experience, such pieces of history have a deep psychological effect. They would help to bring home to them a realisation of their artistic and cultural heritage, so often lost sight of because of our unhappy history, and which is so closely linked with the spiritual continuity of the church in Ireland.[312]

From the early 1950s, Hunt became more widely recognised nationally as an expert on matters archaeological and artistic. His co-option, in March 1950, to the council of the Royal Society of Antiquaries of Ireland, was in recognition of his work in the fields of archaeology and art history and was an unusual appointment, since most of the council's twenty-two members held senior full-time appointments either with academic institutions, museums, or other state bodies. While he had some fellow council members, such as

The O'Dea Mitre.

Ó Ríordáin, with whom he had enjoyed fruitful collaboration, it is unclear as to how such an 'amateur' archaeologist might have been regarded by other antiquarian heavyweights on the council. None of the other members had any involvement with business and certainly not with the business of dealing in artworks.[313] In February of 1952, Hunt received recognition of his role in Irish archaeology when nominated by the Minister for Finance, Seán McEntee, for an initial three-year term, to the National Monuments Advisory Council.[314] This body had been established under the National Monuments Act (1930) to assist and advise on the protection and preservation of national monuments.[315]

In October 1951 the Cultural Relations Committee of the Department of External Affairs appointed Hunt as one of three judges of a competition to select an appropriate design for a statue of St Patrick, after it had been brought to the notice of the Cultural Relations Committee that 'there was virtually no satisfactory small statue of Ireland's National Apostle which visitors might acquire as a memento'.[316]

Hunt's willingness to lend some of his collection of early Irish crucifixes to an exhibition held in the College of Surgeons as part of the second *An Tóstal* in April 1954 brought him further press attention. The exhibition, the highlight of which was a collection of Renaissance bronze statuettes from the Beit Collection, was opened by Mr Justice Cearbhall Ó Dálaigh, later the fourth president of the Irish Republic, who referred to 'the generosity of some of the major benefactors who had contributed pieces for the exhibition and especially to Sir Alfred Beit, Mr John Hunt and Mr Chester Beatty who … deserved to be held in esteem in this country only after Hugh Lane'.[317]

In conjunction with his resumption of active dealing and art consultancy in London, the increased involvement of Hunt in the Dublin art world inevitably meant that the days of rural idyll on the shores of Lough Gur were numbered. Since September 1944 the Hunts had acquired a Dublin base at 6 Lower Pembroke Street, a Georgian townhouse with an exceptional Gothic arched pedestrian entrance, formerly owned by the famed cabinetmaker James Hicks. Later, their living quarters for their Dublin visits was a flat in

a substantial property they had purchased in October 1946, at 71 Merrion Square. This arrangement, as Putzel described 'is so much more convenient for us. The long drive up to Dublin was getting really too much for me.'[318]

In the summer of 1954 they sold the property at Lough Gur to James Wesley Wellesley, a British aristocrat who claimed relationship with the Duke of Wellington.[319] Wellesley met the Hunts' foster-daughter, Dotie Brummer, at the Hunts' flat in Merrion Square and the young couple immediately 'liked each other'.[320] In February 1956, Putzel organised Dotie's wedding to Wellesley in Guildford, in England and the couple later lived for a couple of years in the house at Lough Gur. More than half a century later, Dotie, long resident in her native Germany, was to recall how she 'very much loved Jack. He was a wonderful very sweet person'.[321]

However, before leaving Thomond, Hunt set in train work which would leave to the region a lasting monument of his love for the history of Ireland and the people who lived in it in times past.

The Triptych

Through his hands passed some of the most remarkable
works of art ever made in Europe.
Christina Ruiz [322]

The story of Hunt's involvement with the Mary Queen of Scots Triptych,[323] one of the most important works of European art from the medieval period, provides a unique insight into the excitement, intrigue and scholarship involved in dealing in precious objects of antiquity. Few objects could claim as diverse a cast of owners as the triptych. At some time in its history these included, in no particular order: Mary Queen of Scots, the Bavarian royal family, Adolf Hitler, an Irish senator, the Pope, the head of the Jesuits, an international Jewish banker and a junk dealer in Killarney.

In many cases, only scraps of information survive to provide clues to the provenance of ancient artefacts. However, in the case of the triptych, the object is recorded in oral tradition as far back as the late sixteenth century and, in documentary form, since the early seventeenth century.[324]

Hunt's involvement with the triptych, over a period of more than twenty years, is documented in a considerable volume of correspondence, much of it of a legal nature, left intact in his rather limited family records. This correspondence provides for the first time some of the 'ever elusive' facts on the issue, albeit some that may be stranger than fiction.

Hunt's first contact with this treasure occurred a few years after his arrival

in Ireland and came about through his friendship with Edward McGuire, a wealthy Dublin businessman who was Managing Director of Brown Thomas, the prestigious department store, and later an Irish senator. McGuire and his wife Billie had become good friends of the Hunts since their arrival in Ireland in July 1940, with a mutual interest in precious art objects which, within a few years, would see them both appointed to the Arts Council.[325]

Sometime in 1942, McGuire saw a small blue enamelled triptych with religious motifs in gold frames in the shop window of Wine's, the well-known Jewish antique dealer on Dublin's Grafton Street.[326] He bought the jewel for around £200, a considerable price at that time, particularly since neither he nor Mr Wine knew very much about the background of the object, other than that the person who sold it to Wine's said it had been in a convent for many years.[327]

The triptych was an exquisitely beautiful jewel, made by a medieval goldsmith. Measuring only 3⅝" x 5⅔" when opened out, it consisted of translucent enamel, mostly royal blue in colour, on a gold framework and was typical of many such objects made down the centuries to be used as a 'travelling altar' for daily prayers. It contained four folding panels decorated on both sides; images of the saints were on the inside and various scenes from Christ's life on the outside. A Latin inscription on a gold band around the outside of the triptych read: '*ELIZABETH VAUX DD RMO CLAUDIO AQUA-VIVAE SOCIET. JESU. GENER. PRAETO*' which translated as 'Elizabeth Vaux donated this object to Claudius Aquaviva, the General of the Society of Jesus'.

Sometime after McGuire purchased the triptych, Hunt saw it on a visit to McGuire's house. He was most interested in it and volunteered to try to find out more about this most unusual object. He was provided with photographs by McGuire who said that the piece was believed by the Celtic art specialist, Francoise Henry, as probably dating from the early sixteenth century and German in origin, adding: 'we await your opinion with impatience'.[328]

Hunt set out a written assessment of the piece, bringing his extensive knowledge of medieval craftsmanship to bear on the images, the workman-

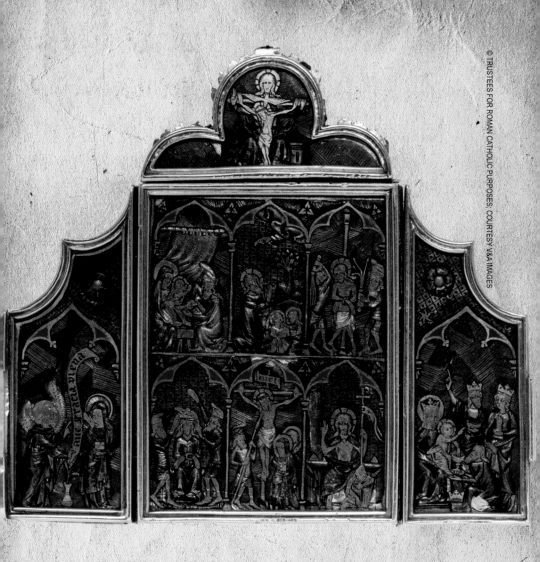

The Mary Queen of Scots (Campion Hall) Triptych.

ship and the materials used. He believed that the saints depicted were the
English saints, Edmund and Aidan, leading him to the conclusion that the
triptych must be English in origin. This was a radical suggestion because, as
far as he knew, there was no comparable English piece in existence.

Hunt wrote from Lough Gur to Tom Kendrick of the British Museum in
terms which showed little of his usual reserve:

> I made the most staggering discovery recently about which
> I am seething with excitement – it is a 14th century triptych,
> quite small, a little jewel, about 3 inches by 4 when open. It is
> translucent basse taille enamel – on <u>gold</u> – and is undoubtedly
> <u>English.</u> It is finer than anything of the sort I have ever seen
> & one of the loveliest – it is in a private collection here &
> the owner had been told that it was 16th century & German.
> I am going to do a note on it & will send you more details as
> I should be terribly grateful for any help & I thought Francis
> Wormald would perhaps be able to help identify the manu-
> script source of the scenes. I long for you to see it & if you
> come over I could bring it to show you.[329]

Kendrick, in reply, agreed that Hunt should contact Francis Wormald, who
Hunt had known in pre-war years as the Assistant Keeper at the Department
of Manuscripts at the British Museum. Having heard from Hunt, Wormald
agreed with much of his assessment of the jewel but disagreed about its origin,
pointing out that there was nothing exclusively English about the triptych as
St Edmund was also prominent in France.[330] Furthermore, Wormald said that
Hunt was mistaken in identifying St Aidan, believing the saint represented
was, in fact, St Giles. Handwritten notes also record a later conversation by
Hunt with Charles Oman, Keeper of Metalwork at the V&A, in which the
latter dismissed Hunt's suggestion that the triptych was unique.[331]

Another party with whom Hunt corresponded was to play a central role
in the story of the triptych for many decades to come. At Christmas 1942,
he had sent details of the triptych and its inscription to Fr Martin D'Arcy
SJ, an old friend who shared Hunt's love of medieval art as well as his deeply

held religious views.[332] Before the war, D'Arcy had been a frequent visitor to Hunt's antique shop in Mayfair. He was based nearby at the English Jesuit headquarters, the Church of the Immaculate Conception, Farm Street, where Hunt had been given religious instruction and was received into the Catholic Church in 1925. Arguably the most influential Catholic clergyman in England in the twentieth century, he was, at various times, professor of philosophy at Oxford University, the Provincial of the Jesuit order in Britain (1945-1950), a prolific writer with twenty published books, a broadcaster and conversationalist. He gained a great deal of publicity in the 1930s by bringing such luminaries as Evelyn Waugh, Allen Dulles and Lord Longford into the Catholic Church.[333]

D'Arcy wrote back to Hunt, a few weeks after receiving the letter, saying: 'What you tell me of your discovery sounds really exciting. I should love to have a look at the triptych. From the inscription it was evidently given to Claudius Aquaviva, the General of the Jesuits. It is interesting that that famous travelling altar of Mary Queen of Scots was also given to Aquaviva.'[334] D'Arcy had earlier become aware of the latter object when it was put up for sale in Germany in 1932 and, as far as he was aware, it was still in a collection in Germany.[335]

During the next three years, little more appears to have been learnt about the object. Hunt made his interest in acquiring it known to McGuire on several occasions and, in January 1946, they agreed a deal to exchange the triptych for some special eighteenth-century antiques, mostly of French origin, from Hunt's English home at Poyle Manor. McGuire wanted these objects for his newly acquired mansion, Newtown Park, at Blackrock in County Dublin but, unfortunately, the deal with Hunt was over-ruled by his wife, Billie, and Hunt accepted that he should forget about acquiring the triptych.

Some months later, however, McGuire wrote unexpectedly to Hunt, saying: 'I really do not want to sell it at all and therefore I find it hard to price it. Your repeated suggestions to me to let you have it, have at last weakened my resolve not to sell it. I feel that unless it is worth £2,000 I would rather keep it … If you feel that this is too much and beyond your wishes I can

assure you that I shall feel happy and even relieved not to have let the triptych go after all ... In a word if the triptych does not realise £2,000 well then I would rather have it and not sell it.'[336]

The final price agreed for the sale between Hunt and McGuire was £2,100, with £600 to be paid in cash and the rest in some of the special antiques that had been agreed to earlier.[337] Hunt handed over the money and the goods, and took the triptych back to his home at Lough Gur.

A few weeks later, on 4 September 1946, the latest edition of the *Burlington Magazine* arrived by post at McGuire's home in Dublin, but not to John Hunt's home in Lough Gur. To the amazement of McGuire, it revealed in a footnote that the triptych he had sold was actually the Mary Queen of Scots Travelling Altar. In a lengthy article on a Sienese panel in Christ Church Library, Oxford, the author had included a small photograph and a footnote with just a few lines of background details referring to: 'a small enamel tabernacle ... formerly in the Schatzkammer at Munich ... a 'pocket altarpiece' for Mary Stuart (1542-67) ... Later in the hands of Paul Drey, art dealer of Munich'.[338]

Despite the small size of the black and white photograph, the article made clear to McGuire that the triptych Hunt had bought from him was the famous piece that had once belonged to Mary Queen of Scots. As well as being amazed, McGuire was also 'very sore about one or two points', suspecting that Hunt, as an authority on medieval art, may have betrayed their friendship in knowing the true provenance of the triptych when he bought it. [339] He wrote to Hunt the next day telling him about the article and stating that he had earlier considered writing to him after a friend had informed him about being told by Hunt that the triptych had associations with Mary Queen of Scots. He spoke of statements made by Hunt about the triptych 'which greatly influenced my decision to let you have it', recalling a dinner party when Hunt's comments that the triptych 'was not by any means unique' and 'was only worth about £900' had served 'to depreciate its importance in the eyes of our friends'.[340] Without making any request for the return of the triptych he concluded by saying: 'My family have not forgiven me for parting

with it nor you for inducing me to sell it … It would never have been sold only for the intimate friendly relations which you have with us and because of your repeated pressure to sell made within that friendship'.[341]

Hunt was equally astonished at this turn of events and while there is neither a carbon copy or photocopy of his reply on file, along with most of the correspondence, both handwritten and typewritten, which he was to generate on this matter during the next few weeks, there are several drafts of his reply in his personal papers.

Hunt replied to McGuire saying he was 'terribly distressed by your letter' and indicated that he had not yet seen the article, saying: 'I am amazed to hear that the triptych is illustrated in the *Burlington*'.[342] He attempted to prove he was unaware the triptych could have been the Mary Queen of Scots, as experts had dismissed his idea that the piece was English. He pointed out that his original suggestion to this effect had been dismissed by Francis Wormald of the British Museum 'pouring cold water on the whole thing'.[343] He defended his quoted dinner-party remarks that the jewel was not unique, as his own ideas to this effect had been rejected by Charles Oman in the V&A 'who made me look rather foolish' by pointing out several other such gold triptychs with translucent enamel.[344] He also asked D'Arcy to write to McGuire and confirm that the Jesuit had been the first person to tell Hunt about the coincidence that the Mary Queen of Scots Travelling Altar had also been given as a present to Claudius Aquaviva, but that it had never occurred to D'Arcy himself that the object in Ireland could be the Mary Queen of Scots Triptych.

However, before he had received Hunt's letter, McGuire sent a further missive in which he apologised, saying 'I am sorry, I feel that the tone of the letter was harsh and accusatory … I should hate to fall out with you on account of this matter. Life is too short and friends are too few'.[345] McGuire concluded by suggesting that the exchange of the triptych for furniture and cash be called off.

Both parties met to discuss the matter and Hunt wrote the following day: 'I solemnly repeat that I did <u>not</u> know the enamel came from Munich and

that it was the so-called Mary Queen of Scots one, about which I had heard, however, merely as part of art history. I was never more surprised when I saw the *Burlington* article which I beg you to believe is one of the most amazing coincidences I have ever struck. As for my persistence, you cannot know the insatiable collector whether it be of stamps, stone axes, or medieval art. If I had been less of a collector & loved things less I dare say I would have been a more successful dealer'.[346]

Hunt sought legal opinion from his trusted friend and legal advisor, Arthur Cox, who assured him that McGuire had no claim on the triptych, although Hunt's own title to the object could be challenged by a legitimate owner in Germany, from whom it would appear the triptych was stolen.[347] Hunt made it clear to Cox at the outset that he now felt that the Jesuits were the moral owners of the triptych and stated his intention to restore it to them. He then summarised his attitude in a letter to McGuire, making it clear that his honour and reputation were more important to him than any monetary value of the triptych:

> I am quite frankly, not primarily concerned with the financial
> value. I bought the triptych, not as a speculation, but because I
> love such things and wanted to own it. The additional inter-
> est which I now know it has, has affected me, not financially,
> but in my joy of possession. Much as I might value the jewel
> I value my honour more. I am not going to put myself into
> a position in which it could ever, under any circumstances,
> be afterwards suggested by anyone that I had acted as if I had
> done something wrong.[348]

After his initial assertions, McGuire's tone softened and he replied to Hunt saying 'Your presence in Ireland and your friendship has meant a great deal to us. You have given us much pleasure by your company and your knowledge. I can assure you that things are now back to where they were – in a word we are friends'.[349]

Less than a month after the difficulty between the two good friends had arisen, and despite some subsequent misunderstandings which nearly put the

reconciliation off the rails, Hunt made an offer to McGuire which was both generous and ingenious. His suggestion, which kept both honour and friendship intact, was that the two of them would be joint owners of the triptych and McGuire readily accepted this proposal.[350]

When Arthur Cox produced the first draft of the legal agreement on shared ownership, Hunt had made clear his wish that the triptych would eventually go to the Jesuits and had inserted an option to acquire McGuire's share in the triptych, if he or his family at any time wished to dispose of their interest.[351] He later gave explicit instructions to Cox that 'I want to be able to leave it to the Jesuits'.[352] It is clear from Hunt's efforts to restore the object to the Jesuits that he assumed that at some point in its history it had been seized from them. In this he was mistaken and it is fairly clear that, in late 1946, he was not conversant with much of the background history of the object up to that time.

The triptych's connection to Mary Stuart, Queen of Scots, had been documented as far back as 1617 when it was described in the inventory of the treasures of Duke Maximillian I of Bavaria.[353] Queen Mary had used the triptych for devotional prayer and, from the inscription, it appears that shortly before her execution the unfortunate Mary had given the altar as a memento to the Vaux family, who were staunch Catholics, living near Fotheringay Castle in Northamptonshire, where Mary was executed in 1587. We cannot be certain as to how the triptych got to Claudius Aquaviva, the head of the Jesuits in Rome (1581-1615) but a probable route was through a family member, Elizabeth Vaux, who was smuggled to France in 1582 by the Jesuits and became a Poor Clare nun. It is plausible that, when giving up her worldly goods and taking vows of poverty, she might, as an expression of gratitude, 'have given the triptych as a present to the head of the Order which had helped her'.[354]

It then appears that Aquaviva gave the triptych in 1605 to the newly crowned Pope Leo XI as a coronation present and, with the Pope dying within a few weeks, the triptych, along with other coronation presents, were returned to the donors, in this case to Aquaviva's family, the Dukes of Afri.

Shortly after the death of Claudius Aquaviva in 1615, and possibly on his instruction, his family gave the triptych to Maximillian I, Duke of Bavaria and head of the powerful Wittelsbachs, Bavaria's staunchly Catholic royal family and one of Europe's most powerful and widespread dynasties.

The Wittelsbachs recorded the triptych in their inventory in 1617, including the link to Mary Queen of Scots.[355] A covering case made for the triptych around that time, but later mislaid, also recorded the historical connection, the inscription in Latin reading: 'This image was the companion of the exile and prison of Mary Stuart Queen of Scots; it would have been the witness of her murder also if she had lived.'[356]

The Wittelsbachs kept the triptych as a royal treasure for more than 300 years before they loaned it in the 1920s for display in the Treasury Chamber of the Muenchener Schatzkammer, their former royal palace in Munich, famed for its collection of gold and jewellery. Their power and possessions greatly reduced in the aftermath of the Great War, the Wittelsbachs needed revenue from the sale of precious objects and, in 1926, the triptych was offered privately to the V&A in London and, later in 1932, they had put it up for sale in Germany but no deal had taken place.[357] The cover telling of the link to Mary Queen of Scots had been lost since 1876 and the origin and value of the triptych may not have been recognised.

McGuire transferred the sum of £1,050 to Hunt and the triptych was placed on joint deposit in the names of both Hunt and McGuire in the Bank of Ireland, College Green, Dublin, while their solicitors set out to conclude the necessary legal agreement to implement their deal to share ownership of the triptych.[358] Understandably, Arthur Cox raised the issue that somewhere there must be a legal owner of the triptych who might one day make a claim for its repossession. Therefore, any agreement must incorporate this possibility.

In December, Hunt wrote again to his friend D'Arcy, telling him about the latest turn of events and making it clear that he wanted to give his share in the triptych to the Jesuits: 'My only desire in the first place was that it should eventually go either to you or to some religious body ... I have done

my utmost to protect it for you and I feel there is now a good chance of its one day coming into your possession. Maybe the prayers of your order will bring this about'.[359]

D'Arcy replied, clearly showing that he understood the nature of Hunt's generosity to himself and his order: 'I think you have been quixotically considerate ... when I think how much you yourself and Gertrude loved the piece, you have made a great sacrifice. What is more you have been extraordinarily generous in your intentions to me. I am most grateful. I must now get Heaven bombarded by prayer! How extraordinary the whole story is!'[360]

While the lawyers were busy drafting and exchanging legal documents, Hunt had a mystery to solve, namely, how did the triptych manage to be transported from Munich to Ireland, apparently in the midst of a World War? He proceeded to get in touch with some of his wide network of contacts in the international art world, although communication with the European continent and particularly with Germany, then still under Allied military control, was extremely difficult.

The first clue in solving the mystery of how the triptych had come to be in Wine's antique shop did not come from Hunt's contacts in the art world, but from good old-fashioned police work. On 19 February 1947, Hunt received a letter from Arthur Cox saying that he had a visit from Chief Inspector Weir of the Garda Síochána Detective Branch who wished to see the triptych in the Bank of Ireland and asked Cox if the agreement between Hunt and McGuire was proceeding.[361] Weir's enquiries had been triggered by the police in London whom he said: 'had some information that it had been picked up in a London street after the blitz'.[362] Cox added that he gathered that the Gardaí did not know who owned the triptych but were 'merely making enquiries ... there was nothing hostile in the enquiry'.[363]

In replying to Cox, Hunt highlighted the police report suggesting that the triptych had been picked up in London, noting 'they must have traced it back further than the South of Ireland in that case'.[364] Nonetheless, it was still a puzzle as to how a piece of royal Bavarian treasure ended up in a London street during the Blitz – unless it fell out of a German bomber! Cox later

advised Hunt that the Gardaí had mentioned that the value of the triptych was £37,000, without saying how they had arrived at such an extraordinary figure for that time.[365]

The ongoing investigations in London began to fill in more of the missing pieces of the jigsaw. Just over a month later, Hunt received a letter from a Fr Buggy SJ who wrote to say that the London Metropolitan police had visited the Jesuit headquarters making enquiries about the triptych because they knew it had once belonged to their order.[366] According to the letter, a detective inspector from Scotland Yard stated that the triptych 'was sold in January 1941 by an Irish labourer, who claimed he had found it while doing demolition work in England, to a junk dealer in Killarney. The dealer, who had bought it for 15 shillings, sold it as scrap gold for £2.10 shillings; and, after passing through several hands, it reached the price of £2,400 and is reckoned to be worth a great deal more'.[367]

The letter concluded that 'the police reckon that both the British Museum and the Dublin Museum are trying to lay their hands on it in the event of its being on the market legitimately'.[368] This might indicate that the British Museum had initially tipped off the British police, having heard rumours that Hunt and McGuire had somehow acquired an incredibly valuable jewel, which they could only hope to acquire if the mystery of its provenance was solved. The information gathered by the London police clearly contradicted the story told by the person who sold the object to Wine's and said it had come from a convent, where it had been for a considerable time.[369]

By this time Hunt was clearly getting some feedback from his continental art dealing contacts as to what the Wittelsbachs had done with the jewel. When D'Arcy met the police in early April he said that Hunt had told him that 'a Dutch Jew, named Oppenheim or Oppenheimer had bought it.'[370] D'Arcy suggested to the police 'that when Germany invaded Holland the Dutch Jew must have had a bad time, that in all likelihood some of his possessions were scattered or looted'.[371] According to D'Arcy, the detective knew of Hunt's part in the matter from the British Museum, who had spoken of his 'expert knowledge'[372] D'Arcy wondered how the enquiry started, suggesting

that McGuire may have got 'nervous'.[373] But, as there was no report of such an item being reported missing, the opportunity for the police to investigate further was limited.

The mystery as to how the triptych wound up on the streets of London during the Blitz was finally unravelled in a letter received by Hunt a few weeks later from a London art dealer, Raphael Rosenberg. Before the war, Raphael and his brother Saemy had been fine art dealers in Frankfurt and, being Jewish, had fled from Germany when Hitler came to power.[374] When war broke out in 1939, Saemy moved to New York and established the firm Rosenberg & Stiebel. In his letter, Raphael Rosenberg stated that his brother Saemy had informed him that 'the small triptych from the Muenchener Schatzkammer was sent to London … and was destroyed in a safe deposit during the war … it belonged to a group of objects which Dr Mannheimer gave to Alice (sic) Mannheimer'.[375]

Raphael Rosenberg later confirmed to Hunt that his brother was, in fact, the person who had sold the triptych to Dr Mannheimer and was in touch with the latter's widow in New York, Jane Mannheimer.[376] He also informed Hunt that Mrs Mannheimer believed that the triptych had been destroyed when the safe deposit in which she kept it with other objects was bombed.[377]

Dr Fritz Mannheimer, the triptych's erstwhile owner, was the most powerful banker of the inter-war years in Europe, described by *Time Magazine* as: 'one of the richest men in the world, a man who by floating loans could keep whole countries from sinking'.[378] A German Jew, born in Stuttgart, he had moved from Germany to head a branch of the private bank of Mendelsohn & Co. in Amsterdam and had become a naturalised Dutchman in 1936. An obituary in *Time Magazine* described him as: 'a fat-lipped, mean, noxious, cigar-smoking, German Jew, one of whose mistresses had a gold bathtub and who after 20 years in the Netherlands, could not speak enough Dutch to boss his own chauffeur … His was the last Jewish-owned bank allowed to do business in Germany'.[379] This latter comment, which implies favouritism from the Nazis, is misleading as Mannheimer was guided in his business decisions by his anti-Nazi political views.[380] Described elsewhere as

'a fervent anti-Nazi (who) effectively used his financial expertise as a banker to frustrate the ambitions of Hitler and his henchman' his power in financing sovereign debt made him a bitter enemy of the new rulers in Berlin. [381] Mannheimer died in Vaucresson, France, on 9 August 1939, just three weeks before the outbreak of World War II, creating headlines around the financial world to the effect that '(his) death and its subsequences may cause a political crisis in France'.[382]

At the time of his death, Mannheimer had arranged huge loans for the French government whose Finance Minister, Paul Reynaud, had been best man at his wedding just two months earlier.[383] Mannheimer's bride was Marie Annette Reiss-Brian (known as Jane), a twenty-one-year-old Brazilian, born in China where her father, of German Jewish origin, had been Brazilian consul in Shanghai.[384]

Two days after Mannheimer's death, the bank in Amsterdam suspended payments and, within weeks, the statement of affairs showed that Mendelsohn & Co. was insolvent and that the personal estate of Mannheimer was a large debtor of the bank. Prior to his death, Mannheimer, in order to keep some personal assets out of the hands of creditors of the Mendelsohn Bank, had given instructions that the triptych and some other precious items were to be sent to London for safe keeping under the name of his wife. The firm of Chenue & Co. deposited the triptych along with other goods in the safe depository in Chancery Lane, in London. On the 23 and 24 September 1940, during a German bombing raid, the Chancery Lane safe depository was severely damaged and it was assumed that the triptych, along with most other items stored there, had been destroyed in the resulting inferno.

Based on the information about a possible rightful owner, Hunt decided that, despite the substantial sum he had paid McGuire, he could no longer enjoy possession of an object that he now believed was not his and agreed with Cox that a hold should be put on completing the deal with McGuire until he could further investigate Mrs Mannheimer's claim.[385]

Hunt wrote a confidential letter to Saemy Rosenberg in New York, saying that as far as he was concerned he wanted to restore his share of the triptych

as soon as possible to Mrs Mannheimer, provided she could supply some basic information to confirm her previous ownership of it: 'I feel it only fair that Mrs Mannheimer should be informed about this. Though it has been pointed out to me that there is no need to pursue the matter in law, I cannot help feeling that I am doing the correct thing in writing. You being a friend of hers and a friend of ours strengthens me in this resolution. I am sure you will be able to decide the right thing.'[386]

Some days later, Arthur Cox forwarded a letter addressed to Mrs Mannheimer c/o Rosenberg & Stiebel in New York. It included a picture of the triptych and, without mentioning Hunt's name, stated: 'Our client has received information which leads him to believe that this may at one time have been your property. If you have any claim in connection with it, would you please write us fully by return of post, giving complete particulars.'[387]

Seven weeks later, a reply from Rosenberg & Stiebel said they had only recently given the letter to Mrs Mannheimer who would discuss the matter with her lawyer and revert.[388] They also advised that she had re-married and was now known as Mrs Charles W. Engelhard Jr.

The delayed response can probably be explained by the fact that Mrs Mannheimer, having got married in August 1947, was probably still on honeymoon when the Cox letter arrived in New York. Her new husband, Charles Engelhard Jr, was another very wealthy businessman. Known as 'the Platinum King', Engelhard was already prominent in society where both he and his wife later enjoyed great public esteem as major benefactors to a wide range of charities and cultural institutions.[389] In later years, Jane Engelhard enjoyed considerable influence at the highest levels of American government, serving on committees to preserve the White House and being assigned to special diplomatic roles under several US presidents.[390]

Another month passed before Arthur Cox received a letter from Slaughter & May of Austin Friars, London, acting on behalf of Mr Korthals Altes of Amsterdam, trustee administrator of Mannheimer's estate. The letter acknowledged Mrs Engelhard's ownership and set out a formal claim for her repossession of the triptych:

The triptych is apparently a small portable altar which was one of a number of valuable works of art stored in the Chancery Lane Safe Deposit, Chancery Lane, London in 1939 for safe custody. At that time ownership of the Tryptich (*sic*) and other works of art was claimed by Mrs Mannheimer (who has since remarried and is now Mrs Charles W. Engelhard) and our client, Mr Korthals Altes of Amsterdam (Trustee Administrator appointed by the Dutch courts) and proceedings were pending before the English Court with regard to the ownership. The Chancery Lane Safe Deposit was destroyed by enemy action in September 1940 and when salvage was completed it was reported that the Tryptich (*sic*), together with certain other works of art, had been destroyed. It now appears from your letter that the Tryptich (*sic*) was not in fact destroyed but has found its way into the possession of your client.

The dispute between Mr Korthals Altes and Mrs Engelhard as to the ownership of the works of art has now been disposed of and we are making a claim on behalf of Mrs Engelhard under the English War Damage Act 1943 for compensation for the loss or damage of the articles due to enemy action. The Triptych cannot now be included in that claim and we shall be glad therefore if you will treat this letter as formal notice of a claim to the Triptych on behalf of Mrs Engelhard and Mr Altes. We cannot supply any information as to how the Triptych found its way into the possession of your client, but we have no doubt but that we can establish that it was in fact one of the articles belonging to Mrs Engelhard and placed in the Chancery Lane Safe Deposit for safe custody.

We shall be glad if you will let us know if your client admits this claim or what information is required to satisfy him or you of the accuracy of the facts as set out in this letter.

We shall also be glad if you will let us know exactly in what circumstances your client came into possession of the Tryptich (*sic*) although you will appreciate that no imputation of any kind is made against him.[391]

Cox forwarded the letter to Hunt adding: 'It is, I think, clear that Mrs Engelhard is the owner of the Triptych'.[392] Hunt agreed to surrender his half share in the triptych and Cox accordingly wrote to Slaughter & May stating that 'provided their client satisfies us that she is the rightful owner, Mr Hunt will transfer to her all his rights'.[393]

Quite surprisingly, there was no response from Slaughter & May during the next month and, but for a chance meeting in New York, matters might have remained dormant on the legal side of things. However, in March 1948, Hunt received a letter from D'Arcy, who was quite excited that by 'an extraordinary coincidence' he had been introduced to Mrs Jane Engelhard and that there would be no problem in dealing with her to get the triptych back to the Jesuits.[394] D'Arcy wrote: 'You can imagine my surprise when I met a tall young woman – of French Culture with Irish and Brazilian blood – a keen Catholic and married to the 'Platinum King' of the USA, a Charles Engelhard. She knew all about the altar and I think she is not likely at all to let the matter rest where it does. When you and Putzel are next in London I must tell you more about this.'[395]

Putzel Hunt wrote immediately to Arthur Cox enclosing D'Arcy's letter and Cox responded saying that 'Mrs Mannheimer being well off and a Catholic will probably be very glad to let the Jesuits have what is morally their property. It will be a happy ending to all your worry and a reward to you and Mrs Hunt for your unselfish generosity'.[396]

Cox now gave the name of his client, for the first time, to Slaughter & May and disclosed the background, as they had requested, as to how the triptych had come into Hunt's possession. He concluded as follows: 'Both Mr Maguire and Mr Hunt are gentlemen of considerable wealth. Their interest in the object is artistic rather than material. There is this difference between their views: Mr Hunt on his part would, provided he is satisfied with the

proofs of ownership by your client, be prepared to relinquish to her whatever interest he may have. Mr Maguire on the other hand is advised that, having purchased the Triptych in good faith, and in the circumstances of the purchase, that he would have a good title.'[397]

Slaughter & May asked what proof of ownership Hunt would require and Cox replied: 'Mr Hunt will not be unreasonable. He will act on our advice … the interest of Mr Hunt is Firstly, not to withhold from the true owner property which legally does not belong to him, but Secondly to have sufficient clear and definite proof to safeguard himself in the event of any claim ever hereafter being made by any third party.[398] Slaughter & May wrote saying that they should be able to provide evidence 'sufficient to prove ownership of the Triptych', adding, 'we appreciate Mr Hunt's attitude and that he is only in a position to dispose of his one-half interest.'[399]

Remarkably, there was no response of any kind during the next three years from Slaughter & May to the request of Arthur Cox for basic evidence to support Mrs Engelhard's claim to the triptych. One can reasonably surmise that there may have been a problem for Jane Engelhard in swearing an affidavit because, having been married to Fritz Mannheimer for only two months, she may never have seen the object and only became aware of it after the war as an item stored on her behalf at the Chancery Lane Safe Deposit Company. It is also unclear how she had resolved her dispute with the trustee administrator of Mannheimer's estate, Korthals Altes. Shortly after the latter's appointment to this role in 1939, he had discovered that Mannheimer had arranged for the transfer of certain valuable art objects to England under the name of his wife and, on grounds of insolvency, he had challenged the legality of that transfer.

Adolf Hitler, as part of his grandiose scheme to establish an art museum in Linz, Austria, to house the world's greatest Aryan cultural achievements, was to acquire title to the entire Mannheimer Collection, including the triptych, along with all the other items stored in London.[400] In 1941 the Dutch part of the Mannheimer Collection was sold by Altes on behalf of the creditors of the Mendelsohn Bank for 5.5 million guilders and, in May 1944, the French

part of the collection, which had been removed by Mannheimer's wife from Paris to Vichy France in 1940, was sold for 15 million French francs.[401] Both prices were well under market value as a result of other bidders being blocked. The details of the final post-war settlement between Altes and Jane Engelhard are not known, but it is reported that she relinquished her claim to part of the collection returned from Germany to France.[402]

'I thought this matter had finally gone to sleep',[403] Arthur Cox wrote somewhat wistfully to Hunt after he received a letter in August 1951 from a Dublin firm of solicitors, Hayes & Co., on behalf of Slaughter & May, asking if the offer still stood.[404] Cox wrote to Hunt the next day suggesting they agree to confirm the original offer on the grounds that: 'it is of course apparent that Mrs Engelhard is entitled to the jewel if she can prove that it is hers, so we are really giving nothing away by agreeing.'[405] However, given the long delays that had taken place, Cox introduced a new proviso that Mrs Mannheimer should pay Hunt's legal costs in the matter.

Hunt contacted McGuire, with whom he was 'on very friendly terms again', and advised Cox that, despite taking a more adversarial attitude to the matter, McGuire also knew that 'if satisfactory and absolute proof of owner-ship is put forward, he would also understand that the rightful owner should have it'.[406] Having consulted with his client, Arthur Cox sent a brief reply and the matter died again with no further response of any kind from either Hayes & Co. or Slaughter & May in the next six months.

However, things took a new turn in April 1952 when D'Arcy got a call from Mrs Engelhard to say that she would be staying at Claridges Hotel, London, and wished to meet with him for lunch on 7 April to discuss the triptych. D'Arcy immediately wrote to Hunt saying that she wanted to know: 'On what conditions you and Mr McGuire are prepared to release the altar ... save her time by letting her know how to proceed immediately ... I once told her – I hope not indiscreetly of your good intentions towards me and that is why I think she asks me to find out from you the conditions. From previous conversations with her I know she is prepared to pay a certain amount for the return of the Altar but thought it was Mr McGuire who was

the difficulty. In her letter she writes 'I am prepared to pay them for it and give it to you' but she does not say how much. I feel terribly embarrassed at all this but I cannot very well say on Monday when I shall see her that I have done nothing. Could you then let her or me know by Monday next?'[407]

The main surprise to emerge from this letter was that it seemed to suggest that Mrs Engelhard was not being kept fully up to date by Slaughter & May on the affair. Since the previous September, Cox had re-confirmed Hunt's willingness, on payment of his legal costs, to restore the triptych to the rightful owner without any reimbursement of the £1,050 he had paid McGuire for his share in the jewel, and the only issue was to establish the position of McGuire. The proposal by Jane Engelhard meant that at least now he might not be out of pocket. Hunt replied by telegram 'tried ringing unsuccessful. Cannot contact McGuire until today. Suggest you sound position on basis of cost price twenty one hundred … If helpful Putzel could come London'.[408]

At the lunch with D'Arcy, Jane Engelhard confirmed that she was not interested in having the triptych for herself but wanted it to go instead to the Jesuits and gave a cheque to D'Arcy for £2,100 to expedite the purchase of it from Hunt and McGuire. D'Arcy obviously briefed Hunt on his successful meeting and, displaying perhaps a certain naivety, asked Hunt to send over the triptych by post immediately. Hunt in turn briefed Cox and two days later Cox wrote to Hayes & Co. 'to inform (them) of… this new development so that you may take instructions'.[409]

In his letter, Cox set out Hunt's understanding of the history of the triptych: 'It was at one time the property of the Jesuit Order, it having been given, it is believed, by Mary Queen of Scots to the Superior General of the Order at that time. It would appear that at some later date the Triptych was stolen from the Jesuit Fathers who were its true owners'.[410] Cox reconfirmed that Hunt would be willing to agree to Mrs Engelhard's proposal that following a payment by her of £2,100 to Hunt and McGuire, the triptych should be 'restored to the Jesuit order jointly by her, Senator McGuire and Mr Hunt.'[411]

He set out the following conditions for the transfer: 'Mr McGuire should

state his claim; the £2,100 should be paid; there should be a full release by Mrs Engelhard of all claims that she might have; that the permission of the Irish Finance Authorities should be obtained'.[412] Cox also pointed out that, naturally, Mr Hunt and Mr McGuire 'must act together and that no arrangement of any binding nature will have been reached until both have assented'.[413]

Having copied McGuire's solicitor McVeagh on the letter, the latter reluctantly conceded that: 'apparently, however, my client has agreed to sell all his interest in the Triptych for £1,050 and on receipt of such sum within a reasonable time it will be accepted in full settlement'.[414]

On the following day John Hunt wrote to D'Arcy explaining that Arthur Cox had said they had no proof that Mrs Engelhard was the undisputed owner of the triptych and, that if a subsequent claimant emerged, then both Hunt and McGuire could be sued for the return of the triptych or, alternatively, its then value which was likely to be very considerable.[415] He went on to explain that the lawyers were quite right to suggest that: 'everything should be finally and legally settled so that there could be no question arising about heirs' claims or anything like that which is of course in your interest as well … if Mrs Engelhard had given authority to her lawyers to act for her, it would speed matters, otherwise she might have to sign something herself'.[416]

D'Arcy replied four days later saying: 'I feel so grateful to you for being such friends and so helpful about the altar. I quite realise that the lawyers must come into it … If it is of any use I vouch of course that she has made over to me the altar and relinquished her claims'.[417] At this stage, D'Arcy's impatience to get his hands on the triptych became increasingly evident and he wrote in his third letter to Hunt in eight days that: 'I have a cheque burning in my pocket but I suppose that I had better hold on to it … Will the lawyers take a long time or is the end near?'[418]

A week later he wrote again, this time to Putzel, saying: 'You have done everything you can and I am most grateful. I too thought this transfer would be simple and did not think of asking Mrs Engelhard for sworn statements or for the name of her solicitors. I am writing to her now to ask her to give

authority to her solicitor'.[419] The following week, a clearly frustrated D'Arcy wrote once more to Putzel stating 'what an extraordinary tribe lawyers are! They can make delays, money and mountains out of the simplest thing … Mrs Engelhard has told me about Mr Slaughter (*sic*), so I will go and see him'.[420]

The following morning D'Arcy met a Mr Howard of Slaughter & May and wrote to Putzel with news of a dramatic new development. The latter firm were now dealing with the altar from the point of view of the Dutch government's claims and 'would not admit Mrs Engelhard's or those other claimants who quarrel about it in Ireland. I had heard of the Dutch claim, though Mrs Engelhard did not take it seriously in any way. With the lawyers coming into it, I foresee a case going on for ever. Once these lawyers bicker on points of law, they will never cease and expenses will mount up.'[421]

Cox was informed of this 'disturbing letter from poor Fr D'Arcy'.[422] He was most perplexed and wrote to Hunt, saying: 'I am quite at a loss to understand the conversation between Father D'Arcy and Mr Howard. I know Slaughter & May very well. They are one of the leading firms of lawyers in the world. I find it extremely difficult to see how he could have said that he did not admit the claim of Mrs Engelhard when, in fact, his firm had previously stated that they acted for her. I rather think that Father D'Arcy must have taken him up wrongly.'[423] He went on to raise the only possible way out as an indemnity from the Jesuits but clearly did not favour such an option as 'the very fact of accepting an indemnity seems to imply that there may be a doubt'.[424]

Both Hunt and McGuire were now in a quandary. Over the next ten days or so they discussed the matter very closely and grasped at the only straw of hope offered by Cox in his letter of 21 May, namely to get indemnities from the Jesuits and Mrs Engelhard. McGuire wrote to Hunt stating that he was 'willing to hand over the triptych to D'Arcy for the sum already mentioned, subject to an indemnity from D'Arcy on behalf of Mrs Engelhard that, in case of any future complications, she will be fully responsible' and Cox began to draft up the appropriate agreement.[425]

D'Arcy now began a campaign to keep Jane Engelhard's name out of any legal document. In July, he made changes to the draft agreement to remove any mention of her name on the not unreasonable grounds that: 'Neither the Dutch or her nephew could make use of the document to cause further trouble in the future to ourselves or her husband and herself'.[426] He added that, having looked at her recent letters, he felt 'there cannot be any doubt that in purchasing the Altar for me she is at the same time relinquishing all claims to it. She and her husband want the Altar to go to the Church, specifically the Jesuits'.[427] Evidence of some of the potential claims can be found in this letter, with D'Arcy writing that Mrs Engelhard 'had persuaded her nephew to give up any claim he was making on the same condition the Altar is bought for me and she has just sent me a letter from her nephew stating this'.[428] D'Arcy then wrote to Hunt thanking him for 'all the trouble you have taken. I shall say more of this when all is finished.'[429]

The agreement was eventually signed, including appropriate indemnities and undertakings, that the Jesuits were responsible for the costs of any future third party claims against Hunt and McGuire. So, on 4 October 1952, five years after Hunt's first contact with Mrs Engelhard through Saemy Rosenberg in New York, the triptych and Mrs Engelhard's cheque were exchanged at the Bank of Ireland, College Green, Dublin. After some 347 years, the Mary Queen of Scots Travelling Altar was once more in the possession of the Jesuits.

D'Arcy initially decided that the object should be assigned to Stonyhurst College in Lancashire, because that college had already in its possession the Book of Prayer that Queen Mary had at her execution. All parties hoped that this would be the end of the affair – a hope that only lasted for barely a year!

Some six months later, D'Arcy agreed to lend the triptych as a possession of Campion Hall to a Coronation Year exhibition of the *Treasures of Oxford* at London's Goldsmiths' Hall. He wondered in a letter to Putzel: 'whether I was wise to do so. What do you think?' Hunt was later informed by Charles Oman of the V&A, who prepared the catalogue for the exhibition, that having 'got very nervous … (D'Arcy) would not let me say anything about

the history of the piece after it reached Aquaviva!'[430]

'You will be surprised to hear that this matter has reopened,' wrote George McVeagh to his client, Senator McGuire, on 14 October 1953, after both Hunt and McGuire had received correspondence from solicitors representing Marc Maartens of Port Chester, New York, who asserted that he was the nephew of Fritz Mannheimer and had been given the triptych by his uncle just two weeks before the latter's death in 1938 (*sic*).[431] His lawyers enquired as to whether Mr McGuire and Mr Hunter (*sic*) were prepared to hand over the triptych to Mr Maartens, 'as the legal owner thereof'.[432] Arthur Cox replied on behalf of John Hunt saying that the triptych 'was historically the property of the Jesuits (and) had been handed back to them … with the approval and consent of Mrs Engelhard, Mr Hunt and Senator McGuire'.[433]

Despite a Plenary Summons and a note that the Statement of Claim would follow, no further correspondence was received on this claim.[434] However, the development clearly worried D'Arcy, who wanted particularly to keep confidential the fact that Mrs Engelhard had provided the money to him to purchase the triptych.[435]

No sooner had the initial flurry of correspondence in the claim by Maartens ceased, than a much more serious threat was to emerge. On 18 December 1953, without any prior notice to either Hunt or McGuire, an application for letters of administration of the personal estate of Fritz Mannheimer was heard in the High Court in Dublin on the application of EJ Korthals-Altes, described as: 'the Trustee-Administrator of Mannheimer's estate as appointed by the Dutch Courts in August 1939'.[436]

The solicitors acting on behalf of Korthals-Altes were Hayes & Co., who had come on record in August 1951 as agents for Slaughter & May, acting on behalf of Jane Engelhard. While the name of Slaughter & May did not appear anywhere in the proceedings it seems improbable that they would have dropped out of the case, having earlier acted in 1947 and 1948 on behalf of both Korthals-Altes and Mrs Engelhard in correspondence with Arthur Cox, and through Hayes & Company on behalf of Mrs Engelhard in 1951.

The story was the source of much gossip in Dublin, with the entire affi-

davit of Korthals-Altes reproduced in *The Irish Times* and the *Irish Independent*.[437] Under the headline 'Irish bank holds lost triptych' the news article recited the history of the triptych as set out in court.[438]

Hunt wrote to D'Arcy bringing him up to date on this latest development, and asking him to write to Arthur Cox telling him that it was in order to incur costs, such as briefing senior counsel, in defence of the claim. He also mentioned that: 'unfortunately the rumours about it have caused a tremendous stir in Dublin but not very much has come out in the papers yet'.[439]

The following day, Arthur Cox wrote to D'Arcy requesting him to contact Mrs Engelhard and obtain a full statement of the circumstances of the gift to her. He also wrote to Hunt raising the question as to whether to avoid 'the possibility of a long vista of difficult and expensive litigation' they should not just inform the solicitors for the other side that they no longer had the triptych. [440] He wrote again to D'Arcy on 2 January 1954, reminding him of the indemnities given by the Jesuits and asking him to come to Dublin 'for a consultation with Counsel at which the whole position could be discussed'.[441] A Fr Caraman SJ travelled to Dublin on 7 January and his attitude was that 'Fr D'Arcy will not be willing to surrender the triptych unless there is a decision of the Court'.[442] The position of the Jesuits was re-confirmed by Mr Goodier, the solicitor for Stonyhurst College, stating that: 'Fr. D'Arcy had handed the Triptych over to the College which already held the Book of Prayer used by Queen Mary at her execution ... it is the decision of the Jesuit fathers to fight out the case in Dublin as they think they are morally the owners'. [443]

In a statement of claim in February 1954 the plaintiff contended that, on instructions given by the deceased Mannheimer before or at the time of his death, the triptych was given after his death to the firm of J Chenue for delivery for safe keeping to the Chancery Lane Safe Deposit Company. [444] Korthals-Altes demanded the return of the triptych or its value or damages for its retention, damages for its conversion and a declaration from the court that it had formed part of the estate of Fritz Mannheimer.

The case was to move at a slow pace over the following years. The key

point of the defence of both McGuire (lodged in May 1956) and Hunt (lodged in November 1960 along the exact same lines as McGuire's four years earlier) was what is known in legal terms as 'estoppel by conduct'. This means that in law a person is prevented from making an allegation or denial that contradicts what one has previously stated as the truth.[445]

Both McGuire and Hunt in their submissions contended that Slaughter & May, 'acting as Solicitors and duly authorised agents for the plaintiff stated that the said tabernacle or triptych was the property of one Mrs Charles W Engelhard. Relying on the said statement, this defendant and the second named defendant had transferred the property in and possession of a tabernacle or triptych to the Reverend MC D'Arcy SJ of 114 Mount St., Grosvenor Square, London with the consent of the said Mrs Engelhard. If the tabernacle or triptych so transferred by the Defendants to the said Reverend D'Arcy was the same as that the subject of these proceedings the plaintiff is estopped from claiming the same'.[446]

Once the defence of estoppel was submitted, one could reasonably surmise that neither Altes nor his legal advisors would have been keen to let this case go to a public hearing where the legal flaw in first asserting Mrs Mannheimer's claim and then an opposite interest would have undermined their case. This point had been highlighted years earlier by Arthur Cox when, referring to a reported statement from Fr D'Arcy that Slaughter & May was now acting for the Dutch official assignee, he stated with some incredulity that: 'I find it extremely difficult to see how he could have said that he did not admit the claim of Mrs Engelhard when, in fact, his firm had previously stated that they acted for her.'[447]

In October 1961 a brief reply to the defences of both Hunt and McGuire dealt only with the issue of the triptych not being in Ireland on the date the hearing commenced in 1954. There was no mention of the estoppel defence. Both Korthals-Altes and his legal advisors were no doubt anxious to let the matter drop quietly, and on 7 December 1964, before the Master of the High Court in Dublin, upon joint application by Arthur Cox and Hayes & Co. as solicitors for the plaintiff, the action was dismissed

by consent without any order as to costs.

Hunt's actions in his dealings with the triptych provide an insight into his ethical standards and his lack of drive to maximise material gain. He demonstrated his sense of fair play and the importance he placed on reputation and friendship by returning a half share in the ownership of the triptych to McGuire, despite legal advice showing no legal imperative to act accordingly. He made clear at the same time his intention to eventually surrender his own share to the Jesuits, a gesture appreciated by D'Arcy who wrote at the time, saying: 'when I think how much you yourself and Gertrude loved the piece, you have made a great sacrifice'.[448]

HUNT FAMILY ALBUM

Apart from the sacrifice of giving up a beautiful treasure whose possession he enjoyed, Hunt also made a financial sacrifice when he unselfishly returned a half share of the triptych to McGuire, because, even for a wealthy individual, the value of the piece at that time was significant – possibly as much as the £37,000 suggested by the Gardaí to Arthur Cox.[449] Finally, his efforts to track down Jane Mannheimer and surrender his share of the jewel to her, demonstrated an ethical imperative to do 'the correct thing'.[450]

Above: Edward McGuire and John Hunt at the RDS.

Bunratty

*For all my life and for many generations before me the castle stood
desolate, a slowly crumbling ruin ... a forsaken old relic. And then a
few years ago came John Hunt — that learned, impassioned student
of the past and of forgotten arts, forsaken skills and beauties, a man of
pure and scholarly devotion, a lover and servant of Ireland if ever there
was one. He decided, studied, plotted, planned, implored, begged and
everyway thought and importuned — to restore Bunratty Castle to
what it was when Barnaby 6th Earl was a child there at the
beginning of the seventeenth century.*

Kate O'Brien [451]

While John Hunt's name and reputation, both in Ireland and abroad, was well established by the early 1950s in the esoteric circles of art and archaeology, his role in the renovation of a roofless, ivy-covered ruin in County Clare was to bring him to the attention of the wider public for the first time. The restoration of Bunratty Castle to its medieval splendour was a unique undertaking, both in relation to the structure of the castle itself and to the decoration of its interior. It was 'the first castle in Britain or Ireland to be restored to its original fifteenth/sixteenth-century condition without making further additions', and the exceptional fit-out of the interior made it 'the only medieval castle in Europe which is furnished in its period'.[452]

Living just twenty miles away in Lough Gur, Hunt was familiar with the

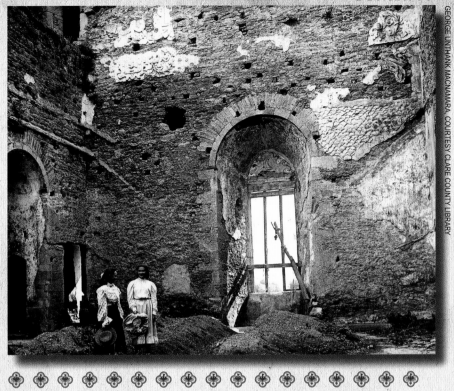

Above: Two ladies visit the romantic ruin that was Bunratty.

Below: The exterior of Bunratty Castle before restoration, showing police barracks, later removed.

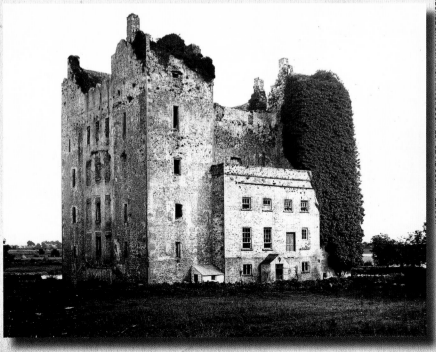

castle and, from his knowledge of medieval architecture and furnishing, had a clear vision as to what a restored and refurbished castle could look like: 'I myself have always been interested in the castle. The great tower rising from the river often set me picturing it in times long past and I idly dreamed how wonderful it would be if it were restored.'[453] He could also appreciate the educational and cultural benefits of having the castle restored as a demonstration of life in late-medieval Ireland and the skills of Irish craftsmen of that period. He shared his vision for Bunratty with many others and may well have prompted the first official mention of the castle's restoration as a project to develop Irish tourism in a tourism development plan (1950), submitted to the US and Irish governments.[454] The report's co-author, Brendan O'Regan, subsequently chairman (1957) of the Irish Tourist Board, Bord Fáilte, and the first director (1959) of Shannon Development, was later quoted as saying that 'it was possibly the Hunts that prompted me to suggest the restoration of Bunratty.'[455]

Hunt became involved with the Bunratty project on many levels. He introduced Lord Gort to Bunratty, guided him on his purchase of the castle and, later, received formal power of attorney from him over all matters to do with the castle's restoration. He acted as one of two trustees holding legal title to the property and had overall responsibility for furnishing and decorating the castle interior.[456] At his own expense, he renovated a section of the castle as his personal quarters and, as first curator of the newly re-opened castle, had a brief that encompassed such diverse tasks as writing the illustrated guidebooks and researching medieval menus for the nightly banquets. In addition, Hunt played a key role in promoting the concept of an outdoor museum adjacent to the castle, which came to fruition with the opening of the Bunratty Folk Park.

Over a fifteen year period, from late 1952 until 1967, Hunt may have spent a quarter of his working life dealing with the affairs of Bunratty. Yet he never sought or received material reward, with his attitude best summarised in his own words in a 1959 letter to Brendan O'Regan: 'I shall be curator, for this of course I shall expect no pay.'[457]

Bunratty Castle was a substantial fifteenth-century tower house, just off the north shore of the River Shannon, and the principal stronghold of the O'Briens, the strongest clan in North Munster. In 1645, Archbishop Rinuccini described Bunratty as: 'the most beautiful place I have ever seen. In Italy there is nothing like the palace and grounds of Lord Thomond, with its ponds and parks and three thousand head of deer'.[458] It was shortly afterwards occupied for a time by Admiral William Penn, father of the founder of Pennsylvania and, over the centuries, the castle changed hands several times. It eventually fell into ruins to the extent that, in 1842, the writer William Thackeray wrote that the building 'should be made the scene of a romance, in three volumes at least'.[459]

In 1935, Clare County Council, concerned about the deterioration of the ruin, requested the Office of Public Works (OPW) to take over and maintain Bunratty Castle as a National Monument. During the World War II period, no progress on the matter was made, but the guardianship of the castle was again pursued when the new owner, Richard Henry Russell, wrote to the OPW on 2 October 1952 offering to place the castle in state care as a National Monument under the guardianship of the Commissioners of Public Works.

While there is little doubt that the deterioration of Bunratty Castle would have been arrested by its being taken into care as a National Monument in 1953, it almost certainly would have been preserved as a roofless ruin of cold, lifeless stones, as was the case with other National Monuments, such as that at the Rock of Cashel.

The dream of full restoration of Bunratty might have remained unfulfilled were it not for Hunt's role in introducing Lord Gort to the project. Standish

Robert Gage Prendergast Vereker, the 7th Viscount Gort, generally known as Lord Gort, was descended from an Anglo-Irish family whose main business and political interests had been in Limerick City, but whose largest land holding was at Lough Cutra Castle, just outside the County Galway town of Gort. After suffering severe financial losses in the Galway estates as a result of the Irish Famine, Lough Cutra was sold and the family moved to the Isle of Wight in England. The most prominent member of the family was undoubtedly Gort's elder brother, John, who, as head of the British Expeditionary Force in France, went down in history as 'the hero of Dunkirk' for his role in saving so many of his men in the evacuation from the beaches there.

Following his purchase of Bunratty, Gort was generally viewed in Ireland as a nobleman of some considerable wealth, with the sobriquet 'multi millionaire' being widely used in press reports.[460] His plan to restore Bunratty was perceived to be an aristocratic eccentricity, possibly driven by affection for the manifest symbol of a nobleman's power which a substantial stone castle represented. There was little awareness of Gort's deep interest in medieval art and architecture, or of his active involvement in restoration and heritage projects. Gort was president of The Bowes Museum, which housed the greatest collection of European fine and decorative art in the North of England and, in Manitoba, Canada, he donated the Viscount Gort Art Collection of fifteenth- and sixteenth-century tapestry panels, depicting religious themes and other items of Renaissance art to Winnipeg Art Gallery.[461]

Gort's initial contact with Hunt almost certainly dated back to pre-war London. A niece of Hunt's has recalled her 'Uncle Jack' arranging for her to 'stay at a flat of his friend Lord Gort in Soho in the immediate post war years'.[462] It was due to the trusting relationship that he enjoyed with Hunt that Gort became involved in Bunratty. This was nurtured by their shared interest in the medieval period and an outlook on life that was generally not materialistic, notwithstanding their mutual accumulation of a substantial measure of wealth. The relationship is evidenced in a collection of more than 150 handwritten letters by Gort to both Jack and Putzel Hunt concerning the Bunratty restoration.[463] Apart from discussing details of the work on the

castle, Gort is very open with both of them in relation to his other business affairs, his personal finances and his dealings with other family members, including his wife.

In 1952, the Hunts had made Gort aware of the sale of his family's ancestral estate at Lough Cutra Castle by a Major Gough. Gort asked Putzel to have a look at the castle on his behalf and later wrote to her expressing his appreciation for 'all the trouble you have taken'.[464] Gort then met Gough's representatives in London who advised him that if he moved quickly he might be able to purchase the property. That same evening, Gort boarded a flight from London to New York, which touched down at Shannon, from where he took a taxi to Gort, arriving just before midnight, and visited Lough Cutra the next day. Clearly pleased with what he saw, he wrote to Hunt about his reception in Gort: 'I think they were rather surprised at my turning up in Gort without warning, as it is 103 years since we left'.[465] Before flying back to London, Gort told an *Irish Times* reporter at Shannon Airport that he was planning to buy back the family's former estate.[466]

Overcoming legal complications over an earlier sale agreement agreed on behalf of Gough by his legal representatives, Gort signed a contract to buy Lough Cutra, and wrote expressing his gratitude to the Hunts:

> I think I must have made a good buy very largely thanks to
> you and your husband ... If you are at all serious about a house
> in the courtyard we would love to have you as cheap as we
> could and give you the freedom of the castle and lake.[467]

It was during Gort's second visit to Lough Cutra that he was to see Bunratty for the first time. Writing in 1959, Hunt recalled the moment when he first mentioned the castle to Gort: 'A casual remark of mine to the owner, Lord Gort, when we were passing that way nearly ten years ago kindled the spark'.[468] Gort was immediately interested and wrote to the Hunts on 22 December 1952:

> I had a letter from Sexton re the Castle at Bunratty. It can be
> got for £1,000 and I am beginning to think how I can do it
> ... I personally don't think it would be too difficult to make a

small house inside – I mean 7 tower rooms and the one over the entrance and one chapel for those who like that sort of thing and if we got it we could hold it and eventually put a roof on the large room. I have a lot on at present and must wait a few months … Anyway let's have a look again when I am over.[469]

Having thought about the matter for a few weeks, Gort was keen to pursue the possibility of buying the castle, but needed time to organise his finances. By May 1953, he advised the Hunts of his intention to buy Bunratty: 'I would like to do it by easy stages and tell my wife by easy stages too'.[470]

By this time, the OPW had formally agreed to take the castle into guardianship as a National Monument.[471] Even before the purchase had been completed, Hunt's central role in the restoration of Bunratty had been set out by Gort who wrote to Percy Le Clerc, the Inspector of National Monuments, stating: 'John Hunt will have the best idea of my intentions, subject to the restrictions of your department'.[472] He wrote to Hunt the following day saying 'I had a letter from Le Clerc about Bunratty and replied … I referred him to you to see how unsafe and dishonest I was architecturally and in antiquarian matters'.[473]

In August Gort advised that he was transferring the sum of £2,000 to pay for the castle: 'I have told my wife the Gort estate was buying it, which in a way is true.'[474] Bunratty was now in the ownership of someone with an interest in medieval castles and with the resources to commit funds towards its restoration. Just as importantly, Gort had a trusted friend in John Hunt, living nearby at Lough Gur in County Limerick, who could deal with the various issues posed by the restoration, particularly in liaising with the OPW.

However, very little was to happen during the coming year. In March 1954, Hunt wrote to Le Clerc to encourage the OPW to commence their programme of preservation: 'I understand the place is now vacant, so I think it would be as well for you to start before someone else moves in. I hear already that they are using it as a handball alley and if we do not begin work

soon they will establish a traditional right!'[475] The main challenge now was to ensure that the restoration of the castle received official approval. This was not to be taken for granted, since restoration, as opposed to preservation, represented a major departure from the prevailing norm applied by the OPW in relation to the care of National Monuments. Hitherto this had been confined to preserving the structure from further decay.

It was fortuitous therefore that the person with the key statutory role was Percy Le Clerc who, as Inspector of National Monuments since 1949, had a radically different attitude to the appropriate role of the state in relation to National Monuments from the Commissioners of Public Works. This latter body saw their role, as set out under the National Monuments Act of 1930, as being solely in the area of preservation, in line with the narrow terms laid down in that Act. Le Clerc was keen to break away from the attitude that saw the role of the National Monuments Branch as merely to protect monuments in the condition they were acquired and not to contemplate their restoration. In an interview discussing his predecessor HG Leask, Le Clerc was quoted as saying: 'I remember saying something about access for tourists. His reaction was "we're not interested in tourists" … we were just interested in preserving antiquities – we didn't care whether anybody came to look at them.'[476]

In that sense, what was done at Bunratty was radical at the time and it is likely that the vision of Hunt and Gort might never have been realised if Le Clerc had not been in the key role of Inspector. Le Clerc's clashes with what he considered as the philistine attitudes of the Commissioners of Public Works were certainly no secret. His *Irish Times* obituary reported that: 'In 1974, Percy Le Clerc, long at odds with his colleagues in administration, resigned from the Office of Public Works'.[477]

Le Clerc later outlined how the Gort's proposal to go further than preservation and contribute towards the cost of restoration fitted well with his own plans.

> I had for some years considered it desirable to take a small
> amount of buildings of different types and different peri-

ods and restore them so that the visitor could then see more clearly what the ruins would have been like. The Bunratty project was justifiable therefore as a means of arousing public interest in national monuments by showing what a great fifteenth-century castle was like in its heyday.[478]

From the outset, newspaper accounts emphasised Hunt's central role in the project. An *Irish Press* report in October 1954 reported that: 'Planning the restoration with the skill of a story-book detective is Mr. John Hunt, archaeologist and member of the National Monuments Advisory Council'.[479] In the article, Hunt was quoted on various plans for the restoration:

> We hope to ... restore staircases which were converted into chimneys and bring back all the mod. cons of 1454 ... The Earls of Thomond had cosmopolitan tastes and where we cannot find Irish articles of furniture of that period to put in the castle we will be still within the bounds of accuracy in substituting period articles from England or the Continent ... And the cost? There is a sum voted to preserve the castle as a public monument – make the structure, as it is, safe – it is impossible to estimate how much it will cost Lord Gort to do the rest.[480]

In a similar vein, the *Irish Independent* reported that: 'Lord Gort has purchased 14th century Bunratty Castle, County Limerick. Mr J. Hunt, the well known archaeologist of Lough Gur will supervise the restoration of the castle, a work that will cost about £30,000. Lord Gort intends to set up a museum there'. Hunt's central role was formalised by Gort in a written power-of-attorney he signed as owner on 7 November 1954: 'To whom it may concern. I hereby authorise Mr John Hunt to act on my behalf in all matters relating to any builder's work or other work carried out at Bunratty Castle.'[481]

The guardianship deed was executed on 4 November 1954 and, during the next year, 'preliminary demolitions and clearance' were carried out at OPW expense. These involved the removal of some low-lying structures on

the east side of the castle, the removal of some of the trees growing within the building, a general clean-up of the first floor known as the Main Guard, which was covered to the depth of a foot with cow dung and goats' droppings and the removal of hundreds of tons of waste material dumped in such areas as the dungeons.

When, in early 1955, Hunt, Gort and Le Clerc finally came to a firm decision that Bunratty would be restored, they had only a vague idea of the challenges they were up against. There was no overall plan, no budget, and nothing akin to a timetable as to when the work would be completed. There were no detailed drawings of the castle as it stood at the end of the sixteenth century to guide them, and so it was only by piecing together the clues as they were revealed, when demolition of the more modern additions took place, that they knew what had to be done. There was also no permanent staff of construction workers in the OPW to carry out the task, and the foreman, Thomas Kavanagh, had to recruit direct labour locally in competition with employers who were actively looking for skilled tradesmen with the expansion then taking place at the nearby Shannon Airport. Clearly the only control was that the work would have to stop when the money ran out.

After Russell offered to place the castle in the care of the state in August 1952, Le Clerc, on behalf of the OPW, had prepared a schedule of the work to preserve the castle which he estimated would cost £4,000 and obtained the requisite approval from the Department of Finance. However, despite Le Clerc's wish to see the castle restored rather than merely preserved, 'the Inspector re-stated the principle that the Commissioners will pay only for conservation works that they would have carried out had restoration not been considered or for equivalent works'.[482] Le Clerc was to repeat the point that he could only spend money on preservation, on several occasions over the next few years.

A factor that may have helped Hunt in his initial dealings with Le Clerc was his membership of the National Monuments Advisory Council since 1952. This was an independent body providing advice and assistance on any matter arising in relation to the National Monuments Act to the Commis-

sioners of Public Works, to whom Le Clerc was ultimately responsible. Certainly, in the earliest correspondence on the project, Le Clerc, who was a qualified architect, was highly deferential to Hunt who, despite his expertise on archaeological matters and medieval art and furnishings, did not have architectural training.

In January 1955, Le Clerc reviewed, with Hunt, a draft schedule of restoration works he had prepared and which the OPW, acting as agents for Lord Gort, proposed to carry out at the castle. The following month, he submitted to Hunt a revised schedule and asked him to: 'go through this new schedule to check that it includes all your requirements and can be taken as the working instructions for the preparation of the necessary drawings'.[483] He also sought from Hunt 'details of panelling, plasterwork and other material that we have to incorporate into the structure' and sent a reminder a month later seeking Hunt's 'imprimatur to the schedule of restorations'.[484]

There was no reply from Hunt. Since Gort was not willing to commit more than £4,000 to the restoration of the castle itself, it was unclear, in the absence of any budget figures from Le Clerc, that there would be sufficient funds available to carry out the work. Six months later, the OPW finally produced a budget for the schedule of works which envisaged a contribution by Lough Cutra Estates of £12,000.[485] The main items were the Great Hall roof priced at £3,500, the South Solar (described as 'Curator's flat') at £2,500, and the roofs of the towers and solars at £1,500.[486]

Later that month, Gort and Le Clerc met to discuss the proposed work schedule. Much of the discussion centred on ways to reduce the cost of items such as the castle roof. It appears that Gort did not make his position of a cap of £4,000 on his commitment clear to Le Clerc until a further meeting, held in February 1956 in Bunratty, when he undertook to amend Le Clerc's schedule of the previous year accordingly.[487]

The OPW set out that, with the funds available, they would only be able to complete the Great Hall roof and the glazing and that 'it cannot be said at this stage whether sufficient funds would be available to carry out any of the other works described in the Schedule … the money to be made avail-

able will not suffice to provide accommodation for a resident caretaker.'[488] It was noted by the OPW that, as Gort was committed to spending £1,000 on the roof directly by buying the timber and having it fabricated in Limerick, the Commissioners would only require a sum of £3,000 from him to commence the works, an amount Gort forwarded to them immediately.

Work had been due to start by the middle of 1956 but, in June of that year, Le Clerc wrote to Gort telling him that he couldn't agree to the work commencing in the autumn as he believed that wet weather would create problems with the freshly cut oak which Gort was planning to use in the roof and also make it difficult for other outdoor work on the castle itself.[489]

In July 1956, Hunt became owner-in-trust of the castle, along with Limerick solicitor Desmond J O'Malley, after Gort reorganised his personal affairs and transferred the title to the property from Lough Cutra Estates.[490]

Despite the postponement of work on the castle, Hunt still had to devote considerable time to the project. With Gort being responsible for providing the basic infrastructure, Hunt, on his behalf, engaged directly with electricians, plumbers, and ship agents providing warehousing and transport services on goods imported at this time, such as timber and marble flooring. An important role involved liaising with P Molloy & Sons Ltd. of Limerick, the firm of building contractors engaged, on behalf of Gort, to carry out the manufacture and erection of the roof on the Great Hall. He encountered significant difficulties in obtaining final costings for the roof contract because Le Clerc, in order to ensure that no work was done on the oak in winter time, refused to release drawings of the timbers.

In November 1956, probably in desperation at the delays in getting the green light from the OPW, Hunt went over Le Clerc's head by writing to the OPW Commissioners and asking them 'when the Commissioners intend to start the work'.[491] He pointed out that Molloy would need six weeks to fabricate the timber and that 'if … you intend to start at the beginning of February, I should like to be informed so that I may give them the word to go ahead'.[492]

In this letter, for the first time, Hunt mentions that Bord Fáilte might have

a role to play in financing the restoration: 'I ... understand that Bord Fáilte consider Bunratty to be a work of major importance in the tourist drive. I believe that they are prepared to devote considerable sums of money to the work if this is put in hand before their financial year ends in March'.[493] No doubt he had, by this time, discussed the financial situation with Brendan O'Regan, who was shortly afterwards appointed as Chairman of Bord Fáilte.

After a further two months of frustration at his dealings with OPW staff, and being concerned about possibly losing Bord Fáilte money for the project, Hunt went over the head of the secretary to the Commissioners and met with TJ Morris, one of the Commissioners, on 12 January 1957. This succeeded in breaking the logjam as Morris then spoke to officials of Bord Fáilte, who clarified their commitment to contribute the sum of £1,000, to be expended before 31 March 1957, and a further £3,000 to be made available during the following financial year. This meant that sufficient funds were now available to meet the revised budget of £12,000 prepared by Le Clerc. Morris confirmed to Hunt that work by the OPW would start in February 1957 and that he could 'instruct Messrs Molloy to proceed with their contract for the roof fabrication'.[494]

Work on the castle eventually began on 1 March 1957 and received considerable publicity nationally. There were effectively two separate teams of workers, one eighteen-man team employed directly by the OPW under Thomas Kavanagh worked on repairing stone work, and a second crew, employed by PJ Molloy Ltd., carried out the contract with Gort to install the roof.

The most visible aspects of the repairs were carried out during the spring and summer of 1957 and, by August of that year, the Great Hall was again roofed. However, by September, it was clear that the project would be much more expensive than any of the promoters had envisaged. With money running out, Le Clerc wrote to Gort on 3 October to emphasise that the OPW would not 'agree to do any more work than would have been necessary to preserve the castle as a ruin' and suggested that Gort make a further approach to Bord Fáilte, adding 'Hunt will do this for you I expect'.

At the end of 1957 a total of £11,215 of the £12,000 approved had been spent on the restoration, but it was clear that this would not complete the job. Having reviewed the costs, Le Clerc set out a schedule of work to achieve what he described as 'partial completion'.[495] He obtained approval, strictly based on preservation rather than restoration, for an increase of the OPW budget from £4,000 to £6,130. This left only £2,915 available to spend at the beginning of 1958.

Several important items were now omitted by Le Clerc from the work schedule for partial completion. These included glazing, roof crenellations, and the creation of living quarters for the Hunts in the South Solar and for a resident caretaker in the North Solar. Of particular concern to Bord Fáilte was the proposed omission of a water supply and sanitation for visitors. Initially these extra works were estimated by Le Clerc to cost a further £7,250, later increased to closer to £10,000.

Hunt took on the challenge of trying to get the project over the line and his main target was Bord Fáilte. With Brendan O'Regan as chairman, Hunt now had an old friend at the highest level in the tourist board. In addition, the Shannon Sales and Catering Organisation, which O'Regan personally owned, had evolved into an unofficial development authority promoting both the airport and the surrounding region.[496]

Hunt met with Bord Fáilte on 11 December 1957 and, based on Le Clerc's figures, showed that the cost had now doubled from the estimates of just one year ago. He set out that the necessary works required to 'develop Bunratty as a museum equipped to illustrate the life of fifteenth-century Ireland and to house a valuable collection of period furnishings will now cost nearer £24,000'.[497] In addition, a further sum of between £2,000 and £2,500 might have to be found for the purchase of thirty acres of land around the castle on offer from Richard Russell of Bunratty House to forestall undesirable commercial exploitation if and when Bunratty was developed as a tourist attraction.

To close the gap, Hunt said he was personally prepared to subvent the full cost of the restoration of the South Solar, budgeted at £2,500.[498] In making

this offer he no doubt had become aware of the attitude of Le Clerc who had stated in an internal memo which he made available to Hunt that:

> As a matter of policy … the living accommodation should
> be provided as an entirely separate work under private con-
> tract between Lord Gort and a builder, but under my general
> surveillance. This seems to be necessary to avoid giving the
> impression that the Board or Bord Fáilte are providing flats for
> the wealthy.[499]

Gort also agreed to increase his contribution to the project by a further £2,000, but this still left a sum of at least £8,000 which had to be found from somewhere to complete the restoration project properly and secure the land around the castle.

Negotiations between Hunt and Bord Fáilte dragged on throughout 1958. As they were going to be the largest single financial contributor to the restoration, Bord Fáilte naturally decided to set down appropriate conditions so that their contribution would lead to the creation of a long-term attraction for visitors. These conditions included requirements regarding the curatorship and operation of the castle for visitors and the setting up of trusts to own the furniture in the castle.

In the midst of all their tough negotiations over financial matters, Hunt and Bord Fáilte found time during 1958 to co-operate on promoting the castle as a visitor attraction. In an article in the July-August edition of *Ireland of the Welcomes*, a bi-monthly publication of Bord Fáilte aimed at attracting foreign tourists to Ireland, Hunt wrote that 'Bunratty is the first castle in Ireland in which an attempt has been made to recreate the past and restore a great historic building to its ancient glory'.[500] For the first time the public was given a glimpse of what the restored castle would look like and the article included reproductions of some of Gort's sketches of the interior furnished with his collection of tapestries, armour and works of art.[501]

During the year, the issue of the land purchase was resolved quite satisfactorily when the land was bought by Albert G McCarthy, a wealthy Irish-American businessman and philanthropist to Catholic missions, who had

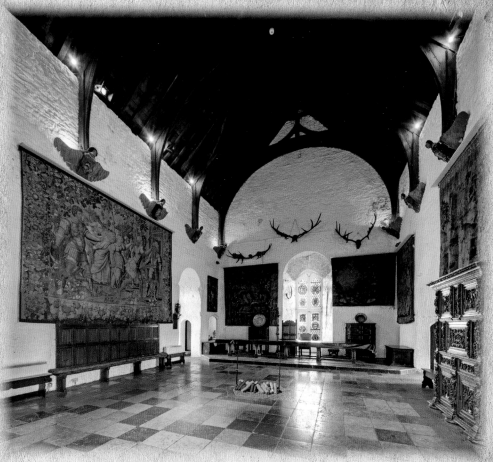

The Great Hall, Bunratty Castle.

apparently provided assurances that any development he undertook would not conflict with the castle or the public interest.

After almost nine months of negotiations, Hunt received, on 1 September 1958, a letter from Gordon Clark of Bord Fáilte confirming that a further '£6,100 would be made available towards the completion of work on Bunratty'.[502] However, many of the conditions attached to the approval, such as an unlimited indemnity requested from the Trustees to provide whatever further funds might be required if the new budget proved inadequate, were objected to by Gort, and other conditions created new complications. Hunt wrote to Brendan O'Regan in early November that he was 'so anxious ... to get the position with regard to an agreement between Shannon Authority and Bunratty settled because, until I do, Bord Fáilte will not make the funds voted already available and Percy Le Clerc, I am afraid, will get tired of waiting'.[503] Outlining the various outgoings, such as insurance, electricity, firewood, rates, expenses of caretaker and wife, and his own travelling expenses, he set out as an over-riding principle that 'the venture must stand on its own feet and not be looking for further subsidies in the shape of an annual income'.[504]

Hunt suggested to O'Regan that he and his wife be given some 'ex-officio post with Shannon Development or the Airport' as he understood that 'Bord Fáilte wish the actual director to be a member of your staff'. He concluded by noting that 'all the delays spoil things so and make the Office of Public Works very difficult to handle'.[505]

By the end of November things were still not yet settled. Gordon Clark of Bord Fáilte wrote to Joe McElgunn of Shannon Airport Authority pressing him to conclude an arrangement with Hunt and emphasising that, 'while the Board of Works are maintaining a small staff at the castle in order not to abandon the works, they are pressing us very hard for the release of the money to complete the job'.[506] Towards the end of that year, with all approved monies spent, the OPW eventually withdrew its skeleton staff from the site.

Finally, on 6 December 1958, Brendan O'Regan wrote to confirm that, as soon as the Airport Development Authority formally became agents of Bord

Fáilte regarding management of the castle, Hunt was 'appointed as director and Mrs Hunt as assistant to represent the Development Authority in management matters concerning the castle. While a fee will not be attached to the post you will be covered for travelling expenses, provided the overall revenue from the castle is sufficient to cover these expenses in addition to those already decided upon.'[507]

With the Bord Fáilte funds eventually released, the OPW re-commenced operations at the castle in March 1959 and, by January 1960, could finally withdraw its staff from the site with only some minor work still to be completed at a cost of less than £800.

Throughout the restoration there were several occasions when Hunt and Le Clerc had differing views on issues of medieval castle architecture. Perhaps the most important matter that Le Clerc was to insist on was to remove all additions from the end of the fifteenth century, apart from the South Solar and the decorative plasterwork from around 1600 which was carried out during the reign of the Great Earl and which can be seen in the chapel off the Great Hall.

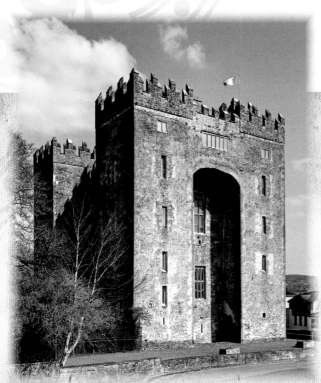

PHOTOGRAPH © LIAM BLAKE, COURTESY OF REAL IRELAND DESIGN

The exterior of Bunratty Castle after restoration.

Hunt and Le Clerc enjoyed a mutual veto over how the restoration should proceed. On the one hand, as the castle had been a National Monument since November 1954, nothing could be done in terms of either preservation or restoration without the approval of Le Clerc. However, at the same time, because the National Monuments Acts confined the powers of the inspector to the field of preservation, he had no power or resources to take any initiative in relation to restoration. Le Clerc pointed out the anomaly that the National Monuments Act: 'if it precluded the Board of Works from undertaking restoration it also precluded the Inspector of National Monuments from undertaking restoration! In other words what I did at Bunratty was in addition to my official duties and unpaid'.[508] In practice, this meant that restoration could only proceed as an unofficial activity with external funding and the permission of the owner, which, in this case, meant John Hunt, the owner's proxy.

Another area of conflict concerned whether to have a wooden mullion window on the northern wall at the Great Hall entrance. Gort and Hunt felt a mullion window would allow logs and other equipment to be brought in by pulley, whereas Le Clerc insisted on having an authentic slit for an archer, asserting that this would have been part of the defences of the original castle. Hunt and Le Clerc also clashed over the size of the windows in the chapel off the Great Hall. Hunt wanted three small windows to bring light into the chapel behind the altar, whereas Le Clerc correctly pointed out that, during the era in which the castle was built, there would only have been two windows there. Le Clerc eventually 'for the sake of peace and quiet' made a unique concession to architectural correctness on the grounds that 'the chapel meant a lot to Hunt, he was very religious … he even had it consecrated'.[509]

Le Clerc, in a subsequent paper given at the Thomond Archaeological Society, was fulsome in his praise for Gort and Hunt: 'The castle would not be the living and attractive place it is without the furnishings provided by Lord Gort. These furnishings are valued at more than £30,000 or £40,000, which is far more than was spent on the building'.[510] However, Le Clerc

tried to confine Hunt's role to that of the furnishing of the interior and for his curatorial role after the restorations were complete by saying: 'I think it is correct to say that Bunratty is the only medieval castle in Europe which is furnished in its period and due credit must go to Mr. John Hunt for having suggested to Lord Gort in the first place that Bunratty Castle restored would be the ideal place for his collection of antiquities; for having advised Lord Gort on the furnishing of the interior and for his interest in the castle and its contents since the restorations were completed.'[511]

While the OPW and Bord Fáilte, as providers of state funds, were closely involved in every decision regarding the castle building itself, the decoration of the interior was a matter solely for Gort and Hunt. More than three-quarters of the 440 items in the castle, ranging from furniture, tapestries and paintings to kitchen utensils and armour, were from the fifteenth to the seventeenth centuries, the period during which the castle owners were at the height of their power. Hunt himself loaned forty valuable items for display in the castle, which were later removed to Craggaunowen.

Hunt's greatest time commitment to Bunratty probably occurred during 1959 and early 1960. With the restoration of the fabric of the building largely completed, the remaining challenge was to complete the works on decorating and furnishing the interior of the castle. This work included the repair and filling of the internal walls, making all the doors from oak boards, laying the marble floor in the Great Hall, and putting the tapestries and furniture in place in the various rooms of the castle.

In May 1959, Hunt himself employed a local man, Pat Crowe, on a full-time basis for this work and also arranged that his own carpenter, Sam Waters, would come down from Dublin for three days each week to help Crowe in re-assembling the larger and more intricate pieces of furniture which had mostly been shipped by Lord Gort from England. Hunt himself would come every fortnight with Putzel and remain for two or three days at a time. Crowe makes clear that Hunt was supervising the task involved in finishing out the interior works in the castle. 'Mr Hunt told me what to do, he organised what room all the furniture went into'.[512]

Crowe's first assignment was to fill up all the holes in the internal walls. This particular assignment was fraught with potential for conflict with Percy Le Clerc, as Crowe soon discovered: 'Percy Le Clerc was very exact, fierce fussy, if he saw a stone out, he was all for its originality. I used to think it would look a lot better if you saw a stone out of the wall to fill it in'.[513] Crowe recalls: 'I got this kind of plaster bond, though a lot of it was poly-filla; you could do more with your hands than you could with a trowel because you were burrowing between the stones – a slow process, I was at it about six months all together'.[514] However, after three months, Crowe was left in peace to complete the task of re-creating medieval stonework, after Le Clerc accepted an assignment to take up a position in Switzerland with the International Castles Restoration Institute in September 1959.[515] With some pride on the durability of his workmanship, Crowe reflected, more than fifty years later, that: 'It's still attached to it anyway'.[516]

The task of making and installing all the doors, using oak boards that Hunt had obtained in Dublin, became a further cause of tension with Le Clerc, as recounted by Crowe: 'if he saw me with a hammer and chisel he'd say "Pat, what are you doing with that?" When I'd say "I have to hang a door" he'd reply "but where are you going hanging it?"'[517]

Crowe recalls his most difficult task as putting up tapestries on the walls under Hunt's guidance: 'he had them old tapestries, thirty-five-feet wide; you can imagine to put that up on a rough wall with just a hammer and chisel, put pegs into them and then put a slate lath along, and doing it all off a ladder, there were no scaffold there, no helpers'.[518] Years later, he recounted, with mock outrage, how his primitive tapestry-mounting techniques managed to cope with Hunt's attention to detail in regard to the optimal location for the tapestries: 'You'd put up the tapestry and he'd say "that's fine Pa, you're a wonderful man, that's great, but I don't like it, it's six inches too high". God! To take it down again on your own!'[519]

He also told how Hunt had taught him everything he knew about the furniture and the history of the castle itself: 'when you'd be putting a table together he'd say 'it's from a famous school'. I'd only be anxious to get it

together ...but he had so much *meas* [respect] on it he could talk for an hour'.[520] He also spoke of how Hunt made him appear as an expert on many of the pieces: 'People would come over talking to you saying, "that's a grand piece of furniture, where did that come from and what year is that now?" and I'd say "that's early sixteenth-century maybe" and Hunt would say, he wouldn't mean to put me down, "I'm afraid Pat is a bit out – its early fifteenth-century"'.[521] With obvious pride, Crowe recalls an incident from his early time working in Bunratty, when Hunt stood aside and insisted that Crowe was the best one to give an after-dinner talk on the history of the castle to a visiting party of dignitaries, saying to Brendan O'Regan: 'I'm too long-winded for that – ask Pat Crowe, he's quite good at it'.[522]

The time he spent working directly for Hunt is remembered fondly by Crowe. 'John Hunt was as nice as ever I met, he was a man I liked great because he was very mild, I got on the finest with him always'. Reflecting on Hunt's interpersonal skills, 'he had great *meas* on me always; he'd often ask my opinion, saying: "What do you think of that?"'[523] Crowe, with the benefit of all that he picked up from Hunt, was to become somewhat of a Bunratty institution and is fondly remembered as the 'Knight of the Castle', standing with the Irish wolfhound on the

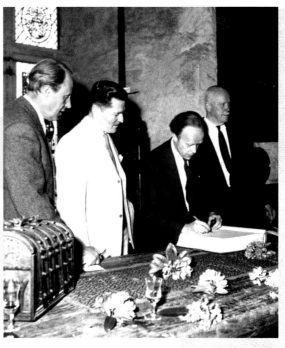

The official opening of Bunratty Castle.
From left: John Hunt, Brendan O'Regan, Erskine Childers, Minister for Transport and Power, and Lord Gort.

castle drawbridge, collecting tickets from those attending the medieval banquets.

A summary of Hunt's role in the fitting out of Bunratty was later penned by James White, Director of Ireland's National Gallery: 'he assembled objects and pictures and laid out the castle with love and enthusiasm. His eyes gleamed as it took shape and I really believe he was expecting Cardinal Rinuccini to reappear once again, after some 300 years to show his appreciation.'[524]

Left to right: Actress Anjelica Huston with her mother, 'Ricki' Soma, and Lord Gort, at the opening ceremony.

The opening ceremony, attended by some 400 guests, took place on 28 May 1960, also Hunt's sixtieth birthday. As Le Clerc was still in Switzerland, it fell to Hunt, prior to the ceremonies, to outline the restoration work undertaken on the castle and to conduct guests on tours where he pointed out some of the more important carvings, tapestries and other art treasures.

The castle was formally opened by Erskine Childers, Minister for Transport and Power, after a Solemn *Missa Cantata* in the chapel, presided over by the Bishop of Killaloe. After the high Mass, O'Regan chaired a public session in the Great Hall, acknowledging Hunt's central role in the restoration:

> Lord Gort … bought Bunratty seven years ago with the
> dream of restoring it as it was in the days of the Princes of
> Thomond – a dream which was fostered by John Hunt, one
> of the leading authorities on buildings and furnishings of
> the Gothic period … The collaboration of Percy Le Clerc,
> the Inspector of National Monuments and of John Hunt has

recaptured for us the image of Bunratty as it was long ago. We are fortunate to have such scholarly minds brought to bear on this great work.[525]

There was extensive coverage of the re-opening in Ireland and abroad. The *Sunday Independent* even managed to involve the British Royal family in the story, reporting over a headline 'Skips Lunch with Queen' that:

> A millionaire viscount had to skip a lunch with the Queen
> and the Duke of Edinburgh in order to watch with pride
> yesterday as a dream came true for him in Bunratty, County
> Clare. Lord Gort, the 72-year-old former sheriff of Durham
> County in England, was to have attended the opening of a
> new town in County Durham, but he and Lady Gort were
> busy instead receiving the 400 guests who attended the open-
> ing of the restored Bunratty Castle yesterday. [526]

In an editorial piece two days after the opening, *The Irish Times* stated:

> It is highly improbable that Bunratty Castle as a showpiece
> will ever 'pay its way': if only three or four of the stately
> homes of England, with all the resources of publicity at their
> disposal, fail to do so, what hope is there for an obscure castle
> on the Shannon in a country that commands only an infini-
> tesimal fraction of the sentimental tourism trade from the
> United States.[527]

The art critic of the same newspaper, however, was to write an extensive and highly favourable critique, referring to Hunt's role as follows: 'There is no one else in these islands with his particular feeling for the medieval and his capacity to read the significance of objects and the uses to which they were put. One feels that just as Bunratty is a lasting tribute to the taste of the collector Lord Gort, it is equally a justification of the knowledge of John Hunt'.[528] An *Irish Times* columnist, Brian O'Nolan, writing under the pseudonym of 'Myles na Gopaleen', commented favourably on the generos-ity of Lord Gort in 'retrieving Bunratty Castle from time's rot ... displaying generosity as well as taste. This is most unusual behaviour'.[529]

The restored Bunratty Castle proved an instant success in attracting visitors, many of them foreign tourists, and Hunt was not shy about giving details of this: 'When we opened in May we expected 8,000 visitors a year. We have had that number within six weeks'.[530] The same article reported that Hunt would 'soon be taking over a flat at the top of the castle, "so that I will be on hand to meet the people personally"', and quoted his statement that 'when complete we expect to make the castle a cultural centre-piece unique in Europe'.[531]

Bunratty South Solar, which the Hunts rented for their own living quarters.

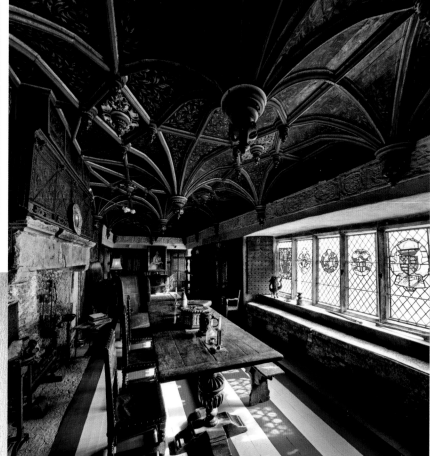

PHOTOGRAPH © LIAM BLAKE COURTESY OF REAL IRELAND DESIGN

After the opening, Hunt had a significant time commitment as curator, with new responsibilities for overseeing the income and expenditure on the visitor operations, as well as the ongoing work of finishing the fitting out of the castle with period furniture and dealing with various contractors working to make the south and north solars habitable. The work on the South Solar was completed in 1962 and Hunt was to stay there intermittently, until he handed back the lease to Shannon Development in 1967.[532]

Hunt is not usually credited with the development of Bunratty Folk Park, which became a most important extension of the visitor experience at Bunratty, and possibly as great a magnet for tourists as the castle itself. However, Hunt played the key role in prompting this initiative and in particular in the vital task to get the first structure in place.

Even before the castle restoration was completed, Hunt, in his role as trustee of Bunratty Castle, had set out his vision of a 'folk village' in the castle environs, containing farmers' houses from the nineteenth century from different parts of Munster, fitted out with all the furniture. In a report dated 1959, which he later forwarded to Bord Fáilte, he summarised the concept as follows: 'The development envisaged at Bunratty would eventually form a complete epitome of Irish folk life. There would be the great castle, with the houses of the country folk clustered around its base.'[533] He sought background information on his concept from Bord Fáilte, whose reply would suggest that they had little to add to what Hunt already knew: 'You were talking about the possibility of a folk museum. What information we have here you are probably well aware of'.[534]

The site for the proposed 'folk village' was owned by wealthy Irish-American property developer Albert G McCarthy, who had acquired from the Bunratty Estate a substantial land-bank adjoining the castle, that had earlier been offered to Gort through Hunt. In August 1959, McCarthy, whom Hunt described as 'a most public-spirited man', had completed construction of a

169

new hotel, the Shannon Shamrock Inn, on part of these grounds and was 'prepared to make a most generous gift of this land if it can be put to the use of the state'.[535] Both McCarthy and Hunt felt that 'this is too important a venture to be in the hands of private enterprise'.[536] McCarthy appears to have accepted Hunt's ideas for the folk park and both he and Hunt enjoyed a close and trusting relationship. McCarthy's background as a prominent Catholic philanthropist, may, quite possibly, have helped the friendship develop.[537]

An opportunity to get the project off the ground occurred in 1959 when plans to modernise Shannon Airport for trans-Atlantic jet planes required the removal of a traditional farmhouse, formerly belonging to John (Red) McNamara, which stood in the way of a proposed runway extension. Locals were unhappy with the demolition of the house in question as it had been the social focus in the area for generations.[538] However, Hunt had espoused the concept of a folk village for some time, and someone, most likely a member of Brendan O'Regan's staff at the newly incorporated Shannon Free Airport Development Company (SFADCO), suggested that the house should be removed and re-erected beside the castle. This solution satisfied local sensibilities and kick-started the folk village.

SFADCO wrote to the Department of Transport and Power seeking permission to remove the McNamara farmhouse, and advising that: 'this idea is sponsored by the Trustees of Bunratty Castle and the village is to be built on land owned by the Trustees or which they will acquire'.[539]

Prompted by Hunt, McCarthy had agreed to provide the site and contribute £1,000 for the house to be erected on it, and appointed Hunt to deal with this transaction on his behalf. Hunt arranged for the architect Andrew Devane, who had also designed the Shannon Shamrock Inn, to make drawings of the house in Shannon and submitted these to Kevin Danaher of the Irish Folklore Commission, asking him for his comments on what changes if any to make when the house was being re-built. Material from the demolished McNamara farmhouse, including timbers, doorways, windows and stone was removed from Shannon and used as part of the construction of the recreated house at Bunratty. The farmhouse, faithfully incorporating all the

elements of a typical building of its type, was completed over the next few months to coincide with the formal opening of the Castle.

Hunt's role in the creation of the folk village at this stage was quite central. On 29 September 1959, he personally pegged out the site in Bunratty for what became known as the 'Shannon Farmhouse' with a surveyor from Andrew Devane's office.[540] The survey drawings were forwarded to the Dublin building firm, AJ Jennings & Company Ltd, who were advised that 'any further information which you may require regarding layout and construction may be obtained from Mr J. Hunt'.[541]

Shortly afterwards, SFADCO wrote to Hunt, following correspondence from a journalist, on what she described as 'Mr Hunt's Folk Park idea of reconstructing Ireland of the past' and suggested setting up a tri-party meeting in Dublin 'to discuss how … (we) can jointly speed up the inauguration of the Folk Village'.[542] On 20 October 1959 Hunt formalised his ideas on a Folk Park in a detailed report which he forwarded to Bord Fáilte.

Matters progressed slowly over the next two years, with finance once again being the main obstacle. It was clear that, for the folk park to proceed, it would need money to purchase land and erect buildings. In October 1960, Devane presented O'Regan with a map of land to be acquired from Albert McCarthy for the proposed folk village and it was agreed with Lord Gort in January 1962 the folk park would be operated jointly with the castle. Sometime later, McCarthy gave SFADCO an option to acquire the land for the sum of £3,350, but, by early 1963, clearly unimpressed with delays in decision-making, he threatened to withdraw his offer, and made the Shannon Farmhouse inaccessible for visitors.

With pressure on SFADCO to get the project up and running, Brendan O'Regan, in March 1963, convened a meeting with Hunt, Devane and two of his SFADCO staff.[543] A plan to implement the project was put in place, based on the assumption that funding of £18,000 would be made available, one-third each being contributed by Bord Fáilte, Shannon Development and Clare County Council.[544] A five-person advisory committee of Hunt, Devane and folklore scholar Kevin Danaher, along with O'Regan and

SFADCO special projects manager, Christy Lynch, was set up. Because of their specialised knowledge, Hunt and Danaher were also given the responsibility of sourcing other suitable houses for the folk park.[545] Within two months O'Regan could report to the committee that the required financial support would be available and that 'the purchase of the land was now in hand'.[546]

The future of an expanded folk park was finally secured in July 1963 when Childers, moving a bill in the Irish Senate to provide further financing for SFADCO, announced that 'a folk park will shortly be added to the attractions of the Shannon Region'. Childers then proceeded to claim credit for being the person who had prompted the idea in the first place, telling the assembled senators: 'I visited the folk park at Arnhem and was utterly convinced of its natural value and attraction to tourists that I suggested a similar development to the Shannon Company.'[547]

The park was opened on 10 July 1964 by Minister Childers. It consisted of two small farmhouses, a fisherman's house and a forge. More than twenty other buildings including a church, a school, a pub and a late nineteenth-century street have now been added, with various enclosures for farm animals. Brendan O'Regan, popularly associated with bringing the Bunratty Folk Park to fruition, later acknowledged that Hunt was the most likely source of his inspiration: 'I don't know where I got the idea in regard to the cottages; I suspect that I got it from John Hunt'.[548]

After the Hunts moved to Dublin in 1954, they maintained an interest in the Thomond region of Limerick and Clare. With professional management in place, Hunt was able to relinquish his role as honorary curator and surrendered his lease on the South Solar apartment in the castle. But he was not about to sever his ties to the region where he had first established his home in Ireland and, around this time, was busy formulating plans to create a further project of significant cultural importance in the region.

By the mid-1960s the castle and folk park at Bunratty, under the management of SFADCO subsidiary, Shannon Castle Banquets and Heritage Limited, had become a major attraction for American tourists visiting Ireland, with a host of distinguished celebrities enjoying the internationally acclaimed medieval banquets in the castle. Bunratty Castle and Folk Park, which received some 360,000 visitors in 2011, was to become, by a comfortable margin, the biggest fee-charging tourist attraction in Ireland outside of Dublin, quite an achievement for what *The Irish Times* had earlier described as an 'obscure castle on the Shannon'.[549]

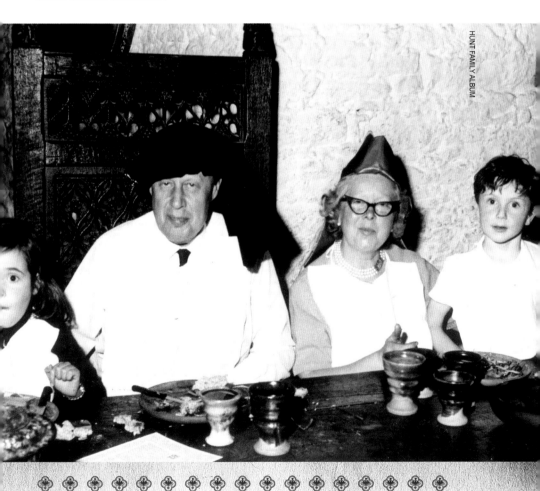

Jack and Putzel with Trudy and John Jr, 21 July 1963, during the first month of the Bunratty Banquets.

CHAPTER 7

60 Park Street, Mayfair

The 1960s saw the end of the years during which collectors like Hunt could buy major medieval, Renaissance and Baroque objects at prices which now, looking back, seem derisory.

Ronald Lightbown [550]

From the early 1950s, the Hunts began spending more of their time in London, visiting there perhaps about four or five times a year between 1950 and 1952. During these visits, they would carefully check out what pieces were coming up at forthcoming auctions of house contents and attend viewing days prior to sales scheduled by the two big auction houses, Sotheby's and Christie's. On weekends, they would go 'antiquing' among the stalls on Portobello Road in Notting Hill or the newly relocated Caledonian Market in Bermondsey Square, Southwark, as well as the established antique shops in Bond Street or Chelsea. On many of these excursions they were accompanied by their old friend from pre-war days, Peter Wilson, whose career in Sotheby's was in the ascendant. In order to avoid any competition between them on these excursions, it was agreed that Wilson had first call on all bronze items and the Hunts had priority on all medieval ivories.[551]

They were very well known and respected for their ability to spot treasures

among what appeared to others as junk heaps or pieces of scrap metal. An American journalist who went on one such expedition with them describes the scene: 'I once went antiquing with the Hunts in London. It was like a form of royal progress ... I've never been so bowed and scraped to.' [552]

Until the end of 1951, Jack was heavily committed to archaeological excavations in Ireland, particularly the three-year investigation he led at Ballingarry Down, as well as writing academic papers. Putzel was certainly less interested in archaeology than Jack, and focused more on the art dealing business at this time. She had concluded the Hunts' first direct sale to the Met, a silver enamelled fifteenth-century Burgundy spoon, after a meeting with curator James Rorimer in London in October 1948. [553] Apart from dealing in art objects, Putzel also began to engage on a small-scale in the property market, buying up, re-modelling and re-selling a number of residential properties. [554]

At a Sotheby's auction in December 1949, in the absence of Jack, Putzel had created a stir by out-bidding the V&A Director, Leigh Ashton, for an Early English crucifix. [555] After the auction, Jack, who was clearly embarrassed, wrote to Ashton from Lough Gur, explaining that 'although I left a much lower figure on the crucifix figure, she (Putzel) tells me she has bought it'. [556] He went on to seek approval to bring the crucifix to Ireland 'for a few months to study it' adding that 'it is a very nice addition to our collection of crucifix figures, which has now risen to 14 of before 1200.' [557] Ashton replied stating quite curtly that 'there is no question of your taking the crucifix to Ireland ... we consider it to be of considerable interest to the National Collections and much regret that you thought it necessary to overbid us.' [558] In a letter sent to a third party, Ashton explained how he had personally bid on the crucifix in order to make others realise that, with the V&A wishing to acquire the crucifix for the National Collections, no export licence would be issued: 'I went to the sale myself and bid. Much to my regret, when I started bidding, Mrs. John Hunt, whose husband now informs me that she far exceeded his instructions, proceeded to run me up and overbid me through an agent who was standing beside her ... the tiresome thing is that the cross

is comparatively small and no doubt would be taken back to Ireland'.[559]

The cross in question was an early twelfth-century crucifix found sixty years earlier under the chancel floor of a church in Holderness, Yorkshire and now being disposed of by the younger daughter of the first recorded owner after the discovery.[560] The discovery created quite a stir in antiquarian circles, with a note by the editor of *The Reliquary* noting that: 'Metal crucifixes of such a date are exceptional. The British Museum contains nothing within two centuries of it.'[561]

By 1952, the couple decided that Putzel would spend most of her time in London dealing in art, while Jack, with no archaeological excavations planned for that year, remained back in Lough Gur to finish his book on the stone figure sculptures of Irish medieval tombs. In the spring of that year, they rented a flat in a substantial four-storey property at Sloane House, 149 Old Church Street, Chelsea. During the following year, with Jack struggling to complete his *magnum opus*, Putzel lived on her own in London for several months, as she explained to Rorimer: 'I shall be here in London for about 3 months. Mr. Black is going away for this period and he asked me to look after things for him. It will be a change for me and fun and I get a good salary as well.'[562] Jack will I hope be able to concentrate and finish his book on Irish medieval sculpture'.[563]

In November 1953, Putzel moved to what she described as 'a little house of my own'.[564] This modest description hardly seemed to fit the property in question at 60 Park Street, a modernised five-bedroom period residence in the heart of Mayfair. For most of the next decade the Hunts leased this property from the Grosvenor Estate, making it their London base for accommodation and business. The spacious ground floor room, with its Adams ceiling beautifully patterned with leaves, flowers and urns, was later set up as a gallery and office. However, there was no nameplate on the outside of the building since its residential zoning, under planning regulations, did not permit use of the premises for business purposes.[565]

There are frequent references in correspondence to the couple's temporary detachment, with Jack noting that 'Putzel seems to be enjoying herself

very much in London … everyone is so kind to her. I hope to come over for a few days myself soon'.[566] There is no indication that their living apart was the source of any tension between the couple. Rather they appeared to look forward to the occasions of being together again, either in London or Lough Gur. Putzel told one correspondent: 'I hope Jack will come over next month and then we will go to Paris together'.[567] Jack, writing just after Christmas 1953, noted: 'we are only here in Lough Gur for 2 days and I am so happy because Putzel is with me … she is going back to London on the 2nd'.[568]

In early 1954, Putzel became involved in a business with Kenneth John Hewett, a 'major post-war London dealer in ethnographic art and antiquities'.[569] Hewett, 'a well-built bearded ex-Guardsman of much dignity', had first been introduced to the Hunts, sometime after the war, by Peter Wilson of Sotheby's, who had encountered him selling his wares from a tiny stall in Sydney Street, Chelsea. Hewett spent some time in Ireland over the next few years and assisted Hunt on the archaeological excavation at Ballingarry Down in the summer of 1949.[570]

Their business involvement was formalised in 1954 with the formation of KJ Hewett Limited, with Putzel taking a shareholding, and John Hewett and herself acting as the only two directors. The company notepaper listed 60 Park Street as the address for 'KJ Hewett Limited – Works of Art'. Shortly after Putzel had started to work with Hewett, Sandy Martin, another former Scots Guard and associate of Peter Wilson at Sotheby's, also came on board. While Jack was often on hand to provide advice to the dealership, Putzel, according to Martin, was 'the Hunt who was the real dealer with the three essential qualities to be a success in trading art, namely, knowledge, good taste and business sense'.[571] James White, Director of Ireland's National Gallery, recalled many years later how Putzel's instinct for a bargain had been described to him at this time by a well-known London dealer: 'It was extraordinary … it was if she had a Geiger-counter in her brain which fluttered when she came across a work of quality'.[572]

While Hewett and Martin worked full-time in KJ Hewett Ltd., with Barbara Hare as a permanent secretary, Putzel could only do so when she was

in the UK, which in the first three years or so, was probably about half her time. The Hunts, in addition to contributing their own expertise in the area of medieval art, and a share of the capital for purchases, also provided the property at 60 Park Street as a base for the business, and part of the accommodation was also made available for use by Hewett. Martin recalls that 'the accounting side of the business was relatively simple – essentially all deals at that time were in cash'.[573]

Jack made no secret of the fact that Putzel was more involved in art dealing than himself, writing to James Rorimer in 1955: 'I have been very lucky lately and Putzel has been getting me some marvellous additions to our collection'.[574] Similarly, Putzel also emphasised the lines of demarcation to outsiders: 'I am answering this letter because although your letter was addressed to my husband, the collection of gold is being dealt with by a firm in London of which I am a director'.[575]

While Putzel was focused on the business, Jack, when in London, was more engaged on consultancy work for Sotheby's and various collectors. From the early 1950s he was contracted by Sotheby's to evaluate collections for death duty purposes, such as the valuation on the estate of Philip Nelson of Liverpool in 1953. He also carried out commissions on behalf of Sotheby's, to provide appraisals and valuations in the area of Romanesque and Gothic art for some of the world's greatest collectors, including the Aga Khan and Robert Von Hirsch.[576]

When an object that Hunt had special knowledge about came up for auction, he would frequently be asked to bid on behalf of KJ Hewett Ltd at the sale. For example, Martin states that when a Romanesque gilt-bronze crucifix, reportedly made in Anjou, France, came on the market at the Palais Stoclet sale in 1965, it was Hunt who bid it up all the way to £21,120 to purchase it on behalf of the British Museum. However, the British Museum records show only that it was acquired on behalf of the Museum by KJ Hewett Ltd.[577] Martin recalls that there were no conflicts between Hunt and KJ Hewett Ltd: 'when something interesting was coming up, and Jack would say that he wished to buy it for his own collection, we wouldn't bid'.[578]

Whereas the expertise of the Hunts was mainly in medieval art objects from Northern and Central Europe, as well as art objects from the ancient civilisations of Greece, Rome, Egypt and Byzantium, the most important aspect of art dealing introduced to the partnership by Hewett was in the area of primitive art. Until well into the twentieth century, most Western collectors considered objects made by Africans, native Americans or Pacific Islanders as merely curios, and the few serious collectors were motivated by a desire 'to preserve the relics of dead and dying cults'.[579] Hewett also had a good eye for modern art, and Martin tells of how, from the late 1940s, he had been buying art produced by the Swiss sculptor Alberto Giacometti and the then relatively unknown Dublin-born artist, Francis Bacon, for whom Hewett later sat as a model for a triptych of heads.[580]

Even before the dealership was established, Hewett was looking for good bronzes from Benin in West Africa and, in January 1952, had paid the highest price at a Sotheby's sale for a figure of a 'huntsman with antelope and dog'.[581] In January 1956, KJ Hewett Ltd paid the remarkable price of £880 for another Benin piece, this time a sixteenth-century ivory chalice.[582] Through the Pitt-Rivers Museum in Farnham, Dorset, with which Hunt had established contacts since the 1930s, KJ Hewett Ltd had access to a treasure trove of primitive art, particularly the collection of Benin bronzes. The owner, Captain George Pitt-Rivers, was anxious to sell items in order to fund his extravagant lifestyle, and Martin recalls how: 'We used to go down to the museum and get the pieces and bring them back to 60 Park Street and put them on the floor'.[583] One key asset for Hewett was his good reputation as, in an area such as primitive art, where provenance was almost non-existent, one needed to be able to trust the dealer who was selling you the object.[584]

According to Martin, apart from Sir Robert Sainsbury, there were practically no customers for primitive art in Britain in the 1950s. Initially, the only dealer with whom they regularly traded was Charles Ratton in Paris, whom Martin described as 'a very fine man'. However, the partnership soon developed close links with Robert Goldwater, first director of New York's Museum of Primitive Art, founded by Nelson Rockefeller. According to

Martin, while Rockefeller's own collection formed the core of the items displayed at the Museum of Primitive Art, an even greater interest came from his son, Michael, to whom the study of primitive peoples was a passion. KJ Hewett Ltd sold several pieces of primitive art, which had originated in places such as Benin, Tahiti and Australia, to Goldwater. By Martin's reckoning, 'the most valuable object we sold to Goldwater was a large brass Benin Flute Player for £4,000, which today I would consider to be worth £1,000,000'.

On the question of export licences for the Benin objects, Martin recalled that, in the early years, given that the values of the majority of such objects were below the minimum value thresholds for licences set after the report of the Waverley Committee in 1952, 'nobody even thought about it.'[585] Then, as the items became more valuable and awareness of them increased, 'it was too risky as a dealer to export without a licence'.[586] Given that the Benin pieces were neither British, nor at that time recognised as being of outstanding aesthetic importance or historical significance, such licences were readily obtained.

Other collectors whom Martin recalls dealing with during the Park Street era included the flamboyant Hunt brothers, based in Texas, whose interest lay in bronzes, coins and vases, and Sir Robert Sainsbury and his wife Lisa, who were major clients for tribal art, as well as paintings by the young Francis Bacon and sculptures by Alberto Giacometti.

Martin remembered Jack as a very mild mannered individual who was 'a bit of an absent professor type … he'd arrive at the airport and come rushing in because he had no money to pay the taxi or he'd forgotten his airline tickets – then he went to France or other places two or three times with his passport out of date'.[587] On the question of Hunt's attitude to matters commercial, Martin says he 'just wasn't interested in making money'.[588]

Similar memories of Jack as being somewhat disorganised and forgetful can be found in museum archives. On one occasion, when the V&A had been allowed to collect three pieces of English furniture without any agreed price being settled, the Keeper of Woodwork wrote to Jack saying: 'I must

say you are a mighty unbusinesslike pair … Pull yourself together please and let me have the price in each instance, which is an indispensible preliminary to do anything at all.'[589] The keeper later wrote: 'Despite your exceedingly happy-go-lucky methods the whole transaction is now tied up.'[590] On another occasion Putzel had written to the V&A seeking the return of a valuable piece of Canterbury glass, only to discover that Jack had collected it sometime earlier, but omitted to tell her. In a letter of apology, she wrote that: 'He is very vague and forgetful, and as I am looking after things, I am sorry I did not find out before bothering you about it'.[591] Later, Jack was stopped by Putzel from paying twice for the transport of an object he had sent to the British Museum, and wrote that: 'without Putzel I would have paid it again!'[592]

The contrast between Jack and Putzel's organisational skills was reflected in their methods of business negotiation. When she was based in London in 1953, Putzel had no qualms in quoting Leigh Ashton of the V&A a 'monstrous figure' for three items of English furniture, consisting of a daybed, screen and armchair from the seventeenth and eighteenth centuries, notwithstanding her role in outbidding him for the Early English Crucifix in December 1949.[593] After a letter of protest from Ashton, Jack replied from Lough Gur that he 'was reducing the enormous figures she quoted' and reduced the earlier price of £715 by £100.

While the tone of correspondence between Hunt and the V&A staff at this period was at all times warm and friendly, in 1955 he came into open conflict with the museum over an export licence for an English religious vestment. The case became one of the major *causes célèbres* of the 1950s British art world, and eventually required the British Chancellor of the Exchequer to obtain the approval of Parliament for a supplementary grant to keep the object in Britain.

The piece in question, the Butler-Bowdon Cope (1330-1350), was made using a type of English embroidery known as *opus anglicanum*, and considered by the V&A as 'undoubtedly the most important English vestment of late 13th or early 14th century date that is likely ever to come on the market'.[594] Made

of silk velvet, embroidered with silver and silver-gilt thread and coloured silks, it had been in the Catholic Butler-Bowdon family possibly for more than 400 years, surviving the Reformation when countless religious objects were destroyed in line with the iconoclasm of the new religious order.[595]

Hunt had been prompted a couple of years earlier by James Rorimer, of New York's Metropolitan Museum of Art, to try to procure the cope for the Met. Rorimer had a special reason for wishing to acquire this piece because, in 1927, the Met had purchased a chasuble of *opus anglicanum* of similar design that may once have formed part of the same set, and the acquisition the cope would bring both objects together again. Hunt wrote to Rorimer in September 1952, saying: 'You must not be optimistic about the *opus anglicanum*. The owner whom I know well is not anxious to sell the moment and even if he would, would we ever get export licence?'[596]

Nonetheless, Hunt kept touch with the owner, Col-William Butler-Bowdon of Mayfield, Sussex, over the two years, and finally succeeded in getting him sign an agreement on 19

Opus Anglicanum Cope.

December 1954 to sell the cope to the Met for £33,000 which included £3,000 commission for himself as seller's agent, subject only to the issuing of an export licence. In doing this, Hunt was taking a risk, at least to his reputation, in that he hadn't received formal approval from the Met. He wrote to Rorimer the same day telling him 'I hope this news will give you pleasure for Christmas … I hope you will not think that I was precipitate as I realised that officially you will have to put this before your trustees'.[597]

Rorimer moved to get the formal approval from his vetting committee and wrote to Hunt saying, 'Congratulations, you naughty boy' and confirmed that he had obtained the necessary approvals to purchase the cope.[598] Clearly anxious to conclude matters, Hunt wrote that Butler-Bowdon, then aged 74, 'is a queer man and I would like to get things settled as early as I possibly can'.[599]

In a follow-up letter, written a few days later, Hunt told Rorimer that he was optimistic that the deal with the Met would succeed because 'in the event of the export being refused, the cope will have to be purchased at the same price for some institution in this country. None of the museums here have any such funds and this therefore means that there would have to be a special treasury grant or a national collection of some description'.[600] Hunt suggested a stratagem, which may have been somewhat too calculating, whereby Rorimer should also agree to purchase the stained-glass window with two roundels from Canterbury Cathedral, which Hunt had offered to him from the estate of Philip Nelson, and make a second export licence application. He suggested that active lobbying by the Friends of Canterbury Cathedral would put pressure on the government to provide funds to buy these objects rather than the cope. However, Rorimer declined Hunt's somewhat Machiavellian scheme, being conscious of maintaining the reputation of probity for the Met in the eyes of European museums, and of British sensibilities towards the export of outstanding works of art and antiquities of national importance to the more wealthy museums in the US.

Hunt made his formal request to the Export Licensing Branch of the Board of Trade within days and the V&A lodged a strong objection: 'in view

of the great importance of this cope our recommendation is that an export licence should not be granted. This is one of the finest English 14th century copes; it is one of the few left in England and unquestionably an English work of art of the greatest importance'.[601]

Hunt attended the Reviewing Committee on the Export of Works of Art meeting on 16 March, acting, with Rorimer's agreement, on behalf of the Met. The committee decided that unless the V&A could match the deal by 30 June the export licence would issue.[602] Rorimer cabled Hunt saying, 'I do not see how we could have asked for a better solution to our problem'.[603]

Hunt wrote to Rorimer setting out his information on the state of play regarding the cope: 'I learned from private sources that the textile department are very anxious to secure it and will make a big effort, but I also hear that the Treasury are very much against making a special grant so that the National Arts Collection Fund etc, will have to be approached, I hear that this means that there is quite a good chance of their not being able to raise the money.'[604]

Hunt's intelligence 'sources' were quite accurate. The V&A wasted no time in trying to raise the necessary money and Ashton wrote to the National Art Collections Fund (NACF) seeking financial assistance to purchase the cope, saying: 'the price is extremely high, namely £33,000 … by scraping the bottom of the barrel I could find £13,000 and I therefore appeal to the fund to know whether they would provide £20,000.'[605] Ashton also sounded out the Treasury and received a very cold response from the Permanent Secretary of the Ministry of Education, saying: 'I think it is only sensible for me to say that the Minister is not at all keen that we should lay a supplementary estimate in 1955-56 for this purpose'.[606]

Ashton wrote again to the NACF, this time to the Chairman: 'The minister is not prepared to ask for a Supplementary Vote, though he very much wants us to have the object … with the election coming on, I do not suppose that any of the politicians will take much interest in the object.'[607] He elaborated on the political obstacle in a further letter stating: 'A supplementary vote involves a political issue as the Minister has to answer for it in the

House of Commons and is probably attacked by the Opposition for being parsimonious on education and liberal on works of art.'[608]

An appeal to the Pilgrim Trust elicited a response from their chairman reflecting a widely held view at the time: 'So long as our present legislation is operating I presume we have to match the price which a wealthy foreign country is prepared to pay if we are to save those of our treasures upon which they cast envious eyes'.[609] Ashton agreed: 'as the Waverley report has induced the Americans to pay exorbitant prices to outbid the English museums, it is up to the Treasury to help.'[610]

Sometime later, Ashton sought permission to inspect the cope and received a somewhat brusque reply from Colonel Butler-Bowdon: 'The cope is not here. It is in a bank several miles from here and is in the same condition as when you saw it. It is no longer my property having been bought by the Metropolitan Museum of New York who have paid me part of the purchase price. The Museum's agent here is Mr John Hunt, 71 Merrion Square, Dublin. He can take over the cope when he likes. I am not prepared to undertake the fetching and packing and unpacking. I suppose Mr Hunt could keep it in his bank.'[611] Ashton's reply could be construed as an attempt to undermine Hunt in Butler-Bowdon's eyes: 'I think you must be acting under a misapprehension. The cope cannot be the property of the Metropolitan Museum as they have no powers to buy an object in this country unless an export licence is given for it. If Mr Hunt did not explain this to you he has deceived you.'[612]

On the very same day Ashton wrote to Hunt in a rather different tone: 'Dear John, I am writing to you in the interim to let you know that things are going fairly well with regards to raising of the money for the cope. If I do raise the money I feel it is essential that I should see the cope before committing this vast sum. Perhaps therefore you would advise me whether you have the power to give me an opportunity of seeing it; indeed some idea from you as to its present condition would be of considerable help. As I remember it, the red of the velvet was not particularly brilliant and as we know, it has been considerably damaged.'[613]

Both Ashton and Digby finally got to see the cope at Colonel Butler-

Bowdon's home, but Ashton had another reason for the visit – he wanted to cut Hunt out of the deal. Having seen the cope and agreed it was in very good condition, he told Butler-Bowdon that 'he had got the money but that he wasn't going to pay £3,000 to John Hunt'.[614] He followed up that night with a telegram to the Colonel which read: 'Grateful to know before I go to America early May whether we can fix at thirty thousand. Ashton'.[615] Butler Bowdon's reply the next day was curtly dismissive of this stratagem: 'The price is £33,000. It is not open to negotiation.'[616]

Ashton continued to pull out all the stops in an effort to raise the necessary funds and, after an appeal to various guilds in the City of London, he succeeded in raising a further £841.00 from organisations such as the Worshipful Company of Goldsmiths. The NACF came up with £5,000 and the Pilgrim Trust eventually agreed to provide £3,000.

The British General Election took place on 26 May 1955, with the Conservatives being returned with an increased majority and David Eccles, who was 'so extremely sensible and interested in it (the cope)', being re-appointed as Minister of Education. With the political atmosphere now becalmed, Eccles was less concerned about any political charge of favouring the arts over education and felt free to follow his inclination that the cope must remain in Britain. In a written reply in Parliament on 23 June, just a week before the deadline was due to expire, he announced: 'It has been strongly represented to me that the cope is of the highest national importance and that special Exchequer help should, if necessary, be given towards its purchase so that it may remain in this country'.[617] He went on to say that he had obtained the agreement of the Chancellor of the Exchequer for a sum of £9,000 to be provided from public funds towards the purchase of the cope, subject to the approval of Parliament. This story was covered with large front-page paragraphs in the newspapers, with a naturally delighted V&A spokesman quoted as saying: 'It is a remarkable specimen of *Opus Anglicanum* at its finest period'.[618]

Jack and a representative from the V&A went to Butler-Bowdon's house on 30 June 1955 to pay over the full £33,000 for the cope. A file note on

the handover of the cope written by the V&A's Keeper of Textiles noted that after receiving the cheque for £33,000, Butler Bowdon 'then repaid the 15,000 advanced by Mr. Hunt plus 3,000 commission!'[619] Despite the disappointment Hunt may have felt at not being able to bring off the deal for the Met, he at least had the satisfaction of earning a substantial fee for his efforts.

Butler-Bowdon wrote to Rorimer saying how sorry he was that the deal hadn't gone through, but set out his ambivalence about the outcome: 'I am naturally glad it should remain in England but very sorry you couldn't have it to go with the Raleigh Chichester Constable's chasuble … I hope John Hunt will find you something good instead of it but I fear the market in XIV (*sic*) Copes is getting a bit tight.'[620] The conflict over the cope does not appear to have had any lasting effect on relationships between Hunt and the V&A, which were consolidated with the donation of a much appreciated gift.

When the new Medieval and Renaissance Galleries of the V&A opened in 2009, the Butler-Bowdon Cope was displayed along with another piece of English cultural heritage connected to Hunt – a Canterbury Cathedral stained glass panel that he gave as a gift to the Museum in 1958. This particular border panel, dating from the late twelfth century, formed part of the background of a medallion window devoted to scenes from the life of St Thomas à Becket. Clever back-lighting brings out the rich and varied palette of colours in the stained-glass in much the same way as the daylight streaming through the glass would have illuminated the story of the martyred archbishop to pilgrims of the Middle Ages. The following year the V&A purchased two further pieces of Canterbury Cathedral stained glass from Hunt at a price of £240.

Earlier, in September 1956, Hunt had offered to the V&A, on behalf of the executors of Dr Nelson, another piece, consisting of a large window (7ft x 3ft approx) with two roundels for the substantial sum of £20,000. This piece had already been offered to Canterbury Cathedral at the same price, but rejected as being too expensive. Not surprisingly, as Hunt might have anticipated from the saga of the Butler-Bowdon Cope, the V&A similarly declined his offer.

The fact that Hunt was in a position to sell or donate objects that had apparently been alienated from the Cathedral remained a source of puzzlement in some quarters, even within the V&A itself. *The Art Newspaper* reported in 1998 that: 'Claude Blair, formerly Keeper of Metalwork at the Victoria and Albert Museum, recalls visiting Hunt's flat in Earls Court to discover thirteenth-century stained glass roundels from Canterbury Cathedral. To this day Mr Blair is not quite sure why they were there'.[621]

According to Hunt, all the Canterbury stained-glass that he had for sale had been sourced from Dr Nelson, who in turn had acquired it from the cathedral glazier, Samuel Caldwell Jr, in 1908. Hunt had documents which Caldwell had provided to Nelson to the effect that the pieces were among hundreds that had been removed in 1852 by the cathedral's glazier, George Austin, who replaced them with panels newly-cast by himself.

Canterbury Cathedral window with roundels.
Virginia Museum of Fine Arts, Richmond. Adolph D. and Wilkins C. Williams Fund.

Caldwell claimed that Austin had subsequently been given title to the pieces by the Dean of the cathedral. Austin gave the old glass to his nephew and successor as glazier, Samuel Caldwell Sr, who in turn bequeathed them to his successor in the same role, his son, Samuel Caldwell Jr.

While Claude Blair was not the only one who was sceptical about Hunt's entitlement to sell the glass, the evidence of provenance provided by Nelson was corroborated in a 1944 press report, which may have been missed by most people in the art world who were no doubt pre-occupied with disparate wartime distractions at the time. In October of that year, *The Times* reported that 'an important acquisition of medieval stained-glass was sanctioned at a meeting of the Council of the Friends of the Cathedral ... the Dean who presided stated that this glass had been a source of anxiety for years. The Cathedral has no sort of property in it. It had been inherited by Mr. Samuel Caldwell who was now willing to sell it for £311.'[622]

Hunt had also maintained his contacts with the British Museum in the post-war years and, in 1954, sold them a large devotional panel in lead recalling the life of Thomas, Earl of Lancaster, who had led a revolt against Edward II, and become venerated as a martyr following his execution in 1322. That same year, Hunt made a donation of three medieval items to the museum, including a bronze monumental plate. In 1956, acting on behalf of the executors of Philip Nelson, Hunt sold four rare silver seals to the museum, two of them episcopal signets attesting to the authority of the bishops of Ely and Dunblane.

However, the most substantial acquisition by the British Museum from Hunt was a rare piece of Anglo-Saxon sculpture that is displayed today in the museum's Queen Elizabeth II Great Court. The piece in question is a late eighth-century broken sandstone cross-shaft with a running vine scroll, formerly in the grounds of Lowther Castle, in Cumbria. Apart from its presence at the main focal point of the museum, with thousands of visitors passing by every day, it is the only representation of British workmanship among the nine sculptures on display there.

That Hunt should have been able to get his hands on this cross, and

be in a position to sell it to the British Museum, is remarkable. The object had 'an impeccable pedigree' and for many years was 'well known to specialists in the field.'[623] Two photographs of the cross-shaft had appeared in a publication by the Royal Commission on Historical Monuments in 1936. Two years later, the shaft had featured in the book *Anglo-Saxon Art to A.D. 900* by the British Museum's Keeper of British and Medieval Art, TD Kendrick.[624]

Yet, when a series of almost twenty auctions of the Lowther Estate properties began in 1954, nobody from the British Museum or the V&A appears to have attempted to track down this rare piece of Anglo-Saxon sculpture. It was most likely at this time that Hunt acquired the piece and shipped it to Ireland, although it is unclear whether he dealt directly with the demolition contractors or bought it at 'A Series of Demolition Sales' which commenced in April, 1957 at Lowther Castle.[625]

It is probable that Hunt paid far less than the threshold of £500, which would have triggered an export licence requirement under the Waverley Criteria. The British Museum never raised an issue as to how the shaft had been exported to Ireland, nor did anyone seek to ask Hunt how he had obtained the piece.

Rupert Bruce-Mitford, Keeper of British and Medieval Antiquities at the British Museum, first made a note of the object in July 1963, after receiving

The Lowther cross-shaft. The only representation of British workmanship in the British Museum's Queen Elizabeth ll Great Court.

a photograph of it from Hunt and an indication that, if it were ever for sale, the price would be in the range of £6,000 to £8,000.[626] In March 1964, prompted by their purchase of a house in the south of France, Hunt wrote to Bruce-Mitford saying that he wished to sell the cross-shaft 'fairly soon' as the doing-up of the property 'was a bit of an unknown quantity'. In June 1964 Bruce-Mitford stayed with the Hunts in Dublin and inspected the cross-shaft, and agreed with Hunt to have it shipped immediately to the British Museum, which was given first option to purchase the item for £7,000.[627] Negotiations, however, were slow, and the acquisition of the cross-shaft was not approved until April 1967 with the assistance of Hunt, who had offered 'to contribute £1,000 towards this ourselves, thus reducing the net cost to the Museum to £6,000', and a further donation of £1,000 from the National Art Collections Fund.[628]

The hey-day of the Park Street dealership was the five years between 1953 and 1958. In October of the latter year, Peter Wilson was appointed Chairman of Sotheby's and persuaded Hewett to join the firm, even though he was still permitted to continue trading on his own account through KJ Hewett Ltd. The Hunts also had other calls on their time, particularly after acquiring their home in Dublin and a young family, so the deals continued at a somewhat slower pace and, by the time the Hunts put the lease on Park Street up for sale in November 1962, their involvement in art dealing had been greatly wound down. To accommodate their visits to London, they bought what Putzel described as 'a quite dreadful 2 roomed flat in a Victorian house … and it is really all we want.'[629]

Towards the end of the 1950s, Hunt himself was acting less as a dealer buying to re-sell and more as a collector, or as an advisor to other collectors, such as Lord Fairhaven of Anglesey Abbey in Cambridgeshire, or to Sotheby's.

Howard Ricketts, who became head of the Medieval Art and Sculpture section in Sotheby's in 1962, had many dealings with the Hunts and has put their involvement with the firm in context, stating that he 'never knew them as active dealers – by this stage in their lives they were simply collectors':[630]

Sotheby's was a fairly small company in the 1950s, with probably less than one hundred people and only seven or eight partners. There weren't experts in each department, so, where there were gaps, the heads of departments commissioned outside advice. Hunt acted as a consultant on medieval works of art before about 1500, prior to their inclusion in the Sotheby's sales catalogues. For this he received a modest commission, which Putzel told me once "was very nice to have because it was the only guaranteed income we had". I think they were asset rich and there were times when not a great deal of money was coming in.

The great period for collecting medieval art was 1850 to 1939 – by the time I got to Sotheby's in 1959 there was only a trickle of material coming on the market … so you really did depend on someone of Jack's vintage who had experienced a good flow of material in the 1920s and 1930s to have a much better understanding of the field. His knowledge was invaluable to us – it was a generational thing.

Anything from the Dark Ages, Romanesque or early Gothic period would be looked at by Jack who would offer his ideas as to the dating of the piece. If it was an object of some substance he would offer advice on the object's importance relative to other known pieces and might well follow this up with references drawn from his encyclopedic library. All of this would enable us to undertake a valuation of the piece with confidence and also to prepare an authoritative catalogue description.

Jack was extremely useful when it came to making a judgment on off-beat things. I remember not being able to decide if a Fatimid rock crystal was genuine or a later copy, but Jack, who had had pre-war experience of hardstone carvings, would tell us if a piece was right or wrong and how it related to

similar pieces in books written in the 1920s and 1930s which might not have existed in our departmental library.

Both my wife and I look back on our friendship with Jack and Putzel with great affection. Shortly after we got married in 1965, Jack and Putzel came to visit us in a house in Parson's Green in Fulham. Very few of the rooms were done up but, as soon as Putzel went into the drawing room, she spotted the rather stained Victorian fireplace. She immediately said she would give us a wood fireplace that they had in store which would be much more in keeping with the style of the room. It was delivered two days later. [631]

Elizabeth Wilson, who started in Sotheby's in 1963 and was later head of the firm's European Sculpture and Works of Art Department in London, remembers Hunt as a consultant to Sotheby's and a 'father figure with an unimpeachable reputation' who was 'very generous with his advice and particularly helpful' to her as a young person.[632] She described Jack and Putzel as 'very kind and generous friends and a good laugh – all I want to say about them is positive'.[633]

The high esteem in which John and Putzel were held by the flamboyant Peter Wilson of Sotheby's must have contributed to the close and mutually beneficial relationship they were to develop with the firm. Wilson, Chairman of Sotheby's from 1958 until 1980, was 'more than anyone else responsible not only for the expansion of Sotheby's during that period but for the rapid growth of the world art market as a whole with its high prices and attendant publicity'.[634] His impact on the art market has been likened to 'that of Henry Ford on the mass production of cars, Rothschild on banking and Fleming on medicine'.[635]

The friendship between the Hunts and the younger Wilson was based on an intense passion which they shared for works of art. The Hunts' initial contact with Wilson probably went back to 1935 when the newly married twenty-two-year-old penniless aristocrat was selling advertising for *Connoisseur*, an art magazine in which Hunt occasionally placed advertisements for

his antique shop in Bury St. Putzel later recalled the Wilsons as having to improvise with orange boxes as bedside tables and spoke of how Wilson's wife, Helen, in the first years of her marriage, would regularly confide in her that the couple had no money at all.[636]

Having joined Sotheby's as a porter in the furniture department in 1936, Wilson's 'eye' for objects and hard work enabled him to make a good impression on his colleagues. In December 1938, using money which his wife had just received as an inheritance, he purchased the shares of a retiring director and became a junior partner in the firm.

The couples remained in touch right up to the outbreak of war when Wilson, called up for National Service, departed for Gibraltar where he worked on counter-espionage duties with the Imperial Postage and Telegraph Censorship organisation.[637] Both Jack and Putzel saw Wilson on the day he departed for Gibraltar and made plans to keep in touch with Helen Wilson during his absence.[638] He was later transferred to Bermuda and reportedly became a full-time spy as early as 1941, being recruited by MI6 for whom he served during the later years of the war.[639]

After Wilson's return from his role with MI6 in 1946, he resumed his career in Sotheby's and his contacts with the Hunts. Although he came from aristocratic stock on both sides of his family, Wilson chose not to surround himself with friends of similar background and the relationship with Jack and Putzel was noted in a corporate biography of Sotheby's which referred to: 'the nucleus of Peter Wilson's off-duty family, the bearded Hewett and the scholarly Hunts, friends in thrall to the romantic power of beautiful objects, swapping tips on the telephone, weekending in Mersham – and wheeling, dealing all the time during the 1960s'.[640] By 1947, Wilson was divorced from his wife, Helen, and the kind of secret life he had lived in his espionage career was paralleled in his private life. He was obliged to be discreet about his sexual orientation in an era when evidence of homosexual behaviour on his part would have left him open to criminal prosecution.

The question can reasonably be asked as to how much the Hunts might have known about the details of Wilson's colourful style as Chairman of

Sotheby's. His methods in expanding the firm's business have been the subject of at least four major corporate biographies. Apart from an authorised history of the firm first published in 1980, and described as 'not only uncritical ... at times openly partisan', the other three books called into question Wilson's methods and his business ethics in achieving his goals.[641] For example, in *Sotheby's Bidding for Class* (1999), Robert Lacey describes how Wilson would regularly arrange for false bids to increase prices and how Sotheby's, up to 1970, reported fictitious names of buyers of items which had failed to reach their reserves.

Howard Ricketts, one of the few surviving witnesses who observed the relationship between Wilson and the Hunts, pointed out that even Wilson's critics acknowledged his singular ability to relate to art objects, and considered that some of the portrayals of Wilson were 'unbalanced' and 'malicious' and regarded associating the Hunts with Wilson's sharp practice as 'absolute rubbish ... I think that the Hunts were personal friends ... Peter would have kept up, as he did with perhaps so many people, a kind of Chinese wall. OK, even compartmented as they were they probably knew more than most people'.[642]

The friendship with Wilson was to continue outside Sotheby's. In the 1950s Wilson acquired Chateau de Clavary, a large property on almost 100 acres near Grasse in France, with several attractive features including a Picasso mosaic in the entrance hall and several water gardens.[643] This later became his permanent home after his retirement as Chairman of Sotheby's. Jack and Putzel, after staying there as his house guests, in 1964 acquired a small shepherd's hut across the road which they restored over the next few years, calling it appropriately 'Le Bergerie de Clavary'.[644]

CHAPTER 8

Your house and your garden and your spirit are like nothing
I could ever have imagined to exist.
Jacqueline Kennedy [645]

In the early 1950s the increasing involvement of the Hunts in social and cultural activities in Dublin meant that they found themselves spending more time there, and, by the summer of 1954, after the sale of their home at Lough Gur, the flat at Merrion Square became the Hunts' sole residence in Ireland. They were generous hosts and widened their network of friends in Dublin's social circles. Sandy Martin, a business partner of Putzel's from London, recalled frequent visits he made there in the 1950s:

> I remember several wonderful evenings in Merrion Square
> where Putzel would be the centre of the party and would
> unobtrusively slip away from the room to take care of the
> cooking. She was a typical German Hausfrau. She was also
> extremely generous; I casually remarked one night that I
> admired a dress and a few weeks later a copy of the dress
> arrived at my flat in London for my wife. I had not realised
> that it was the latest creation by Sybil Connolly. [646]

However, they were on the lookout for a more substantial residence they could call their home and, in July 1955, purchased Drumleck, on the Howth peninsula just outside Dublin. Putzel wrote to a former neighbour from Lough Gur saying: 'I do hope that this will be our last home on this earth. We

196

love it very much and are very fond of it. In fact we still feel it is too good to be true, as it really has such a lovely situation, overlooking the sea and the town opposite.'[647]

The house had been constructed on grounds of more than ten acres and, while it didn't quite match Poyle Manor in scale, it surpassed it in its spectacular setting above a rocky cliff-face commanding panoramic views southwards across Dublin Bay.[648] Approached by a long shaded driveway from the entrance gate, Drumleck was a spacious early Victorian-era house with eight bedrooms and four reception rooms. An extensive conservatory adjoined the house and the property also included a hard court tennis court, three greenhouses, a walled garden and extensive out-buildings including a 'head gardener's house'. Originally built in the 1840s by William M'Dougall, a Dublin solicitor, the Hunts acquired the property for a consideration of £8,000 from Violet Jameson, the elderly widow of Henry R Jameson, a member of the renowned family of Irish whiskey distillers. [649]

Before taking up occupation of Drumleck in January 1956, Jack and Putzel commenced a programme of extensive renovations, with a view to

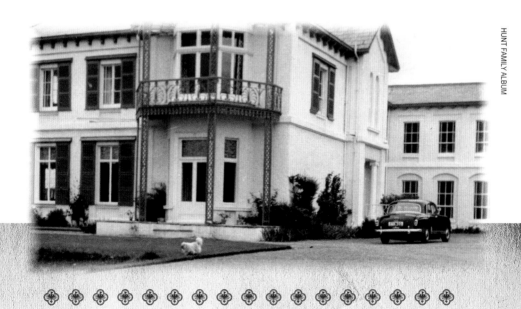

HUNT FAMILY ALBUM

Drumleck after 'Georgianising' by Putzel.

giving a Georgian ambience to the house by adding green exterior wooden window shutters which stood out against the white-washed walls. Hunt made extensive use of architectural salvage from recently demolished eighteenth-century properties, having seen the decorative potential of such relatively inexpensive items from his earlier days working with the world's leading firm in this area, White Allom. A newspaper report on the renovation of Drumleck, some years later, noted: 'Cornices, ceiling motifs, wall embellishments, carefully replaced in their new setting by Mr Hunt, came from some of Dublin's razed Georgian mansions. The staircase was once in a house in Merrion Square.'[650]

Working in conjunction with a carpenter, Sam Waters, Hunt created a 'secret room' off the library, to store and display some of his more valuable objects and in particular his collection of crucifixes and monstrances. [651] This room was fitted-out with display cases and lighting, with the entrance door camouflaged by some learned tomes on the bookshelves.

The decoration of the house provided Jack and Putzel with the opportunity to exhibit, on a much more substantial stage than at their previous Irish properties, some of the finest pieces from the collection that they had been assembling for more than twenty years. Each room had a stunning variety of pieces on display, with stained glass and ceramic pieces juxtaposed with bronze, wood or ivory. Objects from various eras were displayed together, ranging from such medieval treasures as Ligier Richier's statue of the Virgin in wood on the first stairs landing, to pieces from more modern times, such as a framed sketch for a boxwood carving by Henry Moore.[652] Many household items, notwithstanding their value as antique pieces, were used for the purpose envisaged by the original craftsman who made them. Precious Chinese Ming vases from the sixteenth century were used to display flowers and, as in Lough Gur, many of the kitchen utensils and crockery in everyday use had been in service centuries earlier in widely diverse societies. While there were many visual representations displayed from the medieval period, the Hunts' appreciation of the finest exemplars of the graphic arts from the Impressionist era onwards was reflected in works by artists such as Picasso,

Renoir, Giacometti, William Orpen, Jack B Yeats and Roderick O'Connor. The Hunts' solicitor and friend, John O'Connor, recalled the many works of art in Drumleck, and recollected his professional concern that 'they had the most wonderful stuff in the place, all uninsured, despite my pleadings for them to get some kind of cover'.[653]

Many of those who visited the house found it a source of wonderment which left indelible memories. Dr Peter Harbison recalled that: 'to go into Drumleck was an artistic joy – you'd go into the hall and up against a vast mirror was the great Catalan Majestat – the wooden figure of Christ – and the small Picasso at the bottom of the stairs transposed from the kitchen at Lough Gur'.[654] Howard Ricketts, a director of Sotheby's, remembered it from the perspective of a dealer in beautiful things:

> I think it meant a hell of a lot to Jack and Putzel having the drawing room looking as it did at Drumleck – it was just a wonderful room with the furniture and the carpet and the paintings … you would have to spend maybe a million pounds today to fill a room with things of that sort of quality. That wall in the ante-room at the end had shelves just full of the most wonderful pottery collection, with cauliflower tou-reen dishes, fruit and vegetables, animals and birds all done in eighteenth-century Strasbourg faience.
>
> They hadn't spent a huge amount of money in decorating the house. Putzel was awfully clever when it came to interior decoration – she had such wonderful eyes for bits of furniture that would fit in – what they did was to go 'off-piste', buying large pictures that were unfashionable. A painting by Wootton (1682-1764) of a horse in the hall – it was life size, provenance uncertain – would have been cheap in the sale because of all those attendant problems. They bought a lot of material after the war, knowing that it was very good. It wasn't necessarily a very fashionable collection in the fifties, but gradually became more fashionable in the sixties and seventies.[655]

Ricketts also noted that the floor covering on the floors in all the upper rooms was felt, rather than Wilton carpet, and that their priorities in those rooms were to buy very decorative pieces which looked wonderful. He recalled Putzel telling him 'always use felt on the floor because it's cheap – don't go buying expensive carpet. Felt, if it's good quality, will last a long time.'[656]

Ricketts highlighted how the art treasures on view provided the back-drop for what was invariably a pleasurable social occasion:

> I shall always remember our visits to Drumleck in the sixties,
> eating a roast lunch cooked by Putzel in the kitchen, with its
> brightly coloured modern Delft tiling surrounding the cooker,
> a door surround made from pieces of an eighteenth-century
> German cupboard, groups of paintings and small fragments
> of gothic stained glass hung from sash windows. We would
> then spend hours going through the collections of medieval
> ivories and enamels kept in a small room concealed behind
> book cases in the library. It was a hugely pleasurable education
> conducted in the nicest possible surroundings with the most
> generous of friends.

For others, the most striking feature of the property was the nine-acre garden set on south-facing terraces sweeping down to the cliffs, Drum-leck's 'almost unbelievably lovely variety in its gardens and grounds from rugged rock and heather to greenest lawns, rose gardens, lily ponds and flower borders, interspersed with flowering shrubs and trees'. [657] Helped by just one full-time gardener, Jack McGuinness, the Hunts set out as a team to restore and remake the gardens with the same enthusiasm and creativity that they had shown years earlier in building the terraced garden at the rear of the house at Lough Gur. While both took a great interest in design and layout, Putzel excelled at the mundane practicalities of planting, feeding, and weeding.[658] They visited several gardens in Britain, and Putzel spoke afterwards of ideas gleaned from Sissinghurst Castle Gardens in Kent which, with its compartmented garden 'rooms', had been created just some

twenty years previously.[659]

The most significant change that the Hunts introduced involved creating an Italian water garden incorporating aquatic features on a series of terraces, with the water directed through various pipes, channels, fountains, formal ponds and water staircases as it cascaded down to the shore. Another feature was the introduction of a range of ornaments and statuary, many from the demolished properties of the Anglo-Irish ascendancy. Hunt had acquired a statue of Neptune which had been brought back to Ballinagarde House, not far from Hunt's former home at Lough Gur, Limerick, by a member of the Croker family on his Grand Tour, and which Hunt asserted was probably from the workshop of the great Italian Sculptor, Bernini. From nearby Santry Court, then recently demolished, Hunt procured a stone fountain and a balustrade that was painstakingly re-assembled to form an edging for the wall of the rose garden. The stone steps which ran down through the various garden 'rooms' alongside the water channels were flanked by Georgian stone columns that had formerly framed the doorways of houses on once-fashionable Dominick Street on Dublin's north side. A bronze statue of King Charles II, dressed as a Roman gladiator, came from Kilkenny and stood on the terrace in front of the house. The Irish garden designer, Jim Reynolds, recalled a visit to the gardens in the early 1970s:

> Exploration revealed a sequence of settings and garden scenes
> with each area – be it glade, wood, terrace or lawn – focused
> on an architectural feature or a garden ornament … The inspi-
> ration for this undertaking was Renaissance Italy. Italy and the
> Mediterranean have provided impulse and genius for other
> Irish gardens, but nowhere else quite captures the spirit and
> feeling of a Tuscan or Roman hillside in the way the Hunts
> have achieved here.[660]

Putzel, in her correspondence over the years, frequently mentioned the gardens in a way that showed how much they meant to her: 'Our garden here is getting so nice now, the rhododendrons are out and the sight is breathtaking. I look and look and can't believe that they all belong to me'.[661]

John and Putzel Hunt with Trudy and John Jr. circa 1965.

The move to Drumleck with its very ample accommodation may also perhaps have been the factor which prompted the Hunts' life-changing decision, in 1957, to adopt an infant boy and, the following year, an infant girl, who were named after their newly adoptive parents as John and Trudy.[662]

Taking on the rearing of two small children at the relatively advanced ages of 57 and 54 had the effect of curtailing travel plans, particularly for Putzel. In addition, Jack's health had become an increasing concern for Putzel, with several hospital visits being mentioned in her correspondence. Nevertheless, the couple became very devoted parents, applying the same energy to child-rearing as to their other endeavours.

Some ten weeks after the adoption, Jack wrote to James Rorimer of the Metropolitan Museum of Art explaining why they couldn't come to meet up with him during his stay in Paris: 'Our position is somewhat difficult; first of all we have adopted a little baby which is now 8 months old. We have had him 2½ months and as we are looking after it ourselves it means that we are rather tied'.[663] It is possible to detect a sense of pride in their new family member, as they signed off the same letter 'Fondest love from us both and greetings from our new son, John'.[664]

This theme is continued in correspondence over the following years: 'the two little children are now 5 and 6 years old and they do need an awful lot of attention and help is so difficult to get'.[665] A letter written to Tom Hoving of the Met after his visit to Drumleck notes: 'you have seen how busy we are with the children here; the children are getting more interesting and the whole day it is why? why? why?'[666] Amid plans to travel to America, Jack wrote to James Rorimer, saying: 'I am so looking forward to seeing you and your beautiful museum. Putzel is heartbroken that she is not coming with me, she has to baby-sit'.[667]

Over the following quarter century the Hunts were to host many visitors, and a visit to Drumleck became an essential part of the Irish itinerary of many of the world's leading art curators and collectors. Members of the American Society of Architectural Historians fitted a visit to Drumleck into a brief trip to Ireland in 1959. Two directors and more than half a dozen

Throughout the 1950s and 1960s the Hunts became involved in a wide variety of social activities related to the Irish arts world. During his first year living in Drumleck, Hunt became actively involved with a special committee of the Friends of the National Collection in Ireland that helped to organise the highly acclaimed *Exhibition of Paintings from Private Collections* (1957). Under the chairmanship of his old friend, Senator Edward McGuire, Hunt and his fellow committee members had spent more than a year touring the country before making the final selections from eighty-one collectors of two hundred of the finest paintings not normally on public view. The works chosen included those by Rembrandt, Rubens, Titian, Tintoretto, Van Dyck, El Greco and Constable, as well as Irish artists, including Barry, Barrett, Hone, Osborne and Orpen.[680]

However, Hunt, as a lover of contemporary art, could see that something needed to be done to complement the work of the Friends of the National Collection in Ireland, which had forsworn the purchase of works by contemporary Irish painters. In 1962 he was amongst a group of what were described as 'nine art conscious people' who decided to form an informal committee that evolved into the Contemporary Irish Art Society.[681] The so-called 'Magnificent Nine' had a rather ecumenical composition, including three prominent members of the Irish Jewish community: Cork solicitor and later mayor, Gerald Goldberg; former master of the Rotunda Maternity hospital, Dr Bethel Solomons; and prominent art collector Serge Philipson. The group, under the chairmanship of Sir Basil Goulding, either subscribed their own funds, or sourced benefactors to purchase artworks by living Irish artists and present them to Dublin's Municipal Gallery of Modern Art.[682] Within three years, this gallery had received from the society works by the leading Irish contemporary artists such as Louis le Brocquy, Camille Souter, Nano Reid, Norah McGuinness and Gerard Dillon.

Having put Drumleck in good order, Jack took on a new but more manageable challenge in early 1964 when he decided to renovate a small cottage, formerly a shepherd's hut or 'bergerie', on the estate of Sotheby's chairman, Peter Wilson, at Clavary, near Grasse in the south of France. Putzel wrote:

'He is so full of planning and building like a child with a new toy! We are going there for our holidays July and August, although it will be not quite ready, we can use it. I had collected furniture etc, for it; now we are told one cannot send anything into France unless one moves there as permanent residence ... instead of the pretty painted furniture I had planned it will be bamboo'.[683] Jack himself also referred to the cottage later that year: 'we were very busy doing it up surrounded by hordes of workmen. Terrible, but the children loved it'.[684]

The Hunts' donations continued when they lived at Drumleck and included many small gifts to individuals as well as bequests to institutions. A former chairman of the National Museum Board, Joan Duff, recalled dinner parties where there would be a small gift, generally something quite ancient, wrapped in the napkin as a present for every guest.[685] American journalist Eleanor Lambert told a similar story and recalled being offered a choice of three items: a fourth-century BC Greek bronze, a third-century BC Roman enamelled brooch, or an eighteenth-century pair of silver shoe buckles.[686] The artist, Graham Sutherland, was the grateful recipient of 'the most marvellous jersey I have ever seen', knitted for him by Putzel. Sutherland, who claimed to 'get all my clothes covered in paint', promised that this 'prized garment' was 'never to be touched by the wretched stuff'.[687]

These personal generosities, however, were relatively small in value compared to the many items that they bequeathed to museums and galleries throughout the 1960s. Dublin's Municipal Gallery was a beneficiary from the Hunts in 1961, when it received a sculpture, *The Street Singer* by Jerome Connor.[688] In 1969 Jack and Putzel presented the National Gallery of Ireland with a portrait of their friend Senator McGuire, in red chalk and charcoal by Seán O'Sullivan RHA. However, the main gift to the National Gallery was contained in Hunt's will when he made a 'wonderful bequest' of all thirty-eight items on loan to the National Gallery at the time of his death in 1976.[689] These were mostly religious objects from the late medieval period (1350-1600), including many ecclesiastical garments and several fine crucifixes.

The generosity of the Hunts as benefactors was an integral part of their role as collectors. While the odd donation of some small artefact may have helped to cultivate relations with museums, such as the British Museum, the V&A, or the Museum of Fine Arts in Boston, who were potential customers for art objects, there is nothing in the pattern of such donations to suggest that this was the driving motive. Various biographers have tried to gain an understanding into the mind-set of benefactors who give away much of their accumulated wealth, despite being highly acquisitive during their earlier life and frequently known for their parsimony, as in the case of Sir William Burrell. Certainly, prior to their coming to Ireland, the Hunts would appear to have modelled themselves on some of the collectors, such as Burrell and Nelson, with whom they had come in regular contact. In this role they would have begun to gather many of the finer pieces, initially acquired for dealing purposes, into their own collections and also absorbed the culture of 'giving' and adopted it as a central tenet of their lifestyle. Many gifts were displays of friendship, whereas others were expressions of gratitude, such as the gift of a crucifix to Eamon de Valera given in thanks for providing them with the sanctuary they found in neutral Ireland from the horrors of war. While not remotely in the same league of wealth as many of the great benefactors such as Carnegie and Mellon, the Hunts arguably gave a higher proportion of their net assets as donations to museums and galleries than most philanthropists.

During the time when Drumleck was the Hunts' main residence, there is little evidence that they either socialised with or dealt to any degree with members of the antique dealing trade in Dublin. Few works of art sold in antique shops in Dublin, or indeed anywhere else in Ireland, dated from earlier than the Georgian period and what was on offer was therefore of limited interest to the Hunts. There is also some evidence that they were viewed with suspicion, and perhaps envy, by many of the established antique dealers. Jane Williams, one of the few surviving dealers who knew the Hunts, recalled a 'deal of jealousy among other dealers about the Hunts' and, when setting up her own shop, was counselled by the well-respected antique dealer,

Ronnie McDonnell, that John Hunt was one of 'certain people to be careful of'.[690] Williams confessed that she had mixed feelings about Hunt coming into her shop: 'I worried that he would spot something that I hadn't properly valued'.[691] Perhaps reflecting how little was known about the Hunts among the local antique trade, she understood that 'both had escaped from Germany' before the war.

Hunt was recognised internationally as 'the world's authority on the crucifix figure' and was proud to display his collection.[692] Showing little concern about possible burglary, he allowed television cameras into Drumleck to make a thirty-minute feature film on his art collection, particularly his collection of crucifixes, which appeared on Telefís Éireann on Good Friday 1963.[693] The cover of that week's *RTV Guide* magazine featured a full-page photograph of the Catalan Majestat crucifix in the mirrored entrance hall at Drumleck.

Hunt was known to travel everywhere with one of his crucifixes and he confided an extraordinary story concerning one of these beloved pieces to the archaeologist and author, Peter Harbison.[694] According to Hunt, during a visit to Naples, Italy, he received permission to enter a bank vault where the dried blood of one of the patron saints of the city, St Januarius, was kept in two sealed phials in a silver reliquary. For centuries, Neapolitans had gathered, three times a year, in their thousands at the main cathedral to witness the so-called 'miracle of the blood', when the red powder in the phials liquefied. Entry to the vault was an exceptional privilege, with the keys of the door being kept by a commission of notables, including the mayor of Naples. When the time came for Hunt to be released, the commissioner noticed with some consternation that the miracle had occurred – the powdered blood of the saint had liquefied. Hunt was firmly instructed to remain where he was while senior clergy were hastily summoned from the cathedral. When these experts arrived and inspected the liquid in the phial they could see that the miracle had indeed happened, without precedence, on what was not one of the special feast days. After much difficulty translating the Italian being spoken excitedly by the clerics, it was communicated to Hunt that such an

event could only occur in the presence of the cross borne by Jesus at Calvary. At this point, Hunt put his hand into his trouser pocket and slowly drew out a small wooden crucifix shaped by a medieval craftsman. He explained to his rapt audience that the piece of wood from which the cross had been fashioned had indeed been long believed, by oral tradition, to have been a fragment of the true cross.

As part of his drive to create awareness of the richness of ancient Irish art, as well as emphasising the European links created by the Irish missionaries who brought Christianity in the sixth and seventh centuries to much of central and eastern regions of the continent, Hunt played a central part in bringing about an exhibition of early Irish art staged by the German Art Council in 1959 in West Berlin, Munich, Düsseldorf and Hamburg. Some 150 objects which came exclusively from the National Museum of Ireland and Hunt's private collection were exhibited, mainly Irish metalwork from the Bronze and Iron ages along with some early Christian material.

There is little doubt that, through his links to the O'Malley family in Limerick, Hunt was in a position to influence policy on the arts when Donogh O'Malley was appointed, in 1961, to the role as Parliamentary Secretary to the Minister for Finance with responsibility for Public Works. O'Malley echoed the words of Hunt in declaring that 'we should preserve (our monuments) for their own sake; they are the foundations and cornerstones of our history'.[695] O'Malley's accession to the role of Minister for Education, in July 1966, provided further opportunity for Hunt to influence government policy on the arts and O'Malley formalised the relationship in July 1967 by making Hunt 'an honorary advisor to the Minister in relation to forthcoming exhibition on paintings and antiquities'.[696] Certainly, from this time, O'Malley took a much greater interest in art and heritage matters, suggesting that a study of visual arts should be part of the school curriculum, that an artist should be appointed to the senate, and successfully spurring the directors of the National Gallery to send their paintings 'on tour to towns and cities all over Ireland so that Irish children could see them and learn from them … there is more to our culture and heritage than the language alone'.[697]

After the conclusion of Rosc '67, an international exhibition of modern paintings at the RDS, in conjunction with a display of ancient Irish monuments at the National Museum, Hunt's enterprising mind, combined with his love of ancient Irish art, prompted him to make a proposal to O'Malley to bring the glories of ancient Irish art to a much wider audience. In February 1968 he outlined his ideas for what he described as 'An International Exhibition of Keltic Art' (*sic*).[698] He suggested to O'Malley that such an event 'would rank with any of the great exhibitions which any country has ever held. It's been a dream in my mind for many years but I wouldn't have had the temerity to put it forward if you hadn't been at the receiving end'.[699] The memorandum outlined the many sources that could be available for material from museums throughout Europe and suggested a period of three years to prepare for the comprehensive exhibition which he believed 'would be a sensation'.[700] Sadly, Hunt's vision was never realised. Just three days after signing a reply to Hunt stating that he would be in contact when he had considered the proposal in detail, O'Malley died from a heart attack while canvassing at a parliamentary by-election in County Clare.

CHAPTER 9

American Museums

Some three hundred new art museums had been established in the
United States between the two World Wars … For the first time
art museums outnumbered museums of science and natural history.
Calvin Tomkins [701]

From the pre-war years as a dealer in Bury Street, Hunt had displayed considerable interest in establishing contacts with the many curators of American art museums, who had displayed interest in acquiring medieval artworks from Europe. However, it was not until the 1950s, when he increasingly focused his attention across the Atlantic, that his relationships with such curators led to their institutions becoming some of his more significant customers.

Exchanges of correspondence with many of these curators contain frequent references to the Hunts' desire to visit America. In 1955 they wrote to the Director of New York's Metropolitan Museum of Art (the Met): 'we both feel strongly that we must come over to America soon … it would be one of our dreams realised to see The Cloisters'.[702] When Jack finally paid the first visit in November 1963, he again wrote to the same director, saying he was: 'so looking forward to seeing you and your wonderful museum'.[703] Other visits to America followed in the next few years, including two lengthy consultancy assignments that involved Jack and Putzel in the appraisal of the Gothic art collections of two of America's most prominent businessmen.

Several American art museums, including the Virginia Museum of Fine

Arts, Richmond, Virginia; the Walters Art Museum in Baltimore, Maryland; the Snite Museum at Notre Dame University; and the Loyola University Museum of Art, Chicago, have pieces sourced from the Hunts, but perhaps the two most significant accumulations of these objects are to be found in the Met and the Museum of Fine Arts (MFA) in Boston.

The relationships which both Jack and Putzel established over almost half a century with the directors and leading curators of the Met provide an insight into their standing in world terms as art historians and their ability to develop lasting friendships with the select few who understood and shared their very special interests.

By the time Hunt started dealing in artworks in the 1930s, the Met (established since 1870) had become 'the largest and richest art museum in the western hemisphere', second only in attendance to the Louvre in Paris.[704] Its success, relative to the many other American art museums, had been achieved largely by attracting the financial patronage of several wealthy businessmen.[705] Like other American museums, most of the objects in its galleries had been acquired on buying trips to Europe, either by its own staff and agents, or by American collectors who subsequently donated their collections to the museum. In parallel with the growth of its collections, the Met had also raised the bar regarding art scholarship, and its eleven departments had the largest curatorial staff in the US, containing some sixty persons, including several world experts in their field.

The Department of Medieval Art, constituted in 1933, became relatively pre-eminent in the museum's activities. George Blumenthal, President of the Trustees (1933-1941), and a sequence of three directors from 1940 to 1967, were all medievalists, as was one of the museum's greatest benefactors at that time, John D Rockefeller Jr. With Rockefeller's financial support and the leadership of a young curator, James Rorimer, the Met had built a separate medieval museum on its own site, near the northernmost point of Manhattan island, known as The Cloisters, which opened to great acclaim in 1938 as an integral part of the Medieval Art Department.

While still employed in Acton Surgey, Hunt had met Rorimer, then an

associate curator in his twenties in the Decorative Arts Department, on a purchasing trip to Europe.[706] Shortly after starting his own business in 1933, Hunt offered Rorimer a set of alabasters forming an altarpiece from a church, which was declined.[707] Later the same year, Hunt made a much more extensive offer to the Met to which Rorimer, now Curator of the new Medieval Department, replied.[708] Once again, 'due to the lack of funds at present', nothing happened.[709]

Throughout the pre-war era, various other offers were made by Hunt, and turned down by the Met, including that of two wooden statues of the Virgin and John the Evangelist by Ligier Richier in 1937.[710] However, items bought from Hunt between 1936 and 1938 by the private collector, Robert Lehman, were eventually to find their way, decades later, to the Museum's West Wing. Prominent among these is a set of nine drawings now included among the 140 European drawings from the fifteenth to eighteenth centuries which constitute an important part of the overall Robert Lehman Collection at the Met.[711]

If the Hunts had travelled onwards to America as planned in 1940, the Met would have been a prime target for the sale of some of their works of art and Jack, for a time, would have been able to renew personal contact with Rorimer. In 1943 however, the latter enrolled in the American army and was assigned to the Monuments, Fine Arts and Archives (MFAA) unit, established to assist in the protection and restitution of cultural property in war areas, during and following World War II.[712] He moved to England prior to D-Day, and took charge of the Louvre after the fall of Paris. Here he acquired detailed records of the Nazi operation, the Einsatzstab Reichsleiter Rosenberg (ERR), set up in France to seize art from private owners, particularly Jews and, armed with this information, succeeded in rescuing the major part of the art looted by the ERR from France and hidden at Neuschwanstein Castle in Bavaria. Rorimer, who was Jewish, spent a further year setting up collection points for stolen art and restoring looted objects to their owners or, where the owners had perished in the Holocaust, trying to establish the legitimate heirs.

During the post-war years contact with Rorimer was resumed and Putzel finally met up with him in London in October 1948. This meeting led to the Hunts' first sale to the Met, a fifteenth-century spoon of painted enamel and silver from Burgundy, for £200.[713] Rorimer also expressed considerable interest in a fourteenth-century tapestry fragment, which was purchased from the Hunts a few months later by John D Rockefeller on behalf of the museum.[714] In October 1951, the Hunts met Rorimer again after he wrote to them, as he was planning to embark on an extended trip throughout Europe, saying, perhaps tongue in cheek: 'you would not come to America so I have to come to Ireland'.[715] The meeting was a great success both from a business and social point of view. The Hunts sold Rorimer, for $500, a German copper alloy pot and ten glazed jugs, mostly fifteenth-century and of English origin, the latter having come from the John Ball collection. More importantly, Jack and Putzel acted as hosts to Rorimer in Lough Gur and their other properties in Dublin and London, and were to seal a lifetime bond of respect and friendship with the curator. On Rorimer's return to New York, he sent the Hunts a most fulsome note of thanks: 'Needless to say the nicest part of my trip to thirteen countries was my stay with you at Lough Gur, Dublin and London. I don't know that I am supposed to use Museum stationery to tell you that I liked you both very much and that the Museum appreciated your many kindnesses – but those are the facts … There are mountains of correspondence on my desk and I am busy with the building program but this letter must be one of the first'.[716]

From these exchanges in early 1952, further correspondence followed. Rorimer had spotted a set of objects owned by the Hunts that he would have liked to buy, but he was encountering an attitude from the Hunts that was more appropriate to a collector than a dealer. These objects were the Three Kings, life-size representations of the Magi, in wood, dating from the fourteenth century and formerly on a church altar at Lichtental, near Baden-Baden in Germany. Hunt had purchased these in Sotheby's in July 1939 for £16 and, apart from cherishing them as objects in his collection, had considered returning them to the church at Lichtental for which they had

originally been made.[717] Rorimer asked the Hunts to quote a price and 'be good and kind and remember that I love you, our public and your statues dearly'.[718] The Hunts replied: 'We can't help feeling that we would like to keep the question of the Kings ect (*sic*) over until we meet. Their original home has sent us the most embarrassing reminder in the shape of Christmas greetings, handpainted'.[719]

A month later the Hunts had re-considered their position, and wrote to Rorimer saying: 'We have decided in view of what you said to part with the Three Kings! We would not want to sell them in general principle, but your description of the most marvellous crib anybody has ever seen, in the rocks behind The Cloisters has fired our imagination and overcome our scruples as to their return to the church they came from. If you are interested, would it be possible to make casts of them for the Church. They would be so grateful and it would be rather a wonderful gesture on your part.'[720] The museum agreed to the Hunts' asking price of $8,500 for the Three Kings and they were shipped to New York the following month.

❖ ❖ ❖ ❖ ❖ ❖ ❖ ❖ ❖ ❖ ❖ ❖ ❖ ❖ ❖ ❖ ❖ ❖ ❖

The Three Kings.

In New York, the Magi were to enjoy their biggest outing in nearly 2,000 years! For Christmas 1952 they were included in the crib, as Rorimer had described, and received widespread publicity. Rorimer sent the Hunts a double-page spread from the *New York Times* and a full-page colour spread from *Time* magazine telling the story of the wooden statues of the Three Kings. He reported that they were the feature pieces of the crib: 'In six-foot high letters on one of the signs on Times Square friends have read "go to The Cloisters to see the Three Kings – Balthasar, Caspar and Melchior"'.[721]

Following the sale of the Three Kings, the Hunts' position as one of Rorimer's most trusted sources of medieval objects was consolidated. At a time when a Director of the Met was quoted as saying that 'The Met owns so much art that nowadays … we are reaching only for the superlative', only those dealers who could source objects of the highest standard were likely to succeed in adding to the museum's collections.[722]

After Rorimer's appointment as Director of the Met in August 1955, the Hunts continued to correspond in most friendly tones, and Rorimer directed them towards other members of the curatorial staff with whom they developed relationships, both on a personal and professional basis. Dick Randall, Assistant Curator in the Medieval Department, an ivories expert, was to become a lifelong friend. Arising from his enquiry about a collection of medieval brooches, which Randall had noticed during a visit to Drumleck, the Met agreed in 1957 to purchase the collection for the Hunts' asking price of

The Figdor Brooch.

£400. The most significant item in the collection was a brooch from the collection of the Viennese collector Albert Figdor, in the form of a flower and set with five pearls, an emerald and a sapphire, and with the letters AMOR ('love') hanging from the circumference.[723]

Drumleck was to become a place of pilgrimage for a succession of Met staff during their trips to Europe, including Research Curator, Vera K Ostoia, and Cloisters Director Margaret B Freeman. In the summer of 1963, a young protégé of Rorimer, Tom Hoving, visited Drumleck and struck up a particularly warm bond of friendship with his hosts. Some three months later, Hoving met Hunt in New York, having assisted with the planning of the trip by offering to help 'start all the machinery to aid you in any way I can – things to see and people to meet etc.'[724]

Within four years Hoving was to become the youngest ever Director of the Met and arguably had a higher public profile than any of his predecessors. Hunt was to make a significant contribution to *The Year 1200*, the major medieval exhibition held during Hoving's tenure as director, and described as 'the most complex medieval art show in history'.[725] Seven pieces belonging to Hunt were selected and shipped from Ireland for the three month show in 1970, the centennial of the Museum's foundation. These consisted of two ivories, two bronze crucifixes, including the Red Abbey crucifix from Longford, and three pieces of stained glass originally from the windows of Canterbury Cathedral.[726] An internal memorandum to Hoving from the Curator of the Department of Medieval Art, William Forsyth, shows that Hunt was most supportive of the planned exhibition: 'I had a very successful time with John Hunt in Ireland. He will lend us <u>anything</u> we want (<u>except</u> glass).'[727] Hunt also advised the Met on how they might approach the Irish authorities to obtain other antiquities on loan for a proposed Irish Masterpieces exhibition. Regarding the possible sourcing of the Book of Kells the note recorded: 'Hunt advised no approach by me and I made none … If the highest possible American authority could ask both the Minister of Education (The Honourable Neil Blaney) and the Minister of Finance (The Hon. Charles Haughey, a real power behind the throne) it might work.'[728] Hunt also advised on how to

approach the National Museum: 'I called on Raftery, the curator of medieval art in the National Museum, and he introduced me to the director (a very heavy-set type). <u>They</u> brought up loans and were very negative. I did not ask for anything, following Hunt's advice. They will not lend.'[729]

Jack Schrader, Curator of The Cloisters, first visited the Hunts in June 1973 and exchanged correspondence over the following years. He became a particularly good friend to Putzel after Jack's death, spending the subsequent Christmas of 1976 with the family in Drumleck. Putzel wrote to say how she 'did so appreciate having you here. I don't seem to be able to get over the loneliness of not having anyone to talk over the things we are interested in.'[730]

Charles T Little, then Associate Curator of the Department of Medieval Art and The Cloisters, visited the Hunts when in Dublin making arrangements for the visit of the *Treasures of Early Irish Art Exhibition* to the Met. He remembers, with some amusement, taking extended comfort breaks from the dinner table in order to write down details of some of the many interesting

❀ ❀ ❀ ❀ ❀ ❀ ❀ ❀ ❀ ❀ ❀ ❀ ❀ ❀ ❀ ❀ ❀ ❀ ❀

Reliquary Chasse.

objects on display. His reports back to New York of the treasures he had seen may have prompted a visit to Drumleck by William Wixom, who came in September 1979, shortly after joining the Met as Chairman of the Department of Medieval Art and The Cloisters. Wixom visited again in July 1981, this time to Drumleck Cottage after the main house had been sold by Putzel. He exchanged correspondence with Putzel over the next five years and, during that time, the Met acquired from her four valuable pieces. In 1979 the Met purchased, for what is reliably believed to have been a substantial six figure sum, the Brown Madonna, an object described as 'an exceptionally beautiful and rare early 14th century English ivory sculpture of the Virgin.'[731] The museum's online site subsequently described the sculpture as 'one of the great masterpieces on view at The Cloisters'.[732] In 1980 an English reliquary chasse that had been loaned by the Hunts to *The Year 1200* exhibition at the Met was acquired for The Cloisters, and the following year an ivory crozier stem from Northern Spain became a further addition to the collection there. [733]

A leaded brass casting of a monk scribe on a dragon, believed to be of twelfth-century North German origin, was sold in 1982 to the department of Medieval Art, and was later described at a 1999 exhibition by one critic as 'my favourite work in the show'.[734]

Wixom has gone on record to place the Hunts among those who played a key role in the history of medieval art collecting. In a retirement interview in 1999, he included them in a list of a handful of dealers whom he labelled as 'tastemakers' in the field of medieval art: 'It was their sleuthing and salesmanship

Ivory crozier stem from Northern Spain.

that brought major works to the attention of museums and collectors in this country.'[735] In subsequent correspondence, Wixom recorded how he: 'found Putzel Hunt to be a highly intelligent and animated woman. She obviously had a keen understanding of both people and works of art ... Together the Hunts were undoubtedly a formidable force in the art world at their time.'[736]

Among American museums, Boston's Museum of Fine Arts (MFA) has been most associated in the public mind with Hunt, particularly due to his friendship with curators Georg Swarzenski and his son, Hanns.[737] In his pre-war years in London, the MFA might not have been seen by Hunt as a potential customer, since its medieval collections were not well established, and the earliest records of objects originally owned by Hunt which are in the MFA collections are two pieces sold by Hunt to New York's Brummer Gallery in 1934 and 1935. These objects were later acquired by the MFA from Brummer, one of them, an early sixteenth-century alabaster head from Spain, in 1942 at a price of $1,300.[738] The American banker and collector, Philip Lehman, later gifted to the MFA a half-dozen other objects which his family had acquired from Hunt around this time. These include a hood and silver bells for a falcon, a piece of English lace embroidery with silver and silk threads and a pair of leather gloves with embroidered cuffs in silk, gold and silver which Hunt acquired at Christie's, acting on behalf of Lehman's wife, Carrie Lauer.

In 1939, the relative indifference of the MFA to medieval art was to change. In that year, museum director, George Harold Edgell, appointed Georg Swarzenski, a former director-general of all Frankfurt museums, as a Research Fellow in Medieval Art, with a brief to develop the medieval collections of the MFA. Swarzenski, who had fled to the US in 1938 because of his Jewish background, was later joined as a research fellow at the MFA in 1948 by his son, Hanns.

However, it was not through the Swarzenskis that Hunt first made contact with the MFA. That introduction was made by Kurt Ticher, a German Jew and a well-known silver collector, who had acquired Irish citizenship in 1936. He wrote to MFA Director, GH Edgell, in 1948 saying: 'Jack Hunt is

the greatest expert on Art we have in Ireland, and nobody could advise you better.'[739] Edgell had sought guidance on a suitable choice of object which the MFA might purchase with $1,000 in funds available from the Eire Society of Boston. In his letter, Ticher stated that he had 'mentioned the matter to my friend Jack Hunt of Lough Gur, Co. Limerick … Jack Hunt has a fine collection of Irish bronze ornaments and weapons, and I believe he would be prepared to dispose of some pieces and you could be sure of getting good value. Perhaps some bronze swords, Axes and Fibulae may appeal to you?'[740] In reply, Edgell asked for photographs of Hunt's bronzes.

Hunt wrote to Edgell and told him that he had 'a small and representative collection of Celtic objects, mainly consisting of Bronze Age antiquities such as axes, spearheads, swords etc. but amongst them there are a few Iron Age objects such as ring brooches, handpins and ringpins.'[741] Edgell replied negatively to Hunt, advising that the MFA was 'purely a museum of Fine Arts and the things you describe are really of archaeological rather than of artistic importance'.[742] When Hunt made a further attempt a year later to suggest that the museum might consider a Celtic ring brooch that could be available in Dublin, Edgell informed him that they had solved their problem: 'We found in a dealer's hands in New York a Celtic gold treasure and were able to buy two penannular armlets and a very lovely torque'.[743]

Both Hunt and Edgell were most likely unaware at that time of a most unusual coincidence; the three objects in question formed part of the collection of ten Celtic gold objects from the Pitt-Rivers Collection which Hunt had attempted to sell on two occasions in 1935 and 1939 to the National Museum of Ireland.

From 1950 onwards, when Hanns Swarzenski periodically lectured in medieval art at the Warburg Institute in London, he and Hunt probably became acquainted. In 1952, even before any commercial transaction with the MFA had taken place, Hunt commenced his established method of developing relationships with museums. In July of that year, he offered the MFA, through Swarzenski, a gift of two small enamel plaques, believed to have been made by the famous medieval goldsmith, Nicholas of Verdun,

'the greatest enamellist and goldsmith of his day and an important figure in the transition from late Romanesque to early Gothic style'.[744] In November 1953, Hunt concluded his first direct sale to the MFA, consisting of two objects, one a fourteenth-century glass container with gilded silver mounts and the other a Gothic-style casket incorporating a wide variety of materials including tortoiseshell, boxwood, copper alloys, glass, gold leaf and silver.

Hunt greatly admired this casket, which had been in his possession for many years, and had earlier written: 'it is the finest workmanship one can possibly imagine … the finest thing of its type I have ever seen'.[745] He planned to publish a paper on the object and wrote to Dr Philip Nelson in 1947 seeking his help in deciphering an inscription on the casket written in a form of letters he believed to be exactly like those on an early fifteenth-century ring which had been discovered in Thame, Oxfordshire and written up in *The Antiquaries Journal*.[746]

Without publishing the casket, or solving the enigma of the inscription, Hunt decided to sell the piece and offered it to the MFA in 1953. Hanns Swarzenski, in describing the object for an MFA committee wrote: 'This precious casket is an outstanding piece of intimate domestic luxury from the Gothic period … the application of tortoise shell is very attractive, apparently an unique feature. No other example seems to have survived, although a work of art with tortoiseshell (*Ecaille*) is mentioned in the inventory of Duc de Berry, 1416 … The superb quality of the object in design and in every detail of the craft is evident; and the price, although rather high, is not unreasonable'.[747] On 12 November 1953 the MFA agreed to purchase the object for £350.

Hunt did not forget about the casket and some twenty years later he wrote to Swarzenski, who was then about to retire, and asked if he could do a paper on the object, saying he had 'discovered something related which makes it very exciting'.[748] The following year, Hunt published 'Silver Gilt Casket and the Thame ring' as his contribution to a *Festschrift* for Swarzenski. In his paper, Hunt made the case that the casket and ring had come from the same late fourteenth-century workshop, located, most likely, in

England rather than France.[749]

Twenty years later, and with the benefit of advanced technology and more exhaustive provenance research, the casket was no longer judged to be the late fourteenth-century object so admired by Hunt and Swarzenski. Professor Nancy Netzer of Boston College, categorised the piece among 'Objects of Doubtful Authenticity' in her publication *Medieval Objects in the Museum of Fine Arts Boston – Metalwork* where she set out a fairly compelling case to suggest that the casket may have come from the late nineteenth-century Paris workshop of Louis Marcy, arguably the most skilled forger of medieval objects in history, whose fakes 'are still deceiving experts after more than a century'.[750] If Netzer's assertions are indeed correct, both Hunt and the MFA are in good company in being taken in by one of Marcy's fakes, since both the British Museum and the V&A purchased a wide range of his medieval 'finds' in the 1890s. The quality of the craftsmanship on the casket is such that the MFA still displays it on its website as 'Imitation of Gothic, Late 19th to early 20th century' with Marcy listed as the possible maker.[751]

Two major deals between Hunt and the MFA occurred in 1954, with both objects being sold for the then very significant sum of $9,835 each. One involved an English silver cup, and the other a large thirteenth-century limestone statue of Saint Malo from Normandy, France, possibly the most important, and certainly the most studied, object that Hunt ever supplied to the MFA. Hanns Swarzenski described it as 'an outstanding piece of monumental sculpture in the round … a work highly representative of the genius of this coun-

Statue of St Malo.

try in its great period of Proto-Humanism and proto-Renaissance ... that will certainly mean a new artistic experience for visitors to our collections.'[752]

The statue had been removed from the chapel of a castle in a small Normandy village of St Hilaire d'Arcouet after the First World War and shipped to Paris. From here it was purchased and brought to London by art dealer Sidney Burney, who shared premises with Hunt at 13 St James's Place in the 1930s and was a witness at his wedding. Hunt acquired the statue sometime before the war, displaying it prominently in the drawing room of his residence at Poyle Manor. Later, despite the statue's considerable weight, it was shipped to Ireland and installed on the staircase in Lough Gur, where it was seen and carefully examined by Hanns Swarzenski. The sale of the house at Lough Gur in 1954 may have been the trigger which prompted the Hunts to eventually part with this much loved but rather monumental sculpture.

The MFA acquired a number of other significant objects with Hunt provenance in the following years. In 1956 a twelfth-century limestone wall panel, which had adorned the drawing room in Park Street, Mayfair, was sold for $6,720 and, in 1957, an English porcelain jar with silver gilt mounts was acquired by the MFA for $10,097, having been put up for auction by Putzel in Sotheby's in May of that year. [753] It can reasonably be surmised that the Hunts made a very substantial mark-up on the sale of the latter, which they had owned 'for years', as the object had been sold in July 1939 at Sotheby's to another dealer for only £140.[754]

In 1958 the MFA acquired a pair of polychromed wood statues, crafted by the Bavarian master of Baroque carving, Ehrgott Bernhard Bendl, in the early eighteenth century, and described by Hanns Swarzenski as a 'most momentous addition' which 'would make our new baroque gallery a true success'.[755] Standing 8ft in height, the statues had been earmarked for the Hunts' dining room in Drumleck, but they agreed to sell to the MFA at a reduced price of £2,700, which they asked Swarzenski to keep confidential from other dealers.

The correspondence with the Hunts in the MFA files gives an interesting insight into their attitude to dealing, providing evidence of their reluctance

to part with items from their collection. Putzel wrote to Hanns Swarzenski twice before the sale of a marble relief from Languedoc in 1956. In the first letter she wrote: 'should your museum be interested we would like you to have it … we have never offered it for sale and have always refused parting with it, especially as it is rather small and manageable'.[756] In the second she added: 'as you know we never wanted to sell it … We really only wanted to part with it because you love things and make others love them … I really had to do some persuading and found it difficult to make John agree … He is a terrible old hoarder as you know and clings to everything. He feels now that he would rather not part with it'.[757]

Hanns Swarzenski regularly emphasised to the director how reluctantly the Hunts agreed to part with any pieces from their precious collection. Referring to a purchase in 1963 he wrote: 'It took much persuasion to get the Hunts to part with the cup'.[758] In 1967 he concluded a request for the purchase of two silver pieces, saying: 'after many years of negotiations, Mr Hunt could be persuaded to part with these two objects and to offer them to the Museum'[759]

Many of the more valuable items eventually sold to the MFA were not formally offered for sale but, on display in the Hunt homes in Lough Gur, Dublin and London, caught the eye of admiring visiting curators. The Saint Malo statue, displayed for years at Poyle Manor and Lough Gur, fell into this category, as did the two polychrome-wood sculptures by Bendl from the dining-room at Drumleck.

Of the twenty-five objects owned at some time by Hunt and purchased by the MFA, in six cases some aspect of the object's provenance has been subject to question, either by in-house or external experts. As well as the casket, one of the two enamel plaques gifted to the MFA by Hunt in 1952 is possibly a more recent creation and is now described as 'in the style of late 12th century, probably modern'.[760] An English silver gilt tankard, purchased for £480 in 1959, was shown, with the benefit of spectrographic analysis, to be of much later date of manufacture and has been de-accessioned, while the provenance of another silver tankard, sold as of early seventeenth-century English origin

at Christie's in 1892, and many years later acquired by Hunt, has remained unresolved for the past thirty years and is now listed as 'possibly German or Low countries, about 1620'.[761] In 1990 it was suggested that the tankard was 'almost certainly not of English manufacture … (and) of a slightly later date'.[762] The College Cup, acquired in 1954 as being of fifteenth-century manufacture, is now considered to be later due to evidence of casting, and has been dated as 'style of late 15th century'.[763] Finally, determining the precise purpose and provenance of a tiny gilded silver barrel, acquired in 1962, seems to have eluded proper understanding by the museum curators who attribute to Hunt, in inverted commas, its purpose as: 'Liturgical use for holy oil at consecration of Bishop'.[764]

After Sotheby's acquisition of the New York auction house, Parke-Bernet, in 1964, Hunt obtained several consultancy contracts in the United States. One of the more interesting of these was for Harry Frank Guggenheim at his home at Falaise, on Long Island, New York, which was planned to become a museum on his death.[765] Hunt's assignment was to produce a short book with photographs to describe the house and its Gothic furniture and works of art as well as the extensive gardens. Along with his renowned experience in Gothic works of art, Hunt may have been attracted to this particular assignment by his keen interest in architecture and gardening, which were highlighted to Guggenheim by Peregrine Pollen of Sotheby's Parke Bernet, who proposed Hunt to undertake the task.

Hunt, accompanied by Putzel, who was making her first visit to the US, spent over a week working in Falaise in late May 1966, when the gardens were at their best for the photographs. The house and its contents had been aptly described as 'an elegant Normandy-style manor … a vivid example of the American desire to transplant medieval and renaissance art and architectural fragments from Europe and incorporate them into elaborate design plans'.[766]

After his visit, Hunt researched the works of art as well as writing the text for the booklet, which also described the architectural style and the wide variety of construction materials, ranging from Dutch tiles to Spanish wood,

used in its construction. In November 1967 he sent a draft to Guggenheim explaining that he 'wanted to consult various experts to verify my attribution of the pictures and the sculpture, the standing Madonna in the hall.'[767] Interestingly, despite the Guggenheim's Jewish faith and involvement, Falaise was without any Jewish works of art, with most objects being Late Gothic, and more than three-quarters of the more important pieces illustrated in Hunt's book had Christian religious themes.

Guggenheim was very impressed with Hunt's work and replied: 'Your manuscript is delightful. I find it skilful, charming and scholarly. It is everything to be desired and hoped for. Please accept my congratulations and thanks ... I am most pleased with your splendid labor and most grateful to you'.[768]

Another advisory contract which Hunt obtained through the good offices of Sotheby's Parke Bernet was to follow some years later and involved a month-long appraisal of works of art and furniture in the Hearst Castle Collection at San Simeon, California, in 1970. [769] The enormous Hearst Castle collection had been assembled by the newspaper magnate, William Randolph Hearst, over a period of fifty years. Some 20,000 items from the collection had been sold by Hearst from 1937 onwards, due to financial difficulties, and the castle had been given to the State of California in 1957. The Hearst Castle Collection however, still remained in the ownership of the Hearst Corporation in 1970 and the appraisal was undertaken for taxation reasons.[770]

A particular aspect of the collection, which coincided with Hunt's own expertise, was its strong religious theme, since the majority of the collection of paintings and sculptures were of Spanish and Italian Renaissance origin. From the same Mediterranean source came the very extensive furniture collection which Hearst had accumulated in the castle itself and its three large guest houses, including some forty-five seventeenth-century tables from Spain. Accompanying Hunt and Putzel, on what was to be their last visit to the US, were three young Sotheby's representatives, including Letitia Roberts from the New York office, who later wrote to Putzel:

After that wonderful month at San Simeon and my subse-
quent visit to Drumleck I always considered you both as my
ageless and rather superhuman mentors from whom I learnt
more about all of the decorative arts in one month than I have
learned in the rest of my eight years at S.P.B. I shall always
think of Mr. Hunt armed with a torch and straight pins,
crouched or supine beneath the Hearst 'treasures' emerging
with that twinkle that you and I knew immediately was not a
sign of approbation.[771]

By the late 1960s Hunt had developed relationships with a number of
newer museum clients in the US including the Virginia Museum of Fine Arts
(VMFA) in Richmond, Virginia, an institution containing one of the finest
collections outside a major city. Between 1968 and 1971 Hunt sold some
sixteen pieces to the VMFA in five separate deals. With one exception, all
were dated between the sixth and fifteenth centuries and most were inspired
by religious themes.

The first deal for eight pieces in 1968 included a gold and jewelled plaque
from the Shrine of the Three Kings (*c.*1181-1220) in Cologne Cathedral.
This shrine is the largest and most splendid reliquary to survive from the
Middle Ages, and various plaques that were stripped from it, particularly
during nineteenth-century restoration work, wound up in prestigious muse-
ums such as the V&A and the Met, the latter pinpointing that their exhibit
conformed to examples on the shrine in Cologne based on the colour pal-
ette and the location of the mounting holes.[772]

Hunt's second deal with the VMFA, for five pieces in 1969, included an
exceptionally beautiful piece of twelfth-century stained glass from Canter-
bury Cathedral, for which the VMFA paid Hunt the considerable sum of
$130,000 over two years. The window, with two roundels depicting *St Ste-
phen Disputing with Jews* and *The Last Judgment*, had been originally in the
collection of Liverpool art collector Philip Nelson, who had purchased the
stained-glass from the cathedral glazier before the First World War.[773] After
Nelson's death in 1953, Hunt had offered it to the Dean and Chapter of

Canterbury Cathedral, who had received two other Canterbury stained-glass windows as a bequest under Nelson's will. However, a combination of a lack of available funds to meet Hunt's price of £20,000 for the piece, as well as a certain amount of resentment about buying something which they considered had been lost to the cathedral in questionable circumstances, meant that Hunt's offer was not accepted. A subsequent offer to the V&A was declined for the same reason.

Hunt then spent considerable efforts over several years in trying to interest James Rorimer of the Met in acquiring this most exceptional piece. To deal with the provenance question as to how such pieces of twelfth-century stained-glass had been alienated from Canterbury Cathedral, Hunt commissioned a report on the window, on Rorimer's behalf, from Bernard Rackham, the leading expert on Canterbury stained-glass in Britain. Rackham reported that the glass was 'an example of early English glass-painting of the highest order', and raised no issues about its provenance.[774] Some months later, Rorimer, conscious of British sensitivities to the purchasing power of wealthy American museums, hesitated to buy the piece. In February 1963, the Met finally wrote to Hunt advising him: 'we have decided at long last that we cannot consider the purchase of the Canterbury glass at this time'.[775]

As with his much-loved and studied silver-gilt casket, Hunt was caught out by Louis Marcy in regard to a very beautiful silver cradle, which he believed to be of Flemish origin and sold to the VMFA in 1971. The museum, while retaining the piece in its collection because of the skill of its maker, now considers it to be another one of Marcy's nineteenth-century forgeries of medieval objects.

Hunt also developed a rela-

Marten's Head.

tionship with the Walters Art Museum (WAM) in Baltimore, Maryland. Of the ten objects with Hunt provenance now in its collection, three are quite exceptional pieces. The first of these, sold to the WAM by Hunt in 1946 as part of one of his first recorded transactions with an American museum, is a cameo crafted from the hard gemstone, sardonyx, in honour of the Holy Roman Emperor, Frederick II, in the first half of the thirteenth century.[776] Frederick, one of the most powerful emperors of the medieval period, had led the Sixth Crusade and the engraved gemstone depicts him crowned with laurels, in the mode of an ancient Roman emperor.

Hunt's next deal with the WAM did not occur until 1967 and involved an exchange with his old friend, Dick Randall, who had become WAM Director in 1965. The piece in question is a jewelled marten's head (c.1550) of English origin, made from gold with enamel, rubies, garnets and pearls and meant to be worn as an attachment to a lady's fur. Shortly after it had been sourced by Putzel in 1957, Jack had given Randall, then Associate Curator of Medieval Art at the Met, a detailed description of the jewelled head, telling of feeling so excited about 'getting some marvellous addition to our collection'.[777] This piece has been exhibited widely by the WAM, featuring in a *Highlights from the Collection* exhibition (1998-2001) and being loaned to the V&A for a Renaissance exhibition in London (2006-2007).

The third of the exceptional pieces is a ceremonial cup made of gold, agate, silver-gilt, enamel and precious stones that was originally commissioned for the King of Poland and Elector of Saxony, Augustus the Strong (1670-1733). The piece was on display for more than two hundred years before being acquired in 1924 by wealthy German banker, Fritz Mannheimer. As with several other objects from Mannheimer's Dutch Collection, this piece was returned to the Netherlands from Germany after the war. It was sold at auction in Amsterdam in 1952 to the prominent New York art collector, Alastair Martin, from whom it was subsequently acquired by Hunt.

Other WAM acquisitions from Hunt included three English medieval pieces consisting of two rings, one in gold, the other in silver, along with a fourteenth-century ring-brooch purchased together in 1969, as was a small

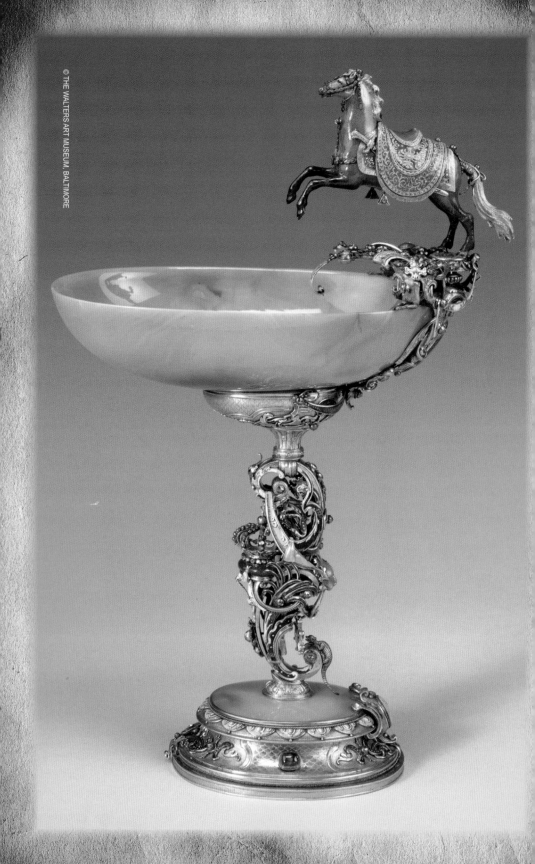

Opposite: Ceremonial Cup

bronze toy of a mounted knight from the thirteenth or fourteenth century which the museum asserts is 'one of the earliest known toy soldiers'.[778]

During the spring of 1952, ironically at the very time that Jack was deeply involved in the *Art Treasures in Thomond* exhibition, one of the most precious pieces of Irish cultural heritage associated with the Thomond region was being spirited out of the country and shipped across the Atlantic to the United States.[779]

The Emly Shrine, a hand-sized Early Christian house-shaped reliquary dating from the late seventh or early eighth century, has been described as 'one of Ireland's most priceless early Christian Archaeological treasures'.[780]

Arguably, the shrine ranks somewhat behind the Book of Kells, the Ardagh Chalice and the Tara Brooch, but would be included amongst the dozen or so most important objects of Ireland's Early Christian heritage that have survived down to the present time. However, in one very important aspect, it differs from these other treasures – its export from Ireland in 1952 to the Museum of Fine Arts (MFA) in Boston made it the most significant cultural item ever removed illegally from the country.

The question as to whether Jack had any connection with the removal of the object was to gain some traction after his death in January 1976 and to hang as a question-mark over his reputation in some quarters. Dr Pat Wallace, Director of the National Museum, stated in 2006 that the notion that John Hunt had been involved in the export of the Emly Shrine 'was part of the *folklore* within the National Museum for as long as I can remember', although adding that he had no knowledge of any basis for such a claim.[781] Dr Peter Harbison, a friend and associate of Hunt's, also confirmed that some people believed Hunt had an involvement in the export of the shrine.[782] In 2003,

these rumours surfaced in an article that referred to the Hunts' 'involvement in the illegal export of the famous Emly Shrine from Ireland to the Boston Museum of Fine Arts'.[783]

There were, indeed, circumstantial reasons why Hunt could have come into the frame as a potential suspect in the export of this object. He had a working relationship as an art dealer with the Museum of Fine Arts (MFA) in Boston, particularly through his friendship with the museum's medieval art experts, Hanns Swarzenski and his father, Georg.[784] He had sold seventeen items to the MFA between 1953 and 1967 and donated a further three pieces, including a Limoges pendant to mark the retirement of Georg Swarzenski in 1957. In addition, the last known owner of the shrine lived not far from Hunt in Limerick. Commander Edmond Monsell RN, married to a

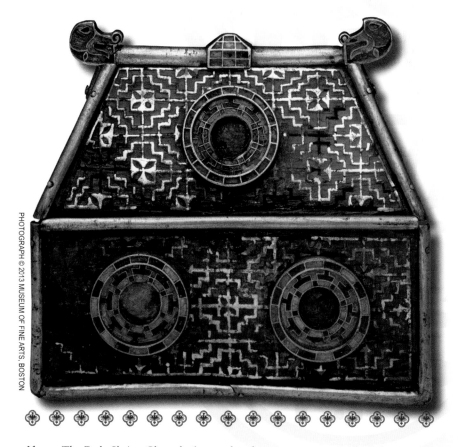

Above: The Emly Shrine. Champlevé enamel on bronze over yew wood, gilt bronze moldings, inlay of lead-tin alloy.

daughter of the second Lord Emly, lived in 1952 in retirement at Rosbrien, just outside Limerick City and was well known to Hunt.

In the museum and archaeological circles in which the Hunts moved, exporting an archaeological object without ministerial licence would have been seen as cultural treason that deservedly left the perpetrator exposed to a fine and up to six months' imprisonment for a serious breach of the National Monuments Acts. There is no evidence that such a charge was ever made against Hunt in his lifetime, as evidenced by his appointment in 1955 by the Minister of Finance to serve another term on the National Monuments Advisory Council (NMAC) or his appointment and successive re-appointments by the Government, from September 1962 onwards, as a member of the Arts Council.

Documentary confirmation of the existence of these accusations, as well as their refutation, can be found in Hunt family papers, including two hand-written memorandum notes on the matter made by Putzel in 1978. In one she recorded being informed by some unnamed party that National Museum Director Dr Joseph Raftery was telling people that her beloved Jack had 'smuggled the Emly Shrine out'.[785] In a second note she wrote that a woman by the name of Joan Duff had told her that the Monsell family had confirmed that the Emly Shrine had been offered to the National Museum, but had been refused.

More importantly, the papers contain a letter from Putzel to Hanns Swarzenski of the MFA seeking his assistance in refuting the allegations, telling him that her late husband was rumoured to be 'responsible for helping to smuggle the Emly Shrine out of the country'.[786] She claimed that, as a result of these allegations, the Royal Society of Antiquaries of Ireland had refused to give Jack an obituary in their annual publication and President Hillery had refused an invitation to open the Hunt Museum at the National Institute for Higher Education in Limerick, some three months earlier.[787] She asked Swarzenski to 'write me to the effect that the shrine was purchased by your Museum and that you know that Jack had nothing to do with its purchase or export and that you are ready to sign such a statement in an affidavit'.[788]

Swarzenski replied immediately saying that the charge 'is just an outra-
geously wrong accusation' and referred to the rumours as 'this infamous and
perfidious calumnia', adding in relation to the proposed obituary that he was
'sad about the ignoble attitude of the Society of Antiquaries ... to refuse Jack
this more than well-deserved honour ... Jack whom I always saw and still see
as an ardent and passionate lover of and fighter for Irish Art (not a chauvin-
ist) – upsets me very much'.[789] He also said that, despite his friendship with
Hunt, he had not told him about his negotiations to acquire the shrine. This
was for the sound commercial reason that he feared Jack would try to block
the deal and possibly try to buy it for himself:

> I hesitated to tell Jack about the offer realising his devotion
> to Irish Art. I recall that Jack whenever I admired an object
> in his collection and asked him if it could be purchased by
> the Boston Museum always refused with the words 'it has to
> remain in Ireland'. However despite his conviction I always
> hoped that he would not resent and approve to see a monu-
> ment of Irish Art represented in another country – especially
> in Boston.[790]

He agreed to Putzel's request for a statement saying: 'I know that Jack
had nothing to do with the purchase of the Emly Shrine and I'll gladly say
so if I'm asked and if I can help you and Jack's reputation.'[791] However, the
following day Swarzenski wrote again to Putzel begging her to keep the
previous day's letter private: 'after long deliberations and soul-searching I
must beg you to keep my letter of August 4th for yourself,' explaining that 'it
was dictated by my deeply felt indignation over the injustice done to Jack in
certain quarters ... it never helps to show letters which are written in emo-
tion'. However, he did agree to provide a statement which 'should be short
and to the point, simply saying that Jack had nothing to do with the purchase
or export of the Emly Shrine.'[792]

For whatever reason, Putzel did not appear to follow up on Swarzenski's
offer to write a simple letter saying that her husband had no involvement
in the export of the Emly Shrine. Clearly, she felt she could not realistically

use the original letter because of Swarzenski's appeal for confidentiality and, being in her seventy-sixth year, she decided to let the matter rest.

Searches of the Emly Shrine files in the National Museum of Ireland and the MFA throw further light on the matter. While the then Keeper of Irish Antiquities at the National Museum, Dr Michael Ryan, had consulted records in the MFA in 1978, he may not have seen the full files. By 2006, as part of a move towards transparency regarding museum objects, new information about the shrine appeared on the MFA website which included the price of $22,874 paid in 1952 to acquire the object and a formal confirmation that the object was 'sold by Lord Emly'. While Hunt's lack of involvement in the affair was confirmed, the files raised new questions on the matter.

The investigation of the National Museum archives on the Emly Shrine was fortunately timed because, had it taken place some weeks earlier, not much might have been found. The pre-1990 National Museum files concerning the Emly Shrine were returned to the Museum in late 2005 by the family of the museum's former director, Joseph Raftery (d.1993). These files may well have been in Dr Raftery's possession since before his retirement in 1979, more than a quarter of a century earlier. They were almost certainly not there in 1990 when Dr Michael Ryan noted: 'I can find no record of this transaction on either the Irish Antiquities Division file or the Director's file'.[793] The recovered files showed that the shrine had been given on loan to the National Museum in 1935, having been re-discovered by Commander Monsell, who had inherited the estate of the second Lord Emly.[794]

In September 1951, having encountered severe financial difficulties, Monsell offered to sell the shrine to the museum, initially for £1,000, later increased to £2,000. When his offer was refused, he had the shrine removed from the museum. The museum's refusal was based on a report by Raftery, then Keeper of Irish Antiquities, who went to great lengths to dismiss the importance of the shrine and to undermine any notion that the museum might consider paying the sum of £1,000 for it:

> The shrine is small and is by no means in a good state of pres-
> ervation. Unlike so many other Early Christian shrines it is

un-inscribed and it is not well documented. Its precise prov-
enance is unknown, though it probably belongs to the south
of Ireland. Artistically, it is not in the first rank of the so-called
'house or Tomb-shaped Shrines'. Thus, in normal circum-
stances, I would assess its monetary value as being not greater
than that of the Moylough Belt Shrine, for which £105 was
paid a few years ago.[795]

Raftery's views on the shrine stand out in stark contrast to those of other
learned experts recorded in the very same National Museum file. A January
1955 letter from Rupert Bruce-Mitford of the British Museum expressed
dismay that such a 'piece of crucial art-historical importance' as the Emly
Shrine 'had gone to Boston' and stated that he would 'have paid any price
had (they) known it was on the market'.[796] The following year, Etienne
Rynne, later Professor of Archaeology at University College Galway, asserted
that: 'this most precious and antique reliquary is one of the best examples of
its type ... few Irish ones can match its beauty or state of preservation'.[797]
Georg Swarzenski had written in a similar vein: 'the museum's collections
were enriched some years ago by the acquisition of an extraordinary object
... the entire front ... is almost complete and in fine condition'.[798]

Most pertinently, Raftery's views appeared quite inconsistent with the
assessment of reliquary shrines in a publication which Raftery himself had
edited in 1941.[799] This publication described such shrines, including what it
described as 'the now well known Emly Shrine', among a select group of just
five 'Masterpieces' of Keltic art 'at its best' alongside four other well-known
pieces as the Book of Kells, the Book of Durrow, the Tara Brooch and the
Dalriada Brooch.[800]

In February 1952 an application for a licence to export the shrine to New
York was made by a solicitor, Thomas Jackson, of the firm Orpen Sweeny on
behalf of an un-named client, whom Jackson claimed had bought the shrine
from Monsell. When the licence application was turned down, Jackson made
an offer to sell the piece to the National Museum for £7,000 but the offer
was refused. Within hours of learning of the refusal, Jackson contacted Hector

O'Connor, one of his clients who enjoyed a very high profile in the Dublin art world. O'Connor wrote immediately to Hanns Swarzenski of the MFA telling him that Jackson now felt free to sell the shrine. Within three weeks a deal was hammered out in Jackson's office, a sum of £8,133 was paid over to Orpen Sweeny by the MFA and the shrine was on its way to Boston.

The official minute of the formal acquisition confirmed that Jackson had represented to the MFA that he was selling the shrine on behalf of the Monsell family, although the minute referred somewhat inaccurately to 'Lord Emly', noting: 'It was voted to negotiate the purchase of the Emly Shrine, Irish, 8th c., from the heir and owner, Lord Emly of Tervos (sic), County Limerick'.[801]

Subsequent responses from the MFA confirmed that there was no reference to Hunt on their files on the shrine: 'According to our records, the acting solicitor for the sale was Thomas Jackson of the firm Jackson, Orpen and Sweeney in Dublin. We don't have any correspondence to or from Mr. Jackson in our files. He received the money for the Monsell family; through him the shrine was purchased from Lord Emly'.[802] And: 'I can also say that absolutely nowhere in our paperwork does John Hunt's name appear connected to the acquisition of this object. Perhaps his name has come up because he was Irish and he did other business with Swarzenski? I don't know'.[803]

In October 1952 the MFA announced their acquisition of the shrine.[804] Two years later they published a detailed scholarly paper on the shrine in their bulletin, which referred to: 'a significant new addition to our collection.'[805] The National Museum remained silent, despite the apparent breach of the National Monuments Act of 1930. No attempt was made to ask the MFA how they had illegally acquired such a piece of crucial Irish cultural heritage or to request its return. There was little mention of the issue in the Irish press, apart from a statement from Hunt's old friend from the excavations at Lough Gur, Professor Seán Ó Ríordáin, who expressed his 'sense of shock … that the Emly Shrine, an important Early Christian reliquary had left the country'.[806] Later that year, Roger McHugh, another UCD academic, brought the matter to the attention of the general public for the first time,

noting that: 'the Emly Shrine, an important Early Christian reliquary was silently exported from Ireland and our public was first informed of the fact by an article in an American journal'.[807]

Indeed, the shrine might have lain forgotten in a foreign museum but for the series of six parliamentary questions put down in May 1956 by Fianna Fáil TD, Donogh O'Malley, to the Fine Gael Minister of Education, General Richard Mulcahy, demanding to know the fate of one of the country's 'national treasures'.[808] O'Malley's questions created a major problem for officialdom, particularly his query as to whether an export licence application had been made. If Mulcahy had confirmed that fact in the Dáil, the Emly Shrine reliquary casket might have become a Pandora's Box for officials of the National Museum and the Department of Education.

The ministerial briefing presented to Mulcahy by his officials left the minister with several false impressions: firstly, that no export licence had been applied for; secondly, that the Department had no idea who had the shrine in their possession prior to its export; and thirdly, that the export had taken place during Mulcahy's watch as Minister, rather than that of his Fianna Fáil predecessor, Sean Moylan.[809] Mulcahy went on to make headlines by telling the Dáil that the shrine had been exported illegally as 'no licence had been applied for' and later added that he had no leads as to who might have been involved in the illegal activity. In November of that year, when O'Malley returned to the fray on this issue, the Minister again stone-walled on the matter, with no attempt to correct the errors in his statement to the Dáil of the previous May.

For more than twenty years the Emly Shrine disappeared from public consciousness in Ireland, with no mention of the object either in newspapers or in learned journals. Interest was rekindled at the time of the *Treasures of Early Irish Art 1500 B.C. to 1500 A.D.* travelling exhibition to five major US cities from October 1977 to May 1979, with the Emly Shrine featuring prominently in *The Irish Times* coverage from New York on the exhibition. Its report stated:

> Ireland is bedazzling the art world here with its treasures
> which went on display at the Metropolitan Museum of Art …

the line for the exhibition starts in the morning and goes on all day winding its way from the Tara Brooch, via the Ardagh Chalice to the Book of Kells, the Emly Shrine and the 66 other gold, bronze and manuscript exhibits. The first three are world famous. The last is largely unknown. It did not come from Dublin, but the Boston Museum of Fine Arts, which acquired it at the turn of the century from Lord Emly in Limerick when laws on the export of national treasures were non-existent or ignored. [810]

When the Education Minister, John Wilson, attended the exhibition in New York and asked regarding the Emly Shrine: 'How did the Boston Museum of Fine Arts acquire it?' the reported reply was: 'With money'.[811] Presumably there were National Museum officials present who could have given the Minister and the journalist a more accurate briefing, to the effect that the illegal export dated from the 1950s, but who chose instead to let the opportunity pass.

CHAPTER 10

The Preparation of a Legacy

A Nation's past is part of its soul. Its history is the basis of its present culture, the root which nourishes not only the spiritual life of the people, but is inextricably interwoven with all its cultural and artistic and economic well-being.

John Hunt [812]

Hunt, in his mid-sixties, entering what turned out to be the last decade of his life, became increasingly driven to create 'a comprehensive museum illustrative of Irish life and art and of its integration and affinities with the general European stream of life and culture'.[813] The visitor centre he envisaged would include an open-air museum to teach Irish people about the lives of their ancestors, from the early Iron Age right through to the late-medieval period, by recreating the buildings and implements they encountered in their everyday lives. As a central part of his overall concept, he also wished to construct a modern museum building to display the collection of Irish and European works of art he had been accumulating since the 1930s. These artefacts, he believed, would provide evidence of the exchange of ideas and cultural influences between the inhabitants of Ireland and those in Britain and mainland Europe from the earliest times.

In seeking an appropriate location to develop his concept, Hunt chose

the Thomond region of north Munster, where he had lived during his first fourteen years in Ireland. In 1965 he had discovered Craggaunowen Castle, roofless and abandoned in a dense and almost impenetrable forest in the parish of Quin in County Clare, and agreed in principle with the Forestry Service and the Department of Lands to purchase it. The castle (c.1550) had been built on a rocky outcrop overlooking a small lake, by a member of the local ruling family, Sioda McNamara. It was 'a typical example of a fortified Towerhouse, which was the ordinary residence of the gentry at that time'.[814] Much smaller than Bunratty and about 100 years younger, it had remained largely unoccupied since the demise of the McNamaras as the principal local Gaelic chieftains in the middle of the seventeenth century.

Given the tourism potential of such a site, Hunt wanted to have the Shannon Free Airport Development Company (SFADCO), on whose behalf he was still acting as Curator of Bunratty Castle, as a partner and a source of funds for the venture. Setting out his plan for Craggaunowen to fellow visionary Brendan O'Regan, he described his concept as displaying 'the five ages of Man in Ireland'.[815] Hunt's dream involved the re-creation of two quite distinct dwelling types first developed in the late Iron Age, but mainly constructed in Ireland in the early medieval period from around 600 AD onwards. The first of these was a crannog, a type of lake dwelling on an artificial island widely seen in Ireland between the fifth and twelfth centuries, on which people built houses where they could live with their livestock in safety.[816] The other was a ringfort, a fortified farmstead of which tens of thousands were recorded in Ireland. Other ideas included the erection of an Early Christian church and the restoration of the late-medieval castle on the site.

A key element in Hunt's vision was a museum building to display the 2,000 archaeological objects and works of art that he and Putzel had collected in their lifetime.

Hunt perceived the ringfort and crannog, which would re-create living quarters from a much earlier historical period, as complementary to what had already been established in Bunratty, where the restored and furnished

castle provided an insight into life in late-medieval Ireland, and the folk park re-created the buildings and artefacts of the late nineteenth century.

Not many people, apart from O'Regan, would have been prepared to entertain Hunt's ideas. The location was off the beaten track, the castle was one of hundreds of tower houses that dotted the countryside and of limited historical importance and, more importantly, practically inaccessible. Nevertheless, O'Regan immediately set about investigating the feasibility of the plan. He assigned Cian O'Carroll, SFADCO's estates manager, as project leader, assisted by Jim Burke from the maintenance section and with architectural services provided by Thomas Sheehan from Limerick.

The first challenge was to inspect the castle, which was no easy task, since the Forestry Service, for insurance reasons, had decided to make the access as impassable as possible. The original entrance road had become flooded and it was necessary to plot a new and safe access route for the committee. O'Regan called in Hughes Helicopters, who were operating out of Shannon at that time and, on the appointed day, the inspection team embarked. The helicopter hovered at what was the shortest and safest access point and, after they entered the forest, Burke recalls how his 'abiding memory was of O'Regan waving a white handkerchief on a stick at the helicopter' so that the pilot could keep an eye on the intrepid explorers as they slashed their way through the dense undergrowth.'[817]

The next task was to create a new access road to the castle.[818] When this was completed, Tom Sheehan was engaged by O'Regan to survey the castle and this was followed by some basic restoration work on the building, including repairing the stairway and roofing the structure.

The funds to purchase Craggaunowen had come from the sale of property in Baden-Baden, Germany, inherited by Putzel on the death of her mother in 1967.[819] Without any agreement on how Craggaunowen was to be financed overall, Hunt immediately set about building a small extension at ground level to house some of his collection of Irish antiquities. The cost of restoring the castle and adding the extension came to some £40,000, with roughly thirty percent being contributed by SFADCO.[820] During this work

HUNT FAMILY ALBUM

The Hunt family camping in County Clare during work at Craggaunowen

both Hunts spent several months each summer living with their children in a caravan on the site. Cian O'Carroll recalls visiting them there and describes the scene as 'quite hippy, with Putzel making delicious nettle soup'.[821]

Unlike Bunratty, the castle at Craggaunowen was not a National Monument and Hunt was less bothered with bureaucratic impositions as to how he carried out his work.

Hunt set up the Craggaunowen Establishment Council (CEC) under the joint chairmanship of himself and his wife and with Brendan O'Regan as vice-chairman. This body, of nineteen members, was intended to garner wide-spread support for the project, while an executive committee, consisting mostly of the Hunts and various executives in Shannon Development,

was charged with the task of carrying out work to advance the project. By 1972, however, little progress had been made on Hunt's plans for Craggaunowen. Jim Burke recalled, 'over the years the idea of building this crannog was raised many times and at the time I thought it was only a dream of Mr Hunt's and that it would never become a reality'.[822]

In January of that year, Jim Burke and Michael Bamber of SFADCO accompanied Hunt on a week-long trip to Germany to study how German museums displayed artefacts from various archaeological periods. Burke remembers the trip as an opportunity to observe at close range a world authority on art: 'It was amazing to see things through the eye of an expert. We must have visited at least twelve museums; the head men in all the museums we visited showed great reverence towards Hunt, who had obviously a great reputation, and everywhere we went we were treated like royalty.'[823]

Following the trip, Michael Bamber drew up initial plans for the museum and presented them to a meeting of the Executive Committee on 26 April 1972. The cost estimates for this scheme came to £130,000 for the museum and £20,000 for the crannog and ringfort. Jack and Putzel offered to provide £20,000 in cash and Bord Fáilte agreed that they might be able to provide one-third, or £50,000. SFADCO offered to provide architectural and building supervision services, and agreed to consider a formal application for funding. The following month it was decided, in order to maintain momentum on the project, 'to proceed with the construction of the crannog and ringfort and with the castle to establish these as an attraction in their own right'.[824]

However, the lack of a proper financial plan soon threatened to bring the project to a standstill. On 25 August 1972 a budget for operational costs for the museum showed that, due to the relatively remote location of Craggaunowen, the expected visitor numbers would make the operation loss-making and in need of a significant annual subvention. SFADCO were therefore unable to provide the funding required for the museum. News of the funding dilemma leaked into the media with a contemporary press report headlined: 'Castle of riches in balance'. The article went on to note: 'a plan by a

leading Irish art historian to give a priceless private collection of Celtic and medieval antiquities and *objets d'art* to the nation has run into trouble'.[825] It also reported that Hunt warned that 'if the costings are too high he would pull out' and when asked why he had not looked into the costings before starting the scheme, Hunt was reported as saying that 'he had not expected it to be non-viable'.[826]

Notwithstanding financial uncertainties, work continued on the initial designs. Jim Burke recalls how some of the earlier proposals for the crannog proved highly problematical: 'the first design involved erecting the structure on a piled foundation but the cost was something like half a million pounds and Brendan O'Regan felt he had only £12,000 available and anyway nobody knew how deep the mud in the lake was. Another scheme proposed to us was to make a table tennis sandwich with two million ping pong balls held between round plates keeping everything afloat. I said I wouldn't be the one to count them'.[827]

Knowing little about crannog construction, Hunt sought advice from the Bord Fáilte archaeologist, Peter Harbison, as well as Professor Barry Raftery of the Department of Archaeology in UCD, who was appointed as consultant archaeologist to the project. After studying a book published in 1886 by a Sligo antiquarian, it was decided to try a method used in the construction of a crannog at Cloneygonnell in County Cavan where large tree trunks had been laid to extend towards the centre as in the spokes of a wheel.[828] In December 1973, approval was received from Bord Fáilte and SFADCO to finance the crannog and the ringfort, and construction began early in 1974. However no expenditure was approved for the museum to house the collection of artefacts.

The site chosen for the crannog was at the edge of the lake at a place where the ground was mostly liquid mud. The crannog itself was planned to be 300ft in circumference and to be made from larch poles from the local forest with access via a small wooden bridge. When the poles had been laid, they were covered with railway sleepers to create a solid platform which could safely take the weight of a large tractor and trailer as required in the

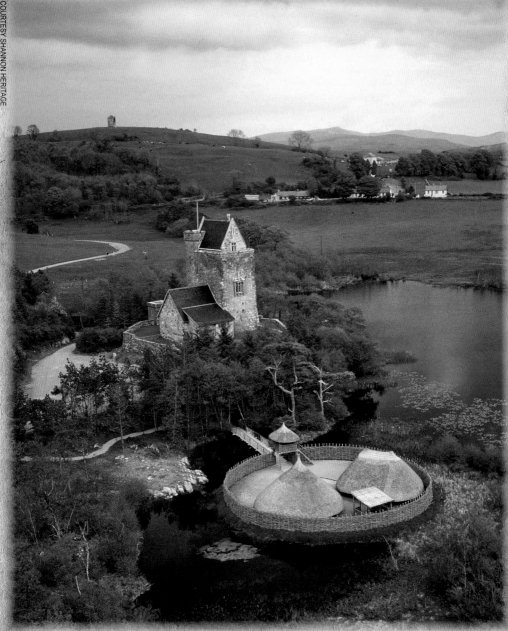

The crannog at Craggaunowen, County Clare.

construction of the dwellings. The circular house on the crannog was made of woven wooden wattles with walls coated with mud and the roof thatched with some 3,600 bales of rushes. Eventually, with some ten tons of mud being used in construction of the walls and 8,000 bales of rushes in the roofs, the dwellings were completed and furnished with tools, weapons and domestic utensils of the Late Bronze Age.

Those in SFADCO who were close to the project recall that the finished dwellings were not without their critics among the archaeological community in Ireland. Cian O'Carroll recalls how, 'there was quite a lot of controversy then about the outdoor exhibits ... some archaeological academics had views that they weren't accurate, the crannog particularly'.[829] Hunt's old friend, Professor Frank Mitchell of Trinity, who approved of archaeology parks such as Craggaunowen on educational grounds, also made reference to 'some archaeologists who seem bitterly against them'.[830] Others, such as Professor Michael O'Kelly from UCC, were appreciative of how the re-creation of a crannog had been carried out and Professors Gearóid Mac Eoin and Etienne Rynne asserted that the use of a gangway and gate tower in the Craggaunowen crannog replica is supported by excavated evidence from Cuilmore Lough (County Mayo) and by literary sources.[831]

Several members of SFADCO have provided recollections of Jack and Putzel. Jim Burke, who was charged with turning Hunt's ideas for Craggaunowen into practice, had an interesting perspective on him: 'I suppose he liked me because I made things; Hunt didn't like people with suits, people behind desks'[832]. Others recall the soft-spoken, academic Jack, a private person yet always polite, and some remember the pleasure of accompanying him on drives in his soft-top dark green Mercedes. Putzel, on the other hand, is remembered as being sharply outspoken and combative, tending to dominate meetings, with a distinct aversion to lawyers and legal agreements and a reluctance to approve expenditure. SFADCO was ultimately dependent on, and responsible to, the Department of Industry and Commerce for its funding, and basic bureaucratic procedures had to be complied with regarding both financial matters and responsibilities for undertaking work on what was

the Hunts' private property. As this was possibly the first time that Putzel was exposed to such constraints, a certain culture clash was inevitable.

The official opening of the crannog took place in June 1975 and the Hunts' desire to use the development at Craggaunowen as an educational tool was exemplified the day following the opening when groups of school-children from Shannon and Limerick were taken on a tour of the crannog.[833] As Cian O'Carroll noted: 'the image of that crannog literally is in every history school-book imaginable … John Hunt was very proud of that himself and if you check it on the internet it appears everywhere'.[834] A year later, work was completed on the ringfort, a reproduction of a type of farmer's house, constructed widely in Ireland from as early as the fourth century AD.[835]

Hunt's health had begun to deteriorate a few months before the opening of the crannog and he was hospitalised later that year. Despite this, he made one last journey to Lough Gur in late 1975 to help Jim Burke, who was then completing the ringfort, to establish the historically correct detail for the entrance to the compound. Burke recalls:

> Putzel was very worried about his health and had clearly lost
> the argument with him (about travelling) and kept telling me
> that I would be responsible if anything happened to him being
> out in the cold weather. We climbed through barbed wire into
> a field and up to the top of a hill where an old ringfort stood.
> There, quite clearly, you could see the two slots in the stone
> wall where a gate could be fitted in and removed to open an
> entrance, so now I knew what to do. Afterwards we drove to
> his old home nearby on the lake and the owners gave us tea.[836]

While things had progressed on the outdoor exhibits, grant approval had not yet been received to display Hunt's personal collection of Irish antiquities in a modern museum building in Craggaunowen, envisaged as 'the most comprehensive outside the National Museum of Ireland and the Ulster Museum'.[837] The sum estimated to construct such a museum had escalated to more than £500,000 by early 1975. In view of a poor response to a call

for funds, Dr Edward Walsh, president of the National Institute for Higher Education in Limerick (NIHE), offered to display more than a third of the Hunts' collection within the new Plassey campus in Limerick, on condition that the CEC raised the sum of £50,000 towards the costs of the required works there. In January 1975 the collection was formally transferred to the CEC on trust for the State, and Professor Patrick Doran of NIHE, assisted by his German wife, Hanne, set about cataloguing the collection for the first time and became the first acting curator. This was seen as a pragmatic option to get some of the artefacts in the collection on display in temporary surroundings until such time as funding would become available for a permanent base in Craggaunowen.

Hunt, although now in his seventy-sixth year and in poor health, contributed as much as he was able to assist in creating the museum on the Plassey campus. It was on his suggestion that Arthur Gibney was chosen as architect to design the layout and 'before his last illness Hunt had seen and approved the general outline of the plans'.[838] However, he was not to live to see his dream of a museum to display the collection come to fruition.

The 'Craggaunowen Museum' was formally opened by Minister Des O'Malley at the NIHE on 17 April 1978. The collection was described in press reports as 'the most representative Irish collection of antiquities and works of art outside Dublin … it is claimed to be the biggest and most valuable gift given to the Irish nation since those of Hugh Lane and Chester Beatty'.[839] The new exhibition was considered a temporary arrangement and the newly opened museum would remain 'linked with the Craggaunowen Castle complex'.[840]

The Craggaunowen Collection, with its emphasis on European medieval art with a religious theme, was representative of the objects which the Hunts dealt with, as dealers and collectors, throughout their careers. The display included some 700 of the objects that they had assembled over more than forty years, including the early twelfth-century lime wood figure of the Virgin from the lower Rhineland described as 'the museum's greatest treasure' and, by Putzel, as 'Jack's favourite possession'.[841] In this latter context,

the two most important criteria in deciding which of the many objects they came across would be traded or retained in their collection were how much the Hunts liked a piece and how atypical it was.

In classifying the collection under various headings, antiquities of archaeological origin was the largest single class of objects. Most of the items among this group were Bronze Age Irish objects representing both the tools and the weapons used by the earliest inhabitants of the island. Containing more than 100 separate pieces, Hunt's collection of bronze axe-heads was the largest single accumulation of such objects outside the National Museum of Ireland and the Ulster Museum. The Irish antiquities included some thirty pieces dating from the Neolithic to the late Bronze Age which had been found in County Limerick by Hunt and his colleagues during his archaeological work in the 1940s and 1950s.

Among the Irish antiquities, two objects, in an excellent state of preservation from the late Bronze Age, and attributed to County Antrim, have been suggested for inclusion among 'the most important pieces in the entire collection'.[842] These are: a cauldron (600-550 BC) found in the parish of Ballyscullion; and a bronze bucket (c.700 BC) discovered in Capecastle Bog.[843] Both pieces, made from bronze sheeting, had been originally in the Pitt-Rivers Collection at Farnham in Dorset.

The next largest group of objects in the collection at that time consisted of 112 pieces of personal ornaments ranging from the Bronze Age to the nineteenth century, predominantly made of bronze but with some of silver and gold. One of the highlights of this grouping is an eleventh-century BC gold-bar torque, measuring more than 1.10 metres, discovered in 1850 at Granta Fen, Cambridgeshire, which is the only object from that hoard not in the British Museum. This piece, authoritatively deemed as being 'made of Irish gold from the Wicklow mountains', was formerly in the Pitt-Rivers Collection in Farnham, Dorset, before being acquired by Hunt.[844]

Hunt's interest in pottery was also reflected by the presence of sixty-five ceramic objects in the collection.[845] This included antiquities from the prehistoric era in Ireland, a few of which had been found during the 1940s

Granta Fen Torque

excavations in Lough Gur and nearby
Caherconlish, the Classical period of
ancient Greece, and the medieval period
in Europe and Britain. However, the largest
single component of the ceramic collection
was the group of more than two dozen excep-
tionally fine blue and white glazed delftware pieces made by a number
of different factories in Dublin in the eighteenth century which Hunt had
earlier displayed at the ROSC exhibition in 1971.[846] The collection also con-
tained some objects which had been the subject of learned papers published
over the years including the Sheela-na-Gig from Caherelly, which Hunt
himself described in a 1947 essay, and two Dublin tapestries which were
published some years later.[847]

Hunt's drive to leave a legacy to the people of Ireland, in the form of his art
collection, was not the only task that he strove to complete, amidst the inevi-
table intimations of mortality prompted by his advancing age. There was also
the unfinished business of finally publishing a lifetime's study, begun with
research undertaken for his 1945 MA thesis in University College Cork, on
the tomb effigies of late-medieval Ireland, the 'only surviving material evi-
dence for the continuance of a native artistic tradition in the centuries fol-
lowing the Norman Invasion of 1170'.[848] His interest in the subject had been
triggered, during his early years living in Lough Gur, by his friend Monsi-
gnor Michael Moloney, 'my guide to the ancient churchyards of Limerick
and Clare where the tombs were embellished with fascinating examples of
the unique art idiom of the Medieval Irish sculptors'.[849]

Throughout his career, Hunt had written many pieces for learned jour-

nals, magazines, newspapers and in several booklets, covering a very broad range of subjects.[850] His contributions to *Connoisseur*, the leading British journal for collectors of works of art, reflected this diversity, with subjects as varied as 'The Adoration of the Magi'; 'Re-dating Irish silver'; 'An Irish villa for an Italian Ambassador', and 'Salvaged treasure of Florida from a 1715 Spanish plate fleet'. [851]

His role as the leading world expert on early medieval furniture saw him contribute the chapter on furniture to *The Tudor Period*, a guide to the arts of that era published by *Connoisseur* in 1956.[852] Almost a decade later, he wrote the chapter on 'The Byzantine and Early Medieval Period' in Helena Hayward's *World Furniture,* a definitive illustrated history of furniture throughout the world, from the furniture in the tombs of the Pharaohs to the twentieth century. [853] He was published six times in the *Journal of the Royal Society of Antiquaries of Ireland* and his work found outlets in other publications such as the Jesuit-run *Studies*, the journals of the archaeological societies of North Munster, Cork, Louth and Kildare, and in the *Proceedings of the Royal Irish Academy.*

The Irish Times published a series of eight short essays by Hunt, on a weekly basis during April and May 1962, entitled 'Heritage in Stone', and drew their readers' attention, by means of a front-page cue each week, to the importance of the article inside. Written in layman's language so as to communicate with a wide general readership, this series covered the gamut of Irish stone structures up to the end of the medieval period, ranging from early-medieval ring-forts and raths, to cathedrals, abbeys and castles.[854]

The wide range of Hunt's interests was illustrated in his published article in the international art magazine, *Pantheon*, under the intriguing title of 'Jewelled Neck Furs and "*Flohpelze*"'.[855] In this, Hunt described the evolution, from the late fifteenth-century Renaissance period, of a lavish fashion item consisting of the pelt of a marten or sable worn around the neck, in the belief that it acted as a distraction to fleas coming to nibble on human flesh exposed below the neck. A bejewelled head and gold claws were added in its most indulgent form.

However, these earlier writings were merely a pre-amble to his *magnum opus*, entitled *Irish Medieval Figure Sculpture 1200-1600*, published in two volumes in 1974. Volume 1, written 'with assistance and contributions from Peter Harbison' consisted of almost 300 pages of text accompanied by a catalogue, with Volume 2 containing some 290 black and white images of the sculptures by photographer David H Davison of the Green Studio, Dublin.

While a large corpus of scholarly research had been published on figure sculptures contained on Celtic crosses, there had only been sporadic individual studies on the stone figure sculptures of the later medieval period.[856] This was because, prior to Hunt's interest in these objects, their significance as works of art had not been appreciated. The destructive nature of Irish history also meant that, compared with England, only a limited amount of such sculpture had survived and the universal destruction of documentary evidence, such as wills, made it difficult to identify and date the persons whose effigies were being studied. In this way, the significance of Hunt's book was 'in its great documentary value, particularly for an age and a society from which so little else has come down to us in the way of tangible remains'.[857] Whereas many studies of English tomb sculptures had been published, one authoritative reviewer noted that 'by contrast Irish effigies have been almost entirely neglected outside the pages of local historical or archaeological journals'.[858]

As far back as 1953, Hunt was making a concentrated effort to turn his thesis and later studies into a book, with Putzel writing that: 'Jack will I hope be able to concentrate and finish his book on Irish medieval sculpture'.[859] In 1967, a renewed effort to complete the work was undertaken in conjunction with David Davison, who had been photographing objects for Hunt for several years so he could send the images to potential buyers. Davison got to know Hunt very well while assisting with the book:

> Jack was a born teacher. I remember one cold winter's day
> and we were alone working on a photographic session in
> the gloomy light of Christchurch Cathedral. Probably driven
> in by a heavy shower some rough-looking gurriers came in,

certainly not to pray or look at the statues. I was a bit worried about my valuable photographic equipment as there had been reports of thefts from visitors. I tried to ignore them and continue on but they approached us and asked cheekily "what are yiz lookin' at?" Hunt turned around like a professor who had been asked a question by the brightest student in the class and proceeded to explain in the clearest terms the role of a knight in medieval Ireland. The young men were incredibly interested in the history lesson and further questions led to full responses from Jack. After twenty minutes I wished he would finish it up but no, he stayed there with his eager "pupils" until they thanked him and left. That was the kind of man he was, no matter who you were, he was courteous.[860]

It was not until 1970, however, that he was to secure the services of the amanuensis without whom, as he described, 'it would have been impossible for me to complete the book'.[861] Hunt had first encountered Peter Harbison, then Archaeological Officer of Bord Fáilte, in Bunratty Castle a couple of years earlier. They became friendly and Harbison later accepted what he described as 'an extraordinarily generous gesture' from Hunt to stay in a small gardener's house at Drumleck, while problems of title to a house he had recently bought were being resolved. Shortly before Harbison was due to leave Drumleck, Hunt asked him whether he would help him complete his book.[862] It was fortunate for Hunt that someone with Harbison's particular background was available to help. Harbison had already published his first book, *Guide to the National Monuments in the Republic of Ireland* (1970) and there were few in Ireland who could combine his appreciation of archaeology, history and publishing.[863]

One of Harbison's primary tasks involved accompanying Hunt in re-visiting the individual effigies referred to in his MA thesis, and writing out in long hand Hunt's detailed comments on each, as dictated to him on the spot. Harbison acted as both driver and navigator on these excursions, arriving on Saturdays at Drumleck to collect Hunt, and heading off in his old Renault 4

on the day's pre-planned itinerary. While most of the sculptures were located within the main areas of Norman control, east of a line from Dundalk to Cork, some, like those in the Dominican Priory in Strade, County Mayo, involved journeys of more than 300 miles.

Remembering Hunt's 'eye' almost forty years later, Harbison recalled: 'the one thing I learned going around with John Hunt was the importance of looking at details and this is something that has stayed with me for the rest of my life. He was a man who knew so much about arms and armour himself and he would point out things which I would never have noticed myself at all.'[864] When he had finished typing up his notes from these expeditions, Harbison would visit Drumleck in the evenings, bringing the draft for Hunt to review. The two of them would repair to a room way up at the back of the house, with a view out over Dublin Bay, and Hunt would go through the text and correct it.

The book was confined exclusively to carvings in stone, almost invariably limestone, mostly crafted in workshops by skilled stone masons. Practically all of the stone statues which have survived from this period were erected in church graveyards or vaults. A third of the effigies in the book are in knightly armour, the remainder being civilians, clerics or saints. Perhaps the best known figure sculpture of a knight of this period stands at the tomb in honour of Strongbow, in Christ Church Cathedral, Dublin.

Most of the sculptures studied were broken or fragmentary. A considerable majority were located in outdoor locations, such as roofless churches, with the elements causing constant damage to the fabric and detail of the sculptures. Hunt identified one of the main causes of the decay as the fact that, after the Reformation, many churches and church lands had passed into the hands of English overlords of a different faith and, in many cases, ceased to be used as places of worship. Even after Catholic religious practice was no longer suppressed from the early nineteenth century onwards, ownership of ancient church properties was rarely under the control of the Catholic Church. Fortunately, some sculptures that had been housed indoors, such as those at St Canice's Cathedral in Kilkenny or Kilcooley in Tipperary, were

in a much better state of repair and had retained much of their detail. Many of the sculptures had originally been coloured, but only a very small number of the objects studied by Hunt had pigment that could be detected by the techniques available to him in his own day.

In many cases, the stone carvings provide the only tangible evidence of the armour and the dress of the people at the time, as there are almost no surviving drawings from the late-medieval period in Ireland. In the few instances where the dress of a particular period was known, particularly female dress, it was used to date the sculpture. However, it was often difficult to reliably date the effigies, since armour in Ireland, due to the greater need for mobility in the more difficult terrain, was different from that used in contemporaneous periods in England. It was also not possible to match the armour shown on effigies with pieces that have survived down to the present times since little medieval armour survived the period. After battles, armour was recycled by the victors, either for their own use as armour, or as a construction material.

Hunt makes it clear that the sculptures can only be appreciated with some reasonably detailed understanding of the history of Ireland during the 400-year period in question. It is also essential to understand that it was only those people who felt that they were important, and who wanted to have their image carved on their tombs. As in his thesis in University College Cork, Hunt writes very much from an Irish perspective. He dismisses the Tudor nobility in unflattering terms as 'upstarts', and frequently refers to the religious oppression of the late sixteenth century in Ireland, ruled as it was by the 'despotism of Elizabeth'.[865]

Harbison has subsequently recalled how putting all the material together 'took an awful lot longer than I had expected' and it was more than three years before the book was in the hands of Irish University Press, based in Shannon, and due to be launched early in 1974. Publication plans received a setback in January, when the publisher went into liquidation.[866] However, Hunt's old friend, Peter Wilson, came to the rescue and, with Sotheby Parke Bernet as joint publishers, the book was formally launched in September of that year.

Hunt's completed work was hailed as a major piece of original scholarship, both in Ireland and abroad, and received lavish praise from the overlapping worlds of art and archaeology. Alan Borg, later Director of the V&A, stated that Hunt had 'produced a major book, which will long remain the definitive study of Irish Medieval tomb sculpture'.[867]

Some thirty-five years later, Harbison felt that Hunt's work had stood the test of time: 'The book itself would be still regarded as the one great book on the subject – there has been nothing to surpass it … When it appeared in 1974, it can be taken as being a pretty comprehensive view of what there was at the time. There were pieces I remember actually bringing in, simply because he hadn't known the material, but they were very, very few'.[868]

After more than two years of driving thousands of miles around the Irish countryside with Hunt, Harbison had an opportunity to observe him at close quarters in his closing days: 'For me he was a father figure, let me admit it, and a man for whom I had a great liking and admiration. He was a gentle man in the best sense, he really was a very gentle person, very courteous, helpful, basically, a lovely man…'[869]

Regarding Hunt's personal traits, Harbison testified to his religious side: 'I would say a very devout Catholic … in fact he had a penal cross with him when he was buried in Sutton; I think one of these wooden penal crosses. I remember him telling me once when I visited him in St Vincent's Hospital that he carried around with him in his trouser pocket a small silver crucifix which contained a piece of the True Cross.'[870] Harbison emphasised that, for Hunt, the spiritual life was private: 'he would go to mass on Sunday in Sutton, but was not one who was showing off his religion in any way'.[871]

James White, Director of Ireland's National Gallery, also described Hunt's devotion to the crucifix as part of his deep spirituality:

> I have never known him to appear to be unaware of Jesus
> Christ as the centre of all his activities. He was perhaps the
> most Catholic man I ever met – in the broad sense of that
> term – but with the additional qualification that the cruci-
> fixion was for him living and real. All images of the subject

attracted him and a look would come into his eyes which suggested the love deep down in his soul conveying so personal a longing, that I always (little religious as I am) felt awe.

I can recall many evenings when we would sit with that incredible collection of medieval crucifixes before us and John would take one up into his hands. Gently he would explain the different emphasis placed by artists of Germany or Spain, England or Ireland on the subject. Of course he would move back into the Carolingian age with absolute authority. He could also expatiate on the fifteenth, sixteenth- or seventeenth- century productions and was absolutely at home with Irish Penal Crosses and rosaries, of which he had such splendid examples. He was a man of wide culture and taste. Yet he was a simple and unassuming man.[872]

Harbison shared this sense of Hunt as someone who never sought the limelight: 'He wanted to get the book out because it was his life's work, but there was no way in which he was looking for publicity or anything like that from it – that would have been totally foreign to him, in my view, and I think self-effacing is probably a very good word.'[873] He also witnessed how Hunt tended to avoid confrontation, particularly where Putzel was concerned: 'I think I can remember in the kitchen he would pout his lips as if blowing a kiss at her, but I think that may have been because he was possibly avoiding any conflict with her, as she was a very strong personality.'[874]

Harbison had a somewhat surprising view of Hunt's financial position, having had some discussion with him in their travels: 'I would never have regarded him as a wealthy man. He never mentioned property, but he said to me, 'listen I don't have very much money in the bank, but any money that I have goes into acquiring the objects in my collection.'[875]

Perhaps Harbison reflected an impression held by many others when he said: 'it never occurred to me that Hunt was actually English and, because he was doing a thesis on Irish arms and armour, I just automatically took it that he was Irish. I never even thought about it that he had a totally English

background ... it never struck me that his accent would have been particularly English, I just accepted it as it was. He was Hibernicised – totally Hibernicised'. [876]

John Hunt had suffered poor health most of his life, and died on 19 January 1976 after a short illness.[877] Putzel was to live for more than nineteen years until March 1995, although for the latter half of this time she was seriously incapacitated following a major stroke. Without the benefit of any substantial pension, her main means of generating cash rested in selling a few carefully selected pieces from the collection of objects gathered over many years.

On each of the four years between 1979 and 1982 Putzel sold one valuable piece to the Met in New York, receiving sums of several hundred thousand pounds from such sales.[878] Other overseas sales included two objects sold to the Walters Art Museum in Baltimore, Maryland – one a walrus ivory chess piece of Scandinavian origin, sold in 1977; and the other an early fourteenth-century French abbess seal in the form of a Madonna, made of ivory and silver and sold in 1981.[879]

Closer to home, a painting by Jack B Yeats, *The Ferry, Kinsale* (alternatively known as *Women of the West*), was sold at James Adams Auctioneers in October 1976.[880] The two wooden statues by Ligier Richier, which Jack had offered for sale to the Met as far back as 1937, were sold to the National Gallery of Ireland in 1978 for the sum of £80,000, their purchase being funded from the Shaw bequest.[881]

Despite the commitment to the Craggaunowen Museum, there was no lessening in Putzel's generous giving to overseas museums and galleries, mostly in memory of her husband. In 1977, she donated Canterbury glass to the Martin D'Arcy Gallery at Loyola University in Chicago in his honour and two years later she presented the same gallery with a crib and two glass roundels.[882] In 1978 she donated children's clothes and toys to the National

Museum of Ireland.[883] In December 1980 there was a further donation of embroidery, a dress and a train holder and, the following year, some more embroidery with a garter of St Oliver Plunkett and some book marks.[884] Other donations over the next four years included a harp, a lace collection, ladies' needlework implements, an embroidered coatee and a children's bonnet dating from 1600.

In memory of her beloved Jack, Putzel made a generous gift of the world's largest collection of antique dog collars to Leeds Castle, Kent, in 1979. The collection is described as 'the only one of its kind in Great Britain … containing examples of collars from fearsome fetters for the great hunting hounds of the past to canine couture for 21st century pooches'.[885] For almost half a century the collection had held considerable sentimental value for Putzel and she had claimed that dog collars were her first personal specialisation as a collector.[886]

In 1981, Putzel donated two Romanesque sculptures and a stone plaque to the British Museum, which were later valued at £6,500.[887] In 1981 she

One of the large collection of antique dog collars collected by Putzel Hunt, which she gave to Leeds Castle, Kent, in 1979.

gave a seventeenth-century Dutch staff to the Walters Art Museum in Baltimore and, in 1982, presented the newly-opened Snite Museum of Art at Notre Dame University, Indiana with a fifteenth-century mother-of-pearl carving.[888] Her last recorded gift was an Irish faience dish which she donated in 1982 to the Hetjens-Museum in Düsseldorf, a municipal museum dedicated exclusively to ceramics from around the world.[889]

In making her will, Putzel made sure that a crucial piece of English cultural heritage was restored to its rightful place in the British Museum. In 1949 she had acquired the Holderness Crucifix, the oldest metal crucifix then known in Britain, by outbidding the Director of the V&A, Leigh Ashton, at a Sotheby's auction. Much as Ashton had feared, this crucifix had been taken to Ireland, where it was enjoyed by the Hunts, and at one stage presumed likely to be included among the collection of objects that were to make up the Hunt Collection. Putzel, however, bequeathed the crucifix to the British Museum where it is displayed today.[890]

Exactly twenty years after a selection of the most important pieces from the Hunt Collection first went on display at Plassey, the public were at last afforded the opportunity to see the entire collection in an appropriate setting. An energetic campaign involving both private and public interests succeeded in having the entire Hunt Collection of some 2,000 objects housed in a dedicated building in Limerick City through the conversion of Limerick's eighteenth-century Custom House. While neither Jack nor Putzel lived to see the latter building re-open its doors in 1998 as the Hunt Museum, it stands today as a monument to them and their generosity to the people of Ireland.

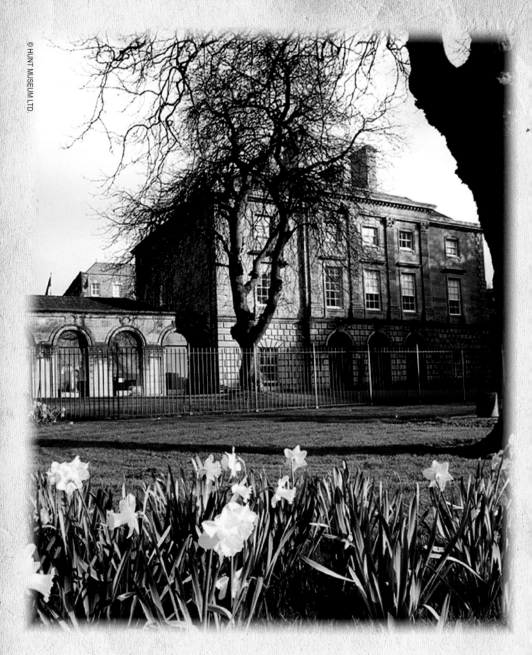

The outside of the Hunt Museum, Limerick.

CHAPTER 11

Hunting High and Low

*They enriched their adopted homeland while they were alive and left
their lifetime's collection of antiquities to the State when they died, but
John and Gertrude ended up damned with the taint of alleged Nazi
links long after they were in a position to defend themselves.*

Paul Cullen [891]

For John Hunt Junior and his sister Trudy, Saturday 7 February 2004 must have dawned as one of the most bizarre days of their lives. On that morning the front page of Ireland's 'newspaper of record', *The Irish Times*, ran a story claiming that 'the leading anti-Nazi group, the Simon Wiesenthal Centre (SWC), has called for an enquiry into the contents of the Hunt Museum in Limerick after allegedly linking the former owners of the collection to "notorious dealers in art looted by the Nazis"'.[892]

The paper stated that it had established 'separately' that a report commissioned by the Hunt Museum claimed that the Hunts were active in the art market in post-war Germany but that 'the essay was never published and there was no investigation into any Nazi connection'.[893] This added credibility to the assertions of the SWC by appearing to suggest that the Hunt Museum may have discovered evidence of a Nazi connection to the Hunts, but had swept the matter under the carpet.

The SWC claims had been detailed in a letter sent during the previous week by the director of their Paris office, Dr Shimon Samuels, to the President of Ireland, Mary McAleese, calling on her to suspend the Museum of the Year award that she had presented to the Hunt Museum the previous November. Samuels' letter also asserted that the Hunts had 'close personal ties in the 1940s' with Adolf Mahr, the Austrian Nazi who had been Director of the National Museum of Ireland, and that the Hunts' arrival in Ireland in 1940 was 'one step ahead of British suspicions of their alleged espionage'.[894]

Established in Los Angeles in 1977, the SWC had quickly become 'the most visible Jewish Organisation in the world' and one that 'at times rivals the venerable American Jewish committee, the Anti-Defamation League and the World Jewish Congress for its impact and access to world leaders'.[895] The SWC had no significant role in the restitution of looted Jewish art, and highlighted the task of 'confronting anti-Semitism' and 'standing with Israel' in its mission statement.[896]

It was quite separate from Simon Wiesenthal's Jewish Documentation Centre in Vienna, although from its inception in 1977 it paid a concession fee to Wiesenthal for the use of his name. The nature of Wiesenthal's relationship with the SWC was summarised in his obituary in *The Times* as being 'not close or, later on, even particularly amicable'.[897]

Contextually, Ireland had been subject to strong criticism from the SWC in the period leading up to the country's assumption of the EU presidency in January 2004.[898] Dr Samuels in a statement asserted that: 'The fact that Ireland is taking over the presidency of the Europe Union reflects very badly on the policy on racism'.[899]

John Hunt Jr responded to Dr Samuels' allegations, saying: 'I have never heard anything remotely like that. I think it's bizarre. It's so over the top that I'm not concerned'.[900] However, while no such charges had ever appeared before in the general media, charges against the Hunts had emerged from two other sources during the previous twelve months, and circulated in the confined arts and museum worlds in Ireland.

The first of these had been made at the annual conference of the Irish Museums Association (IMA) in Coleraine, County Derry, in February 2003 when former Hunt Museum Director, Ciaran MacGonigal, made several accusations against them.[901] He claimed that the Hunts had been members of the 'English Fascist Party', and that, along with Putzel being a German, the reason they had to leave wartime England was 'to avoid internment'.[902] He also pointed to a biography of Bruce Chatwin which outlined 'their role, *an unfortunate role at best,* in the dismembering of the Pitt-Rivers Museum' and suggested that an essay on the history of the Hunts which landed on his desk after taking up the role of director was 'on any reading, a terrible revelation'.[903] In November 2003 MacGonigal's paper was published in *Museum Ireland*, the official journal of the Irish Museums Association, a body which receives generous financial support from the Department of Arts Sport and Tourism as well as the Heritage Council. By appearing in a publication largely funded by the Irish government, MacGonigal's article achieved a certain status and credibility, particularly to an overseas reader.

Some years earlier, MacGonigal himself had reportedly been the focus of a difficulty involving John Hunt Jr, who had, according to press reports, raised issues in 1998 with the manner of MacGonigal's appointment as Director of the Hunt Museum. The offer had apparently been made by the Hunt Museum chairman, Tony Ryan, without any formal interview process or prior approval by the full museum board, and John Jr considered this a breach of due process.[904]

MacGonigal's piece was followed, in the spring of 2003, by an article in the *Irish Arts Review* by Erin Gibbons, described as 'an archaeologist and museum consultant and co-researcher of a forthcoming book on John Hunt', who reviewed a guide to the Hunt Collection and made a number of serious allegations against the Hunts.[905] Saying that their 'professional activities have cast a long and uncomfortable shadow' over the Hunt Collection, she asserted that the Hunts were involved in illegal activities, such as the dispersal of the Pit(*sic*)-Rivers collection and the export of the famous Emly Shrine from Ireland, and that their friends included such individuals as the 'much

discredited' Peter Wilson of Sotheby's. Most significantly, the article, without elaborating on the matter, made a reference to the Hunts' 'Nazi associations'.

Mairead Dunlevy, a former director of the Hunt Museum, wrote a detailed reply to Gibbons' article suggesting that 'it is unfortunate that an archaeologist was asked to review this work.' [906] She dismissed the claim that the Hunts were involved in the export of the Emly Shrine; something she asserted was 'clear to those who read the relevant file in the Museum of Fine Arts, Boston.' [907]

Apart from Dunlevy, there is little evidence that the published claims by Gibbons and MacGonigal were ever challenged or investigated in any quarter, including the Hunt Museum, where the position adopted appeared to be that accusations against the museum benefactors were a matter for the Hunts and not the museum whose sole responsibility was to the collection. The Hunt family in 2003 consisted only of John and Putzel's two adopted children, John Jr and Trudy, as well as their partners and John Jr's three young children. With John Jr's brave fight against lung cancer taking up the attention of the entire family, neither he nor his sister were in a position to engage in the stressful work of dealing with unsubstantiated accusations against their father from sources which they, in any event, may have dismissed as lacking credibility.

Notwithstanding the claims by Gibbons and MacGonigal, a panel of seventeen judges drawn from the Republic and Northern Ireland chose the Hunt Museum as the Museum of the Year and on 25 November 2003, President McAleese presented the award at a ceremony in Dublin. [908]

The Irish Times kept the story alive during the week following its initial report, claiming that an internal Hunt Museum Report written by Judith Hill, a Limerick-based art historian, had suggested that the Hunts 'fitted seamlessly into the post-second World War art market which was coloured by 'wide-scale Nazi thefts'. [909] It mentioned Erin Gibbons for the first time, quoting her as claiming to have made 'a definitive link between the Hunts and two art dealers who are named on Nazi holocaust files in America …' They reported her as saying, 'My belief at this point is that they were part of

a network of Nazi war loot dealers'.[910] Significantly, Gibbons also confirmed that she had contacts with the SWC. [911]

On 10 February, Dr Samuels was interviewed on RTÉ Radio where he claimed that 'there were indications that they [the Hunts] fled from Britain in 1940 to neutral Ireland just a few steps ahead of British Intelligence where they were probably going to be arrested for espionage in Britain'.[912] In reply to a question, he refused to provide any specifics on any work of art that may have been looted, saying that 'according to the code of ethics of museums today the burden of proof regarding unprovenanced art is on the museum … I'm at this point not coming out with names … if necessary we will come forward with more information'.[913] He also made the claim that 'a study had been commissioned by the Hunt Museum in fact which said very clearly that John and Gertrude Hunt were Nazis'.[914]

That same day, Judith Hill issued a press release making a clear and unequivocal rebuttal of the interpretation placed by *The Irish Times* on her report to the Hunt Museum. She stated: 'the issue of whether the Hunts were directly involved in dealing with illegally acquired objects was one that I did not confront and investigate … in no place in my article did I claim that this was the case'.[915]

The Hunt Museum Board acceded to a request from the Minister for Arts, Sports and Tourism, John O'Donoghue, 'to examine claims by the Simon Wiesenthal Centre … in so far as they relate to the collection'.[916] These last words were significant in that they confined any investigation to merely checking the collection for possible looted art, and excluded consideration of the claims of Nazi associations against the museum benefactors.

That following day, John Jr and Trudy Hunt announced 'with a degree of sadness' that they were temporarily standing down from the board of the Hunt Museum 'for the duration of the review process':

> Recent unsubstantiated allegations about John and Gertrude
> Hunt and the Hunt Collection have been distressing to the
> family … We honour the memory of our parents who we
> loved, admired and respected. We never knew them to be any-

thing other than scrupulously honest and fair. We have been privileged to play our part in realising their vision of making the Collection available to the people of Ireland ... Our own priority is to defend and safeguard the good reputation of our family.[917]

The Irish Times asserted that John and Trudy Hunt were 'frustrated that the museum board hadn't dedicated the same level of energy to defending their late parents' reputation' and voicing concerns that 'the Board's reaction was heavy-handed and may give credence to the allegations'.[918]

Defences of the Hunts' character appeared in several letters published in *The Irish Times*. Dr Peter Harbison wrote that he had worked closely with Hunt and 'never encountered the slightest hint of Nazi sympathies'.[919] Brian Fallon, former Literary Editor of *The Irish Times*, Professor Etienne Rynne of UCG, Dr Edward Walsh, former University of Limerick President, and Mary Geary, former president of the Thomond Archaeological Society also had letters in defence of the Hunts published. Perhaps the most compelling testimony on the Hunts was in a letter to *The Irish Times* by Professor Barry Raftery, which was not published. Raftery set out the views of his ninety-one year old mother, Lotte, the German-born wife of Dr Joseph Raftery, the former Director of the National Museum of Ireland:

In 1940 the Hunts came to Ireland. Putzel Hunt, also a German, became friendly with my mother, and from then onwards the Hunts were close friends of my parents for almost four decades.

Thankfully my mother is still alive and ... retains a razor-sharp intellect including a clear knowledge of the Hunts' background and their early days in Ireland. My mother is absolutely certain that any allegation that the Hunts were even remotely pro-Nazi or anti-Jewish is completely without foundation. In her many years of close friendship with the Hunts never was there even the slightest hint of Nazi sympathies. In fact my mother insists that quite the opposite is the case. The

recent charges against the Hunts have thus been matters of astonishment, and, indeed no little distress, to my mother.[920]

In a further radio interview on 22 February, Dr Samuels stated that he was conducting groundwork investigations 'with the support of certain Irish experts who put their own professional reputation on the line'.[921] When asked about the nature of the investigations he replied:

This is like a medical examination. We've revealed the existence of a pustule and it now has to be lanced and the pus allowed to drain ... The archivist and the review committee ... will undertake their research and we will serve as a control mechanism. I intend to withhold any findings that we have until the completion of their report ... So the Wiesenthal Centre will act as a control mechanism for the enquiry and no-one knows who has the placebo.[922]

During this interview, Dr Samuels mentioned Judith Hill and her report and said there were other reports pointing to the Hunts' relationships with known Nazis.[923] Referring to Ireland's role as President of the European Union he added: 'This is a catharsis for World War II neutrality and for the whole question of national collective memory of what happened in World War II'.[924]

In an interview in the *Limerick Leader*, Dr Samuels offered no further information to support his charges, apart from the assertions made during 2003 by MacGonigal and Gibbons. He said 'the SWC 'first became suspicious about the Hunt Collection six months ago following an article in an Irish Arts periodical'.[925] He also pointed out that 'former Hunt Museum curator Ciaran MacGonigal had raised concerns over the provenance of the museum's contents at a meeting of the Irish Museums Association'.[926]

An inquiry team appointed by the Hunt Museum was announced on 20 February 2004 under retired Supreme Court Judge Donal Barrington, assisted by two British experts, Anne Webber, chairwoman of the European Commission for Looted Art, and Hugh Tait, a former deputy keeper of the British Museum.

A significant development occurred in early March when John and Trudy Hunt published the details of the correspondence between their parents and a German Jewish art dealer, Philipp Markus, and with the German Jewish Relief Agency.[927] RTÉ gave comprehensive coverage to this story, conducting an interview with John Hunt Jr on 5 March, and *The Irish Times* also covered the story the following day. Three weeks later, a 1,500 word article in the *Limerick Leader* showed that Holocaust records, readily available on the internet, as well as documentation obtained from the *Stadtarchiv* in Worms, fully corroborated the authenticity of the correspondence in the possession of the Hunt family.[928] Tragically, the records also established that Philipp Markus had not survived the Holocaust.[929]

In April 2004, Judith Hill issued a statement asserting that the original *Irish Times* coverage of her essay was 'misleading' and flatly denying Dr Samuels' statement on RTÉ Radio that her report ever stated that the Hunts were Nazis.[930]

That same month, Mr Justice Barrington wrote to Arts Minister John O'Donoghue requesting funds for his investigation, saying that 'as this enquiry arose out of a letter from the Wiesenthal Centre to the President of Ireland, the good name of the state is, inevitably involved.[931] Having eventually failed to secure such funding, the Barrington Commission disbanded in January 2005.

In February 2005, it was reported that the SWC was now asserting that the Hunts were suspected of espionage: 'the Wiesenthal Centre says that they fled London in 1940 for neutral Ireland because MI5 was investigating their pro-Nazi spying activity'.[932] The same article reported that the SWC claimed to have evidence about objects on display in the Hunt collection, stating: 'we have research about individual pieces and it won't take long before we go public on that. We are holding back. If the Barrington Commission had investigated the items we are concerned about we would have been satisfied. Our researcher is Irish but we are not going into details at the moment'.[933]

That same month, in the first evaluation of a collection connected to John Hunt, Shannon Heritage received a report by Sarah Jackson, the Historic

Claims Director of the Art Loss Register, stating that none of the items in Bunratty Castle had been registered as stolen or missing on their database of stolen or missing art. [934] Dr Samuels had earlier called for the Lord Gort Trust Collection in Bunratty to be placed on the internet 'so that eventual claimants scrutinize these objects in the manner of suspect art held by museums world wide.'[935]

Some months later there was evidence of a change in attitude in official circles regarding the funding of an investigation into the SWC claims. In May 2005, the Hunt Museum Evaluation Group (HMEG) was established by the Royal Irish Academy (RIA), with funding of €150,000 provided by the Department of Arts, Sport and Tourism.[936] Its task was 'to facilitate an exhaustive and internationally bench-marked investigation of the provenance of all objects in the Hunt Museum in the light of the accusations levelled against that institution by the Simon Wiesenthal Centre in Paris.'[937] Chaired by Mr Seán Cromien, former Secretary General of the Department of Finance, the committee drew on the services of an internationally reputable expert in World War II art provenance, Ms Nancy Yeide of the National Gallery of Art, Washington, DC.

The group, in its terms of reference, made a critical decision to investigate only the provenance of the Hunt Collection and not to investigate charges that the Hunts were involved in dealing in looted art or were supporters of fascism, considering such investigation to be neither useful nor appropriate: 'The questions of the particular affiliation of two individuals, no matter how prominent, would appear after this lapse of time to be matters for the biographer or the historian rather than a State-funded enquiry such as this.'[938] The bulk of the money was spent on working on two activities: researching the provenance of the entire collection; and creating a website where the images – as well as all known details – of the two thousand objects were made available for public inspection online.

However, despite its terms of reference, the committee agreed to a request to inspect intelligence archives both in London and Washington. These contained records of the Nazi looting campaign and the names of the 1,300

individuals who engaged in art looting, as well as US intelligence reports from its Irish embassy and consulates on agents and supporters of the Germans in wartime Ireland, and membership lists of Fascist organisations in Britain. This investigation, while not in the main body of the report, was attached as an appendix. [939] However, the committee did not investigate the Irish Military Archive to inspect files on Adolf Mahr or John Hunt held there. The Mahr files had been referred to in *Hitler's Irish Voices* (1998) which detailed Adolf Mahr's role in the Nazi party in Ireland, and the existence of the Hunt file had been noted in a written submission to the HMEG by Ciaran MacGonigal. [940]

In conducting its work, the HMEG tried to make contact with the SWC as well as Gibbons and MacGonigal. Despite writing to Dr Samuels the Final Report merely reported that: 'regrettably no reply has been received to date'. [941] Neither MacGonigal nor Gibbons are mentioned in the report by name but described instead as 'two persons who had been identified in the media as having special knowledge of the issues of concern'. The report confirmed that one person, almost certainly referring to MacGonigal, replied and 'provided information orally' whereas 'the second replied after a considerable lapse of time with a number of questions relating to the nature and constitution of the Group. There has been no further communication with this correspondent'. [942]

MacGonigal's oral testimony to the HMEG was followed by a written submission from him, some details of which were subsequently published in the media. [943] While this offers few clues regarding doubtful provenance of objects in the collection, it does reveal how Erin Gibbons and another archaeologist approached MacGonigal in the spring of 2002 and offered startling information on the Hunts. Some of this information, as recalled by MacGonigal, included the following:

- That John Hunt was briefly interned in the Curragh
- That 'substantial files' [on the Hunts] existed with MI5 and MI6 in the UK and with Irish Military Intelligence and the Dept. of Justice in Ireland.

A subsequent investigation of the Irish Military Archives by a professional archiving company, along with a review of contemporaneous newspapers, confirmed, not surprisingly, that Hunt had never been interned.[944] The research did, however, reveal the likely basis for the claim reported by Mac-Gonigal – the existence of a republican internee by the name of John Hunt, from Athea in west Limerick.[945] No records have ever been produced by the SWC, or anyone else, to support the suggestion that any files ever existed on the Hunts with M15 or M16.

The entire Hunt Collection, consisting of 1,946 items, was put online on 7 October 2005 and the final report of the HMEG was published on 16 June 2006, describing the extensive provenance research work that had been undertaken on the collection. The main finding was that no looted objects had been found and that 'most of the objects in the Hunt Museum with gaps in their provenance are unlikely to have problematic pasts'.[946]

Appendix 2 set out the results of the extensive trawl carried out on all relevant files in the National Archives and Records Administration (NARA) offices in Washington as well as other sources in the National Archives in Kew. General intelligence records from the US embassy in Dublin, and consulates in Foynes, Limerick and Cork, showed the extent to which anyone with any link to the Axis powers was being monitored and the Hunts did not appear on any such file. The extensive body of information gathered on Nazi art looting, and the more than 1,300 individuals involved, were also studied and again the Hunts' names did not appear. All files on the various Fascist groups operating in Britain in the pre-war period were inspected at the British National Archives in Kew but no reference to the Hunts was discovered.

A few days later, a day-long seminar, attended by about fifty people, was held at the RIA headquarters in Dublin to which a panel of international experts was invited. The seminar covered the world-wide scene on Nazi-looted art, including a paper by Hunt Museum Director Virginia Teehan describing the experience of the Hunt Museum in dealing with the SWC accusations.[947] Neither the SWC nor Gibbons were invited due to their non co-operation with the work of the group. Teehan, in her presentation, made

critical comments on the role of both the SWC and, in particular, Gibbons, but made no mention of MacGonigal. In an intervention from the floor, Eamon Kelly, Keeper of Irish Antiquities at the National Museum of Ireland, and husband of Erin Gibbons, questioned the credibility of the work of the Evaluation Group because it had not investigated a file in the Irish Military Archive on the Hunts.[948] He said that the file showed that Hunt had extensive dealings with Swiss people engaged in dealing in looted art and named various individuals such as art dealer, Alexander Von Frey, and Emil Buehrle, an armaments manufacturer and buyer of looted art.[949] Two days later a press release by the SWC repeated Kelly's claim about Buehrle and made it clear that the Irish Military Archive file was their smoking gun.[950]

Referring to the Hunts' correspondence with the Jewish antique dealer, Philipp Markus, Dr Samuels asserted that: 'revelations in that correspondence indicate that Hunt was engaged in acquiring art objects in return for his services, thereby placing him in the role of a war profiteer who, like the ERR, and Nazi-linked dealers, engaged in a systematic programme of stripping Jewish refugees of their cultural property'.[951]

Trudy Hunt considered this to be Dr Samuels' most hurtful statement, as nowhere in the Markus correspondence is there any suggestion that the Hunts sought payment, either in cash or goods, for their efforts to help their friends and, despite Markus's profession as an antiquarian, art objects are not mentioned in any context. From their contacts with other Jewish refugees in London, the Hunts were intimately aware of the legal chicaneries that the Nazis had put in place to strip Jews wishing to leave Germany of essentially all their wealth.[952]

The RIA responded by promising to investigate the Military Archive file on John Hunt and subsequently engaged Lynn Nicholas, arguably the leading world expert on Nazi-looted art, to conduct a review of the RIA report.[953] In conducting her work she sought input from the SWC, but none was forthcoming.[954] Nicholas examined the Irish Military Archive file in detail as well as personal family files held by the Hunt family. The main conclusion of her report, published in September 2007, was that 'the presently

available information and research provides no proof whatsoever that the Hunts were Nazis, that they were involved in any kind of espionage, or that they were traffickers in looted art'.[955] In several places Nicholas was clearly critical of Samuels:

> The sensational and calculated manner in which Dr Samuels announced his suspicions in an open letter containing serious personal allegations and implied criticism of the wartime actions of the Republic of Ireland, then holding the Presidency of the EU, was both undiplomatic and offensive ... The decision to challenge the Irish authorities in a sort of blackmail game was unprofessional in the extreme ... It is regrettable that Dr Samuels chose to pursue the inquiry in such a confrontational and often personally offensive manner, and that he has at times misstated what was in the Military File and made unverified allegations both the suppression of this documentation by Dr Samuels and the exclusion of much of it from consideration by the Evaluation Group, were not useful.[956]

The report was widely covered in the Irish media and internationally. The *Press Association* in Paris did an extensive piece which was syndicated throughout the world. Dr Samuels was quoted in the article as rejecting the charge of blackmail as 'almost defamatory', saying that he would not be issuing an apology and that 'the show is not over'.[957] And indeed it wasn't!

While nothing further was heard from the SWC on the matter during the next four months, the issue re-surfaced when President McAleese made some very strong remarks on the controversy during a visit to the Hunt Museum on 21 January 2008. She was reported as describing the allegations by the SWC as 'baseless' and 'a tissue of lies' and saying that 'the Simon Wiesenthal Centre had diminished the reputation of the late Simon Wiesenthal'.[958] Dr Samuels was 'shocked' and described her criticisms as 'not very presidential' and 'unstatesmanlike'.[959] More importantly, he claimed that a separate investigator on behalf of the SWC would issue a new report con-

cerning the Hunt Museum 'within three months'.[960]

On 11 December 2008, the SWC finally submitted a 'Shadow Report' of 165 pages to Taoiseach Brian Cowen.[961] There were no recognised international experts on looted art involved in compiling the report, which was authored solely by Erin Gibbons, with a seven-page preface by Dr Samuels. The report was accompanied by two separate press releases from the SWC which particularly highlighted new points of information contained in the report: 'Shimon Samuels and Museum consultant, Erin Gibbons, raise questions and provide documentary evidence from intelligence and archival sources. Investigating alleged connections with: Dublin-based Nazi Chief Adolf Mahr; pro-Hitler aristocrats in the United Kingdom; a series of dealers in looted art; the Allied strategic trans-Atlantic flying-boat station in County Limerick; Jewish art dealers in Germany, desperate to get to neutral Ireland – the study reads like a detective novel'.[962] As the Shadow Report incorporated more than five years' work by Dr Samuels, and at least seven years of work by Gibbons, it appears to be the definitive statement of their allegations against the Hunt family and the Hunt Museum.

The most striking thing about the report is that it does not suggest that any object in the Hunt Collection was looted by the Nazis. It is as if the previous five years of claims and investigations and provenance research never happened. Dr Samuels' 2004 press release headed 'Expose Hunt Museum collection on internet for Holocaust survivor claimants', followed by newspaper headlines such as 'Irish Museum's alleged Nazi loot' and 'Museum hoarding Nazi loot' had helped to gain public attention for the SWC accusations by raising the possibility that there might be looted Jewish art in the Hunt Museum.[963] Dr Samuels kept the pot boiling on this issue for years, saying that the SWC were 'holding back' and planned to make specific allegations about objects on display 'soon' and that 'it won't take long' before they went public with 'research about individual pieces'.[964] The Shadow Report contains no such claim, nor does it mention that the entire collection had been catalogued online for three years and had received more than 250,000 visits without a single claim being made against any object.

The Shadow Report does not challenge the findings of the RIA Final Report, which states that the Hunts do not appear anywhere in art looting records, either in the National Archives in Washington, DC, or in records at the Public Record Office in London. Neither does it attempt to challenge the review of this aspect of the RIA report carried out by Lynn Nicholas and her conclusion that 'I have myself reviewed many of the records Ms Teehan consulted and find her work thorough and her conclusions accurate'.[965]

Most of the report is an attack on the character of Hunt, suggesting that there are grounds for investigating the possibility that he may have been guilty of criminal or disreputable behaviour such as: falsely obtaining an Irish passport; having a false date on the passport to assist his espionage efforts; living in Lough Gur in order to spy on the wartime Allied flying boats landing in Foynes; trying to sell an object of doubtful authenticity to the National Museum; possibly being part of a circle of Fascist aristocrats in pre-war London; and having multiple links through Lord Gort and others to fascists in Scotland.[966]

In trying to deal with the myriad of charges against Hunt's character contained in the Shadow Report, it is perhaps best to limit one's focus to the four basic charges made by Dr Samuels in his original letter to President McAleese which link the Hunts to Nazism and were expanded upon in his subsequent public statements. The four charges involved: extensive Nazi connections; suspected involvement in espionage; close relationships with a known Nazi, Adolf Mahr; and intimate business dealings with dealers in looted art.

Dr Samuels' first charge had been to point to an article in the *Irish Arts Review* written by Erin Gibbons which he claimed 'alluded to the extensive pre-war Nazi connections of John Hunt and Gertrude, his German-born wife'.[967] The Shadow Report produced no evidence that Hunt had connections with any Nazi in the pre-war period, apart from the Director of the National Museum of Ireland, Adolf Mahr, with whom Hunt had limited contact in the normal course of his business as an art dealer.

The Shadow Report however points to the fact that Hunt, as an art

dealer in the mid- 1930s, sold ancient objects of Celtic and British origin as an agent for a museum in Dorset, England, owned by a wealthy and anti-Semitic British Fascist, Colonel George Pitt-Rivers, later interned during the war.[968] The report then mentions the book *Bruce Chatwin* by Nicholas Shakespeare, which it asserts 'contains allegations that the Hunts shared George Pitt-Rivers' extreme right-wing political views'.[969] Finally, the report quotes from Ciaran MacGonigal's paper in *Museum Ireland,* which said the Hunts 'were members of the English Fascist Party' although admitting that 'MacGonigal provided no evidence to support these allegations'.[970] Joining these three strands of evidence together, without any further research into the sources quoted, the report concludes: 'The fact that George Pitt-Rivers espoused pro-Nazi politics together with Nicholas Shakespeare's allegations that the Hunts were associated with him and shared his political outlook, gives credence to allegations that the Hunts had Nazi associations.'[971]

There are a number of obvious difficulties with Gibbons's argument. Firstly, as Nicholas pointed out, 'the fact that dealers once knew and dealt with each other is … not sufficient basis for assuming that they shared political ideas'.[972] Further, the Shadow Report appears to equate 'fascist', which covers many right-wing organisations, with 'Nazi', which is usually confined to members of the German National Socialist party.

While it is possible that Hunt may have met Colonel Pitt-Rivers himself at some stage in the 1930s, Gibbons produces no evidence to that effect. On the contrary, documents she reviewed and quoted from elsewhere in the report, state categorically that Thomas Downing Kendrick, a trustee of the museum and, since 1928, the Assistant Keeper of British and Medieval Antiquities at the British Museum, was 'the principal mover in having the gold sold on behalf of the Museum' and had appointed Hunt as agent to carry out this task.[973] Mentioning Kendrick would not have been helpful to Gibbons in making her case, given that his political views were very much in contrast to those of 'Captain George'.[974]

In light of the Shadow Report's interpretation that the book *Bruce Chatwin* had suggested that the Hunts held 'extreme right wing views', contact

was made with the book's author. In April 2006, Nicholas Shakespeare clarified his allusion to the Hunts as follows:

> In relation to the references to John Hunt and his wife Putzel in my book *Bruce Chatwin*. My comments were not intended to suggest that the Hunts were members of the British Union of Fascists, and I am satisfied that they were never members of said organisation. I am also not aware of any evidence of anti-Semitic views on their part. Indeed, I have noted the published accounts of their efforts in working with a Jewish agency in London to obtain the release of one particular family from Nazi Germany.[975]

The Shadow Report makes other attempts to link Hunt by association to pro-Hitler organizations and individuals in pre-war Britain. A four page chapter, entitled 'Galitzine's, London', infers that Hunt was part of a circle of pro-Hitler aristocrats in pre-war London.[976]

It suggests that a letter, written by Alexander von Frey in 1946, that mentions staying at 'Galitzines' may refer to a certain 'Prince Turka Galatzine', once mentioned in a British Intelligence report on the pro-Hitler Right Club. Gibbons writes that: 'Galitzine is not a British name and was therefore unlikely to have been common in London.[977] London phone-books for 1946 show several Galitzine entries, among them a person who was much more likely to have been known by Hunt and von Frey, Vladimir Galitzine, an art dealer with a gallery in Berkeley Square, a short distance from Hunt's former gallery at 30c Bury Street.[978] 'Prince Turka Galitzine' is a misspelling of 'Prince Yurka Galitzine' listed in the phone directory as 'Capt. Y. Galitzine', who was then a young man in his twenties. Ironically, this individual would almost certainly not have been at home in London in 1946, since he was based in the Netherlands and engaged as a member of the SAS War Crimes Investigation Team in prosecuting Nazi criminals.

It is somewhat surprising that the name 'Prince Turka Galitzine' did not strike a chord with Dr Samuels, since Prince Yurka Galitzine, whose exploits have been celebrated for years in press, film and many books, is widely cred-

ited as the person who first documented the horrors of the Holocaust.[979] This was based on his shocking investigation of Natzweiler-Struthof concentration camp in the Vosges Mountains, the first such camp to be liberated by the Allies in December 1944. After the war he played a key role in hunting down Nazi war criminals and assisted a British SOE member to gain unauthorised access to Auschwitz to interrogate the former Nazi camp commandant and obtain evidence later used in the Nuremberg trials.[980] He later circumvented Allied officialdom by maintaining an operational SAS unit specifically to bring Nazi war criminals before War Crimes Tribunals.[981]

The second charge made by Dr Samuels against the Hunts was that they were suspected by MI5 of engaging in espionage activities. In his letter to President McAleese, Dr Samuels stated: 'Further sources point to the Hunts precipitate flight from London to neutral Ireland one step ahead of British suspicions of their alleged espionage activity.'[982] Dr Samuels enlarged on this theme, stating on RTÉ Radio: 'There were indications that they fled from Britain in 1940 to neutral Ireland just a few steps ahead of British Intelligence where they were probably going to be arrested for espionage in Britain'.[983] Although the Shadow Report admits that 'there is no hard evidence to prove that the Hunts were engaged in espionage' and that 'no evidence of spying by the Hunts has been found', it goes to considerable lengths to assert that there were 'unconfirmed suspicions of espionage activities by the Hunts.'[984]

The SWC's claim that Hunt might have been a German spy has to be viewed as rather extraordinary in the context of incontrovertible assertions in official British Government sources on the success of the British Intelligence service, MI5, in dealing with German espionage in Britain during World War II. Based on a post-war study of captured German intelligence records, the British have long held that, with the exception of one individual who committed suicide before capture, every single one of the 115 espionage agents targeted against Britain during the course of World War II had been successfully identified and caught.[985]

The Shadow Report does not provide any evidence to support their earlier statement by the SWC that the Hunts 'fled London in 1940 for neutral

Ireland because MI5 was investigating their pro-Nazi spying activity', or that any suspicion of espionage activity on their part ever existed in any other official quarters in Britain.[986] Given the extensive British Intelligence files in relation to suspected wartime espionage agents, which are open to researchers in the British National Archives at Kew, and which were all stated to contain no reference to the Hunts in the RIA Final Report of June 2006, it is somewhat surprising that no such files appear to have been reviewed in compiling the Shadow Report.

Instead, the Shadow Report tries to make the case that a series of events involving the Hunts create a reasonable suspicion of their being involved in espionage. Dr Samuels, in his preface to the report and later press statements, raises the issue of possible espionage by the Hunts in relation to the trans-Atlantic flying-boat station at Foynes, County Limerick.[987] Gibbons repeats this matter in the report's conclusions, stating that the Hunts' settling in Ireland 'close to the strategically important trans-Atlantic airport at Foynes, may buttress those suspicions'.[988] It is not too difficult to counter this suggestion because, when the Hunts purchased their home at Lough Gur in January 1941, there was no 'trans-Atlantic airport' operating at Foynes. The services, which had commenced in 1939, were withdrawn later that year when war broke out, and no trans-Atlantic flights took place through Foynes for more than a year either before or after the Hunts had bought their home in Lough Gur.[989]

The Shadow Report asserts that there is evidence 'both among their London circle of friends and with Irish Military Intelligence' that the Hunts were suspected of spying.[990] However, the only evidence offered in relation to their London friends is an interview conducted in 2002 by Ms Gibbons with Yvonne Hackenbrook, an art historian resident in London at the time of the Hunts' departure. Hackenbrook made it clear that 'she did not subscribe to the belief that the Hunts were engaged in spying' but stated that 'it was widely believed among their circle that fears of arrest on charges of espionage lay behind their flight to Ireland'.[991]

However, a close reading of this single piece of evidence relating to sus-

picions of espionage in Britain shows it doesn't actually support the contention in the report. The statement quoted does not state that suspicions of spying existed among their London circle of friends, but merely that their friends held fears that they could be arrested as spies. Given that Putzel was German-born, and the prevailing xenophobic climate in Britain at the time, this was not an irrational fear for either their friends or, indeed, the Hunts themselves..

To support the assertion that 'suspicions existed among Irish Military Intelligence' the report states: 'The filed note refusing permission for the Hunts to work at Foynes is given the reference number X/0379. According to the Military Archive staff, 'the use of the letter 'X' as a prefix normally indicates suspicion of espionage.'[992]

Subsequent investigation established that 'X/0379' was not a reference number for the note placed on Hunt's file, but instead was a link to the extensive file in the Military Archives, 'G2X/0379', which covered all matters relevant to the wartime flying-boat base at Foynes.[993] The current head of military archives, Commandant Padraic Kennedy, has clearly explained the significance of 'X' as a prefix on a military archive file, saying: 'the reference "G2X" generally refers to subjects or incident files, while "G2" refers to individuals'.[994]

Further evidence that Hunt was not suspected of espionage by the Irish Military Intelligence can be found in the Shadow Report itself. It quotes from a letter sent to Military Intelligence on 17 April 1943 from the Crime Branch, Section 3, Office of the Commissioner, Garda Síochána, Dublin, stating that Hunt 'does not appear to be interested in any political organisation'.[995]

The Shadow Report also suggests that Hunt's Irish passport may indicate possible evidence of espionage: 'Further investigation is needed to establish the reasons and circumstances by which John Hunt obtained Irish citizenship and an Irish passport, especially in the light of unconfirmed suspicions of espionage activities by the Hunts'.[996]

Based on one Garda report which recorded Hunt's date of birth as 28 June 1900, instead of 28 May 1900, Gibbons suggests that Hunt, in order to con-

ceal his real identity for the purposes of espionage, may have provided wrong information to the Gardaí and other Irish authorities, presumably including those responsible for issuing Irish passports.[997] However, Hunt's Irish passport, C-6040, issued on 30 August 1939, with his correct date of birth, shows there is no basis for such a claim.

The third charge levelled by Dr Samuels against the Hunts when writing to President McAleese was to point to: 'Their close personal ties to Adolf Mahr, the then director of the Irish National Museum and head of the Nazi Party (NSDP-AO) in Ireland'.[998] The Shadow Report states that 'Adolf Mahr and John Hunt were corresponding and holding meetings between January 1936 and July 1939'.[999] This might be construed as quite misleading since an exchange of correspondence occurred only three times during that period, in January 1936, May 1938 and July 1939. In all cases this related to Irish cultural objects which Hunt was trying unsuccessfully to sell to the museum through Mahr, who as director, dealt with all such acquisitions. Similarly 'holding meetings' clearly means they met more than once but the only evidence in the report, or indeed elsewhere, is that they met on only one occasion, in May 1938.

Gibbons does not mention whether she investigated the substantial files on Mahr created by Irish Military Intelligence, who opened and copied his mail at his home, as well as at the National Museum.[1000] These files do not contain any correspondence between Mahr and Hunt, nor any reference to Hunt in correspondence with third parties. The Shadow Report also fails to mention that Hunt's name did not appear on Mahr's list of forty-three 'dependable friends' and 'scientific people' in the fields of archaeology or art in Ireland, who might be able to provide assistance to his daughter, Ingrid, who was going to Dublin to work in 1948.[1001]

The fourth claim in the letter to President McAleese referred to the Hunts' 'intimate business relationships with notorious dealers in art looted by the Nazis'.[1002] These charges are built on the three letters in the Irish Military Archives file G2/4371, received by Hunt from Alexander von Frey, between April 1944 and November 1946, in reply to three letters he had earlier sent

to Von Frey, of which no record exists. A handwritten cover-note on the file explains that the letters were of interest because Von Frey asked Hunt for information as to how he might obtain an Irish visa or passport and the references to such requests are underlined in red in each letter. It also seems, because Von Frey keeps repeating his request for this information in each letter, that he was not a particular friend of Hunt, who did nothing to help in providing information about visas or passports. There is no suggestion on the file by the Irish Military Intelligence or the Gardaí that either Von Frey or Hunt might be involved in dealing in looted art.

The first paragraph of each letter refers to Von Frey supplying coffee as requested to Hunt's mother-in-law in Germany, which would indicate the most probable reason for Hunt writing to Von Frey in neutral Switzerland. Von Frey is recorded in the Art Loss Investigating Unit (ALIU) Final Report as having engaged in one war-time exchange transaction with the Nazis in Paris.[1003] As Lynn Nicholas made clear: 'the fact that dealers once knew and dealt with each other is, therefore, not sufficient basis for assuming that they shared political ideas or participated in looting. Von Frey certainly did trade with the Nazis, but that fact alone does not prove that the Hunts did'.[1004]

Contextually, the report seems to have little understanding of how widespread was the involvement of the dealers in the art and antiques trade throughout both occupied and neutral countries in continental Europe in the trade in Nazi-looted art. With some 1,300 firms or individuals listed in the final report of the Art Loss Investigation Unit as having participated in dealing in such objects, it would not be too far from the mark to say that 'they were all at it'. The list includes almost all of the larger respected dealers in the pre-war era, including such pillars of the art dealing establishment as Wildenstein in Paris and Fischer in Lucerne.

There are no British or Irish names on the list for the simple reason that the English Channel provided a major obstacle for such business.

One could reasonably surmise that not only did John Hunt know Von Frey but surely he could have known countless others on such a list.

The Shadow Report raises some other issues unrelated to Dr Samuels' initial accusations which serve to blacken Hunt's character and reputation and which, it suggests, warrant further investigation. There is not much to be served in dealing with such claims as there is limited evidence produced to support them, apart from a rather selective interpretation of certain items of correspondence in museum archives. Typical of these allegations is the suggestion that Hunt had attempted to sell to the National Museum of Ireland in 1938 an O'Neill seal, which Gibbons described as 'an object of somewhat doubtful authenticity' which 'may create the impression that they, indeed, traded in fakes'.[1005]

The Shadow Report suggests that the authenticity of the seal had been called into question 'by an expert, Charles McNeill, who wrote … expressing doubts about the object'.[1006] McNeill's letter had stated 'the spelling O'Neill is unexpectedly accurate for all the circumstances; but of course accuracy is possible.'[1007] However, a reading of the one-page letter sent by McNeill to the museum not only fails to support this suggestion, but unequivocally states the direct opposite. Hunt had earlier confirmed in correspondence to the museum that the seal belonged to Horace Walpole, the eighteenth-century art historian and writer, and McNeill in his first paragraph refers to 'the authenticity of the seal, which if it be Walpole's, has never been questioned'.[1008]

Rather than raising any doubts about the object, McNeill makes it clear why he wanted Mahr to pursue its purchase: 'my opinion of such unique articles is that when authentic they should be secured at any honest price … I hope you will get the seal'.[1009] That the evidence used to cast doubt on Hunt's honesty appears on the same page as the clear evidence of his innocence of such charge, is surely inexplicable.

What becomes particularly clear in reviewing Hunt's life story is that, throughout both his professional dealings and his social friendships, both he and Putzel befriended an exceptional number of individuals who were either Jewish or strongly opposed to the Nazis. In the pre-war years we have evidence of his friendship with future British Museum Director, Thomas

Downing Kendrick, who 'helped a number of refugees from Nazi Germany find refuge and employment during the 1930s'.[1010] Kendrick obtained for Hunt the agency to sell the Celtic gold collection from the Pitt-Rivers Museum,[1011] and provided an introductory reference for him to the National Museum of Ireland. The Markus correspondence provides proof of the Hunts' willingness to do something practical to help victims of Nazi oppression as well as providing evidence that they were in touch with other Jewish refugees in London who had fled from such oppression.

There is also evidence of how Hunt was perceived by Jews living in Ireland. One of Hunt's earliest recorded friendships in Ireland was with Kurt Ticher, a businessman and silver expert of Jewish origin, who had tried unsuccessfully to obtain Irish visas to rescue other family members from Germany after the Nazis had come to power.[1012] As noted in earlier chapters, Hunt travelled up from Limerick during the war for dinner at Ticher's home in Rathgar and Ticher later provided Hunt's first introduction to the MFA in Boston. [1013]

In later years, Hunt's acceptance by his Jewish contemporaries in Ireland can be evidenced by his association with three prominent members of the Irish Jewish community, who set up the Contemporary Irish Art Society, and his friendship with Dublin Jewish art dealer Louis Cohen.[1014]

In 1953, when there would have been acute Jewish sensibilities towards dealing with any German, Putzel went to London on a three month assignment to run the business of a Jewish art dealer, David Black, whose London gallery was No. 1 Burlington Gardens in Mayfair.[1015] With the scars of the Holocaust still so raw, it is doubtful if any Jewish businessman in London would leave the running of his affairs in the hands of a German whose attitude to Nazis could be called into question. [1016]

In their dealings with American art museums, it is clear that the Hunts managed to cultivate close relationships with individuals who were not only Jewish, but whose lives had been touched by the anti-Semitic campaign of the Nazis. Such persons would have included Georg and Hanns Swarzenski who, because of their Jewish background, had fled as refugees from Germany

to the MFA in Boston in 1938, and the Met Director, James Rorimer, formerly head of the Monuments, Fine Arts and Archives Section in the US Seventh Army. Rorimer stayed as a guest in three of the Hunts' homes and wrote saying how 'very much' he liked them and appreciated their kindnesses.[1017] One might question whether it is credible that the most high profile hero of the recovery of Nazi-looted art in World War II, himself a Jew, was a personal friend of individuals who were part of a circle of 'dealers in looted art'.[1018]

Sotheby's had clearly no fears that any suggestion of anti-Semitic attitudes by Hunt might emerge when the firm recommended him in 1966 to Harry Frank Guggenheim, scion of the wealthiest Jewish family in the world after the Rothschilds, to produce a brochure of the latter's home at Falaise, Long Island, New York.

The Hunts enjoyed other close friendships with several individuals who had taken action against the Nazi tyranny within occupied Europe, including Piet Kasteel, the Netherlands ambassador to Ireland, who fought against the German invasion of his homeland before escaping to Britain where he became secretary to the Prime Minister of the Netherlands government-in-exile. For his wartime services to the Allied cause he was awarded the American Medal of Freedom. In 1964, before his departure to become Netherlands ambassador to Israel, Kasteel was honoured in Dublin by the committee of the Chief Rabinnate of Ireland with a certificate signifying that trees would be planted in his name in Israel.

A particularly good friend was Wolf Donndorf from Stuttgart, whose son, Michael, became Putzel's god-son. Donndorf, who was half Jewish through his mother, became author of the memory book *Erinnungsbuch* for the martyred Jewish landscape artist, Kathe Loewenthal, who has become an iconic figure in highlighting the mindless Nazi extermination of Jews. The Donndorfs had been close friends to Loewenthal, who was murdered in Izbica in 1942 and are widely credited with saving her sister, Susanne Ritscher, from a similar fate by hiding her in their family cabin in the Swabian mountains where, putting their own lives at risk, they brought her

food for more than a year.

In the immediate post-war period, Wolf was appointed to the administrative staff of the French Occupation Zone under General Koenig.[1019] During this time, despite strict controls on the movement of people into Germany, Putzel was able to get the appropriate papers to enable her to visit her mother in Baden-Baden 'through a contact on the staff of General Koenig' and it is highly probable that Donndorf was the contact involved. [1020] Michael Donndorf has stated that it is inconceivable that his parents and the Hunts could have been such good friends if there had been even the slightest possibility that the Hunts had sympathy with Nazis or had ever dealt in Nazi looted art: 'it would not be possible to conceal such a thing, everyone in the art world knew all about each other'. [1021]

The Lynn Nicholas report encapsulated in a pithy final sentence the injustice that had been done to the Hunt family and to those associated with the Hunt Museum: 'It is, of course, important to recover and return items unlawfully taken during World War II, but it is equally obligatory, in the pursuit of justice, to protect people and institutions from unproven allegations'.[1022]

Endnotes

Chapter 1

1 Sybil Connolly to Putzel Hunt, 19 January 1976. Connolly, an internationally renowned dress designer, was a very close friend of the Hunts from the 1950s onwards, basing her operation initially at their former property in Dublin's 71 Merrion Square which she purchased from the Hunts in 1957

2 National Archives of Ireland, file 2006/133/134

3 Joe Floyd to Putzel Hunt, 27 January 1976

4 Richard Randall, Director, Walters Art Museum, Baltimore, Maryland to Putzel Hunt, 23 February 1976, HFA

5 White, James, 'John Hunt, an appreciation', *The Irish Times*, 24 January 1976, p 11

6 Ruiz, Cristina, 'The Legacy of the Ever Elusive John Hunt', *The Art Newspaper*, No. 73, 1 September 1997

7 *Irish Press*, 21 January 1976, p 4; *The Irish Times*, 18 April 1978, p 8

8 Culhane, Rev. James Canon, *North Munster Antiquarian Journal*, Vol. XVIII, 1976, p 93; Doran, Patrick F, 'Studia in Memoriam John Hunt', *North Munster Antiquarian Journal*, Vol. XX, 1978, p 3; Peter Harbison, *Studies*, Vol. 65, Winter 1976, p 322

9 *Limerick Leader,* 28 April 1954, p 3

10 'Central figure in Bunratty Restoration Dies', *Clare Champion*, 23 January 1976

11 A military intelligence report (undated, but probably 1941) recorded that: 'Mr. Hunt is supposed to be 'one of the Limerick Hunts' … His father was Irish and a member of the well known Hunt family of Friarstown, Croom, Co. Limerick'. File no. G2/4371 Military Archives, Cathal Brugha Barracks, Dublin

12 Doran, Patrick (ed.), *50 Treasures from the Hunt Collection*, Hunt Museum/Treaty Press, 1993

13 These latter two issues were raised in a 165 page document, *The Hunt Controversy - A Shadow Report*, written by Erin Gibbons and issued by the Simon Wiesenthal Centre, Paris, in December 2008

14 The Portman Estate held 270 acres of land in London running from the north side of Oxford Street and east from Edgeware Road through the district of Marylebone.

15 Mary Louisa was the daughter of Edward Vinall, the first vicar of St. John's Church in Hildenborough, Tonbridge, Kent.

16 *The Record of Old Westminsters*. London, England: Chiswick Press, 1928, p 494

17 This arose through kinship to John Powell, accountant and executor to the Paymaster General of the British Army, Henry Fox, later the first Baron Holland.

18 While these Hunt ancestors were mostly part of the established order in late eighteenth-century Ireland, one family member, George Blake of Garracloon,

became Commander-in-Chief of the Irish rebel forces in 1798 after General Humbert landed with French troops at Killala, County Mayo. Following the defeat of the Franco-Irish forces at Ballinamuck in County Longford, Blake was captured and hanged from the spokes of a cartwheel. A monument to him stands today in nearby Tubberpatrick cemetery.

19 Victoria Dickenson, daughter of John Hunt's sister, Greta, interview, 21 April 2010

20 Probably Greencroft Primary School, Nottingham

21 John Hunt to 'My Dear Mother', from The Tower, Dovecourt Essex, undated

22 http://www.kings-school.co.uk/

23 http://www.kings-school.co.uk/ link to 'Memories of King's' 'William Simpson, at King's School, 1929 – 1932'

24 Maughan, W. Somerset, *Of Human Bondage*, George H. Doran Company, London, 1915, Chapter XV, line 35

25 Letter to author from Paul Pollak, School Archivist, King's School Canterbury, 1 June 2005

26 'School Speech Days', *The Times*, 31 July 1917, p 3

27 Girouard, Marc (ed.), *Directory of British Architects 1834-1914*, Royal Institute of British Architects, Continuum: London 2001, p xiii

28 *The Irish Times*, April 20 1962, p 10

29 Marks, Richard, *Burrell – Portrait of a Collector*, Richard Drew Publishing: Glasgow, 1983, p132

30 Hunt, John Jr., *The Irish Times*, 18 January 1992, p 25

31 Sandy Martin, interview, 8 December 2006

32 Harris, John, *Moving Rooms, The Trade in Architectural Salvage,* Yale University Press, 2007, pp 112-113

33 Fitzgerald, F. Scott, *The Great Gatsby*, Charles Scribner's Sons, New York, 1925, Chapter 3

34 Harris, *Op. cit.*

35 To this day White Allom can display several Royal Warrants including that as 'architectural decorator' to the present Queen Elizabeth

36 Sandy Martin, interview, November 2005

37 *The Irish Times*, 18 January 1992, p 25; see Marks, *op, cit*. p 108

38 Harris, *Op. cit.*, p 173

39 Baptismal certificate issued by Fr. L Belton, S.J. Church of the Immaculate Conception, Farm St., London, W.1., 11 December 1957

40 Culhane, Rev. James Canon, *North Munster Antiquarian Journal*, Vol. XVIII, 1976, p 94

41 *The Irish Times*, April 20 1962, p10

42 Lambert, Eleanor, New Journal, Mansfield, Ohio, *Collectors Share 'Squirrel Instincts'*, 4 June, 1970, p 18

43 *Ibid.*

44 Richard Hunt, interview, 20 April 2010

45 Victoria Dickenson, interview, 22 April 2010

46 Richard Hunt, *Op. cit.*

Chapter 2

47 Horsley, Carter B., http://www.thecityreview.com/feigen.html

48 E.V. Lucas, *A Wanderer in London*, Methuen & Co., London, 1906, p 45

49 Lucas, *Op. cit.,* Mary Robinson, a mistress of George IV when he was Prince of Wales, was an earlier resident of Hunt's premises at 13 St. James's Place

50 Black, Jonathan, *Journal of the history of Collections,* Vol. 21, No. 2 (2009), p 255

51 When Hunt's mother, Effie Jane, died in 1941, her estate was valued at £303.7s. 4d. and his inheritance consisted of two pieces of furniture and a tea set

52 John Hunt to James Rorimer, 24 January, 1933, MMA-DMAC files.

53 *Connoisseur,* April 1934, p 340

54 Harris, Lucian, 'Collector's Focus: Medieval Art', *Apollo,* 7 January 2008

55 *Ibid*

56 1550, 3 & 4 Edw. VI, c 10

57 Cheetham, Francis, *English Medieval Alabasters: with a catalogue of the collection in the Victoria and Albert Museum,* Boydell Press, Woodbridge, 2005, p 54

58 Carrier, David, *Museum Skepticism: a History of the Display of Art in Public Galleries,* Duke University Press, 2006, p 129

59 William Wixom, *New York Times,* 8 August 1994

60 See Maurice, Clare and Turnor, Richard, *International Journal of Cultural Property,* 1992, Vol. 1, p 294

61 *Export of Objects of Cultural Interest, Report presented to Parliament pursuant to Section 10(1)(a) of the Export Control Act 2002,* London, The Stationery Office, December 2011, Appendix A

62 Kehoe, Emmanuel, 'The remarkable Gertrude Hunt', *Sunday Press,* 23 April 1978, p 8

63 Lambert, *Op. cit.,* p 18

64 The *Altkatholisch* (Old Catholic) church was formed in Germany Austria and Switzerland by Roman Catholics who rejected papal infallibility as set out by the First Vatican Council, 1870

65 'Baden Under Martial Law', *The Times,* 25 February, 1919, p 9

66 Comment by Trudy Hunt relaying her mother's description of life in Mannheim Castle post World War I.

67 Lambert, *Op. cit.,* p 18

68 *Ibid.*

69 Kehoe, *Op. cit.,* p 8

70 John Hunt to James Rorimer, 24 January 1933, MMA-DMAC files

71 *Ibid.* The South Kensington Museum was the original name of The Victoria and Albert Museum (V&A)

72 *Ibid.*

73 Williamson, Paul, *The Burlington Magazine,* Vol. 132, No. 1053, Dec 1990, pp 863-866

74 A brief trip to Bremerhaven in February 1938 appears to have been Hunt's last pre-war visit.

75 John Hunt to Preston Remington, 13 September 1933, MMA-DMAC files

76 *Ibid.*

77 *Ibid.*

78 *Ibid.*

79 *Connoisseur,* May 1937, p 291; these two pieces were eventually sold to The National Gallery of Ireland by Putzel in 1978 for £80,000

80 *Op. cit.*

81 *Connoisseur,* May 1935, p 344

82 Lambert, *Op. cit.,* p 18

83 The main records of such objects are as follows: William Burrell: 159; Philip Nelson: 21; *Burlington Magazine*: 17; *Con-*

noisseur. 30; British Museum: 14; V&A: 16; Metropolitan Museum: 10; Fitzwilliam Museum: 1

84 Alastair Fraser, Acting Assistant Librarian, Durham Cathedral Library, 'Durham Dean and Chapter minute book', DCD/B/AA/23 (1929-1938)

85 Victoria Reed, Research Fellow for Provenance of European Art at the MFA, to author, 20 September, 2010

86 The cover is in the Museum of Fine Arts (MFA) in Boston, Accession number: 38.1082 and the other pieces are in the Robert Lehman wing of the Met.

87 Waymark, Peter, *The Times*, 18-24 February 1984, p 11

88 Marks, *Op. cit.*, p 132

89 *Sir William Burrell in Search of Xanadu*, Scottish Television (STV) production for Channel 4, shown 1984

90 *Ibid.*

91 *Ibid.*

92 William Wells, Keeper, Burrell Collection to John Hunt, 20 November 1962

93 Marks, *Op. cit.*, p 131

94 *Ibid.*, p 132

95 Details of Hunt's dealings with Burrell are taken from the purchase books held at the Burrell Museum, Glasgow.

96 *The Burlington Magazine*, December 1983, p 725

97 *Gentleman's Magazine*, 6 October, 1833, p 305

98 Kendrick, Thomas D, *Antiquarian Journal*, Vol. XVI, 1936, p 51

99 Marks, *Op. cit.*, p 135

100 Marks, *Op. cit.*, p 134

101 www.metmuseum.org/works_of_art/collection_database/the_cloisters/

enthroned_virgin_and_child

102 Marks, *Op. cit.*, p 129

103 John Hunt to Burrell, 28 April 1936

104 Examples include alabaster heads of St. John the Baptist on a plate, Registration no. HCM 034 in the Hunt Collection and Accession No. 1.34 in the Burrell Collection

105 Waymark, Peter, *Op. cit.*

106 Marks, *Op. cit.*, p 129

107 Rushton, Pauline, *Apollo Magazine*, No. 467, Jan. 2001, pp 41-48

108 John Hunt to Philip Nelson, invoice, 13 July 1939, WAGL files

109 Invoice from John Hunt to Philip Nelson, 24 July 1934. The price of the object was £18; Nelson, Philip, 'Two Twelfth Century Bronzes', *Acta Archaeologica*, Vol. V, Fasc.3, Copenhagen, 1935 pp 282-284; Nelson, Philip, 'Limoges Enamel Altar-cruets of the Thirteenth Century', *The Antiquaries Journal*, Vol. 18, January 1938, pp 49-54.

110 Nelson, Philip, *Acta Archaeologica*, Vol. IV, Copenhagen, 1933, pp 252-254; Hunt Museum registration no.: HCA 623.

111 Nelson, Philip, *The Antiquaries Journal*, Vol. 18, No. 2, April 1938, pp 183-184; Zarnecki, George, *Burlington Magazine*, Vol, 101, No. 681 (Dec 1959) pp 452, 454-456; Hunt Museum registration no. : MG 074 A

112 John Hunt to Philip Nelson, 22 March 1939

113 John Hunt to Philip Nelson, 23 September 1947. Hunt, John, 'A silver gilt casket, and the Thame ring', was published in *Intuition und Kunstwissenschaft: Festschrift fur Hanns Swarzenski*, Berlin: Gebr. Mann Verlag, 1973

114 John Hunt to Philip Nelson, 20 December 1937.

115 Margaret Longhurst, V&A, 1 August 1933, V&A files

116 Eric Maclagan to John Hunt, 5 October 1936

117 John Hunt to the Private Secretary to the King of Egypt, Abdin Palace, Cairo, undated

118 The sale to King Faud never took place and Hunt had acquired the oliphant by the time it was published in the *Corpus of Islamic Ivory Sculpture* by Ernst Kühnel, 1971, no. 61. Today it is in the al-Sabah collection in the Kuwait National Museum, (inv. LSN 12 I)

119 John Hunt to the Private Secretary to the King of Egypt, Abdin Palace, Cairo, undated

120 Hunt, almost certainly, acted free-of-charge

121 Ralph Edwards to John Hunt, 11 April 1938, V&A files; John Hunt to Ralph Edwards, 13 April 1938, V&A files.

122 John Hunt to Ralph Edwards, 12 October, 1938, V&A files.

123 Adolf Mahr to Sec'y Department of Education July 1939, NMI files

124 *Connoisseur*, April 1934, p 340

125 Harris, Lucian, 'Collectors Focus: Medieval Art', *Apollo*, 7 January 2008

126 *Connoisseur*, May 1935, p 344

127 *Ibid*

128 John Hunt to Philip Nelson, 1 March 1939

129 *Connoisseur*, October 1937, pp 199-200

130 *Connoisseur*, November 1938, p 258

131 *Burlington Magazine*, Nov. 1938, Vol.

132 Sandy Martin, interview, 8 December 2006

133 Harris, Lucian, 'Collectors Focus: Medieval Art', *Apollo*, 7 January 2008

134 Glueck, Grace, 'Art Review: The High Art Of Dressing For Battle', *New York Times*, 15 October 1998

135 Ruiz, *Op. cit.,*

136 Fitzwilliam Museum Object Number: M.19-1938. Details of the object's provenance in the 1930s were accessed at www.fitzmuseum.cam.ac.uk in June 2012 but have been removed since

137 Hampton and Sons, London, as per *The Times*, 9 June 1936, p 30

138 John Hunt to Ralph Edwards, 12 October 1938, 20 December 1938

139 Marks, *Op. cit.,* p 132

140 Note on object file 1979.402, MMA-DMAATC; Secrest, Meryle, *Duveen: A Life in Art,* The University of Chicago Press, Chicago, 2004, p 7

141 Marks, *Op. cit.,* p 132

142 John Hayward to Putzel Hunt, 23 January, 1976. Hayward was Deputy Keeper of Furniture and Woodwork at the V&A.

143 Howard Ricketts to Putzel Hunt, 5 February, 1976, HFA

144 Secrest, *Op. cit.,* p 163

145 Sandy Martin, interview, 26 February 2007

146 Seligman G., *Merchants of Art: 1880-1960*, New York, Appleton-Century Crofts, 1961, p 14

147 Sotheby's Sales Catalogue, 28 July 1939, item 103, p 16, auctioneers' copy, British Library; John and Putzel Hunt to Rorimer, 5 February 1952, MMA-

DMAC files

Chapter 3

148 Hansard, HC Deb. 8 August 1940, vol. 364

149 This chapter draws extensively on two publications for background on the Holocaust in Worms, Huttenbach Henry R, *The Destruction of the Jewish Community of Worms 1933-1945,* The Memorial Committee of Jewish victims of Nazism from Worms, New York, 1981, and Schlosser, Annelore and Karl, *Kiener Blieb Verschont,* Verlag Stadtarchiv Worms, 1987

150 John and Putzel Hunt to Philipp and Anna Markus, 15 February, 1939, HFA.

151 IAF Kiefel, Stadtarchiv Judisches Museum, Worms, to Sarah Jackson, Art Loss Register London, 5 July 2004 (translation)

152 Huttenbach, *Op. cit.*

153 Huttenbach, *Op. cit.,* p 24

154 Putzel had previously visited the Markuses at their home in Worms

155 Philipp and Anna Markus to John and Putzel Hunt, 25 December 1938, HFA

156 Philipp and Anna Markus to John and Putzel Hunt, 26 February 1939, HFA

157 Philipp and Anna Markus to John and Putzel Hunt, 18 August 1939, HFA

158 John and Putzel Hunt to Philipp and Anna Markus, 15 February 1939, HFA

159 Philipp and Anna Markus to John and Putzel Hunt, 26 February 1939, HFA

160 Philipp and Anna Markus to John and Putzel Hunt, 17 June 1939, HFA

161 Philipp and Anna Markus to John and Putzel Hunt, 18 August 1939, HFA

162 *Ibid.*

163 Stadtarchiv record

164 Police index card in Worms Stadtarchiv

165 Schlosser, *Op. cit.,* p 79

166 Huttenbach, *Op. cit.,* p 39

167 *Ibid.*

168 Schlosser, *Op. cit.,* p 79

169 Huttenbach, *Op. cit.,* p 235

170 Louise London, *Whitehall and the Jews, 1933 – 1948, British immigration policy, Jewish refugees and the Holocaust,* Cambridge University Press, 2000, p 11; www.spartacus.schoolnet.co.uk/2WWgermansBR.htm

171 Jane Williams, interview, 19 April 2009.

172 Patrick Wallace, Museum Director, *Speaking Ill of the Dead,* RTÉ 11 September 2006

173 *Ibid.*

174 O'Donoghue, David, *Sunday Business Post,* April 2004

175 Perhaps €25,000 in today's money

176 H.E. Kilbride-Jones, *Archaeology Ireland,* Vol. 7 No. 3 (Autumn 1993), pp 29-30.

177 Gerry Mullins, *Dublin Nazi No. 1 The Life of Adolf Mahr,* Liberties Press, Dublin 2007

178 David O'Donoghue, *Hitler's Irish Voices,* Beyond the Pale Publications, Belfast, 1998, p27

179 Mahr forwarded information to Germany in the pre-war period on Germans in Ireland, identifying those who were Jewish. Later, during the war, he supported anti-Jewish propaganda in radio services broadcast from Berlin

180 John Hunt to Adolf Mahr, 16 May 1938, NMI files

181 Charles McNeill to Adolf Mahr, 20 May 1938, NMI files

182 John Hunt to Adolf Mahr, 12 July 1939, NMI files

183 Adolf Mahr to Secretary, Department of Education, 14 July 1939, NMI files

184 The gold ornament collection was sold in 1941 to New York art agents, Berry-Hill Galleries, and is now in the Museum of Fine Arts (MFA) in Boston and the Detroit Institute of Arts

185 This was enshrined in law under the Anglo-Irish Treaty of 6 December 1921 (Article 4) and the Oath of Allegiance in the Irish Constitution of 1922 (Article 17). The new Irish Constitution of 1937 left in place all laws arising from the 1922 Constitution

186 Dáil Éireann debates from 31 March 1937 (Vol. 66 No. 1, p 36) and 7 December 1938 (Vol. 73 No. 9, p 58) would suggest that (i) only 21 British nationals, mostly children, were granted Irish naturalisation in the first three years following the passing of the 1935 act and (ii) more than 80% of naturalisation applications were granted

187 S.I. No. 555/1935, Irish Nationality and Citizenship Regulations, 1935, Form No. 13

188 Regulation 18B (1) of the Defence (General) Regulations 1939

189 NMI files (un-numbered), P O'Connor, Acting Director to Secretary Dept of Education, 31 July 1940

190 J.F. de Andrade to Dr Philip Nelson, 5 October 1939, Philip Nelson Archives, Walker Gallery, Liverpool

191 Walter Leo Hildburgh to Philip Nelson, 16 December 1939, Philip Nelson Archives, Walker Gallery, Liverpool

192 *The Burlington Magazine for Connoisseurs,* Vol. 76, No. 442, Jan 1940, back matter, page un-numbered

193 *Ibid.*

194 Panikos Panayi, *Germans In Britain Since 1500,* London, Hambledon, 1996, p168

195 www.militantesthetix.co.uk/yealm/yealm17.htm,

196 *Ibid.*

197 Cesarani, David, and Kushner, Tony, *The Internment of Aliens in Twentieth Century Britain,* Portland Oregon, Frank Cass and Co. Ltd., 1993, p 172; *Manchester Journal,* 11 June 1940

198 *Buckinghamshire Advertiser,* 10 May 1940, p 5

199 *Buckinghamshire Advertiser,* 17 May 1940, p 7

200 Letter to *Daily Sketch,* 10 April 1940

201 Coleman, Peter, *Quadrant Magazine – History,* May 2005

202 Interview with author, 2006

203 Both Trudy Hunt and Howard Ricketts recall this story

204 NA file DO 35/997/5 p 38 Home office notice 1 June 1940

205 John Hunt to Thomas Kendrick, British Museum Files, undated, probably July 1940

206 *Ibid*

Chapter 4

207 Dom Bernard O'Dea, Homily at funeral mass, 24 March 1995, HFA

208 John Hunt to Thomas D Kendrick,

July 1940, BM files

209 NMI files, Dr. P O'Connor, Acting Director, National Museum, to Secretary Dept of Education, 31 July 1940

210 NMI files (un-numbered), P O'Connor, 31 July 1940

211 These objects had been on loan from Captain Ball to the Hertfordshire Museum in St. Alban's, England

212 A Stelfox to Asst. Secy Department of Education, 20 August 1940, NMI files

213 Pronsias Ó Dubhthaigh to Acting Director, National Museum, 14 August 1940, NMI files

214 Stelfox, *Op. cit.*

215 Raftery was later Director of the Museum (1976-1979)

216 Hunt to Kendrick, *Op. cit.*

217 Lambert, *Op. cit.*

218 Cush and Lough Gur in County Limerick and Garranes Fort in County Cork

219 Sr Regina O'Brien, interview, 8 July 2011

220 'Stone-Age Burials Revealed', *Irish Press*, 10 September, 1940, p 7

221 'Archaeology – Enemy of Partition, An English View' *Irish Independent*, 16 February 1940, p 6

222 Grahame Clark, *Archaeology and Society*, Methuen & Co., London, 1939, p 194

223 *Ulster Journal of Archaeology*, Third Series, Vol. 3, 1940, p 81

224 *Irish Press*, 10 October 1940

225 *Ibid*

226 *Irish Press*, 11 October 1940

227 There was evidence of habitation at Caherguillamore since Neolithic times and extensive ancient remains, including dwellings, forts and roadways from later periods

could be seen

228 *Irish Press*, 10 March 1941

229 *Irish Builder and Engineer*, 12 April 1941

230 Ó Riordáin, Sean P, *Proceedings of the Royal Irish Academy*, 47C, 1942, pp 77-150

231 Ó Riordáin, Sean P and Hartnett, P J, *Proceedings of the Royal Irish Academy*, Vol. 49C (1943/1944), p 38

232 Ó Riordáin, Sean P and O Danachair, Caoimhin, *JRSAI*, Vol. 77, Jul. 1947, pp 39-52

233 John Hunt to Joe Raftery, received 22 October 1940, NMI files

234 Advertisement for M.J. Hayes, Auctioneer, Bruff, Limerick Leader, 21 December 1940, p 6

235 Robert Herbert, Limerick Librarian, *Limerick Leader*, 11 April, 1953, p 1

236 *Vogue* (American Edition), 15 August 1954, pp136-138

237 Hunt, John with Ó Riordáin, Sean P, *Journal of the Royal Society of Antiquaries of Ireland*, Vol. 72, 1942, pp 37-63

238 Mitchell developed a long-lasting friendship with the Hunts and in a paper published in Mitchell, G F, 'A pollen-diagram from Lough Gur, County Limerick', *Proceedings of the Royal Irish Academy*, Vol. 56C (1953/1954), pp 481–488 recorded Hunt's assistance in 1948 to erect a pontoon which he moored in the middle of Lough Gur in order to drill into the lake deposits to see whether information on the prehistoric occupation of the area could be established from a pollen-diagram

239 At Ballycullane Bog some two miles away from Rockbarton

240 Edward Walsh to the author, 18 June 2011

241 The re-constructed urn is today on display at the Hunt Museum Limerick, object reference no. HCA 610

242 John Hunt, *Clonroad More, Ennis*, JRSAI, 1946, vol.76, pp195-209

243 *Ibid.*

244 Joyce, Mannix, *Limerick Leader*, 25 January 1976

245 *Limerick Leader*, 19 November 1941, p 6

246 *Ibid.*

247 *Ibid.*

248 Grace Cantillon, interview, October 2009

249 Mary Geary, interview, September 2010

250 Hunt would later pen the obituary to Monsignor Moloney in the North Munster Antiquarian Journal after the latter's death in 1964

251 Cantillon, *Op. cit.*; O Faolain, Sean, *The Irish Times*, 1 June 1967, p 10

252 Grace Cantillon, *Op. cit.*; *The Irish Times,* 20 April 1962, p 10

253 Cantillon, *Op. cit.*

254 Putzel Hunt to Joseph Raftery, 22 July 1943, NMI files; Putzel Hunt to Joseph Raftery, 1944, NMI files

255 Both statues are now in the National Gallery of Ireland, NGI 8246 and NGI 8247; the drawing is in the Hunt Museum, MG 145

256 Neville, Pat, *Limerick Leader*, 13 March, 2004, p 9

257 Sr Regina O'Brien, interview, 8 July, 2011

258 Petrol shortages would probably have curbed this activity during the war years

259 Unpublished replies to questions posed by *American Vogue* magazine prior to the latter's publication of the article 'Lough Gur – the Limerick house of Mr. and Mrs. John Hunt', 15 August 1954, pp 136-138

260 Sr Regina O'Brien, interview, 8 July 2011

261 Cantillon, *Op. cit.*

262 Joan Duff (daughter of Dr Devane), interview, 4 October, 2010

263 When daylight saving time was introduced into Ireland and Britain in August 1916, many farmers, particularly in Ireland, stayed on 'old time'. In October 1940 the clocks in Ireland were not put back and this situation prevailed until October 1946

264 *The Irish Times*, 17 September 1931, p 13

265 William Hunt in 1811 and Vere Hunt in 1828, both from Friarstown Park, less than ten miles from Lough Gur

266 *An Tóstal* was a national cultural festival held annually in Ireland from 1953 to 1958

267 Joyce, Mannix, (An Mangaire Sugach), *Limerick Leader*, 31 January 1976, p 19. Cushcountryleague should read Cush Duntryleague,

268 Fr Bernard O'Dea, homily at the funeral mass of Gertrude Hunt on 29 March 1995

269 Share, Bernard, *Bunratty, Rebirth of a Castle*, Dingle, Brandon Book Publishers Ltd., 1995, p 95

270 Irish Military Archives, File G2 4317, letter from Captain N. Hewett to undecipherable recipient in Military Intelligence Dublin, dated Foynes, 16 March 1944; I&C stands for Department of Industry and Commerce

271 This correspondence was to be used

on Wellington Quay: 'Bloowho went … by
Wine's antiques, in memory bearing sweet
sinful words'.

327 John Hunt to Saemy Rosenberg,
Rosenberg and Siedel New York, 8 September 1947, HFA

328 Edward McGuire to John Hunt,
21 November 1942, HFA

329 John Hunt to Thomas Kendrick,
29 November 1942, BM files

330 Francis Wormald to John Hunt,
20 February 1943, HFA

331 In handwritten notes Hunt records
Oman as saying that there was another
jewel with translucent enamel on gold in
the British Museum and also one in Spain,
HFA

332 John Hunt to Fr Martin D'Arcy,
12 January 1943, HFA

333 The *Associated Press* report on Fr
D'Arcy's death in 1976 noted that he
'counted among his friends the leading minds of the time, physicist Albert
Einstein, philosopher Bertrand Russell and
poet TS Eliot'. D'Arcy was a great patron
of the arts and formed the wonderful art
collection at Campion Hall in Oxford
University. The Martin D'Arcy Museum
of Art in Loyola University Chicago is
dedicated to Medieval, Renaissance and
Baroque art and was named in his honour.
Evelyn Waugh is considered to have
modelled Fr Rothschild in *Vile Bodies* on
Fr D'Arcy

334 Martin D'Arcy to John Hunt,
29 January 1943, HFA

335 Martin D'Arcy to John Hunt,
31 October 1964. D'Arcy had been told of
the possible sale of the altar by Laura, Lady

Lovat, a prominent Catholic, who in turn
had been informed about the matter by
Lady Victoria Herbert, a personal friend of
the Wittelsbachs

336 Edward McGuire to John Hunt,
undated, probably summer of 1946.
McGuire added a postscript saying: 'By the
way should you still decide to take it I will
buy it back at any time for £2,000'

337 The latter consisted mostly of
eighteenth-century items, much of them
French, including clocks, a silkscreen, a
tapestry and, of greatest value, a set of
Louis XV chairs

338 Garrison, Edward B Jr, 'A Ducciesque
Tabernacle at Oxford', *Burlington Magazine*,
Vol. 88, 1946, pp 214-223

339 Edward McGuire to John Hunt,
5 September 1946, HFA

340 *Ibid.*

341 *Ibid.*

342 John Hunt to Edward McGuire, undated hand-written draft, September 6/7
1946, HFA

343 *Ibid.*

344 *Ibid.*

345 Edward McGuire to John Hunt,
7 September 1946, HFA

346 Hunt to Edward McGuire, handwritten draft, possibly September 8/9
1946, HFA

347 Cox was a solicitor and legal advisor
to many state companies established in the
development phase of the Irish State. A
deeply religious man, after his retirement
he was ordained a priest and became a
missionary in Africa

348 John Hunt to Edward McGuire,
11 September 1946, HFA

349 Edward McGuire to John Hunt,
13 September 1946, HFA

350 Edward McGuire to John Hunt,
4 October 1946, HFA

351 Edward McGuire to John and Putzel
Hunt, 12 December 1942, HFA

352 John Hunt to Arthur Cox & Co.,
23 February 1947, HFA

353 Campbell, *Op. cit.*, on p 422, endnote
7, the inventory is referenced as: *Disposition Maximillian1* 20.1.1617 – Geheimes
Hausarchiv Munchen 6/3 nr 1588

354 Campbell, *Op. cit.*

355 Campbell, *Op. cit.*, p 418

356 *Ibid.*

357 Sire, HJA, *Father Martin D'Arcy –
Philosopher of Christian Love*, Leominster,
Herefordshire, Gracewing, 1997, p 148

358 It is unclear from the files whether the
£1.050 was all in cash. Certainly McGuire
suggested cancelling some of the furniture
involved in the original exchange

359 John Hunt to Martin D'Arcy,
27 December 1946, HFA

360 Martin D'Arcy to John Hunt, 1 January 1947, HFA

361 Arthur Cox to John Hunt, 19 February 1947, HFA.

362 *Ibid.*

363 *Ibid.*

364 John Hunt to Arthur Cox & Co.,
22 February 1947, HFA

365 Arthur Cox to John Hunt, 4 March
1947, HFA. The Gardaí investigations
never got anywhere and almost a year later
Detective-Inspector Farrelly was to inform
Arthur Cox that: 'there never had been any
suggestion of anything improper on anyone's part. They had been put in motion

by some enquiry which had reached them
and therefore they had to make their routine investigation'.

366 Fr Buggy, on behalf of D'Arcy, to John
Hunt, 10 April 1947, HFA

367 *Ibid.*

368 *Ibid.*

369 Sire, HJA, *Op. cit.*, reported a more
detailed story saying that 'an English sailor
looking for loot found the triptych among
the rubble and pocketed it. His next posting took him to Cork where he used the
triptych to pay for drinks in a pub; The
pub-keeper then presented it to a convent
for his daughter's First Communion'

370 Martin D'Arcy to John Hunt, 12 April
1947, HFA

371 *Ibid.*

372 *Ibid.*

373 *Ibid.*

374 They initially settled in Amsterdam
and later set up a business together in
London.

375 Raphael Rosenberg, S & R Rosenberg, Works of Art, 32 St James Street,
London, to Mr and Mrs John Hunt, 1 May
1947, HFA

376 John Hunt to Saemy Rosenberg,
Rosenberg and Siedel New York, 8 September 1947, HFA

377 *Ibid*

378 *Time Magazine*, 21 August 1939

379 *Ibid*

380 He reportedly refused to underwrite
financial operations for the German
government and gave a large anonymous
donation to the French Government in
1939 for the National Defence Fund,
for which he was enrolled in the French

Legion d'Honneur. Hitler was later to target his huge art collection which included Rembrandts, Vermeers and Canalettos and bought it from the Mendelsohn Bank receiver at well below the asking price during the war

381 Harclerode, Peter and Pittway, Brendan, *The Lost Masters World War II and the Looting of Europe's Treasurehouses*, Welcome Rain, New York, 1999, Ch.1

382 *Time Magazine*, 21 August 1939

383 Reynaud a year later was Prime Minister of France and brought Charles de Gaulle into the French government in a short-lived attempt to resist the Germans before the surrender of France. His dealings with Mannheimer were used against him in a Vichy government show trial, and he was handed over to the Germans who kept him imprisoned for the duration of the war. Ironically, given the obituary from a year earlier on Mannheimer, Reynaud had featured as a French hero on the cover of the *Time Magazine* on 17 June 1940, his last day as French Prime Minister

384 Her mother was an Irish-American Catholic, Ignatia Mary Murphy, from San Francisco

385 Arthur Cox to John Hunt, 14 August 1947, HFA

386 John Hunt to Saemy Rosenberg, 8 September 1947, HFA

387 Arthur Cox to Jane Mannheimer, 14 September 1947, HFA

388 Rosenberg & Stiebel to Arthur Cox, 28 October 1947, HFA

389 Charles Engelhard Jr., son of the founder of Engelhard Minerals, made a fortune in getting around South Africa's ban on gold bullion exports by making finished art objects from newly mined gold and exporting the objects to be later melted down. He was the inspiration for the character 'Goldfinger' in the James Bond novel written by his friend, Ian Fleming

390 *New York Times*, 3 March 2004

391 Slaughter & May Solicitors to Arthur Cox, 28 November 1947, HFA

392 Arthur Cox to John Hunt, 1 December 1947, HFA

393 Arthur Cox to T G McVeagh, 17 February 1948, HFA

394 According to Sire, H.J.A., *Op. cit.,* p 149, Mrs Engelhard was introduced to Fr D'Arcy by Mrs John Pierrepoint

395 Martin D'Arcy to John Hunt, 22 March 1948, HFA

396 Arthur Cox to Putzel Hunt, 30 March 1948, HFA

397 Arthur Cox to Slaughter & May, 14 September 1948, HFA

398 Arthur Cox to Slaughter & May, 18 September 1948, HFA

399 Slaughter & May Solicitors to Arthur Cox, 21 September 1948, HFA

400 Harclerode, Peter and Pittway, Brendan, *Op. cit.*

401 *Ibid.*

402 http://www.herkomgesocht.nl/nl// collecties/index.html

403 Arthur Cox to John Hunt, 24 August 1951, HFA

404 Hayes & Co. to Arthur Cox, 23 August 1951, HFA

405 Arthur Cox to John Hunt, 24 August 1951, HFA

406 John Hunt to Arthur Cox , 5 Septem-

ber, 1951, HFA

407 Martin D'Arcy to John Hunt, 3 April 1952, HFA

408 Copy of telegram in John Hunt's handwriting, undated, HFA

409 Arthur Cox to Hayes & Co., 9 April 1952, HFA

410 *Ibid.*

411 *Ibid.*

412 *Ibid.*

413 *Ibid.*

414 T.G. McVeagh to Arthur Cox, 10 April 1952, HFA

415 John Hunt to Fr D'Arcy, 10 April 1952

416 *Ibid.*

417 Martin D'Arcy to John Hunt, 14 April 1952, HFA

418 Martin D'Arcy to John Hunt, 22 April 1952, HFA

419 Fr Martin D'Arcy to Putzel Hunt, 1 May 1952, HFA

420 Fr Martin D'Arcy to Putzel Hunt, 11 May 1952, HFA

421 Fr Martin D'Arcy to John Hunt, 12 May 1952, HFA

422 John Hunt to Arthur Cox, 17 May 1952

423 Arthur Cox to John Hunt, 21 May 1952, HFA

424 *Ibid.*

425 Edward McGuire to John Hunt, 30 May 1952, HFA

426 Martin D'Arcy to John Hunt, 7 July 1952, HFA. The reference to 'her nephew' probably referred to a nephew of Fritz Mannheimer who emerged as a claimant at a later date.

427 *Ibid.*

428 *Ibid.*

429 Fr Martin D'Arcy to John Hunt, 8 September 1952, HFA

430 Charles Oman, V&A, to John Hunt, 20 April 1953, HFA

431 John J. McDonald & Co. to Arthur Cox & Co., 10 October 1953

432 *Ibid.*

433 Arthur Cox to John J. Mc Donald & Co., 13 October 1953, HFA

434 John J. McDonald & Co., to Arthur Cox & Co. Solicitors, 22 October 1953, HFA

435 Martin D'Arcy to John Hunt, 26 October 1953, HFA

436 Originating Summons Plenary, High Court of Justice Ireland, 1953, No. 1335P, 10 December 1953, HFA

437 *The Irish Times*, 19 December 1953 p 5; *Irish Independent*, 19 December 1953, p 3

438 *The Irish Times*, 19 December 1953, p 5

439 John Hunt to Martin D'Arcy, 28 December 1953, HFA

440 Arthur Cox to John Hunt, 2 January 1954, HFA

441 Arthur Cox to Martin D'Arcy, 2 January 1954, HFA

442 Arthur Cox to John Hunt, 9 January 1954, HFA

443 Arthur Cox to John Hunt, 13 January 1954, HFA

444 J. Chenue of Monmouth Street, London, was the London branch of Andre Chenue, an art packing and transportation company long established in Paris

445 High Court of Justice, 1954, No. 38 P, Defence on behalf of Edward A McGuire, filed 31 May 1956

446 *Ibid.*

447 Arthur Cox to John Hunt, 21 May 1952, HFA

448 Martin D'Arcy to John Hunt, 1 January 1947, HFA

449 Arthur Cox to John Hunt, 4 March 1947, HFA.

450 John Hunt to Saemy Rosenberg, 8 September 1947, HFA

Chapter 6

451 O'Brien, Kate, in Kemmy, Jim (ed), *The Limerick Anthology*, Gill and Macmillan, Dublin 1996, p 320

452 Ramsay, LGG, *Connoisseur*, pp 74-79, March 1961; Le Clerc, Percy, *Limerick Leader*, 20 April 1963

453 John Hunt presentation to Gene Burke, Milburn McCarty Associates Inc., New York, before 11 September 1959, HFA

454 O'Regan, Brendan and Dornan, Patrick F., to Economic Cooperation Administration (ECA), 'Report on Study Tour USA 1950', 29 April 1950, p 12 (The ECA was the joint administrator of the Marshall Plan.)

455 Share, Bernard, *Bunratty: Rebirth of a Castle*, Brandon Book Publishers, Dingle, 1995, p 148

456 Power of Attorney signed by Lord Gort, 7 November 1954, HFA

457 John Hunt to Brendan O'Regan, 4 November 1958 HM/ARCH/B1a/00027(1)

458 Letter to his brother, Count Thomas Rinuccini, in Rinuccini's papers in the Biblioteca Rinucciniana published by its librarian, G. Alazzi, Nunciatura in Irlanda di Monsignor Gio. Batista Rinuccini (Florence) 1844

459 Thackeray, William Makepeace, *The Irish Sketch Book*, Vol.1, Charles Scribner's Sons, New York, 1911, p 198

460 Wright, Fergus, *Sunday Independent*, 23 May 1960

461 http://www.museumsmanitoba.com/ (20 October 2012)

462 Rosemarie Bolster, daughter of his sister, Joyce, interview, January 2005

463 Hunt Museum, HM/ARCH/B1a/00001 Hunt Family Files – Projects – Bunratty Castle, County Clare, *c.*1952-71

464 Gort to Putzel Hunt, 31 August 1952 HM/ARCH/BIA/00001(1); Gort to Putzel Hunt, 5 Nov 1952 HM/ARCH/BIA/00001(5)

465 Gort to Putzel Hunt, 5 Nov 1952 HM/ARCH/BIA/00001(5)

466 *The Irish Times*, 31 October 1952, p 5

467 Gort to Putzel Hunt, 20 Nov 1952, HM/ARCH/BIA/00001(6)

468 John Hunt presentation to Gene Burke of US Public Relations Company, Milburn McCarty Associates Inc., of New York, undated but shortly before 11 September 1959, HFA

469 Gort to John Hunt, 22 December 1952, HM/ARCH/B1A/00001(11)

470 Gort to John Hunt, 13 May 1953, HM/ARCH/B1A/00001(21)

471 Fanning, B, on behalf of Secretary, The Commissioners of Public Works to RH Russell, 12 March 1953, HM/ARCH/BIA/00003

472 Gort to Percy Le Clerc, 12 June 1953; Share, 1995, *Op. cit.,* p 93

473 Gort to John Hunt, 13 June 1953

HM/ARCH/BIA/00001(23)

474 Gort to John Hunt, 30 August 1953 HM/ARCH/B1a/0000(28);

475 Share, 1995, *Op. cit.,* p 113

476 Share, 1995, *Op. cit.,* p 111

477 *The Irish Times,* 16 March 2002, p 16

478 Le Clerc, Percy, paper delivered to Thomond Archaeological Society, *Limerick Leader,* 20 April 1963, p 8

479 O'Halloran, Michael *Irish Press,* 9 October 1954, p 5

480 *Ibid.*

481 Lord Gort, Power of Attorney, HFA

482 Memo of a meeting held on 14 February 1956 at Bunratty Castle Hotel attended by Hunt, Lord and Lady Gort and Le Clerc, HM/ARCHB1a/00009(10)

483 Percy Le Clerc to John Hunt, 22 February 1955, HM/ARCH/B1a/00006(5)

484 Percy Le Clerc to John Hunt, 11 March 1955, HM/ARCH/B1a/00006(4)

485 L Fanning pp Secy. Commissioners of Public Works, to Whitney Moore and Keller, 3 September 1955, HM/ARCH/B1a/00008(7)

486 *Ibid.*

487 Percy Le Clerc to Lord Gort, 10 February 1956, HM/ARCH/B1a/00009(2)

488 B. Fanning for Secy. OPW, 16 May 1956, HM/ARCH/B1a/00014(2)

489 Percy Le Clerc to Lord Gort, 5 June 1956, HM/ARCH/B1a/00010

490 The trust was to hold the Castle for Lady Gort for her lifetime and, after that, for Gort's niece, Lady de L'Isle

491 John Hunt to Commissioners OPW, 24 November 1956, HM/ARCH/B1a/

492 *Ibid.*

493 *Ibid.*

494 TJ Morris to John Hunt, 15 January 1957, HM/ARCH/B1a/00006(1)

495 Percy Le Clerc Memorandum, 24 February 1958, HM/ARCH/ B1a/00022(1)

496 In 1959 it became Ireland's first and only regional development agency, Shannon Free Airport Development Company, promoting the greater mid-west area or, as it became known, the 'Shannon Region'

497 Internal Bord Fáilte memorandum to Mr Hartnett, Technical Manager, headed 'Estimates', 13 December 1957, HM/ ARCH/B1a/00017(1)

498 Gort subsequently gave Hunt a fourteen-year lease of the South Solar section of the castle at a nominal rent of £1, with the tenant to pay a proportionate share of rates and electricity

499 Percy Le Clerc to P J. Hartnett, Bord Fáilte, 24 February 1958, HM/ ARCH/B1a/00018(2) and HM/ARCH/ B1a/00022(1)

500 *Ireland of the Welcomes,* July–August 1958

501 *Ibid.*

502 Gordon Clark, Bord Fáilte, to John Hunt, 1 September 1958, HM/ARCH/ B1a/00025(4)

503 John Hunt to Brendan O'Regan, 4 November 1958, HM/ARCH/ B1a/00022(1)

504 *Ibid.*

505 *Ibid.*

506 Bord Fáilte (signature indecipherable) to Joe McElgunn, Shannon Airport Authority, 25 November 1958, HM/ ARCH/B19/00028

507 Brendan O'Regan to John Hunt,

6 December 1958, HFA

508 Share, 1995, *Op. cit.*, p101

509 Bernard Share, interview, 1994

510 Le Clerc, Percy, *Limerick Leader*, 20 April 1964, p 8

511 *Ibid.*

512 Pat Crowe, interview, February 2012

513 *Ibid.*

514 *Ibid.*

515 Quidnunc, *The Irish Times*, 9 September 1959, p 6

516 Crowe, *Op. cit.*

517 *Ibid.*

518 *Ibid.* The Charlemagne tapestry, the largest in Bunratty, was in fact only twenty-three feet wide

519 *Ibid.*

520 *Ibid.*

521 *Ibid.*

522 *Ibid.*

523 *Ibid.*

524 White, James, *The Irish Times*, 24 January 1976, p11

525 *The Irish Times*, 30 May 1960, p 4

526 *Sunday Independent*, 29 May 1960, p 5

527 *The Irish Times*, 30 May 1960, p 5

528 *Ibid.*

529 Na Gopaleen, Myles, *The Irish Times*, 7 June 1960, p 6

530 Smith, Noel, *Sunday Independent*, 17 July 1960, p 6

531 *Ibid.*

532 While the surroundings were heated and furnished with rugs, they were as Spartan as the facilities that would have prevailed some four hundred years earlier. Hunt's daughter, Trudy, who stayed there several times as a child, recalled, in particular, the hardness of the beds

533 John Hunt to P J. Hartnett, Bord Fáilte, 20 October 1959, HFA

534 Tim O'Driscoll, Bord Fáilte Director-General, to John Hunt, 3 July 1959. O'Driscoll pointed to Skansen in Stockholm, visited by over 2,000,000 people annually as a possible model, adding that the National Museum had a lot of material that it cannot display because of lack of a suitable space

535 Hunt to Hartnett, *Op. cit.*

536 *Ibid.*

537 McCarthy founded the Loyola Foundation in 1957 which, in the next 50 years, was to donate over $40,000,000 to Roman Catholic missionary activities outside the continental United States

538 Christy Lynch interview, February 2008

539 Share, 1995, *Op. cit.*, p 148

540 Andrew Devane to John Hunt, 26 September 1959 and Andrew Devane to Messrs. AJ Jennings and Co., 6 October 1959, HFA

541 *Ibid.*

542 Richard O'Farrell, SFADCO, to John Hunt, 12 October 1959, HFA

543 Christy Lynch and Joe McElgunn

544 The funds due from Clare County Council never materialised and were replaced by an amenity grant from the Department of Local Government

545 Minutes of Meeting concerning 'The Shannon Folk Park at Bunratty' held at Shannon Shamrock Inn, 15 March 1963

546 Minutes of Meeting held at Shannon Airport, 15 May 1963

547 *The Irish Times*, 27 July 1963, p 11

548 Share, 1995, *Op. cit.*, p 148

549 *The Irish Times*, 30 May 1960, p 5

Chapter 7

550 Lightbown, Ronald, *Irish Arts Review Yearbook*, Vol. 11 (1995), p 237

551 Howard Ricketts, interview, 8 June 2009

552 Lambert, *Op. cit.* p 18

553 Registration no.: 48.153, MMA-DMAC files

554 According to Sandy Martin, who later worked with Putzel, many of these properties were in Chelsea and Fulham and he particularly recalled one particular property which they renovated in Evelyn Gardens off the Fulham Road

555 John Hunt to Leigh Ashton, 18 December 1949, V&A files

556 *Ibid.*

557 *Ibid.*

558 Leigh Ashton to John Hunt, 23 December 1949, V&A files

559 Leigh Ashton to Norton Lee, 23 December 1949, V&A files

560 Sotheby's sales catalogue for 16 December 1949, item 67, p 11; Cox, Rev J Charles, *The Reliquary*, July 1889, p 133

561 Cox, *Op. cit.*, p 119

562 A David Black of David Black and Sons, whose London gallery was No. 1 Burlington Gardens in Mayfair, was, according to Sandy Martin, the 'Mr. Black' referred to. The firm specialized in antique English and Continental material and was seeking to acquire primitive art objects

563 Putzel Hunt to James Rorimer, 13 October 1953 MMA- DMAC files

564 *Ibid.*

565 Sandy Martin, interview, 2005

566 John Hunt to Ralph Edwards, 5 November 1953, V&A file

567 Putzel Hunt to James Rorimer, 13 October 1953, MMA-DMAC files.

568 John Hunt to Fr. Martin D'Arcy, 28 December 1953, HFA.

569 http://www.britishmuseum.org/research/search_the_collection_database/term_details.aspx?bioId=85613

570 *The Irish Times*, 29 August 1949, p 5

571 Sandy Martin, interviews, 2005-2008

572 White, James, *Sunday Tribune*, 26 March 1995

573 Sandy Martin, interview, 2005

574 John Hunt to Dick and Pooh Randall, 15 July 1957, MMA-DMAC files

575 Putzel Hunt to William H. Forsyth, MMA- DMAC files

576 The Von Hirsch evaluation was conducted in Basel, Switzerland in conjunction with Howard Ricketts of Sotheby's. Ricketts, interview, 29 October 2012

577 British Museum Registration number: 1965.0704.1

578 Sandy Martin, interview, 2005

579 Phelps S, *Art and Artefacts of the Pacific, Africa and the Americas: the James Hooper Collection*, London 1976: p 13

580 Bacon, Francis, *Three Studies of Portraits*, Lucian Freud, Isabel Rawthorne and John Hewitt (sic), 1966

581 *The Times*, 17 January 1952, p 8

582 *The Times,* 18 January 1956, p 4

583 Sandy Martin, interview, 2005

584 Waterfield, Hermione, King, Jonathan C.H., *Provenance: Twelve Collectors of Ethnographic Art in England, 1760-1990*, Paul Holberton Publishing, London 2010

585 Sandy Martin, interview, 2005

586 *Ibid.*

587 *Ibid.*

588 *Ibid.*

589 Ralph Edwards to John Hunt, 2 November 1953, V&A files

590 Ralph Edwards to John Hunt, 28 November 1953, V&A files

591 Putzel Hunt to E.A. Lane, 10 March 1960, V&A files

592 John Hunt to Rupert Bruce-Mitford, 18 March 1965, BM files

593 Ralph Edwards to John Hunt, 2 November 1953, V&A files

594 Minute to Director, Sir Eric Maclagan, 1938, V&A Files

595 http://collections.vam.ac.uk/093441/cope/

596 John Hunt to James Rorimer, 3 September 1952, MMA -DMAC files

597 John Hunt to James Rorimer, 19 December 1954, MMA-DMAC files

598 James Rorimer to John Hunt, 29 December 1954, MMA-DMAC files

599 Hunt to Rorimer, 2 January 1955, MMA-DMAC files

600 Hunt to Rorimer, 6 January 1955, MMA-DMAC files

601 GF Wingfield to ETS Adamson, 8 January 1955, V&A files

602 W Derbyshire to Sir Leigh Ashton, 18 March 1955

603 Rorimer to Hunt, 23 March 1955, MMA-DMAC files

604 Hunt to Rorimer 21 March 1955, MMA-DMAC files

605 Ashton, V&A to Mrs. Meldrum, National Art Collections Fund, 17 March 1955, V&A files

606 G.N. Flemming, Permanent Secretary, Ministry of Education to Ashton, 22 March 1955

607 Ashton to The Earl of Crawford and Balcarres, 22 March 1955

608 Ashton to Lord Kilmaine, 24 March 1955, V&A files

609 Kilmaine to Ashton, 31 March 1955

610 Ashton to Kilmaine, 31 March 1955, V&A files

611 Butler Bowdon to Ashton, 6 April 1955, V&A files

612 Ashton to Butler Bowdon, 12 April 1955, V&A files.

613 Ashton to Hunt, 12 April 1955, V&A files

614 Butler Bowdon to Rorimer, 9 July 1955, MMA-DMAC file.

615 *Ibid.*

616 *Ibid.*

617 *Hansard Volume* 542, No. 13, Cols 86&87

618 *Daily Telegraph*, 24 June 1955, p1

619 Note by GW Digby, 2 July 1955, V&A files

620 Butler-Bowdon to Rorimer, 9 July 1955, MMA-DMAC files

621 Ruiz, *Op. cit.*

622 *The Times*, 25 October 1944, p 2

623 Rupert Bruce-Mitford to Sir Mortimer Wheeler, 16 March 1967, BM Files

624 Kendrick, Thomas D., *Anglo-Saxon Art to A.D. 900*, Methuen, London, 1938, Pl. 90, pp 202 and 212

625 Classified Ad. by Messrs. Henry Spencer and Sons. *The Times*, 5 March 1957, p 16

626 Rupert Bruce-Mitford, 22 July 1963, BM files

627 Hunt to Bruce-Mitford, 6 June 1964, BM files.

628 Hunt to Lord Eccles, undated, but late July /early August 1964, BM files

629 Putzel Hunt to Margaret B. Freeman, Curator, Medieval Art Department, Metropolitan Museum, 8 June 1963, MMA-DMAC files

630 Howard Ricketts, interview, 8 June 2009

631 Howard Ricketts, interview, 8 June 2009

632 Elizabeth Wilson, interview, December 2005 and April 2009

633 *Ibid.*

634 *The Times,* 5 June 1984, p 12

635 Norman, Geraldine, *The Times,* 21 June 1984, p 14

636 Howard Ricketts, interview, 8 June 2009

637 John Hunt to Philip Nelson, 15 April 1940, HFA

638 *Ibid.*

639 His MI6 code number was 007 and he was a friend of the author of the James Bond books, Ian Fleming, who served as liaison officer to MI6 from the Director of Naval Intelligence

640 Lacey, Robert, *Sotheby's - Bidding for Class,* Warner Books, London, 2000; p 150

641 Gibb, Frances, *The Times,* 1 December 1980, p 8; the authorised history is: Herrmann, Frank, *Sotheby's, Portrait of an Auction House,* London, Chatto and Windus, 1980. The other books in question are: Faith, Nicholas, *SOLD The Rise and Fall of the House of Sotheby,* New York: Macmillan Publishing Company, 1986; *Sotheby's - Bidding for Class,* London, Little Brown and Company, 1998; and Watson, Peter, *Sotheby's – The Inside Story,* London,

Bloomsbury Publishing PLC, 1997

642 Howard Ricketts, interview, 8 June 2009

643 Clavary became Wilson's permanent home after his retirement as Chairman of Sotheby's

644 Howard Ricketts recalls a meeting at Chateau de Clavary in 1968 at which time the Hunts were just beginning to restore Bergerie (in French a 'sheep pen')

Chapter 8

645 Jacqueline Kennedy to John and Putzel Hunt, probably Tuesday, 4 July 1967, HFA

646 Sandy Martin, interview, 2005

647 Putzel Hunt to Sister Regina O'Brien, 13 August 1956

648 Lisney and Son, Auctioneers, sales brochure, April 1981

649 M'Dougall was father-in-law of the famed Trinity College Provost, John Pentland Mahaffy

650 *Irish Independent*, 13 June 1959, p 9

651 Waters was also involved in the furnishing of Bunratty Castle

652 Ligier Richier's statue of the Virgin, along with a companion piece of John the Evangelist, is now in the National Gallery in Dublin. They are possibly the only complete works of sixteenth-century French sculptor Ligier Richier to be found outside a church in the artist's native Lorraine, or the Louvre in Paris

653 John O'Connor, interview, 2009

654 The Picasso was a drawing, *4 Cats Plat del Dia,* which the Hunts probably brought to Ireland with other favourite pieces in either September 1939 or July 1940

655 Howard Ricketts, interview, June 2008

656 *Ibid.*

657 Jackson Stops and McCabe, Auctioneers, brochure, April 1954

658 Trudy Hunt, interview, June 2008

659 Grace Cantillon, interview, October 2009

660 Reynolds, Jim, *The Irish Times*, 22 April 1993, p 23

661 John and Putzel Hunt to Margaret B. Freeman, Director of the Cloisters, 8 June 1963, MMA-DMAC files.

662 Soe, Sineve, *Sunday Independent*, 8 September, 1996, p 7; John Hunt Jr stated in an interview that he had been adopted from a Limerick convent at the age of six months

663 John and Putzel Hunt to James Rorimer, 16 December 1957, MMA-DMAC files

664 *Ibid.*

665 Putzel Hunt to Miss Freeman of The Cloisters, New York, 8 June 1963, MMA-DMAC files

666 John Hunt to Tom Hoving, 21 August 1963, MMA-DMAC files. Hoving became curator of the Medieval Arts Department and of the Cloisters in 1965 and became Director of the Metropolitan Museum in 1966

667 John Hunt to James Rorimer, received 18 November 1963, MMA-DMAC files

668 David Cornelius Röell to Putzel Hunt, 18 August, 1957; like James Rorimer, Röell had been a member of the Monuments Fine Arts and Archives (MFAA) group (the 'Monuments Men') established by the Allies in 1943 to protect and recover cultural property in wartime Europe

669 Trudy Hunt recalls being tossed in the air by the dancers and said it most likely prompted her to study Russian later in university

670 Peggy Rockefeller to Putzel Hunt, undated, but probably from a visit to Ireland in April 1969

671 Frances Brody to Putzel Hunt 23 August, (year not stated); Brody's own art collection was sold in 2010 for a record-breaking $224 million

672 Charles J Haughey to John Hunt, 2 June, 1970. It is noteworthy that Haughey found the time to write to Hunt, since just five days earlier, on 28 May, he had been arrested and charged in court at the start of a series of legal proceedings known as the *Arms Trial*

673 *Time Magazine*, 23 June 1967

674 Jacqueline Kennedy to John and Putzel Hunt, *Op. cit.*

675 Jacqueline Kennedy to John Hunt, 28/29 October 1967, HFA

676 *Ibid.*

677 *The Irish Times*, 4 June 1958, p 6

678 Hynes, Ita, *Sunday Independent*, 8 June 1958, p 7

679 For example, the Donegal Handwoven Tweed Association promotions were heavily sponsored by the Irish Export Board

680 *Irish Independent*, 20 May 1957, p 3

681 Quidnunc, *The Irish Times*, 2 July 1965, p 7

682 *See* Dunne, Aidan, *The Irish Times*, 6 January 2006, p 14

683 Putzel Hunt to Tom Hoving, Direc-

tor of the Metropolitan Museum of New York, June 1964, MMA-DMAC files

684 John Hunt to Thomas Hoving, MMA-DMAC files

685 Founder of the Irish Museums Trust, and one-time acting director of Dublin's Chester Beatty Library; Hunt was also a patient of her husband, Dr Frank Duff

686 Lambert, *Op. cit.*

687 Graham Sutherland to Putzel Hunt, 25 October 1960, HFA

688 Connor (d.1943) a sculptor from Annascaul in County Kerry, had earlier done the Lusitania Sculpture in the centre of the town of Cobh, County Cork

689 James White to Putzel Hunt, 17 October, 1977, HFA

690 McDonnell was one of the fourth generation of his family involved in the antique trade in Ireland and a founding father of the Irish Antique Dealers Association

691 Jane Williams, interview, June 2009

692 Richard H Randall, The Metropolitan Museum of Art, to John Hunt, 23 January 1957, MMA-DMAC files

693 'Spectrum' 12 April, 1963; Telefís Éireann later became RTÉ 1

694 Dr Peter Harbison, interview, 6 August 2009.

695 *Limerick Leader*, 20 April 1963, p 8

696 Donogh O'Malley to John Hunt, 20 July, 1967, HFA. This was specifically a reference to Rosc'67 which commenced in November of that year.

697 'O'Malley Hopes For tour By Gallery', *The Irish Times*, 2 June 1967, p 8

698 John Hunt to Donogh O'Malley, 27 February 1968, HFA

699 *Ibid.*

700 *Ibid.*

Chapter 9

701 Tomkins, Calvin, *Merchants and Masterpieces,* E.P Dutton and Co. Inc., 1970, p 265

702 John and Putzel Hunt to Rorimer, 28 September 1955, MMA-DMAC files

703 Hunt to Rorimer, received 18 November 1963, MMA-DMAC files

704 Tomkins, *Op.cit.,* p 205

705 The better known of these would have included J.P Morgan and John D. Rockefeller Jr.

706 Hunt to Rorimer, 24 January 1933, MMA-DMAC files

707 *Ibid.*

708 Hunt to Preston Remington, 13 September 1933, MMA-DMAC files

709 Rorimer to Hunt, 27 November 1933, MMA-DMAC files. The refusal reflected the fact that, the Met, under the direction of its then President, George Blumenthal, had severely curtailed its expenditures on acquisitions since the Wall Street crash in 1929 and the onset of the Depression

710 Remington to Hunt, 8 October 1937, MMA-DMAC files

711 These include two sixteenth-century German drawings, one by the printmaker Sebald Beham, (accession no. 1975.1.857), the other by sculptor Hans Schwarz (accession no. 1975.1.873) and three drawings by Flemish Jacob Jordaens, accession nos. 1975.1.830/834/835/837

712 For further details of the MFAA *see*: Edsel, Robert M., and Witter, Bret, *The*

Monuments Men, Center Street, Nashville, 2009

713 Accession no. 48.153

714 Originally part of the *Nine Heroes* Tapestries, Accession no. 49.123

715 Rorimer to John and Putzel Hunt, 3 August 1951, MMA-DMAC files

716 Rorimer to John and Putzel Hunt, 3 January 1952, MMA-DMAC files

717 Sotheby's Sales Catalogue, 28 July 1939, item 103, p 16, auctioneers' copy, British Library

718 Rorimer to John and Putzel Hunt, 3 January 1952, MMA-DMAC files

719 John and Putzel Hunt to Rorimer, 8 January 1952, MMA-DMAC files

720 John and Putzel Hunt to Rorimer, 5 February 1952, MMA-DMAC files

721 Rorimer to John and Putzel Hunt, 4 January 1953, MMA-DMAC files

722 Taylor, Francis Henry, 'Art: Custodian of the Attic', *Time Magazine*, 29 Dec 1952

723 Accession no. 57.26.1

724 Thomas Hoving to Hunt, 28 August 1963, MMA-DMAC files

725 Gross, Michael, *Rogues' Gallery*, Broadway Books, New York, 2009, p 322

726 The Red Abbey Crucifix is now in the Hunt Museum, Limerick, Registration Number: HCM 050

727 Memo to Hoving from William Forsyth, May 1968, MMA-DMAC files. Hunt was later persuaded to send stained glass from Canterbury

728 This was an error. Blaney was Minister for Agriculture and Fisheries at the time

729 *Op. cit.*

730 Putzel Hunt to Jack Schrader, 26 February 1977

731 Press release, Public Information Department, MMA, December 1979

732 www.metmuseum.org/works_of_art/ collection_database/the_cloisters/ enthroned_virgin_and_child accessed July 2012

733 Accession no. 1980.417; Accession no. 1981.1

734 *Mirror of the Medieval World,* 9 Mar- 4 July 1999

735 Kaufman, Jason Edward, *The Art Newspaper*, April 1999, pp 10-11

736 William Wixom in note to author, 14 February 2006

737 John Hunt, *Festschrift fur Hanns Swarzenski,* Berlin, Mann, 1973, pp 345-373. A *Festschrift* is a celebratory publication honouring a respected academic

738 http://www.mfa.org/collections/ object/head-of-a-man-55301.MFA; Accession no. 42.41 accessed July 2012

739 Kurt Ticher to GH Edgell, 12 December, 1948, MFA files

740 *Ibid.*

741 Hunt to Edgell, 19 January 1949, MFA files

742 Edgell to Hunt, 1 March 1949, MFA files

743 Edgell to Hunt, 29 March 1950, MFA files

744 http://www.britannica.com/ EBchecked/topic/414176/Nicholas-of-Verdun accessed July 2012

745 Hunt to Philip Nelson, 23 September 1947

746 Evans J, Leeds. ET and Thompson A, *Antiquaries Journal,* Vol, XXI, 1941, pp 197202

747 Edwin J. Hipkiss to Edgell, 12

November 1953, MFA files

748 Hunt to Hanns Swarzenski, 29 November 1972, MFA files

749 Hunt, John, 'A silver gilt casket, and the Thame ring', *Intuition und Kunstwissenschaft: Festschrift fur Hanns Swarzenski* , Berlin: Gebr. Mann Verlag, 1973

750 Scarisbrook, Diana, *Apollo,* September 2009

751 http://www.mfa.org/search/mfa/53.2375 accessed July 2012

752 Hanns Swarzenski, *Bulletin of the Museum of Fine Arts,* Vol. 54, No. 295 (Spring 1956) pp 2-9

753 The MFA would not have realised that Putzel was the vendor as the jar was described as 'property of a lady'

754 Hanns Swarzenski to Kathryne, 10 May 1957, MFA files.

755 Hanns Swarzenski to Perry Rathbone, Director MFA, 13 February 1958, MFA files.

756 John and Putzel Hunt to Hanns and Brigitte Swarzenski, 28 December 1955, MFA files

757 Putzel Hunt to Hanns Swarzenski, 23 March 1956, MFA files

758 Internal report to Mr Perry Rathbone, Director MFA, possibly from Hanns Swarzenski, 18 September 1963, MFA files

759 Hanns Swarzenski to Rathbone, 13 December 1967, MFA files

760 http://www.mfa.org/collections/object/plaque-61491 accessed July 2012

761 http://www.mfa.org/collections/object/flagon-59325 accessed July 2012

762 Glanville, Philippa, *Silver in Tudor and Early Stuart England,* V&A, 1990, p 338

763 http://www.mfa.org/collections/object/college-cup-59319, accessed July 2012

764 http://www.mfa.org/collections/object/barrel-59434, accessed July 2012

765 Friends for Long Island's Heritage Website: http://www.fflih.org/preserves-7museums_and_preserves.cfm accessed July 2012

766 http://nynjctbotany.org/lgtofc/lgsandpt.html, accessed July 2012

767 Hunt to Harry Guggenheim, 13 November 1966, HFA

768 Letter from Harry Guggenheim to John Hunt, 6 December 1966, HFA

769 The report was entitled: *Appraisal of 'La Cuesta Encantada', The William Randolph Hearst Castle, San Simeon, California* by Sotheby Parke-Bernet Galleries Inc. and submitted on 4 February 1971

770 Peregrine Pollen to AJ Cooke, Hearst Corporation, 12 January 1970, HFA

771 Letter from Letitia Roberts to Putzel Hunt, 1 May 1976

772 Gordon Campbell, *The Grove Encyclopedia of Decorative Arts,* Vol.1, Oxford University Press, 2006, pp 154–155

773 E.A, Lane, V&A, memorandum 27 December 1956, V&A files

774 Rackham, Bernard, *Panel of Stained-glass from the collection of Dr. P Nelson,* 2 December 1954, MMA-DMAC files

775 Margaret B. Freeman to John and Putzel Hunt, 11 February 1963, MMA-DMAC files

776 WAM accession number: 42.1428

777 John and Putzel Hunt to Dick Randall, 15 July 1957, MMA-DMAC files

778 http://art.thewalters.org/viewwos.aspx?id=27938, accessed July 2012

779 *The Irish Press*, 27 May 1952, p 5

780 *Boston Herald*, 30 November 1986

781 Pat Wallace, interview, November 2005

782 Peter Harbison, interview, December 2006

783 Erin Gibbons, *Irish Arts Review*, Vol. 20, No. 1, Spring 2003, p 128

784 Both Swarzenskis had fled from Germany to the US in 1938. Georg became Curator of Decorative Arts and Sculpture at the MFA and was succeeded in this role by his son

785 Putzel Hunt, handwritten memo, undated, but most probably soon after April 1978

786 Putzel Hunt to Hanns Swarzenski, 24 July 1978

787 The museum was opened instead on 19 April 1978 by the local deputy and Minister for Industry, Commerce and Energy, Desmond O'Malley TD

788 *Ibid.*

789 Hanns Swarzenski to Putzel Hunt, 4 August 1978

790 *Ibid.*

791 *Ibid.*

792 Hanns Swarzenski to Putzel Hunt, 5 August 1978

793 Dr Michael Ryan, memorandum to Department of the Taoiseach, 31 January 1991

794 *Irish Press*, 10 August 1935

795 NMI file 1674/51; Joseph Raftery to Dr. J. Quane 5 September 1951

796 Rupert Bruce-Mitford, NMI file 22/51; Letter from Keeper of Medieval and Later Antiquities at the British Museum to Joe Raftery, 14 January 1955

797 Rynne, Etienne, *Irish Press*, 15 May 1956, p 6

798 Swarzenski, Georg, *Bulletin of the Museum of Fine Arts*, Vol. II, No. 289, 24 October 1954, p 5

799 Raftery, J (ed.), *Christian Art in Ancient Ireland'*, Vol. 2, Irish Government Stationery Office, 1941

800 *Ibid.*, p xxv

801 Minutes of MFA 'Committee on the Museum' 10 April 1952

802 Victoria Reed, Research Fellow for Provenance of European Art at the MFA, to author, 17 July 2006

803 Reed to Sarah Jackson, Art Loss Register London, 7 July 2006

804 Accessions 12 June 1952 through 16 October 1952, *Bulletin of the Museum of Fine Arts*, Vol. 50, No. 282 (Dec 1952), pp 82-88

805 Swarzenski, Georg, *Op. cit.*

806 Ó Riordáin, Seán P, *JRSAI*, Vol. 85, No. 1, 1955, p 18

807 McHugh, Roger, *Sunday Independent*, 4 December 1955, p 12

808 Dáil Éireann Debate, 9 May 1956, Vol 157, No. 2, p 11

809 Department of Education, 'Ard-Oifig' (Head Office), *Note for Minister - The Emly Shrine*

810 Cronin, Sean, *The Irish Times*, 25 October 1977, p 7

811 *Ibid.*

Chapter 10

812 Hunt, John, 'Care and Conservation', *The Irish Times*, 23 May 1962, p 8

813 Draft of letter (c. May 1974) from John Kelly, T.D. Parliamentary Secretary

to An Taoiseach, Liam Cosgrave and the Minister for Defence, Patrick Donegan. Hunt Museum archives

814 *http://www.clarelibrary.ie/eolas/coclare/archaeology/cragno.htm*

815 Jim Burke of SFADCO, interview, 25 January, 2010

816 *http://www.clarelibrary.ie/eolas/coclare/archaeology/cragno.htm*

817 Jim Burke, interview, 25 January, 2010

818 Cian O'Carroll, interview, 9 June, 2009

819 Putzel Hunt, hand-written note, HFA

820 *Irish Independent,* 29 September 1972, p 9

821 Cian O'Carroll, interview, 9 June 2009

822 Jim Burke, *The Other Clare,* Vol. 1, 1977, pp 13-15

823 Jim Burke, interview, 25 January 2010.

824 Executive committee meeting on 5 May 1972

825 Khan, Frank, *Irish Independent,* 29 September 1972, p 9

826 *Ibid.*

827 Jim Burke, interview, September 2009

828 Wood-Martin, WG, *The Lake Dwellings Of Ireland: Or, Ancient Lacustrine Habitations Of Erin, Commonly Called Crannogs,* Dublin, Hodges Figgis, 1886; Wilde, WR, *Proceedings of the RIA,* Vol.8, (1861-1864), pp 274-278

829 Cian O'Carroll, interview, 9 June 2009

830 Mitchell, Frank, A Man and the Landscape, *Archaeology Ireland,* Vol.3, No.3, (Autumn 1989), p 94

831 Rynne, Etienne and MacEoin, Gearóid, *NMAJ, 20,* 1978, pp 47-56

832 Jim Burke, interview, September 2009

833 Viney, Michael, *The Irish Times,* 7 June 1975, p 13

834 Cian O'Carroll, interview, 9 June 2009

835 http://www.shannonheritage.com/Attractions/Craggaunowen/RingFort/

836 Jim Burke, interview, January 2009

837 Viney, Michael, *Op. cit.*

838 Doran, Patrick F, *NMAJ,* Vol. 20, 1978, p 3

839 *The Irish Times,* April 18th 1978, p 8

840 *Ibid.* p 4

841 Hunt Museum registration no.: HCM 001; *The Irish Times,* 18 April 1978, p 8; Kehoe, *Op. cit.* p 8

842 *Ibid.* p 5

843 *Ibid.,* pp 5-6

844 Fox, Cyril, *The Archaeology of the Cambridge Region,* Cambridge University Press, 2010, p 51

845 The Hunt Museum Collection has currently some 300 ceramic objects, many of the pieces added representing household items retained at Drumleck at the time of the opening in 1978

846 One of these pieces, a rare eighteenth-century Dublin spirit barrel, featured on a 9p postage stamp in 1976. Hunt Museum, Registration Number HCL 031

847 Hunt, John, *JRSAI,* Vol 77, No. 2, 1947 pp158-159; Longfield, Ada K,, *JRSAI,* Vol. 81, No. 1, 1951. pp 34-36

848 Claude Blair, *British Book News,* February 1975

849 *Limerick Leader, Inspired by Limerick priest-historian,* 13 April 1974, p 17

850 For a complete bibliography of Hunt's published works *see:* Peter Harbison, *Stud-*

ies, Vol. 65, Winter 1976, p 322-329

851 *Connoisseur,* April 1954, pp 156- 161; March 1961, pp 94-95; September 1965, pp 2-6. November 1966 pp 151-153

852 Ralph Edwards and L.G.G. Ramsay (Eds.), *The Tudor Period 1500-1603,* London, 1956

853 Helena Hayward (Ed.), *World furniture – An Illustrated History,* London, Hamlyn, 1965, pp 19-24

854 Reprinted in *Studia in Memoriam John Hunt,* NMAJ, Vol. XX, 1978, pp 63-79

855 John Hunt, *Pantheon,* Vol. XXI, 1963, pp 151-157

856 Authors of such studies would have included Marie Duport, Helen M. Roe, and Edwin C. Rae

857 Richard Camber, *Dead Likenesses, Times Literary Supplement,* 1 November 1974

858 Alan Borg, *Connoisseur,* Vol. 188, No. 756, February 1975, p 152

859 Putzel Hunt to James Rorimer, 13 October 1953, MMA- DMAC files

860 David Davison, interview, 2 August 2012

861 John Hunt, *Irish Medieval Figure Sculpture,* Acknowledgements, p ix

862 Peter Harbison, interview, 6 August 2009

863 Published by Gill and Macmillan, Dublin, 1970; expanded edition, 1992

864 Harbison, interview, 6 August, 2009

865 John Hunt, *Irish Medieval Figure Sculpture,* General Introduction, p 18; p 5

866 Harbison, interview, 6 August 2009

867 Borg, *Op. cit.*

868 Harbison, interview, 6 August 2009

869 *Ibid.*

870 *Ibid.*

871 *Ibid.*

872 James White, *The Irish Times,* 24 January 1976, p 11

873 Harbison, interview, 6 August 2009

874 *Ibid.*

875 *Ibid.*

876 *Ibid.*

877 The official cause of death was arteriosclerosis and cerebral thrombosis. Hunt's daughter, Trudy, noted that he had suffered poor health most of his life and had been particularly affected by coronary problems

878 While precise sales prices for particular objects are normally kept confidential by the Met, it is clear that a substantial six-figure sum was achieved

879 Registration nos. 71.1157 and 71.1162 respectively

880 Acquired by John Hunt in 1946, it was sold by a later owner in 2000 for £938,500 at Sotheby's Irish Sale, USA (artnet.com) sell in 2000 for £938,500 at Sotheby's Irish Sale, USA (artnet.com)

881 James White to Putzel Hunt, 16 October 1978, HFA; *see* National Gallery of Ireland website for objects NGI.8246 and NGI.8247

882 John H Reinke SJ, Chancellor Loyola University of Chicago, to Putzel Hunt, 4 February 1977, HFA ; John H Reinke SJ, to Putzel Hunt, 22 August 1979 and 7 November 1979, HFA

883 Mairead Reynolds, NMI, to Putzel Hunt, 29 July 1980, HFA

884 Mairead Reynolds, NMI, to Putzel Hunt, 3 Dec 1980 and 28 July 1981, HFA

885 Follow link from: *http://www.leedscastle.com*

886 Kehoe, *Op. cit.*, p 8

887 Registration numbers 1981,1102.1, 1981,1102.2,1981,1102.3.; Putzel Hunt to Neil Stratford, Keeper of Medieval and Later Antiquities, British Museum, of 31 October 1981, HFA

888 Robert Bergman, Walters Art Gallery, Baltimore to Putzel Hunt, 15 October 1981, HFA; Dean Porter, Director Snite Museum of Art to Putzel Hunt, 8 October 1982, HFA

889 Dr J Naumann, Hetjens-Museum, Düsseldorf, to Putzel Hunt, 26 May 1982, HFA

890 The crucifix is displayed in the Paul and Jill Ruddock Medieval Europe Gallery

Chapter 11

891 Cullen, Paul, *The Irish Times,* 6 October 2007, p 42

892 Beesley, Arthur, *The Irish Times,* 7 February 2004, p 1

893 *Ibid.*

894 *Ibid.*

895 Teitelbaum Sheldon, *Los Angeles Times Magazine*, 15 July 1990, p 6; Dart, J, *Los Angeles Times*, 10 March 1990

896 It employs no specialists in the area of restitution of looted art and is not a member of the Conference on Jewish Material Claims Against Germany, the main body recognised by the Israeli, German and US governments since 1951 as representing victims of Nazi persecution and their heirs in seeking the return of Jewish property lost during the Holocaust http://twitter.com/simonwiesenthal

897 *The Times*, 20 September 2005

898 For some years prior to this, former

Irish President, Mary Robinson, had been a particular target of attack from the SWC for her view that 'the root cause of the Arab-Israeli conflict is the occupation'. (Robert Fisk, *The Independent*, London, 24 April 2004)

899 *The Irish Times*, 5 December 2003, p 1

900 Beesley, *Op. cit.*

901 Ciaran MacGonigal, *Museum Ireland*, Vol. 13, 2003, pp 13-14

902 *Ibid.*

903 *Ibid.*

904 'Hunt Museum boardroom battle settled at eleventh hour', *Limerick Chronicle,* 13 August 1998, p 1; 'Showdown at Hunt Museum', *The Phoenix,* 14 August 1998, p 18

905 *Irish Arts Review,* Vol. 20, No 1, Spring Edition, 2003

906 *Irish Arts Review,* Vol. 20, No 2, Summer Edition, 2003

907 *Ibid.*

908 *The Irish Times*, 26 November 2003, p 9

909 *The Irish Times,* 9 February 2004

910 Beesley, Arthur, *The Irish Times*, 13 February 2004 , p 6

911 *Ibid.*

912 Shimon Samuels interview with Cathal MacCoille, 'Morning Ireland', RTÉ Radio, 10 February 2004

913 *Ibid.*

914 *Ibid.*

915 Judith Hill, Hunt Museum website, 10 February 2004 (since removed)

916 *The Irish Times*, 10 February 2004, p 6

917 Press release, Hunt Museum website, 14 February 2004 (since removed)

918 Hanlon, Karl, 'Hunts stand down from

museum board', *The Irish Times*, 16 Feb 2004, p 3

919 Peter Harbison, Letters to Editor, 'Hunt Museum Collection', *The Irish Times*, 19 February 2004, p 17

920 Copy given to author by John Hunt Jr. March 2004, HFA

921 'The Sunday Show', interviewer Tom McGurk, RTÉ Radio, 22 February 2004

922 *Ibid.*

923 *Ibid.*

924 *Ibid.*

925 Dwane, Mike, *Limerick Leader*, 14 February 2004, p 1

926 *Ibid.*

927 Hanlon, Karl, *The Irish Times*, 6 March 2004, p 3

928 O'Connell, Brian, *Limerick Leader*, 27 March 2004, p 18

929 http://www.calzareth.com/tree/exhibits/worms_book.pdf, accessed October 2012

930 *Limerick Leader*, 18 April 2004

931 Arthur Beesley, *The Irish Times*, 17 August 2004, p 5

932 Burns, John, *Sunday Times*, 13 February 2005

933 *Ibid.*

934 The Art Loss Register is a London-based organisation with a database of 140,000 stolen objects and World War II–related works of art, which has dealt with many Holocaust claims in conjunction with two New York–based agencies, one set up under the umbrella of the World Jewish Council

935 Dr Shimon Samuels to President Mary McAleese, 26 January 2004

936 Ward, Colm, *Limerick Leader*, 26 March 2005

937 *Interim Report of the Hunt Museum Evaluation Group*, January 2006, p 9

938 *Final Report of the Hunt Museum Evaluation Group*, June 2006, Section 23, p 12

939 *Final Report of the Hunt Museum Evaluation Group*, June 2006, Appendix 2, pp 30–38

940 O'Donoghue, David, *Hitler's Irish Voices*, Belfast, Beyond the Pale Publications, 1998; Dwane, Mike, *Limerick Leader*, 2 February 2008, p 27

941 *Final Report of the Hunt Museum Evaluation Group*, June 2006, p 14

942 *Ibid.*

943 Dwane, Mike, *Limerick Leader*, October 2008, p 27

944 Report by Arcline Ltd., November 2006

945 This individual was interned for membership of the IRA or other subversive groups, and later rose to prominence as Chairman of the Gaelic Athletic Association in North America

946 *Final Report of the Hunt Museum Evaluation Group*, June 2006, p 11

947 Teehan, Virginia, *The Hunt Museum Case: Accusations, Research, Response*, paper delivered at RIA seminar, Dublin, 19 June 2006

948 Burns, John, Hunt Museum links to Nazi art 'were covered up', *Sunday Times* (Irish Edition), 25 June 2006

949 *Ibid.*

950 Simon Wiesenthal Centre, Press release, Paris, 21 June 2006 (since removed)

951 *Ibid.*

952 'Nazi Restrictions, Special Taxes Strip Jews of Wealth', *Jewish News Archive*, 25 December 1938

953 Royal Irish Academy, Press release 25 June 2006

954 Nicholas, Lynn, *Report on the Final Report to the Royal Irish Academy by the Hunt Museum Evaluation Group, June, 2006*, Washington DC, 8 August, 2007, endnote 24, p 21

955 Nicholas, *Op. cit.,* p 19

956 Nicholas, *Op. cit.,* pp 11-12, 19

957 Pogatchnik, Shawn, with Barchfield, Jenny, Associated Press, Paris, 29 September 2007

958 Kenny, Colum, *Sunday Independent*, 27 January 2008

959 *Ibid.*

960 *Ibid.*

961 Gibbons, Erin, *The Hunt Controversy, A Shadow Report*, Simon Wiesenthal Centre, Paris, December 2008 (a Shadow Report is a report submitted to an international human rights body by any organisation other than the Government).

962 Simon Wiesenthal Centre, Press release, 12 December 2008

963 Simon Wiesenthal Centre, Press release, 26 January, 2004; *International Herald Tribune*, 5 March 2004; Lister, David, *The Times*, 1 March 2004, p 6

964 Burns, John, *Sunday Times*, Irish edition, 13 February 2005

965 Nicholas, *Op. cit.,* pp 9-10

966 Gibbons, Erin, *Op. cit.,* pp 11, 79, 91, 92, 109, 110, 111, 118, 119, 120, 124, 147

967 Shimon Samuels to President Mary McAleese, 26 January 2004

968 Gibbons, December 2008, *Op. cit.,* pp 93-104

969 Gibbons, December 2008, *Op. cit.,* p 140; Nicholas Shakespeare, *Bruce Chatwin*,

Vintage, London 2000, p 185

970 MacGonigal, *Op. cit.*

971 Gibbons, December 2008, *Op. cit.,* p 104

972 Nicholas, *Op. cit.,* p 16

973 Joe Raftery, NMI file IA/237/47, 28 January 1947

974 His active support for Jewish refugees is highlighted in the following biographical note: http://www.dictionaryofarthistorians.org/kendrick.htm

975 Nicholas Shakespeare to author, 28 March 2006

976 Gibbons, December 2008, *Op.cit.,* pp 78-81

977 Gibbons, December 2008, *Op. cit.,* p 78

978 Vladimir Galitzine had an exemplary war record as a member of British Intelligence and father of a renowned Spitfire pilot, *see* 'Meet the Russian Prince in Wilmslow', *Cheshire Life*, 17 April 2010

979 'The Secret Hunters', Television South (UK), 16 September 1986

980 Stevenson William, *Spymistress: The life of Vera Atkins the greatest female secret agent of World War II*, Arcade Publishing, New York, 2007, p 310

981 'The Secret Hunters', *Op. cit.*

982 Shimon Samuels to President Mary McAleese, 26 January 2004

983 Shimon Samuels, 'Morning Ireland', RTÉ Radio, 10 February 2004

984 Gibbons, *Op. cit.,* p 111; p 146, p 11

985 https://www.mi5.gov.uk/home/mi5-history/world-war-ii.html

986 Burns, John, 'Team probing 'Nazi Loot' in museum quits', *Sunday Times*, 13 February 2005

987 Gibbons, December 2008, *Op. cit.,* p 11

988 Gibbons, December 2008, *Op. cit.,* p 147

989 O'Shaughnessy, Margaret, Director, Foynes Flying Boat Museum, *Information on records of all flights from Foynes Flying Boat base 1939 -1945,* communication to author, February 2011

990 Gibbons, December 2008, *Op. cit.,* p 146

991 Gibbons, December 2008, *Op. cit.,* p 111

992 *Ibid.*

993 Meeting and discussions with Captain Stephen MacEoin, January/February 2009

994 Commandant Padraic Kennedy email to author, 12 February 2013

995 Crime Branch, Section 3, Office of the Commissioner, Garda Síochána, to Military Intelligence, G.2 Branch, Department of Defence, 17 April 1943, Irish Military Archive file G2/4371; Gibbons, December 2008, *Op. cit.,* p 118

996 Gibbons, December 2008, *Op. cit., Preface by Shimon Samuels,* p 11

997 Gibbons, December 2008, *Op. cit.,* p118

998 Hunt Museum Evaluation Group, *Final Report to the Royal Irish Academy,* June 2006, p. 3

999 Gibbons, December 2008, *Op. cit.,* p 92

1000 Irish Military Archive, files nos. G2/0130 and G2/130

1001 Mullins, Gerry, *Dublin Nazi No. 1,* Liberties Press, Dublin,2007, p 221

1002 Shimon Samuels to President Mary McAleese, 26 January 2004

1003 Art Loss Investigating Unit, Final Report, Section V, *Biographical index of individuals involved in art looting,* Office of the Assistant Secretary of War, Washington D.C., 1 May 1946, p 131

1004 Nicholas, *Op. cit.,* p 16

1005 Erin Gibbons, *Op. cit.,* p 91; Erin Gibbons, *Op. cit.,* p 124

1006 Erin Gibbons, *Op. cit.,* p 92

1007 Charles McNeill to Adolf Mahr, 20 May 1938, (2nd note), NMI files

1008 John Hunt to Adolf Mahr, 16 May 1938, NMI files; McNeill, *Op. cit.*

1009 McNeill, *Op. cit.*

1010 http://www.dictionaryofarthistorians.org/kendrickt.htm

1011 Adolf Mahr to Sec'y Dept. of Education, 14 July 1939, NMI files; Joe Raftery memorandum, 28 January, 1947, NMI file IA/237/47

1012 Irish Military Archive file G2/0221, Kurt Tichauer (*sic*)

1013 Irish Military Archive file G2/4371, 20 October 1944; Kurt Ticher to GH Edgell, 12 December 1948, MFA files

1014 Fitzgerald Desmond in: McCarthy, Michael (ed), *Lord Charlemont and His Circle,* Four Courts Press, 2001

1015 The firm specialised in antique English and Continental material and was seeking to acquire primitive art objects

1016 Sandy Martin who knew Putzel well at this time stated that Black was Jewish

1017 Rorimer to John and Putzel Hunt, 3 January 1952, MMA-DMAC files

1018 Rorimer, James, *Survival: the Salvage and Protection of Art in War,* Abelard Press, New York, 1950

1019 Koenig was a Jew and later, as a

French minister, one of the most staunch
supporters of Israel in France
1020 Kehoe, *Op. cit.,* p 8
1021 Michael Donndorf, e-mail to author,
19 July 2012
1022 Nicholas, *Op. cit.,* p 20

Glossary Of Endnote Abbreviations

HFA: Hunt family archive

MMA-DMAC: The Metropolitan Museum of Art-Department of Medieval Art and The Cloisters

V&A: Victoria and Albert Museum

NMI: National Museum of Ireland

MFA: Museum of Fine Arts, Boston

NA: National Archives

S.I.: Statutory Instrument

BM: British Museum

RSAI: Royal Society of Antiquaries of Ireland

JRSAI: Journal of the Royal Society of Antiquaries of Ireland

OPW: Office of Public Works

MMA: The Metropolitan Museum of Art

WAM: Walters Art Museum

SFADCO: Shannon Free Airport Development Company

Index